SMILING BANJO

ERIC L. RING,
JAYNE TOOHEY &
JOHN T. LUPTON

A HALF CENTURY OF LOVE AND MUSIC AT THE PHILADELPHIA FOLK FESTIVAL

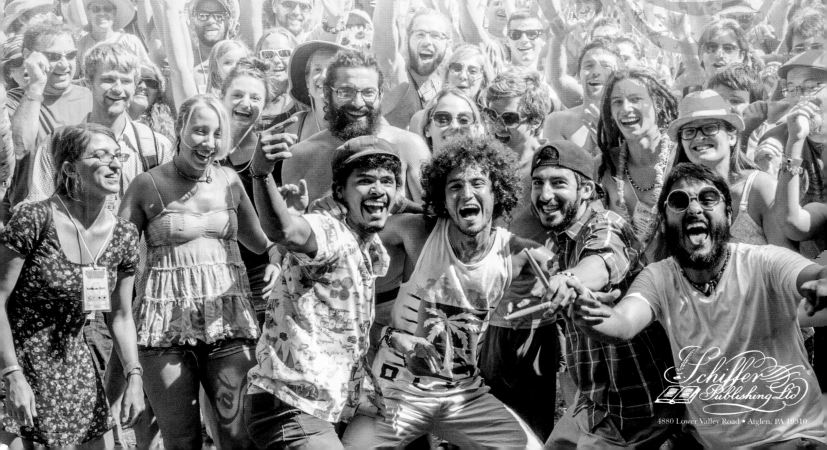

Schiffer Publishing Ltd
4880 Lower Valley Road • Atglen, PA 19310

Designed by Molly Shields
Cover design: John Saal from Untuck, LLC
Cover photo: Jayne Toohey
Type set in Poplar Std /Cambria

ISBN: 978-0-7643-5372-7
Printed in United States of America

Published by Schiffer Publishing, Ltd.
4880 Lower Valley Road
Atglen, PA 19310
Phone: (610) 593-1777; Fax: (610) 593-2002
E-mail: Info@schifferbooks.com
Web: www.schifferbooks.com

For our complete selection of fine books on this and related subjects, please visit our website at www.schifferbooks.com. You may also write for a free catalog.

Schiffer Publishing's titles are available at special discounts for bulk purchases for sales promotions or premiums. Special editions, including personalized covers, corporate imprints, and excerpts, can be created in large quantities for special needs. For more information, contact the publisher.

We are always looking for people to write books on new and related subjects. If you have an idea for a book, please contact us at proposals@schifferbooks.com.

This is my home
This is my only home
This is the only sacred ground
That I have ever known

– Dave Carter, "Gentle Arms of Eden"

contents

FOREWORD

the Philadelphia Folk Festival: A Brief History from Emcee Gene Shay

The story of the Philadelphia Folk Festival starts with one of the most overused clichés in the world: "It was a cold and rainy night." The Philadelphia Folk Festival made its debut on an end-of-summer evening one week after Labor Day, on Saturday, September 8, 1962. It was a night so cold you could see Pete Seeger's breath hanging in the air before you could hear his voice. Bonnie Dobson—a lovely young folksinger from Toronto—was shivering in a borrowed pair of oversized combat boots, and Reverend Gary Davis— legendary street singer from New York City—was swathed in a bundle of scarves and wore an old beat-up fedora. Others braving the cold included the Greenbriar Boys, Ramblin' Jack Elliot, ballad singer Tossi Aaron, and gospel singers Mabel Washington and Professor Clarence Johnson.

"Who would have thunk it?!" is a question that has crossed my mind many times in the more than fifty-five years since then. Having the longest continuously operating folk music festival in the United States on our hands sure wasn't on our minds during those early days. We weren't thinking so far ahead when we started talking about putting together an outdoor event. We just wanted to share what we loved. We wanted to get together and listen and play and sing. We just got started, and it just kept right on going, right from the very first song.

Let's roll back my memory tape (fast fading by the way!) to the 1950s, to tell you how it happened. From what I figure, it all started with George Britton—a recording artist for Folkways Records who sang traditional Pennsylvania Dutch folksongs in a *"Big-Basso-Profundo"* kind of voice. George, his wife Charlotte, and some of his friends—Bob Siegel, Joe and Penny Aronson, Ed Halpern and his wife Esther, Tossi and Leon Aaron, Linda LaBove, and Joel Shoulson, to name a few—were interested in folk music, folk craft, and folk dance—all things folk. This early group of regulars liked to jam together and throw "Hoot-A-Nannies," singing songs and playing banjos, guitars, and fiddles. First, they'd sing in each other's homes, then the Halperns launched a coffeehouse (the Gilded Cage) a short walk from Philadelphia's famous Rittenhouse Square. It was known as "The Cage," and soon became a popular folk hangout. Esther Halpern would sing her songs and ballads in the back room known as the "Perch Room," where she appeared on a regular basis.

This small bunch of pals eventually grew into a bona fide organization: The Philadelphia Folksong Society. Around the time the society was gathering steam, folk music was spreading across the region, and new folk music fans were collecting in different parts of the city to sing their songs, make music, and to have fun.

At that time, I was a young radio announcer and DJ studying broadcasting at Temple University and working part-time at the campus radio station, WRTI. In 1957, after getting my degree in communications, I launched a career as a professional broadcaster at a new station (WHAT-AM), but was then called to serve in the Army and shipped out to Europe to work as a radio announcer and DJ on the American Forces Radio Network out of Frankfurt, Germany.

Around 1959, after coming back to the States, I was introduced to some of that early folk crowd, got to know about their music, and decided *this* was the music for me.

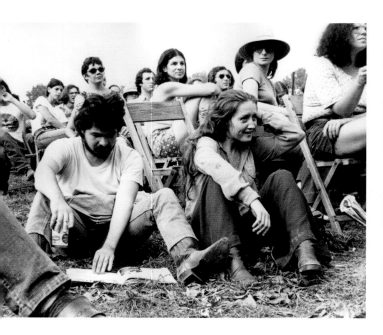

I traded in the jazz riffs for Child Ballads, story songs, Celtic reels, the blues, protest music, and more. I got to know the first-class folklorists studying and researching in the Folklore program at the University of Pennsylvania. I learned all about folk music, liked it, sang it, and even *attempted* to play it on my harmonica. I studied folk guitar with Tossi Aaron. I audited classes in the Folklore program, where I found a great mentor and friend in Dr. Kenneth "Kenny" Goldstein. I am forever grateful to Kenny, and to the lovers and collectors of folk music, including MacEdward Leach and Tristram Coffin, who introduced me to this wonderful world of music, folklore, and fun—a world that became my home away from home, my second family.

I became a confirmed folkie, hosting a Sunday night folk radio program on WHAT-FM and serving as an active member of the Philadelphia Folksong Society's Board of Directors. A brilliant young folk activist, David Hadler, also served on the Society board. David was an expert in banjos, sound reproduction, music, and stagecraft. He introduced me to Joel Shoulson, his wife Barbara, and others in our small group of folkies: guys like Steve Kennen and his wife Polly Fox, Bob Siegel, Howard Yanks, and Bob Gerofsky.

In 1961, David came to me and said, "Gene, I have an idea for something I want you to help me with." He asked if I would talk to the top brass at the Society to convince them to sponsor an outdoor event, one with workshops, discussions, and concerts, and all kinds of folk music— folksongs, ballads, folk, blues, and bluegrass—for an entire weekend in the countryside. The Philadelphia Folksong Society seemed to be the perfect group to pull this off; they were already putting on shows at the auditorium at the Gershman YMCA at Broad and Pine, at area schools, the Penn Archeology Museum—any place they could find a stage and enough seating.

David's idea caught on, and eventually the Philadelphia Folksong Society said, "Well, let's have a Folk Festival! Yeah! Let's make a show."

The first catch: we had to find a place to put on a festival. Society Director Bob Siegel knew a patron of the arts by the name of C. Colkett "Collie" Wilson III. Collie, his wife Martha, and their family had a beautiful little farm up on Swedesford Road in Paoli, Pennsylvania, with a swimming pool, along with lots of small hills and creeks running behind it. Collie was a craftsman and expert horseman who built an open stage in one of his meadows where the Pennsylvania Ballet ran their summer rehearsals, sometimes breaking for a swim in the pool. There was no canopy, no sides—just an open platform on cinder blocks—but Collie graciously offered the use of that stage, and the rest of the family farm, for the entire weekend. We were elated!

Now, what about the money? Luckily for us, Dave Hadler had a relationship with Martin Guitars in nearby Nazareth, Pennsylvania. They were just the right partners, as they were generous, kind, and cared for folk music. They got involved from the start, helping us not only with money, but with good advice. Thank goodness for Martin Guitars, their great product, and their great attitude toward the music.

And so we started on that cold night in 1962. More than 2,500 people showed up for that first festival. And the word spread. By the second year even more showed up, listening to music while lying on blankets in the natural amphitheater of the Wilson farm. And the music was growing. After the first few years in Paoli, we moved to the Spring Mountain Ski Slope in Upper Salford Township, before coming to the Old Pool Farm—the Godshall family farm that has hosted us for so many years.

Around the time the Philly Folk Festival was finding its long-time home, the Vietnam War was boiling over and a protest movement was growing. Also during this time protestors were rising up against racist politics in southern communities where "Jim Crow" was still rampant. There was a lot of injustice in the southern states at that time, and man, it was terrible. Just as folk songs came out of strikes in the steel mills, coal mines, and knitting mills, from workers across the north and south in the early days of industrialization, folk music was in the air at this time in America. Young people were learning and singing these new songs. People just all ganged together, singing their protest songs and listening to the songs of Phil Ochs, Tom Paxton, and a very young guy named Bob Dylan. Music that protested the inequities of work and discrimination became the music of the young people, and the music was reflected in the festivals and in the attitudes. Folk music was here to stay!

And festivals were popping up all over. Even though it is now the longest continuously running folk festival, the Philly Folk Festival was not the first. Folk style music festivals go way back to the 1930s, when old-time fiddlers and pickers gathered for conventions, contests, and competitions in many little towns all around America. In the 1960s, folk festivals were growing, drawing crowds from Asheville, North Carolina, to Newport, Rhode Island, and even to local college campuses like Bryn Mawr and Swarthmore, and inner city parks, like the "be-ins" at Belmont Plateau. Many were recorded by the Library of Congress and issued on albums that are still available today.

Like many of these festivals, the backbone of our Fest is the volunteers. Everybody loves volunteering at Fest. The first campers at the festival were early volunteers—many talented musicians themselves—who decided to camp on the Fest grounds to be able to play music together—and to have fun and party! They wanted to play their guitars, they wanted to meet other people, and to be a part of it all. It was the beginning of camping for Festival patrons and it became wildly popular over many years—and still is.

The early success of the Fest brought us even more volunteers. Everyone wanted to be a part of it. And it just went on and on. The early volunteers grew up, had kids, and the kids took over those volunteer spots. And now their grandkids are here! Some volunteers, now in their thirties, have been coming here since they were babies. We now have about 2,500 volunteers, and many more "alumni" who have been at the Festival for decades, who love it, and call it their life.

And we've always loved our audiences. Philly Folk Festival audiences are the best—and I get to be at the center of it! What a privilege to stand in front of an audience of folkies and get laughs. Laughs and love. Silly things happen at the Festival, like when Festival volunteers arranged for the state police to walk on stage, put me in handcuffs, read me my Miranda rights, and arrest me for "impersonating a comedian"; and the annual audience participation chant: "Hi Gene, how's your hygiene?" People have proposed to one another from the stage and from the audience to the stage. I've served as proxy, announcing from the stage "Hey Marty, would you marry Lisa? She's in the audience and she is asking me to ask you!"

Then there are the many annual traditions: the chair burning over in Groundz every year; ladies' night every year in the camping area; and pre-fest, which gave lots of young people a chance to roll out the snow fence, hammer together a stage, and put a tent over it—to build a festival from scratch. Dulcimer Grove for the kids—crafts, juggling, magic, and music. The campsites: Azzoles, the Jug Band . . .

That is pretty much the start of the Philly Folk Festival as I see it. Now fast-forward to today, and here we are, presenting some of the best music in the world to people who come to the festival from California, Europe, and all over the world. We've done more than fifty-five years of the Philly Folk Festival, and I hardly hear, "Hey, how long are you gonna keep this going?" It just seems like we always have. And I think we always will, because of the love of the music and the arts—and the love of the people involved.

And so I invite you to enjoy this book of photographs from the Philadelphia Folk Festival. And I invite you to pick up some music from the festival, buy your ticket, or join us as a volunteer. We are waiting for you to come! If you haven't been here, you are missing the annual event of a lifetime.

Gene Shay signing off. Have a great festival! Thanks for listening to the stuff we do and paying attention to us all these years, and for being a big fan! Hey, we need you guys and we always will. Thanks.

[Signed]
Gene Shay

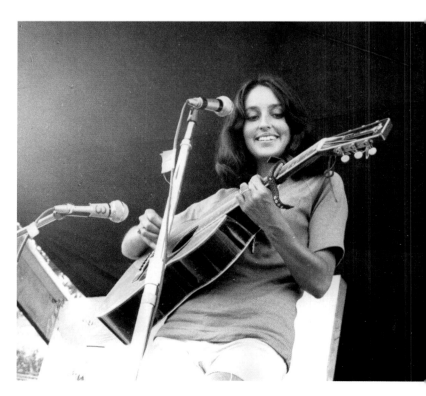

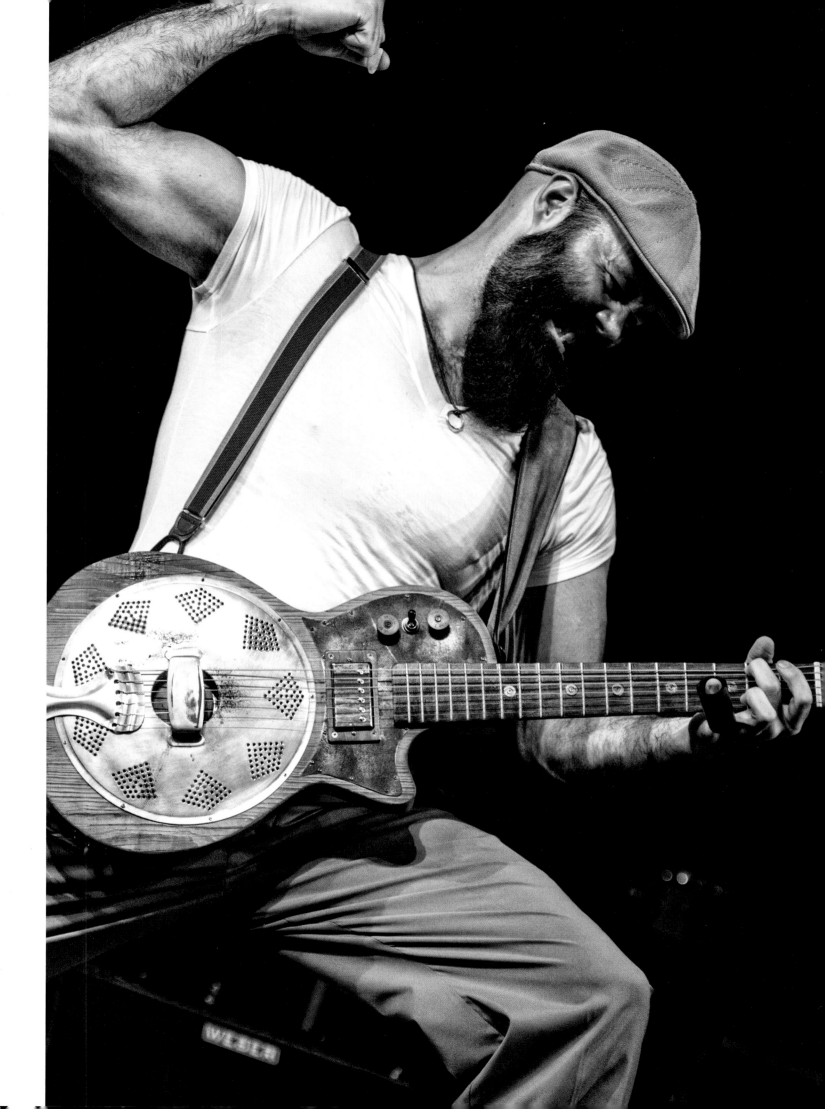

PREFACE

Like many, if not most of those who will read and view the words and photographs in this book, the authors have made it a ritual to carefully and judiciously manage our vacation time, clear our calendars, put our lives on hold, and make plans in the middle of August each summer to camp on a rolling hillside in Montgomery County, Pennsylvania, that is nearly twenty miles from the nearest limit of the City of Philadelphia.

Nonetheless, the celebration of music and life that takes place on that one-time dairy farm has its roots in the vibrant folk music scene of Penn's City, beginning fully six decades ago, when an assortment of coffeehouse owners, academics, professional people, broadcasters, political activists, and a few of what were then quaintly known as "folk singers" got together to form the Philadelphia Folksong Society. After enduring the usual growing pains of a fledgling non-profit organization, they reached the point where it did not seem like such an audacious idea to say, "Why don't we hold a 'folk festival?'"

In 2014, a Philadelphia lawyer (thankfully not of the notorious type that Woody Guthrie famously wrote about) named Eric Ring realized that extensive photographic and textual histories of the Festival were noticeably hard to find. He contacted his longtime friend, Jayne Toohey, a freelance photographer based in the Philadelphia suburb of Media, and proposed they collaborate on such a book, with Eric writing the text and Jayne serving as photo editor. Like Eric, Jayne has been a regular Festival attendee for many years, and has not only photographed it since the 1980s, but has also built relationships with many of the other talented photographers—both professional and amateur—who have captured untold thousands of beautiful and compelling images from the earliest days.

With the permission and cooperation of the Folksong Society, the project was begun with the initial plan to have it complete and ready for publication in time for the 2017 Festival, marking the sixtieth anniversary of the Society. As work progressed, though, and more and more material was accumulated through interviews, research, and acquisition of countless photographs from many sources, Jayne's husband, John Lupton—a folk and country music writer for the past twenty years—was invited to join and assist with editing both words and images. Things do not always go according to plan—or schedule—but finally, in 2018, we have the finished product available for you to enjoy.

It has been an extraordinary amount of work to collect and select the images presented on these pages, and to conduct interviews and assemble the stories and commentaries of the many people who have been deeply involved with the Festival: not only the staff and management, but also the paying customers who walk through the gates. We believe that it was well worth the investment of time and effort on our parts to produce this record of and testament to the achievements of the thousands and thousands of people who have come together for more than fifty-five years to make the Festival happen.

It would be impossible to mention the names of *every* person who made a measurable contribution, to present an image of *every* memorable performer, to tell *every* great story (some, regretfully, are better left unpublished), and describe *every* notable feature and aspect of the Festival. We have done our best, in the hope that the reader who has experienced the Festival will see *themselves* in these pages —perhaps literally—and the reader who has never been to the Festival will go online to find out how to buy advance tickets.

Eric L. Ring
Jayne Toohey
John T. Lupton
April 2018

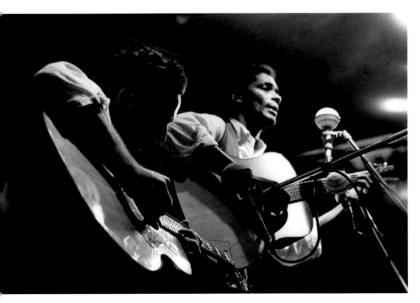

ACKNOWLEDGMENTS

Writing a book is difficult, and without support and encouragement it is even more difficult. As such, I would like to thank the following people who have inspired me over the years to write this book. I would first like to thank the Philadelphia Folksong Society for their approval, partnership, and support. The PFS is the beneficiary of the profits and royalties for this book, and they have given all of us years of entertainment and the opportunity to have something to write about.

I would like to also thank Gene Shay for his time and the ability to become a friend. Gene's spirit, professionalism, and kind heart have inspired me to do the best I could to properly represent the Philadelphia Folk Festival. Also my friend, Joe Langman, who was an advocate for this book and is just as responsible for making this happen as are Jayne Toohey, the photo editor, and John Lupton, my co-writer, both of whom made this book much better than it would have been if I did this on my own.

To Pete Schiffer, because literally without his help, approval, and support this book would not be a reality. To Ben Levy—God rest his soul—who introduced me to this craziness that happens every August. To Nancy Ring, who joined me, kept me company, sang with me, and danced with me during most of my twenty years (and counting) at Fest. To the Main Gaters—my original home at the Festival—who will always have a special place in my heart, and to the characters on Central Control who adopted me and make me feel at home at Fest.

It always helps to have a pair or two of "fresh eyes" looking over our shoulders to catch typos and flat-out errors, and we owe a great debt to Fred Kaiser and Mary Lou Troy for graciously volunteering (as they both did for so many years at the Festival) to proofread and fact check as this work progressed. Their combined knowledge and expertise saved us numerous awkward "oops" moments.

And a *huge* "thank you" to all the contributing photographers. This book was inspired by the quality and dedication you have all demonstrated in chronicling this Festival over the years. As can be seen in the amazing photographs that fill this book, you are talented beyond words.

An especially heartfelt "thank you" to all the volunteers and musicians, many of whom gave interviews, information, and support. This book is for and about you, and I hope we did you justice in representing the backbone of what this festival is all about. A special "thank you" to Lisa Schwartz, who first approved this project and has been a big advocate of it, and to Justin Nordell, who agreed that we'd rather have a good book that arrives a year later than planned than a bad book that is finished in time for the initial deadline.

Thank you as well to the people in my life who gave me love and support, including my brother, Steven Ring—God rest his soul—who might not have been interested in the same type of music, but was a lover of music in general. To my step-sister Susan Samitz, who encourages me with everything I do, and introduced me not only to coffee, but to Crosby, Stills, and Nash, and other music that led me to enjoy folk, jazz, blues, classical—*all* types of music.

To my friends, new and old, who encouraged me to keep writing and always ask, "Are you still writing that book? Can't wait to read it!": Greg Frost, Mary Ann Volk, Melissa Wallen, Andy Packel, Lora Packel, Jeff Algazy, Howard Pitkow, Lisa Schaffer, Gary Pendleton, Karyn Molines, Mike Schmucki, and many others.

Lastly, and most importantly, a huge "thank you" to everyone who has attended this Festival, especially the people who love it. The volunteers and musicians can come every year, but would not do so for long but for your attendance, enjoyment, love, and—frankly—monetary support for this Festival. *You* are the ultimate reason that the Philadelphia Folk Festival is the longest continuously running folk festival in North America. You should know that the authors and all the contributing photographers have given up any claims to compensation or royalties in favor of the Philadelphia Folksong Society. Your purchase of this book will benefit the Society, and in turn the Philadelphia Folk Festival.

Eric L. Ring

I came to my first PFF in 1985 as a ticket buyer, and camped with Patchwork. In 1986, while volunteering on the Security Committee at the Festival, my friend, Tom Coughlin, introduced me to Chair of the Press Committee Lisette Bralow, who gave me my first Festival photo pass. This was the beginning of the path of my career in folk photography. I have photographed every Festival since then, as well as many other festivals. Through friends I have met in the folk music community, I have had the opportunity to meet and work with many musicians and others in the music world. Thanks to the opportunity given me at PFF, my life changed and I found a great community.

I was excited when Eric said he had the opportunity to do a book about the Festival. Back in the '90s, as I got more and more involved in the Festival and the Folksong Society, I had suggested we do a book. Logistics and costs got in the way. So now was the chance, and I offered to help. This has been quite a project. We are just touching the surface of a fifty-five-year-old institution. Many of the photographers who have covered the festival have donated images, and I know there are many great images out there that have not been included. I have spent over two years collecting images and going through my archives. It has been fun to look back over the past few decades. My husband John was so helpful, and spent months scanning about 10,000 old negatives and slides. I am so grateful to Eric, John, and the Folksong Society to have the opportunity to produce this tribute to the festival. I feel blessed to have made so many friends over thirty-plus years at the Festival. So many of us share similar stories about Fest. I hope you see a bit of your own story here.

Jayne Toohey

"WE'RE OFF to FEST!"

THE ODYSSEY BEGINS

Each year, for more than a half-century, as the heat and humidity of August grip the Mid-Atlantic seaboard, thousands of otherwise normal, sensible people have been stuffing an astounding assortment of groceries, clothing, camping equipment—and kids—into every available cubic inch of space in vehicles ranging from sub-compact cars and rented vans to full-size RVs, busses, and even the occasional semi-trailer.

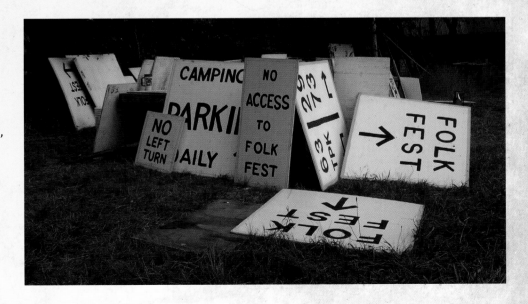

With springs and shocks creaking and groaning just a little more than usual, they call out to their neighbors, "We're off to Fest!" and head out on the road en route to eighty acres or so of farmland along Perkiomen Creek, in the northern reaches of Montgomery County, Pennsylvania. Many of them meet up with friends along the way—some of whom they see only this one week of the year—and become caravans of fellow travelers, perhaps not of the sort seen on the Silk Road of bygone legend, but if their passing by brings to mind a Steinbeck-like scene of the Joads on their way to California, that's not too far off the mark.

"Off to Fest!" requires no "the," and odd as it may seem, the capital "F" is clearly audible. In the argot of these annual gypsies there is only one Fest: the Philadelphia Folk Festival, the oldest continuously operating annual folk music festival in North America. It has taken place since 1962, and its home of the past four decades and more, the Old Pool Farm near Schwenksville, in Upper Salford Township, is the ultimate destination of these caravans. If it seems that collectively they have enough equipment and supplies to

build a new city, well, that is precisely what they have in mind. Like Brigadoon, when Fest is over, they will take it all down, go home, and start preparing to do it all over again the next year.

The pilgrimage converges from all points of the compass, with most starting out from homes in Pennsylvania, New Jersey, Delaware, and Maryland. Some come from as far away as Europe. A few start out a day ahead of the rest and spend the night camped out in a parking lot of a local shopping center, church, school, or other convenient gathering place—but be sure to get permission from the owners! Soon, the painted wooden signs come into view at the side of the road—white, rectangular, with faded orange borders and simple block letters "Folk Fest," with an arrow pointing the way. The moment you see your first sign the excitement builds, and you feel like you are coming home.

Though some of the travelers plan to enjoy the relative comforts of RVs and other vehicles designed for camping, many look forward to the "old school" way of finding enough open space to pitch a tent and lay a simple sleeping bag out inside it. Whichever style of camping is chosen, once through the gate and established in your new home, you can look around you with an air of satisfaction. As you wander about, you see the equipment and supplies pour forth out of the vehicles and tents, and indeed, within an hour or two, you watch a new city rise up in the grassy fields of a Pennsylvania farm.

Congratulations! You're at the Philadelphia Folk Festival!

Above: The Campground Gate, 2011 (fiftieth anniversary). Philadelphia Folksong Society Archives

Left: Waiting for the "Land Rush" to begin, 2015. Photo by Jayne Toohey

Previous: "Sign, sign, everywhere a sign . . ." The Festival Graphics Committee produces these signs and posts them along local highways and roads to direct traffic towards the Old Pool Farm. Philadelphia Folksong Society Archives

WHAT'S A "FOLK FESTIVAL"? WHAT'S "FOLK MUSIC"?

Not *everyone* at the Philadelphia Folk Festival has come to camp for four days. Like virtually all music festivals, Philly relies heavily on "day trippers" who commute to and from the grounds, taking in as many of the stage shows and workshops as they desire. And while in strict terms it is certainly possible to hold a festival devoted to folk arts other than music, the term "folk festival" has come to mean in common usage an event, usually at least one full day, at which attendees can experience a wide variety and selection of "folk music."

That, of course, prompts the question: what exactly *is* "folk music?" Longtime Festival emcee Gene Shay says that it is many different things to many different people, but one definition he gives is, "Folk Music is the music of the people." There could be few better places to gauge informed opinion on this question than the grounds of the Philadelphia Folk Festival in mid-August, and if a random sample of fifty people in the audience at the Main Stage were asked to answer, there would certainly be a substantial agreement among all of the responses.

Yet paradoxically, it is virtually certain that there will be widespread disagreements and contradictions. As in the famous parable of the blind men describing an elephant, just about everybody in the world of folk music sees "their music" in a different way. Rather than trying to define "folk music," some people will paraphrase the late Supreme Court Justice Potter Stewart and simply respond, "I know it when I hear it."

One view of the question could be called the "academic" answer, the result of folklorists and ethnomusicologists setting out with tape recorders into the remotest corners of the landscape to research, document, and publish the music that the common people—the folk—have been devising for their own art and entertainment for centuries, and continue to do so today.

Another view might be called the "commercial" answer. With the advent of the recorded music industry in the early decades of the twentieth century, along with the revolution of the radio airwaves, many of the same "folk" musicians who were the subject of research by academics found that they could make a living performing and recording music that could liberate them from the drudgery—and poverty—of working on farms, in mills, or in urban sweatshops and factories.

Though they were both raised in a family devoted to the academic study of music of the people, and were academics themselves in their own ways, brothers Pete and Mike Seeger both made a substantial portion of their livelihoods performing and recording folk music for pay.

Joe Aronson, one of the founders of the Philadelphia Folksong Society, tells the story of one evening in the late 1950s at The Gilded Cage—the coffeehouse operated in Philadelphia by Ed and Esther Halpern, who were also involved in the founding of the Society. Late in the proceedings, Joe says, the evening was interrupted when a squad of city police burst through the doors.

"They were there, ostensibly, to find drugs," Joe remembers. "What they did was pick on homosexuals and interracial couples."

Leading the raid was a young police captain already becoming a legend on the streets of Philly who a couple decades later would become one of the most controversial mayors in the city's history—Frank Rizzo. Joe wrote a song about the episode and performed it later as part of a concert at the University of Pennsylvania Museum, receiving a rousing response as the audience joined in on the chorus:

If the threat of coffee drinkers
And chess players makes you nervous
Have no fear-o
Here's our hero
Captain Rizzo's at your service

Joe says a year or two later, on a tour through the South, he and his wife Penny were arriving for their show at a college in North Carolina when they were greeted by a young man who asked why they were carrying instruments. Joe told him they were folksingers from Philadelphia. "Oh, I know a song about Philadelphia," the young man replied, and Joe laughingly noted, "he began to sing my own 'Frank Rizzo' song to me."

"Where did you learn that?" Joe asked.

"Oh, it's *traditional!*"

In short, there is no simple, clear answer to the question "what is folk music?" that will satisfy everyone who is interested in knowing the answer. When Bob Dylan famously "went electric" at the Newport Folk Festival in 1965, many folk music fans sadly shook their heads and muttered that folk music was on its way out. Others—particularly younger fans—embraced the music of Dylan and contemporaries like Phil Ochs as the vanguard of a new era.

A half-century later, many individuals may now watch a band with the biggest "buzz" in the modern folk music world do their set on the Main Stage at the Philadelphia Folk Festival and walk away muttering, "That ain't folk music." Like everything else, music evolves, even folk music, and as Bob Dylan himself said, "The times, they are a-changin.'"

Like music itself, much has changed at the Philadelphia Folk Festival since the gates were first thrown open in 1962, and the following pages and photographs will attempt to present not only a record of those changes—and an admittedly very incomplete record at that—but also convey in words and images a sense of why thousands of people have returned year after year for more than five decades to make the Festival part performance art, part movable feast, and one hundred percent a celebration of life.

The words and images will be of the people who dared to organize and carry out a vision, of the staggeringly talented artists who have graced the stages, and perhaps most importantly, of the countless ordinary "folk" who, paraphrasing the words of Dave Carter, consider the Festival "their home, their only home, the only sacred ground that they've ever known."

THE FOLKSONG SOCIETY AND THE ROOTS OF A FESTIVAL

GEORGE BRITTON

George Britton was born into the Pennsylvania Dutch culture surrounding his Reading, Pennsylvania, hometown. He began singing as a boy in church choirs, and as he grew, he became possessed of a deep, booming voice.

His son Tim says, "When [Dad] walked into the room, he owned the place. If he was there to play, he had no confusion about what he was up there for . . . His voice was three times louder than anybody you've ever met, and he just got up there, and he radiated joy in singing, and he just included people instantly. When he hit the stage, it was just like a bomb went off."

George developed an interest in the German-American music of his youthful surroundings and began performing traditional songs in the 1940s. Before long, he realized he had become a part of what was quickly becoming known as "folk music," but he also found that it was an occupation that was not always viewed as "socially acceptable."

His daughter, Wendy Britton Young, recalls her father telling the story of how he met her mother, Charlotte, and went to Charlotte's father to formally ask permission to court her, only to be told he was "lower than dirt" *because he was a folksinger*. As Gene Shay recalls, George recorded for Folkways Records, and eventually opened up a guitar store and began giving guitar lessons, becoming one of the most in-demand teachers in the Philadelphia area.

In a paper published on his site (historian4hire.net) in 2010, historian David Rotenstein recounts the version of the founding of the Folksong Society that he pieced together for an article he wrote about the Festival in 1992, for the *Philadelphia Inquirer*, for whom he was covering folk music at the time. (Rotenstein was also then enrolled in the doctoral program in the department of Folklore and Folklife at the University of Pennsylvania.)

Rotenstein relates a personal communication from George Britton in which Britton said, "I was the only professional folksinger in the area, and I'd get up on a nightclub stand and start singing folk music, and people would look at me as though they thought I was crazy. They had never heard of it even."

It was sometime around fall 1956, by Britton's recollection, he says, "I was the founder of the [Society]," and brought together a group that included Joe Aronson, Mike Marmel, and Dick Gale, with the latter appearing to have disappeared into the mists of history and memory.

"These were the three foremost folksingers in the field," Britton told Rotenstein. "The time was ripe for a folk song group . . . I wanted to do something for folk music. I thought that this would bring together and afford a platform for young singers and people who didn't perform themselves, but who were very much interested in folk music. That it would give people a chance to meet."

Even with the rising prominence of folk artists like Pete Seeger coupled with the emergence of the "Folk Craze" of the late 1950s and early 1960s (wryly called by some the "Folk

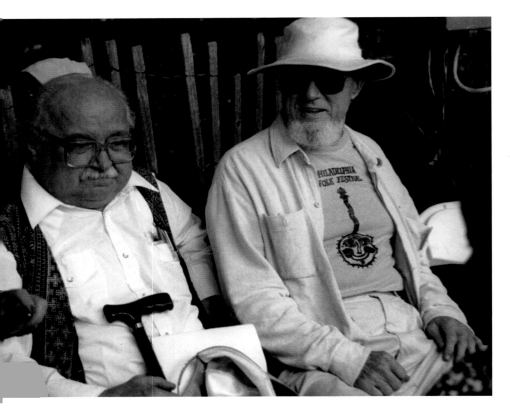

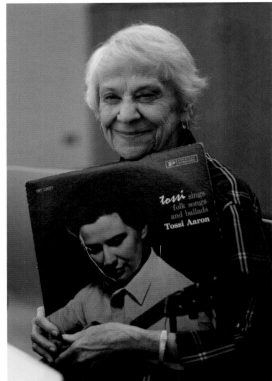

Scare"), the number of places to hear and see folk music in the postwar years remained small relative to other forms of popular music.

HOLLYWOOD STREET

As the 1940s drew to a close, Leon Aaron and his wife, Tossi (née Blumberg), had been married only a few years and were living with their two young daughters in one of the row houses lining Hollywood Street in the Strawberry Mansion neighborhood of Philadelphia. Her voice still strong and vital as she nears her ninetieth birthday, Tossi says that she and Leon had known each other since childhood, when her family lived two doors away from the grocery store that Leon's father owned and operated.

Leon had been working for the *Philadelphia Record* and became involved with the union representing the workers. When the paper folded in 1947, in the aftermath of a strike, he changed careers and became a full-time organizer over the ensuing years for the International Ladies Garment Workers Union and others.

At a get-together in their house sometime around 1949 or 1950, Tossi recalls one of their guests showed up with a mandolin, and by the end of the evening, everyone had joined in singing every song they could think of. Before long, she says,

the gatherings became a standing Friday night session.

"Pretty soon we had fifteen or twenty people, and we'd be rushing to put the kids in bed so that we could have our little eight-foot square living room, a room for people to sit, instead of on the floor."

"I had no idea what [folk music] was," she remembers. "I had no idea what the difference between a ballad and a folk song was. I just knew I liked them, I knew I could sing them, and I knew I was learning them quickly. I knew if I said to someone, 'I love that one—play it again [they would play it].' And before I knew it, the calluses [on my fingertips] were growing and I was getting to play guitar."

The experience would eventually lead to a folk music career of her own, and Tossi was part of the lineup at the inaugural 1962 Festival. Little did she know it then, but those gatherings became the kernel of the folk music scene in Philadelphia.

JOE ARONSON

Joe Aronson recalls a time during his military service at the end of World War II when he heard some soldiers from the South singing amongst themselves and was intrigued to realize that they were not just singing the country songs of the day; he was also hearing some old songs that he was

unfamiliar with. His experiences in the service had ignited strong political feelings in him, and on returning to Philadelphia after discharge, he joined a political organization, where he first met George Britton.

"One of the things that shook me up when I was in the service was the way blacks were treated. So much so that, when I got out of the service I wanted to do something to help the situation . . . I met George through a political organization I belonged to. It was a liberal group that was involved in integrating society, getting blacks involved. We were also involved in the Henry Wallace [Progressive Presidential] campaign, back in '47–'48. That's how I met George." 🎵

After reading in *Sing Out!* that Pete Seeger would be giving a workshop in Philadelphia, Joe attended and worked up enough courage to sing a song in front of the group. Pete sized him up and said, "We *need* voices like yours!" With that encouragement, Joe immersed himself not only in his own singing and performing, but in reading and studying about the history and folklore behind the music.

Along with George Britton and Mike Marmel, Joe was a regular at The Gilded Cage location in the years before it was acquired by Ed and Esther Halpern. "Mike started singing there on Saturday nights in the back room, and not that many people joined him, because Mike was not the most welcoming kind of person."

"Esther came in one night," Joe continued. "She was new in town, and she was a little girl with a big guitar. I was there, and I welcomed her, [but] Mike *wasn't* happy to have her there. But she was one of the ones who helped us get started. The Gilded Cage—I forget the name of the owner of it—but at one point he asked me, would I start singing there on Sunday afternoons? . . . Eventually that became the heart of the folk movement in this town. However, before that it was Leon and Tossi Aaron . . . I became aware that [they] lived in Strawberry Mansion, and on Friday nights a group of people used to come over there and sing folk songs. I started going there about 1948 or '49, and it lasted for about five years. That was before The Gilded Cage."

THE FOUNDING OF THE PHILADELPHIA FOLKSONG SOCIETY

By the mid-1950s, the Aarons had moved to Easton, Pennsylvania, and the Friday night folk music sessions had ended, though both Leon and Tossi made regular commutes back to the city. In Tossi's case, she was giving guitar lessons at a studio she shared at 21st and Chestnut Streets. The focus of the folk music scene in Philly had shifted to The Gilded Cage, the coffeehouse nearby at 21st and Rittenhouse Streets that had been taken over by Ed and Esther Halpern.

At this point, accounts of the genesis of the Folksong Society begin to diverge slightly, though six decades later, all

have basis in fact and are not necessarily contradictory. Tossi Aaron remembers that many of the original cast of characters would meet and discuss the idea of a folk music society at her Chestnut Street studio. "Not," she quickly adds, "on Hollywood Street. Hollywood Street had *no idea* there was going to be a Folksong Society."

Though she no longer remembers the names of the original founders, Tossi says, "The Folksong Society formed in the upstairs floor of an insurance office [on Emlen Street] in Germantown. That's where the office still is [in 2015] . . . the woman who was really running it is gone, but we met for years there." (The office of the Folksong Society moved at the end of 2016 to a new office in Roxborough.)

Esther Halpern recalled that it was in the back room at The Gilded Cage that the new organization was born, with Britton, Aronson, and Marmel as founders. In the coming decades, the Halperns would become influential and productive members of the fledgling organization, and Esther eventually became chair of the Merchandise Committee at the folk festival that would emerge. David Baskin, who would in later years become a longtime Chairman of the Festival, had begun visiting and performing at The Gilded Cage, and told Rotenstein, "I don't know the *exact* place it started. It was either The Gilded Cage or Esther's living room. They were kind of interchangeable at the time."

Joe Aronson remembers that while he, George Britton, and Mike Marmel were in fact the founding trio, "It was George's idea . . . I bumped into him on the street, and he proposed it to me."

However the various accounts of the founding can be reconciled, the inaugural meeting of the Philadelphia Folksong Society took place in October 1957, at International House, just off the corner of 39th and Spruce Streets on the campus of the University of Pennsylvania. Giles Zimmerman, a former student of George Britton's, was director of International House at the time and agreed to allow the organization to meet there on the condition that Penn students could attend the meetings at no charge. Organizational dues were set at $2 per year, with a meeting admission surcharge of fifty cents per meeting for four meetings. As things got rolling, the Society began to average about nine meetings per year, in addition to sponsoring a few concerts.

Joe Aronson was the first Program Chair of the Society, and part of his duties included bringing musicians in to perform at the meetings. He laughs as he recalls that it became something of a feather in his cap when he snagged the newly formed New Lost City Ramblers for their first public appearance before they got to New York City.

"There was a woman in New York named Ruth Rubin," he remembered, "and she was the foremost collector of Yiddish folk songs in this country. I hired her every year because *she drew the biggest crowd.*"

Some years later, after International House moved to new quarters across campus on Chestnut Street, the building at 39th and Spruce became the home of Penn's radio station (WXPN), until they moved to new facilities in 2004. The basement of the church next door was the home of The Cherry Tree for several decades, a folk music venue of long standing (sadly now defunct) whose management would come to include many of the same

Ken Goldstein, George Britton, and Bob Siegel at the 1995 Festival, three months before Ken passed away. Philadelphia Folksong Society Archives

Ken Goldstein, circa 1967. Photo by Diana Davies

people involved in running the Folksong Society and the Festival.

The connections between Penn and the Society have been close throughout the decades, and as Esther Halpern would often point out, a large chunk of the money that the Society made over the years from operating the Festival went directly to help support Penn's Department of Folklore and Folklife, providing scholarships and maintaining the department's archive.

MOVING TO ROXBOROUGH

Though an official announcement would not come until the 2015 Festival, by then it had become known that the Philadelphia Folksong Society would leave its longtime offices in the old storefront on Emlen Street and relocate a couple miles away to Roxborough, on Ridge Avenue.

In an interview for the *Roxborough Patch*, Executive Director Justin Nordell said that the move was initiated because the Emlen Street location was beginning to feel "less a place for community and more a place of business." Justin added, "We have relocated to the community of Roxborough, which has been so supportive of our organization and cannot wait to have our community as a part of their community."

The November 2016 move signifies a new era in the history of the Folksong Society, and although the current location may be temporary, it is the hope that the next home for the Philadelphia Folksong Society will be one where the community can enjoy the past, the present, and the future of folk music in the Philadelphia area. We remember it would never have come about without the dedication and hard work of the people who attended those early meetings at International House and dared to dream of holding their own festival.

"LET'S HAVE A FOLK FESTIVAL!"

CHAPTER THREE

INSPIRATION, ORGANIZATION — AND FUNDING

In the early 1960s, with those five short words, David Hadler began a push among a contingent of Society members to promote and stage an annual outdoor festival. He wrote about the inception of what became the Philadelphia Folk Festival in the introduction for an article in the 2005 program book—the forty-fourth year. He had been to the Newport Folk Festival, was mesmerized by Odetta, and wrote, "I began to study the stage setting and noticed a young girl in a red and blue dress getting ready to go on—a 'la-la' singer I thought dismissively, and then she sang. The

audience was stunned: Joan Baez had brought the house down."

Traveling home from that Newport experience, he said his mind was ablaze with what it would take to stage a comparable event in Philadelphia, and that he was already "obsessed" with planning it. "I presented my thoughts to the Philadelphia Folksong Society Board of Directors. They made us a deal: if we could guarantee the Society a 'break even' or better return, we could begin to plan the festival."

It would be much easier said than done, and as it turned out, there was substantial initial opposition to the idea among the membership. For one thing, the Society was not flush with funds in those early years, and as David Baskin recalled, few of them had practical experience organizing and operating an event of this scale. There had been at least one other recent attempt in the region: a festival staged in 1961, by the C. F. Martin Guitar Company held in Wind Gap,

Pennsylvania, which had not been a notable success.

Frank Martin, a descendant of the historic guitar company's founder and an executive in the family business, was a friend of Hadler's, and listened intently as Hadler suggested that a better approach with greater chance of success would be a festival organized and operated by the Philadelphia Folksong Society with financial backing by the Martin Company, whose offices and world-famous factory were (and still are) just up the road in Nazareth, Pennsylvania. Frank Martin consented to the arrangement and agreed to underwrite the proposed folk festival up to $2,500 in losses, giving Hadler and the Society the green light to move forward. (As things have turned out in decades since, the Martin Company has continued to be an important supporter and partner for the Society and the Festival.)

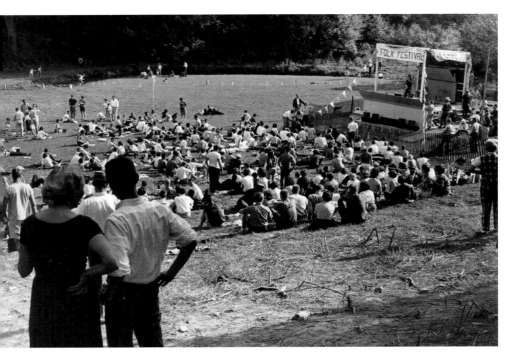

THE WILSON FARM

Once the decision had been made to hold the festival, the next question was . . . *where?* The Wind Gap location was more than an hour's drive from Philadelphia, and many among Society membership disfavored it on the basis that it was too remote. Hadler's original idea had been to hold it at Alverthorpe Park in Abington Township, just north of the city limits near Jenkintown.

Bob Siegel, then President of the Folksong Society, was friends with Polly Butterworth, who was in turn friends with C. Colket "Collie" Wilson III, owner of "The Homestead," a fifteen-acre horse farm on Swedesford Road in Paoli, in the western suburbs along the famous "Main Line." Wilson was a Board member of the Pennsylvania Ballet—then still in its infancy—and built a stage on his grounds for the dancers to use for rehearsals and occasional performances.

Paula Ballan, an early volunteer who would go on to hold the position of Program Chair of the Festival for many years, remembers that Collie Wilson and his wife, Martha, "were just aristocracy, in the *real* sense of the word . . . They were 'Old Railroad' money and they had nothing to prove. They were like *The Philadelphia Story*—they were

Above: The first year (1962) at the Wilson Farm. The original Main Stage is at right, built by Collie Wilson for his Pennsylvania Ballet dancers to rehearse. Photo by Murray Weiss, courtesy of Gene Shay

David Hadler (L) and Gene Shay, circa 1962. Courtesy of Gene Shay

Wilson Farm, 1965. Photo by Lawrence Kanevsky, courtesy Philadelphia Folksong Society Archives

Dave Sear, performing in 1965 at the Wilson Farm. Photo by Lawrence Kanevsky, courtesy of Philadelphia Folksong Society Archives

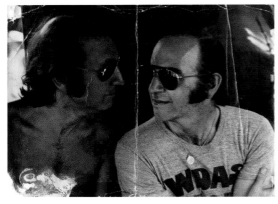

Katharine Hepburn. They loved their horses, and that was their main concern—no bottles on the grounds—'Sorry, you cannot camp here, because God forbid we end up with broken glass anywhere [and] damage our horses—and this land *belongs* to our horses.'"

Accompanied by Polly Butterworth and Mike Marmel, Siegel called on Wilson on what he remembered was a very wet day, with the mud from the melt of a recent snowfall covering all their shoes as Wilson invited them into the living room of his 250-year-old farmhouse. As they were served from a sterling silver tea set in front of a blazing fireplace, Siegel explained the idea of having—hopefully—several thousand people come out to sit in Wilson's horse pasture and listen to folk music. Siegel fully expected that Wilson would consider them a trio of lunatics and order them off the property immediately, but Collie simply smiled and said, "Wonderful!"

The flyer for the first festival (1962) from an original copy provided by Gene Shay.

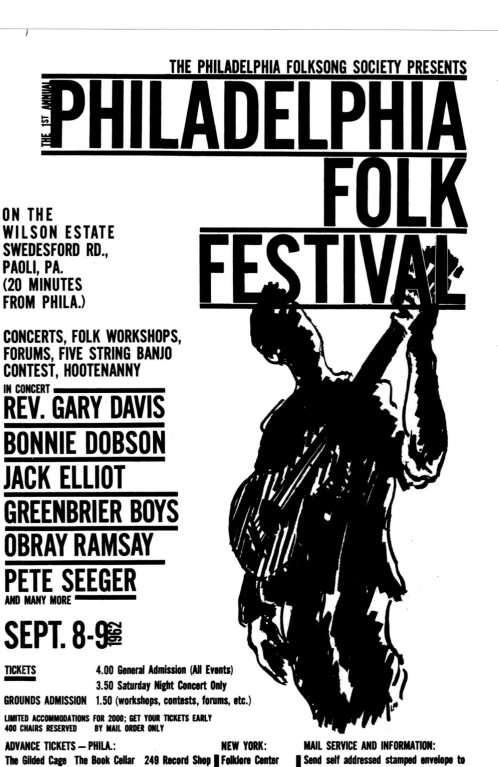

THE PHILADELPHIA FOLKSONG SOCIETY PRESENTS

THE 1ST ANNUAL PHILADELPHIA FOLK FESTIVAL

ON THE
WILSON ESTATE
SWEDESFORD RD.,
PAOLI, PA.
(20 MINUTES
FROM PHILA.)

CONCERTS, FOLK WORKSHOPS,
FORUMS, FIVE STRING BANJO
CONTEST, HOOTENANNY

IN CONCERT
REV. GARY DAVIS
BONNIE DOBSON
JACK ELLIOT
GREENBRIER BOYS
OBRAY RAMSAY
PETE SEEGER
AND MANY MORE

SEPT. 8-9 1962

TICKETS 4.00 General Admission (All Events)
 3.50 Saturday Night Concert Only
GROUNDS ADMISSION 1.50 (workshops, contests, forums, etc.)

LIMITED ACCOMMODATIONS FOR 2000; GET YOUR TICKETS EARLY
400 CHAIRS RESERVED BY MAIL ORDER ONLY

ADVANCE TICKETS — PHILA.: NEW YORK: MAIL SERVICE AND INFORMATION:
The Gilded Cage The Book Cellar 249 Record Shop Folklore Center Send self addressed stamped envelope to
261 S. 21st St. 3709 Spruce St. 1717 Chestnut St. 110 MacDougal St. Festival Committee, Box 215, Phila. 5, Pa.

Right: (L-R): Pete Seeger, Ellen Stekert, Kenny Goldstein, and Mike Seeger, early 1960s. Photo by Murray Weiss, courtesy of Gene Shay

Below: Bluegrass jam at the inaugural festival in 1962 at the Wilson Farm. The fiddler is the late Sonny Miller, from nearby Chester County, Pennsylvania. Photo by Murray Weiss, courtesy of Philadelphia Folksong Society Archives

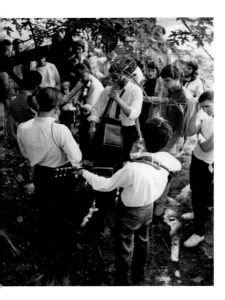

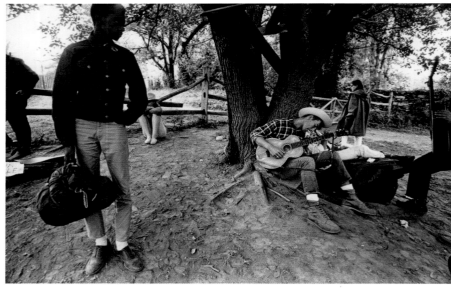

Above: Wilson Farm, 1965. Photo by Lawrence Kanevsky, courtesy Philadelphia Folksong Society Archives

"What's under his kilt?" Wilson Farm, 1965. Photo by Lawrence Kanevsky, courtesy of Philadelphia Folksong Society Archives

An impromptu jam, Wilson Farm, 1965. Photo by Lawrence Kanevsky, courtesy of Philadelphia Folksong Society Archives

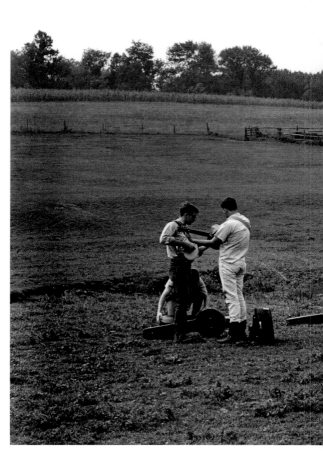

The job of assembling the lineup of performers for that inaugural Philadelphia Folk Festival fell to David Hadler, Gene Shay, and Ken Goldstein. Hadler was an accomplished sound engineer. Shay was then in the early years of a legendary folk music broadcasting career that would last until his retirement in 2015. Goldstein was a noted folklorist, field collector, and record producer. In 1963, he became the first recipient of a PhD in folklore from the University of Pennsylvania, began teaching there, and eventually became chair of the Department of Folklore and Folklife until his death in 1995.

Hadler knew who he would try to get first. "Along the way," he wrote in that same 2005 program book article, "someone had given me Pete Seeger's phone number, and with a 'what the Hell' bravado, I called him."

"What a great way [it would be] to start the Festival, with Pete Seeger," Gene Shay says. "He was so famous in those days, especially with the 'folkies.'" After putting out their offer, Gene recalled, it was a tense waiting game until Hadler called and said, "Guess what? Pete's coming!" Gene believes that was the omen they needed, the sign that the Festival would be successful.

The debut of the Philadelphia Folk Festival came on a frosty weekend, September 8–9, 1962, and Gene remembers it was cold enough to see the breath come out of Pete Seeger's mouth as the audience huddled in blankets. The cover of the first program book—more of a pamphlet, really—boldly announced the ticket prices for the extravaganza: General Admission - $4.00; Saturday Concert Only - $3.50;

Ground Events (Forums, Contest, Workshops, etc.) - $1.50.

In addition to Pete, for those who anted up the concert price, the program also promised the Reverend Gary Davis, Bonnie Dobson, Ramblin' Jack Elliot, the Greenbriar Boys, and Obray Ramsay as headliners. Gene Shay recalls that, as Bob Siegel had suggested to Collie Wilson, some 2,500 people made their way to at least some portion of that debut Festival, but by the time Pete Seeger took the stage on that frosty Saturday evening, there were only a couple hundred left huddling in their blankets in front of the stage. Nevertheless, it was indeed a success as Gene had divined, though David Baskin put some perspective on it, saying, "We were all just regular people who had full-time jobs. We weren't professional musicians." This was the start of more than a half-century of a festival that tens of thousands now call home.

The Godshall Family (2001), with Gene Shay at right. Photo by Richard Nassberg

Finding a seat anywhere you can. Wilson Farm, early 1960s. Philadelphia Folksong Society Archives

LOOKING FOR A NEW HOME

After that first year, Collie Wilson's farm was the scene of three more Philadelphia Folk Festivals before it became clear that the festival operation was beginning to strain the facility. In addition to that, many of Wilson's neighbors in Tredyffrin Township were unhappy with the Festival's presence in their midst, going so far as to file a lawsuit claiming the Festival was a nuisance that violated the township's carnival ordinance.

The Folksong Society countered that they had been given a "permanent zoning variance" to hold the Festival, that "permanent" *meant* "permanent," and the variance could not be arbitrarily revoked. A Chester County judge agreed with the Society and ruled in their favor, but the writing was on the wall, and efforts got underway to find a new location.

Still, similar to the defense by Max Yasgur of the legions of counter-culture music fans who flocked to his New York farm for the Woodstock festival a few years later, the early Philly Folk crowd had its share of supporters among the locals. A 1980 article published by the Tredyffrin Easttown Historical Society about the controversy recalled a letter to the editor of the *Wayne Suburban* that concluded:

> *[The Folk Festival] was conducted on a higher plane than many Main Line parties, with no evidence of drinking or rowdiness. If you have no furs, you keep warm in a sweatshirt; if you have no car, you wear flat shoes and walk; if you can't afford a seat, you wear pants and sit on the grass. They were refreshingly free of such refinements of civilization as fake eyelashes, fake fingernails, fake hairpieces, and fake jewelry . . . Folk music is appealing because it is melodious and expresses simple human hopes and fears . . . What is insidious about singing of love instead of hate, peace instead of war? Can we boast about a culture that accepts the corner bar and juke box but suspects the coffeehouse and poetry? I commend the tolerance of the Main Liners for admitting these social outcasts to our suburbs, and suggest we stop judging by appearance, look beneath the surface of these young people, and listen to their words.*

Back stage 63

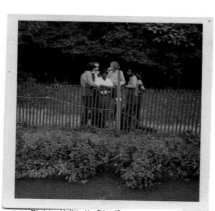

63 back stage, John Hurt and Jerry Ricks and ?

63 stage

63 shot from back stage

? little Blobd girl may be Mary Louise Wilson

I don't know what this shot is

SPRING MOUNTAIN

In 1966, the fifth Festival was held at Spring Mountain Ski Area in Upper Salford Township, along the banks of Perkiomen Creek in the upper northern reaches of Montgomery County. Spring Mountain was only fifteen miles or so due north of the Wilson Farm, but from a cultural perspective, it might just as well have been another country. Paoli was quintessentially "Main Line," while in those years the Perkiomen Valley remained deeply rural, still with many working farms, one of which would soon come to play a critical role in the Festival's future prospects.

Spring Mountain Ski Area proved an unsuitable long-term venue due to, among

other things, inadequate parking. But the biggest problem, as Gene Shay put it with his typical wit, was that it *was* a ski slope, and the audience could not stop rolling down the hill. After that single year at Spring Mountain, it was clear that another move would be necessary.

RAHMER PARK

From 1967 through 1970, the Festival took place only a mile away from Spring Mountain at William Rahmer Memorial Park in Upper Salford Township. The park still exists, nestled between Perkiomen Creek and the former bed of what was originally a passenger railroad that was known through much of the late 1800s as the Perkiomen Railroad (later part of the Reading Railroad, then Conrail until use was discontinued in the 1970s) and is now part of the Perkiomen Trail for hiking and biking.

Over the four years the park hosted the Festival, as had happened in Paoli, relations with the township and neighbors grew strained, and permission to hold the 1971 Festival in the township-owned park was refused. Andy Braunfeld had been attending the Festival as a regular ticket buyer since the Wilson Farm days, but he remembers being a young lawyer at a major Norristown firm when the Folksong Society sought legal representation in a lawsuit stemming from relations between the Festival and the township.

"Stretch Pyott was [Society] President at that time," Andy recalls. "He and Ellis Hershman, Bob Siegel, Howard Yanks, and a few others came to me and asked if I would

handle the lawsuit, which I did. It was litigated partially, and then settled."

Pausing a moment, Andy continues, "And as a result, the combination of the settlement of the lawsuit and the incoming new board of [township] supervisors, we began to forge what has turned out to be a terrific partnership with the supervisors and the [Upper Salford] community which keeps getting better and better every year."

That, Andy says, is how his tenure as part of the Festival management began, "but that was a long time ago," he laughs. "I had hair then, and some of it wasn't even gray."

Above: (L-R): Paula Ballan, Ken Goldstein, and Teresa Pyott. All three served as Festival Program Chair at various times. Teresa was Ken's secretary in the Department of Folklore and Folklife at the University of Pennsylvania. Courtesy of Paula Ballan

Rahmer Park, 1970. Photo by Richard Nassberg

Map of the Festival grounds at Rahmer Park, from the 1970 Program Book. Courtesy of Mary Lou Troy

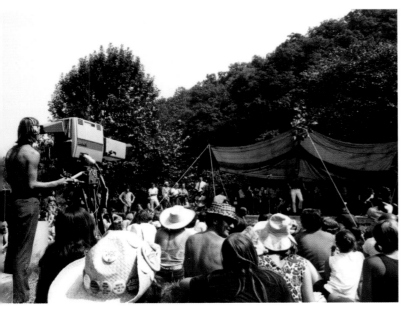

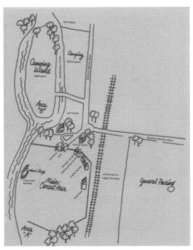

ABE AND MAUD

Jerry and Pat Godshall, the Festival's current "landlords," 2013. Their family has owned the Old Pool Farm for more than a century. Photo by Jayne Toohey

Russell Godshall in 1996, the year before he passed away. Following the passing of his uncle, Abe Pool, he and his mother, Maud Godshall, assumed control of the Old Pool Farm. Photo by Jayne Toohey

Before fences could be mended with the township, there remained the challenge of finding a location to hold the 1971 edition of the Festival. Rahmer Park had previously been part of the adjacent farm on the other side of the tracks that was owned by Abe Pool and his sister, Maud Godshall.

Abe and Maud had been renting space to the Society for Festival parking in their field along Salford Station Road and they stepped in to offer the use of their entire farm, which had been in the family for more than one hundred years. Maud's grandson, Jerry Godshall, remembers that when Folksong Society Board member Howard Yanks first approached Abe and Maud to negotiate terms for the use of the farm to hold the Festival they ended up sealing the deal on a handshake.

Abe passed away in 1973. He had never married, and Maud became the sole owner of the property. She continued to enjoy hosting the Festival and relied on her son Russell Godshall to help. The relationship between Maud and the Society continued to grow until she passed away in 1995, followed by Russell two years later. The Old Pool Farm, as it has come to be known, is now in the hands of Russell's sons, Jerry and Glenn.

"Down in the campground, that was all fields," Jerry recalls. "Some years it was corn, some years it was wheat, some years it was oats—and hay. It was a regular, working dairy farm until around 1966 or 1967. Then Abe and Maud sold everything below the railroad tracks, which is now the [Perkiomen] Trail, [in] what was called back then 'Project 70' [a 1964 statewide legislative effort to acquire land for, among other things, state and local parkland], which they made into a park." (The same park from which the Festival was evicted.)

That first year on the Old Pool Farm was memorable, for tropical storm Doria engulfed the region over the weekend. "They were camping in what we called The Meadow, and that was completely under water that year," Jerry shakes his head as he remembers what was, at the time, an inauspicious first year for the new partners. From the outset, the Godshalls were not just "landlords" to the Festival, Jerry says, as they joined in the party along with everyone else. "My wife and I have never camped, but my kids have, and my oldest daughter, she *still* camps every year."

"I don't remember what year it was," he continues, "but my daughter was in a tent in the campground—my kids always camped out there after they became teenagers. A storm kicked up and it picked up her tent—with her in it! She went tumbling down through the field . . . I think one [other] tent ended up in a tree—and it sat there for a year!"

Like so many of the perhaps more than one million people in total who have roamed his family's farm since 1971, it has been rewarding for Jerry to see kids whom he saw each year at the Festival cavorting in Dulcimer Grove, volunteering, and just enjoying the community later return to the Festival as artists with successful careers of their own. "Amos Lee growing up as a volunteer, and now, with what he's doing—him and John Gallagher [Jr.]. They grew up at the Folk Festival, and now their careers are the way they are—that's pretty great."

Jerry and his wife Pat still live on the property at the top of the campground hill, and more family members live close by. Jerry points out that the original farmhouse that he spent most of his youth in still exists at the sharp bend in Salford Station Road, on the old portion of the farm now owned by the Township. More than four decades after Abe and Maud shook hands with Howard Yanks he says it has all been worth it.

"We've met so many people and made so many friends through the Folk Festival, and we see them once a year, maybe—it's like a big reunion."

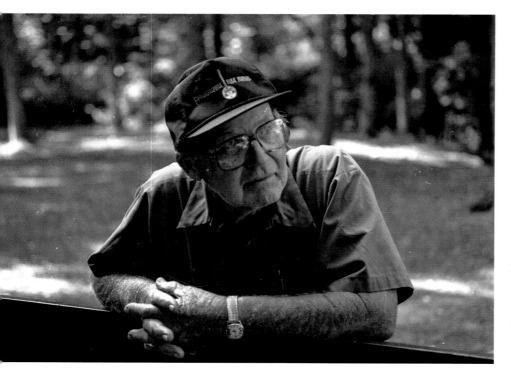

GENE SHAY

Call him the "Godfather of Philadelphia Folk Music" or the "Dean of American Folk DJs," but Gene Shay is the "Gentleman Scholar," the face of the Philadelphia Folk Festival, and the voice of folk music in Philadelphia for more than five decades. He has emceed the Festival every year from 1962 to the present, with the exception of 2016, when health concerns forced him to stay home. Festival goers not only respect and adore Gene for his knowledge and professionalism, but groan with him as he spouts out bad jokes—his favorite way to kill time between acts as the sound crew changes the setup. Among his longtime standards (and appropriate to the occasion): "How do you make a million dollars in folk music?" (Pause for just the right number of beats.) "Start out with three million." And: "What do you get when you throw a hand grenade into a French kitchen? . . . Linoleum Blownapart."

Born Ivan Shaner in Philadelphia on March 4, 1935, Gene grew up in Nicetown, a section of North Philadelphia that was not far from the lingerie shop his father owned on Germantown Avenue. Gene first became interested in entertainment when he attended summer camp. He went to two different camps: first to Camp Sholom in Collegeville, then to Camp Kahagon, near Quakertown, where he also worked as a

Gene with his sister Felice, early 1940s.
Courtesy of Gene Shay

waiter while he was in college. At Camp Kahagon, he worked as the dramatic counselor, putting on shows like *South Pacific* with the other campers. He says musical comedy was among his particular favorites.

Following graduation from Olney High School in 1953, Gene enrolled at Temple University in Philadelphia. In addition to

working at Camp Kahagon during the summers he expanded his interest in entertainment while at Temple, where he was drawn to the school's radio station, WRTI, and met John Roberts, a professor who recognized Gene's talent for radio (not the same John Roberts as the English singer who has often appeared at the Festival with his partner Tony Barrand). During his studies Gene worked three days a week at WFIL-AM, hosting a news magazine show called *What's News?* while also doing radio dramas, to which he contributed various voices. He got to know and work with the late Dick Clark at the studios at 46th and Market Streets at a time when Clark's iconic television/music show *American Bandstand* was just beginning to gain national attention.

It was during this time that Gene enjoyed a brief fling with Hollywood stardom. "I was also in the movies, in *The Burglar*, with Jayne Mansfield. They filmed that in Philadelphia. My friend, Betsy, who I went to Temple with, she said, 'Do you want to be in a scene?'" It was a non-speaking role—"I'm a walk-on, an extra," he remembers.

In 1957, upon graduation from Temple, Gene entered the Army. As there was still a draft, and he would not qualify for a deferment, his college days were over. Asked during induction what he did as a civilian, Gene responded, "Radio." The Army thought he meant that he was a signal operator, so they had him doing Morse code. They also put him in the motor pool, where he intentionally flunked the driving test, thinking it would keep him from ending up as nothing more than a driver during his stint in the Army. Instead, he says they sent him overseas to Germany and put him to work washing the trucks.

"They didn't know *what* to do with me," he laughs. "One day I walked into Stuttgart, and I saw the [Armed Forces Network] affiliate station there, and I said, 'Can I get an audition? I'm a radio disc jockey back in Philadelphia.' They said, 'Sure,' gave me a couple sheets of paper, and I ad-libbed some stuff. The next thing I know I got a letter from Headquarters."

They had liked his audition and wanted him to join AFN, but he needed approval

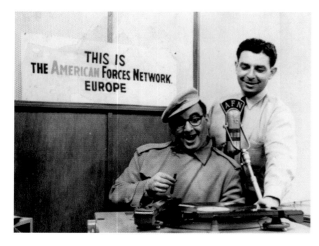

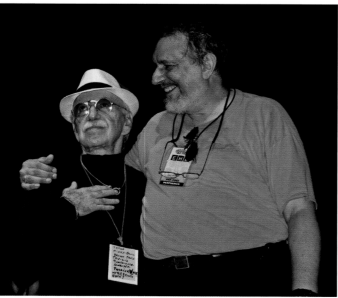

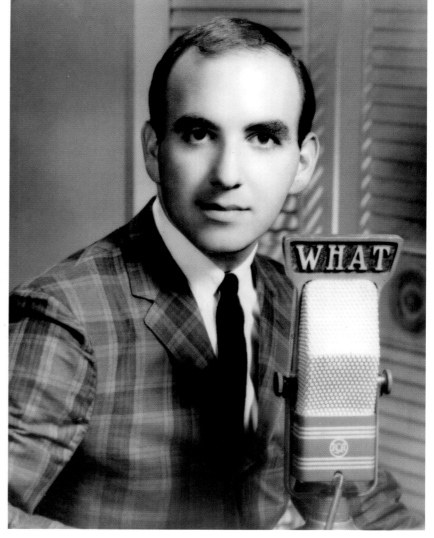

from his commanding officer for the transfer. Gene had been told that his captain—Gene still recalls his name, Rocky Bolton—was averse to letting good people get away from him, and had never approved anyone's request for a transfer before. Bolton must have seen something special in the young Philadelphian, though, because within two weeks Gene got his transfer and found himself living in a thirteenth-century castle overlooking the Main River in the town of Hoechst, a suburb of Frankfurt. It was there, in one of the castle turrets, that Gene worked as a news and music programmer and broadcaster for AFN. It was a great experience for him, one he credits with allowing him to mature as a radio announcer.

Less than a week after returning home following his discharge from military service, Gene got a call from legendary broadcaster Sid Mark, whose radio shows devoted to the music of Frank Sinatra have been a staple of Philadelphia airwaves since 1957. Mark had started an all-night music show on WHAT-FM, which also had an AM

side with the same call letters. The Federal Communications Commission (FCC) had made a ruling to promote FM radio that required companies owning stations on both AM and FM bands to provide content for the FM outlet that was different from its AM sister, at the risk of losing the FM license entirely. In 1958, WHAT had become the country's first twenty-four-hour, live FM jazz station, and Mark wanted to hire Gene as a full-time jazz disc jockey.

In 1962, as David Hadler and his collaborators in the Folksong Society were trying to get the first Festival off the ground, Gene became the public relations director for WHAT and took over the Sunday evening folk music show from Joel Dorn, who was on his way out the door to Atlantic Records and a career producing jazz records that would earn him a couple Song of the Year Grammys in the 1970s for a pair of Roberta Flack hits: "The First Time Ever I Saw Your Face" and "Killing Me Softly With His Song." Gene notes Dorn was not really a folk music fan, and was only too happy to pass the show on to someone else. Little did either of them know

Top left: Gene and Gloria (right) with family, 1969. Courtesy of Gene Shay

Top right: Gene Shay being "arrested" by the Pennsylvania State Police for telling bad jokes, 1990. Photo by Robert Corwin

Bottom left: On stage at the Festival, late 1960s. Courtesy of Gene Shay

Ivan Shaner, Armed Forces Network, during his tour of duty in Germany, late 1950s. On returning to civilian life he took the "stage name" Gene Shay. Courtesy of Gene Shay

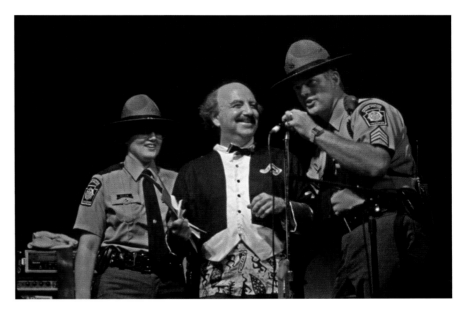

at the time that a half-century later, Gene would still be doing what would come to be known simply as "The Folk Show."

By the early 1960s, Gene had also received a great deal of exposure to the Philly folk music scene through, among other connections, his friendship with Leon and Tossi Aaron, who had moved back from Easton and were living in Cheltenham Township, just north of the city limits. In addition to music gatherings they had often also held "charades" parties. It was at one of these, Tossi recalls, that Gene first met his wife Gloria. More than fifty years later Gene and Gloria are still inseparable, and their marriage was blessed with two beloved daughters, Rachel and Elana—and several grandchildren as an added bonus.

David Hadler was acquainted with Gene, was well aware of Gene's influence as a broadcaster, and asked him to not only become a co-chair of the Festival, but also to become the Festival's first master of ceremonies (emcee). Thus began Gene's close and intimate association with the event. Those meeting and spending time with Gene for the first time are immediately struck by his wealth of knowledge, passion, and dedication to music, especially folk music. Some people have a certain way of making others comfortable the moment they meet, and Gene certainly has that quality.

Gene's tenure as the "Dean of Folk Music DJs" has spanned more than five decades, and many more individual stations than that. For several years he did a Sunday "twofer," broadcasting an afternoon folk show from the WXPN studio in West Philly, then heading into Center City for his evening show on WHYY. The final years of his broadcast career found Gene "at home" each Sunday evening at WXPN-FM, which is owned and operated by the University of Pennsylvania. The station is also the home of the nationally syndicated "World Café," originated and hosted for more than a quarter-century by David Dye, who regards Gene not only as a close friend, but a mentor and pioneer as well.

In an online article published in 2011 on philly.com, David told reporter Jonathan Takiff, "[Gene] virtually invented the delivery and thematic [song] set construction style that would become the standard for FM rock DJs—for me and other guys like Ed [Sciaky] and Michael [Tearson] [both also longtime Philly radio presences]."

In the late 1980s, Gene was a founding figure of what is now known as Folk Alliance International, which can best be described as a "trade association for the folk music business" that produces a large annual conference where artists, promoters, venue operators, record producers, academics, and many other professionals and volunteers from across the folk music world come together and conduct business. A region of this group is the Northeast Regional Folk Alliance (NERFA), and Gene has been very active in both from the very beginning.

Particularly as a broadcaster, the conferences have given Gene the opportunity to meet and exchange ideas, advice, and stories with hundreds of other

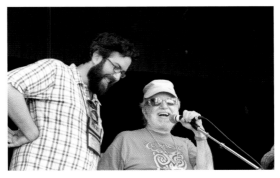

folk DJs from across the land. At each event, there is inevitably a workshop to discuss issues relating to folk music broadcasting, and rare indeed is the radio panel that does not include Gene.

Among the countless folk musicians who regard Gene as one of their closest friends is Janis Ian. Asked what makes Gene special, Janis says, "He loves the music and is a professional. There has been a tendency in folk music [to believe] that if the heart is good, the rest will follow, but it doesn't. You have to learn to be a professional."

Noting the polish and skill of Gene's interviews, she continues, "He knows how to put one song against another and not jar you, but at the same time keep your ears perked up." Back in the 1950s and 1960s, Janis says, there were not that many professionals in the folk music world— mostly there were *well meaning* people— but Gene was and still is the fortunate combination of both.

Another longtime very close friend is Andy Braunfeld, who has served the Festival and the Folksong Society in many capacities, including as in-house attorney, as well as sharing stage duties with Gene. Andy credits Gene for making Philadelphia the hotbed of acoustic music that the city and surrounding area have become known as over the decades.

For many years, the daily schedule featured a late afternoon concert, followed by a dinner break, then an evening concert. Realizing that the break did not afford Gene enough time to go back to his motel room, freshen up (the afternoon concert weather

would often be sweltering), and grab a bite to eat before returning to the stage, Andy says he simply began giving Gene the "afternoon off" and filling in himself, so that Gene could be fresh and ready to go for the evening show. It is an arrangement that continues to the present day.

Barry Sagotsky—one of the photographers whose images appear in this book—always enjoys catching up with Gene at the Festival, and not just to talk about music. "[Gene and I] share a background in magic," he says, "[we're both] in the American Society of Magicians. Gene was a magician—well, you never *stop* being a magician, but Gene wrote a book on magic at one point, I believe." (True! It can be found on amazon.com.)

Sensational Cape Breton fiddle star Natalie MacMaster says warmly of Gene, "[He] has always been a fantastic supporter of folk music in general, and Celtic folk music [in particular]. For me, he has always been a very big part of my performances and my success in the Philadelphia area."

John Gallagher Jr. (star of HBO's *The Newsroom*, and a singer-songwriter who grew up as a "Festival Brat") reflects on what Gene represents to the folk community in general and Philadelphia specifically. "[Gene] was a big celebrity to me growing up," he says. When John performed at the festival in 2014, that sense of innocence and awe kicked in unexpectedly one night.

Though he had found himself surrounded at the close of his set by eager fans and followers of his film and television

Top left: Gene Shay with Andy Braunfeld, 2007. Photo by Jayne Toohey

Bottom left: Gene Shay on the Main Stage with his WXPN Folk Show successor Ian Zolitor, 2015. Photo by Eric Ring

"Hi Gene! How's your hygiene?" Gene Shay communing with the audience. Photo by Barry Sagotsky

Above: Gene Shay (center) with Tom Rush (left) and David Buskin (right), 1980. Photo by Robert Corwin

Backstage with Gene, 2013. Photo by Jayne Toohey

Gene Shay listening for a response from the audience, 2014. Photo by Lisa Schaffer

the "extra time on his hands," as he puts it, to immerse himself even more in folk music. Raised in a "folk music family," Ian had been listening to Gene's Sunday evening show his entire life, and in a "what the Hell" frame of mind he sent an email to Gene explaining he wanted to learn more about the music, and would be grateful for the opportunity to meet Gene and pick his brain.

He did not get an immediate response, but as fate would have it, a short time later, he and Gene were both guests at the wedding of mutual friends. Grabbing the bull by the horns, Ian approached Gene and reiterated what he had said in the email. They had a nice chat, and Ian recalls, "I think the clincher was John Hartford, because I mentioned both in the email and when I talked to [Gene] in person of how John Hartford is just one of my biggest musical heroes, and also what I believe he stood for: he stayed true to himself throughout his entire career. I knew that Gene and John were friends, and I think Gene shared the same sentiments about John."

Gene invited Ian to stop by the WXPN studio while Gene was on the air one night, and both enjoyed the discussion so much that Gene invited him back. Ian began coming nearly every week, and when Gene started needing help with the production

career, he could not help having a "fan moment" of his own the evening before. "I saw [Gene] very briefly passing through the lobby of the hotel [as I went] to check into my room, and I was like—*that's Gene Shay!*"

Ian Zolitor was raised as a "Fest Baby," and while he loved much of the same music his peers in school did, he also had a love and passion for folk music that they did not quite seem to get. Finding himself between jobs in his mid-twenties, he resolved to use

and engineering of the show, Ian became his intern for the final couple years Gene was on the air. When Gene announced he would retire from the *Folk Show* in 2015, Ian made it known to WXPN management that he would like to be considered along with a number of other candidates to replace Gene. He still sounds more than a little stunned that he ended getting the job, but he says, "I think for the most part I had Gene's blessing, which helped a lot."

"When I first approached Gene," Ian admits, "I didn't necessarily have any interest in working in radio. I just wanted to learn about folk music. I never really considered that an option, of eventually getting the *Folk Show*. It seemed so out of reach, it seemed like, well, the *Folk Show* is Gene's, and it will *always* be Gene's."

"I've still got to pinch myself when I go in there on Sundays," he finally laughs. "It's by far my favorite thing in the world."

In 2016, on the advice of his doctor, Gene missed his first Philadelphia Folk Festival. He prepared a video to explain his absence, and with his usual wit and amazing personality tried to make people laugh. Julie Leinhauser, a volunteer and "Fest Baby"— someone who has attended the Festival her entire life—says she started to cry. She knows how much Gene means to her and to the Festival, and commented that she could see in Gene's eyes how much the Festival means to him. Gene also spoke with the concertgoers on Saturday night via telephone with the entire audience shouting to Gene how much they missed him.

A "Smiling Banjo" made of wax presented to Gene Shay, 1986. Philadelphia Folksong Society Archives

Gene Shay, 2015. Photo by Jayne Toohey

SIGHTS & SOUNDS OF THE PHILADELPHIA FOLK FESTIVAL

THE "SMILING BANJO" LOGO

Gene Shay is often called the "Face of the Philadelphia Folk Festival," but it would be more accurate to say he is the *human* face. From virtually the very beginning, the most recognizable symbol of the Festival has been the "Smiling Banjo" logo. Many sources credit Gene as the originator and designer of the iconic graphic, and while he says he played a part, it was not all his doing, and there is a lot more to the story. Though he was rapidly making a name for himself in folk radio, the reality was that Gene needed to make a better living than broadcasting could afford, so he went to work in the advertising business.

Tossi Aaron remembers that she acquired the job of "Social Director" (i.e., hospitality coordinator) for the debut of the Festival at the Wilson Farm in 1962. Part of her duties included handling issues at the nearby motel where the performers were being lodged. She says she was asked to post a flyer, or "broadside," or other suitable sign advertising the Festival on the bulletin board in the motel lobby.

Not having what she considered suitable sign-making materials at hand, she improvised by hanging her own banjo on the board and festooning it with ribbons and cords. She cut a circle out of paper, drew a "smiling face" on it, affixed it to the skin head of the banjo, and wrote information about the Festival on the board around the banjo. Tossi recollects that Gene—who also happened to be one of her guitar students at the time— walked by and paused to admire her work. "Can I take a photo of that?" he asked. "Sure, go ahead," Tossi replied.

"[Gene] took [the photo] off to the ad agency where he worked, and they turned it into this really gorgeous design," she says.

"Things were beginning to grow with the Festival and the Folksong Society," Gene says, picking up the story, "and suddenly I was interested in graphics, which I'd *never* been interested in, and I met a graphic designer who designed the Festival Banjo; his name was Eugene Ellick."

"I told him all of my stories," Gene continues, "what folk music was all about, and then he came up with three sketches. He drew a banjo neck, but he forgot it should have had a fifth string—he didn't put that on." (Later versions corrected this.)

One design stood out to Gene. "I said, 'That 'Festival smile''—great, great, let's use that.' So then [Eugene] drew it up, and he came up with the idea of using the names of the artists alongside the banjo."

Eugene Ellick also developed the typeface that has been a constant graphic element of Festival posters, program books,

Previous: The "Smiling Banjo" logo and familiar typeface, both designed by Eugene Ellick.

Left: Pete Seeger tunes his banjo for a workshop at the Old Pool Farm, 1978. Photo by Richard Nassberg

Below left: Howard "Stretch" Pyott (L) calling for the Reel World String Band: Karen Jones (fiddle), Bev Futrell (mandolin), Sue Massey (guitar), and Sharon Rubble (bass), 1985. Photo by Thom Wolke, from Philadelphia Folksong Society Archives

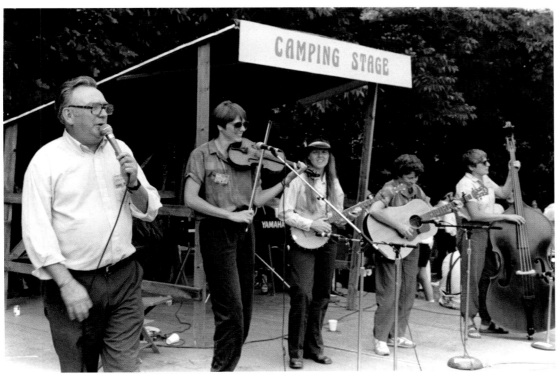

Above: Christine Lavin (L) and Sally Fingerett at the drawing for the Martin guitar, 1993. Each year the famed guitar maker provides at least one fine instrument to be raffled off. Photo by Bob Yahn

Faith Petric, 1984. Photo by Bob Yahn. Courtesy of Philadelphia Folksong Society Archives

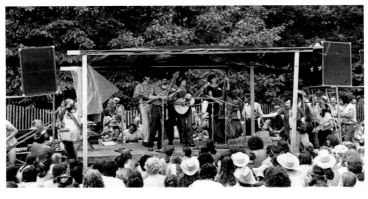

The Strange Creek Singers, 1972 (L-R): Mike Seeger, Tracy Schwarz, Lamar Grier, Alice Seeger (Gerrard), and Hazel Dickens. Philadelphia Folksong Society Archives

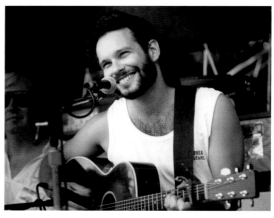

Top left: In the Dulcimer Grove: Dave Perry (at left), Mike Miller (with guitar), and Deborah Pieri (at right, rear). Photo by Charlotte Micklos, from Philadelphia Folksong Society Archives

Top right: John Gorka, 1980s. Photo by Betsy Brody, Courtesy of Philadelphia Folksong Society Archives

Middle: Taj Mahal. Photo by Frank Jacobs III, from Philadelphia Folksong Society Archives

Below: (L-R): Carl Martin, Steve Goodman, and Ted Bogan, early 1970s. Photo by Richard Nassberg

Production meeting. Photo by Neil Benson, from Philadelphia Folksong Society Archives

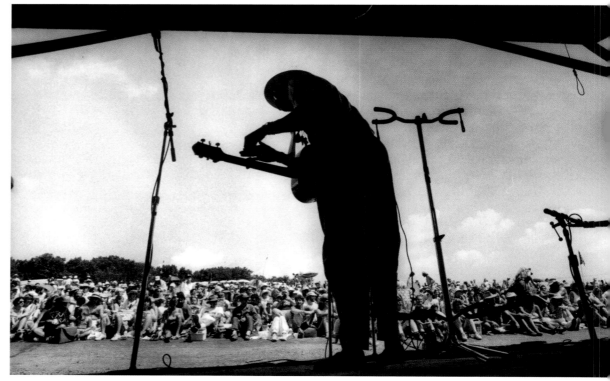

flyers, and other publications over the decades, and now including websites. "[Eugene] made these things look like they were woodcuts," Gene says, "like they were carved out . . . at that time I was working at ad agencies, working with graphic designers. [The Society] put me in charge of anything that came from the stage, and a lot of things to do with art."

Eugene Ellick passed away more than twenty years ago, Gene notes, but it still brings back fond memories when he sees a byline in the *New York Times* by Eugene's son, Adam B. Ellick, a Pulitzer Prize-winning digital reporter for the paper.

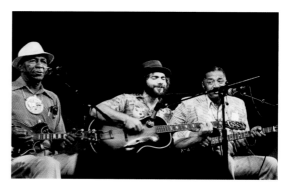

WEATHER

An event that has been held outdoors for more than four decades is going to be at the mercy of the elements from year to year. Depending on the rainfall—or lack thereof—leading up to or during the Festival weekend, some years will inevitably come to be known as "Mudfest" or "Dustfest."

In particular, 1971 (the first year at the Old Pool Farm) turned out to be almost certainly the most memorable of the "monsoon" years. A tropical depression in early August eventually became Tropical Storm Doria and made its way up the Atlantic Coast just in time for Festival weekend. Though it never officially became a hurricane, the distinction was not apparent—or important—to those who showed up and endured the seventy-mph winds and nearly seven inches of rain the storm brought to the Philadelphia region.

As Sonny Ochs, sister of legendary singer Phil Ochs, recalls, "When I heard the weather forecast, [that] there was gonna be a hurricane, I didn't care. I went anyway, and I took my kids, and I had somebody else's teenage kid."

It was standard operating procedure, Sonny says, to set up camp and then sortie out for groceries to last through the weekend. On arrival at the grounds incoming campers were unceremoniously told, "Nobody's going out. Once you're in, you're in. You can't go out."

"I happened to have some fruit and veggies in the car," Sonny continues. "I met

up with some friends and some of them happened to have the makings of chili, and somebody else had some desserts, so we all banded together and combined our food and survived. I remember somebody on the stage saying during the performance, as it was pouring, 'If you guys are crazy enough to sit out there and listen, we're crazy enough to be performing.' And they did!"

David Bromberg also famously remarked during his set that year, "I've been slogging through this mud since noon, man." Asked what she recalls most about the Festival, Janis Ian laughs and says, "Mud slides."

Later that night, during that storm-drenched 1971 Festival, Sonny says, she and

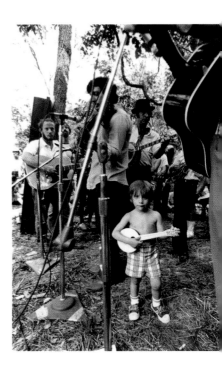

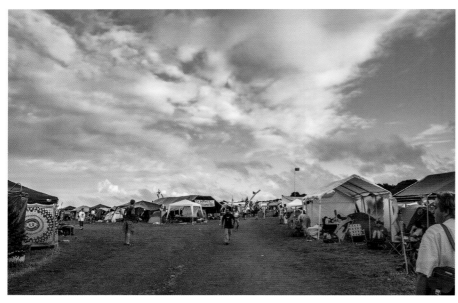

Life in "The Pit," 1977. Photo by Robert Penneys, from Philadelphia Folksong Society Archives

A sunny day in the Campground, 2005. Photo by Jayne Toohey

the kids awoke to find the wind lifting the floor of their tent several inches off the ground. "I said to the kids, 'Ok, here's what we're gonna do. I'm gonna go to the car, I'll sleep in the car, and you kids'—there was a big school bus there—'go knock on the door and see if you can sleep on the floor [of the bus]. Take your sleeping bags.' I turn around and my one son is following me in the rain. So we get to our car, and fortunately my sleeping bag was the kind that spreads out to a regular blanket, so I covered myself on the seat and him on the floor with the same blanket, and that's how we made it through the night."

Though that debut year at the Old Pool Farm turned out to be an extraordinarily soggy one, it fortunately turned out not to be a bad omen, as the Festival has returned there each summer for more than four decades—and counting. Whatever the weather holds in store the crowds still come,

and with very few exceptions the shows go on as scheduled.

Even on what seems to be a typically sunny—but hot—August day, weird weather phenomena and the Philadelphia Folk Festival just seem to go hand in hand. In 2006, as streams of campers were patiently making their way into the campground on Thursday afternoon, a sudden, concentrated thermal updraft caught hold of several unsecured tents and lifted them hundreds of feet into the sky, much to the astonishment and delight of the thousands who witnessed it (with the probable exception of the owners of the tents). (Coincidentally, the theme employed that year by Marketing and Press Chair Lisa Schwartz was *The Wizard of Oz*.)

A number of cell phone videos captured the event, were played on the video screens at the Main Stage throughout the weekend, and were later uploaded to YouTube. (One of the better examples was published online at https://www.youtube.com/watch?v=7fnzdRW0lxc.)

STAGES

The highlight of the programming each year at the Festival may be the performances on the Main Stage, but also an important part of the "Philly experience" is the array of workshops and special concerts held over the course of the weekend at a number of smaller, auxiliary stages scattered across the grounds on the Old Pool Farm. Behind the Main Stage, through the woods and Dulcimer Grove (see **below**), at the bottom of the hill leading up into the campground, is the Camp Stage.

For many years it was the site of the Sunday morning/early afternoon "Cèilidh" (KAY-lee), featuring many of the Celtic and British Isles performers at the Festival, and hosted by Kenny Goldstein, one of the Festival's founders and longtime chair of the Department of the Folklore and Folklife at the University of Pennsylvania. Following Kenny's passing in 1995, the Cèilidh was discontinued for a time, but in recent years has been resurrected on the Camp Stage on Sunday afternoon.

Flanking either side of the Main Stage are the Craft Stage (audience left), which abuts the area where a variety of vendors and artisans display and sell their wares, and the Tank Stage (audience right), named for the tanker trucks that provided fresh water and were parked along the fence line in the years before wells were dug around

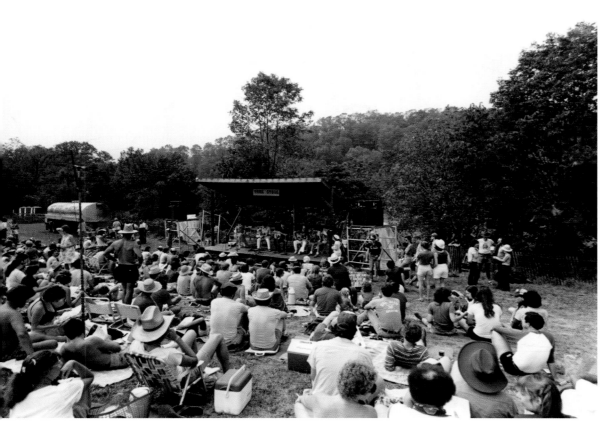

Left: The original Tank Stage at the Old Pool Farm, 1970s. Prior to the digging of wells on the property, water was brought in by tank trucks that parked by the stage, giving it its name. The tanks (and the trucks) are gone, but the name remains. Behind the Tank Stage is Rahmer Park, site of the Festival from 1967–1970. Years later the Tank Stage was moved to a location just off the left edge of this photo. Photo by Richard Nassberg

The Martin Guitar Stage, early evening, 2014. Gene Shay's image can be seen on the video screens on either side of the stage. The screens were an innovation by legendary sound engineer Bill Hanley that were first used at the Philadelphia Folk Festival. Photo by Jayne Toohey

Meghan Cary and the Analog Gypsies perform at the Front Porch Stage in the Campground, 2014. Photo by Jayne Toohey

Main Stage 1967, the first year the Festival was held in Rahmer Park, adjacent to the current location on the Old Pool Farm. When the Festival moved "across the tracks" in 1971, the new Main Stage was approximately 500 feet to the left as viewed in this shot, and with a slight adjustment when the Martin Stage was built in 2001, that continues to be the case. Photo by Diana Davies

the Old Pool Farm to give access to water for all. At the top of the hill, near the Main Gate, is the Lobby Stage, which is often used for dances (square, contra, Latin, French Canadian, and more) and performers who dance as part of their act, as well as showcases and the ever-popular kids concert on Sunday afternoon. Recent times have seen the addition of the Culture Tent, featuring special performances and opportunities to hear performers talk about the music and its history, and the Front Porch Stage in the campground, which is used exclusively for emerging and local artists who are part of the Folksong Society's Philadelphia Music Co-op.

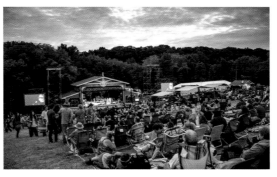

These side stages are used throughout the weekend before the Main Stage starts up for workshops that employ a "mix and match" approach, usually with a theme in mind. Workshop audiences get to see a performance that gives the artists an opportunity to demonstrate their talents "up close," and to work with peers whom they often have never met, and whose music is often in an entirely different style or genre. A good example from 1995 is the "Songs Of The Sea" session on the Tank Stage that featured Jim Albertson, Louis Killen, Tom Lewis, and the Liverpool Judies swapping songs, explaining the history behind them, and joining in with each other.

After many years of service, the original Main Stage on the Old Pool Farm had

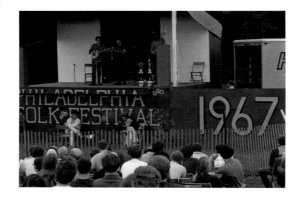

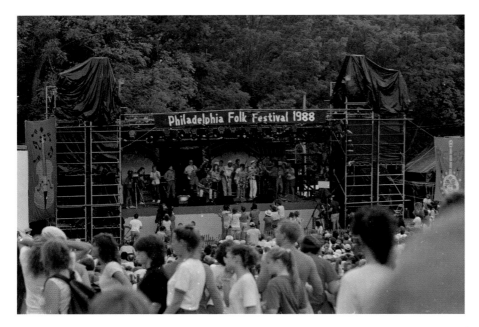

Above: An all-star cast on the Main Stage, 1988. Taj Mahal is at center, in the green shirt. Tom Rush is seated with guitar. Patty Larkin is between them. Photo by Jayne Toohey

John Flynn performs for the kids at the Lobby Stage, 2014. Photo by Steve Sandick

From the back of the Martin Stage as El Caribefunk performs in 2015. Photo by Lisa Schaffer

deteriorated to the point that the safety of performers and stage crews was coming into question. With folk music becoming more and more sophisticated as time passed, the amount of equipment being brought by performers was also straining the capacity of the stage, not only in terms of weight, but also in square footage. Following the 2000 edition of the Festival, it was decided to send the venerable old stage to "Folk Valhalla" in a ceremonial bonfire.

Fred Kaiser, who was the Chair of Programming and Production through much of the 1980s and all of the 1990s, had spent much of that time perched on the top step of the staircase the performers came up to reach the stage, as he watched and managed the ongoing shows. As the doomed stage was knocked apart prior to being torched, Fred managed to grab hold of that top step, and it now occupies a place of honor in the home he shares with his wife, Mary Lou Troy, who also served many years on a variety of Festival committees.

With the assistance of the C. F. Martin Guitar Company, along with a capital fundraising initiative, work began at once to erect a new concrete-based stage facility with not only more performance space, but much more room for backstage operations. In addition, a climate-controlled room underneath the

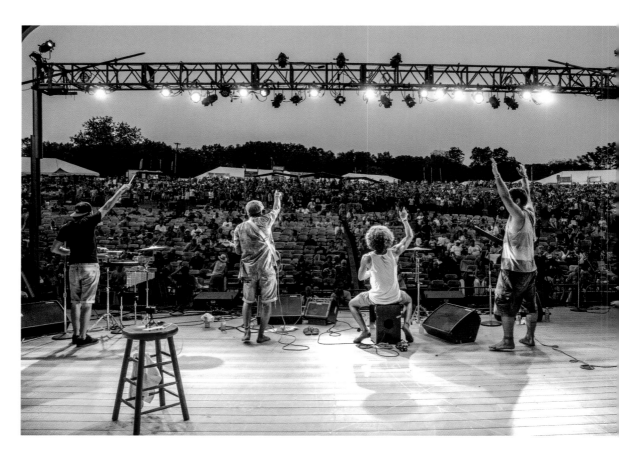

stage, which has come to be known as "The Grotto," was added to house the Festival Archives crew that documents and preserves the audio and video from each show.

In recent years, much of the Festival Archives' work has been viewed by Main Stage audiences in the vintage and classic videos shown on the screens alongside the stage during set changeovers. By the time August 2001 rolled around, the brand-new Martin Guitar Stage was ready and open for business, and has remained the primary performance space for the Festival ever since.

Left: At the Bill Graham bridge, between the Crafts Area and the Campground, 2015. Only paid campers may enter the Campground. Photo by Jayne Toohey

Below Left: Kids cooling off in the wake of the water truck as it tries to keep the dust down. Philadelphia Folksong Society Archives

Below: When your front porch is on your rear bumper, 1994. Photo by Jayne Toohey

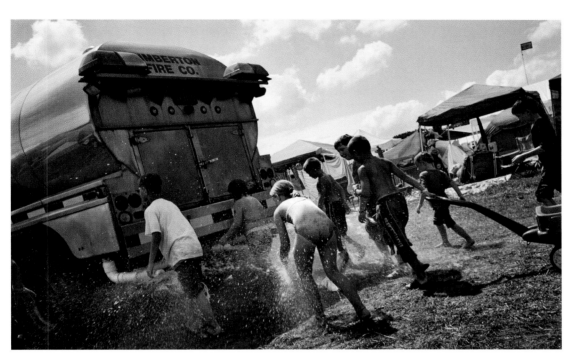

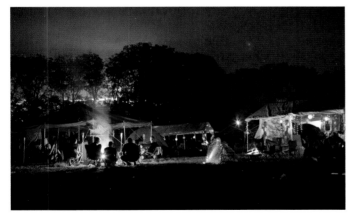

The Campground at night, 2015. Photo by Sandra Dillon

A quiet, late-night jam (LisaBeth Weber and John Gallagher Jr., 2014). Photo by Jayne Toohey

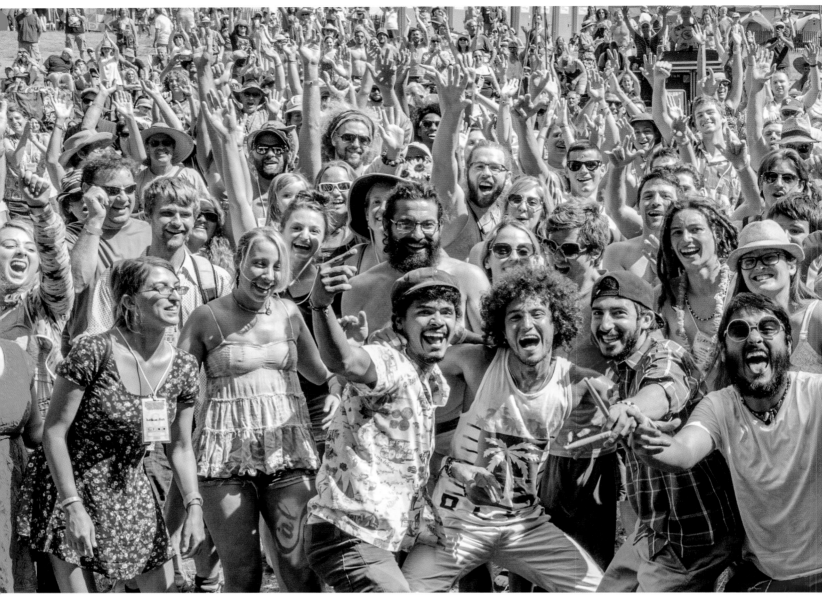

Above: "Say 'cheese!'" Photo by Lisa Schaffer

Are there two pots of gold at the end of a double rainbow? In the Campground, 2014. Photo by Frank Jacobs III

The "Candle Wizard," 1996. Photo by Jayne Toohey

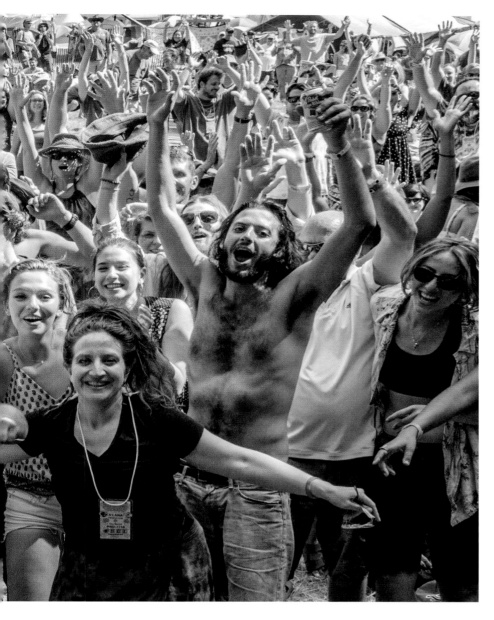

STAGE SOUND, LIGHTING, AND VIDEO

Imagine arriving early at a venue for an evening concert featuring a favorite performer or band. The sound engineers may still be setting up microphones and speakers, plugging in all the cables, and checking for any potential feedback or sixty-cycle hum that might adversely affect the show. Likewise, another technician may still be setting up and aiming the stage lights for just the right illumination and effect.

At some point the band will come out and do a leisurely sound check, with each member individually giving the sound crew a level for voices and instruments. In many instances, the people running the sound board may have prior experience with the performers and have a good idea how to mix the sound, or they may at least be familiar with the band's style of music and have a good idea of what will work best. All this usually takes place in the span of a few hours *before* the band takes the stage.

Now imagine that instead of a single act that has to be staged, it is a festival setting out in the country, with no nearby stores to run to if something is missing or breaks. The setup for an act that has just finished is in the process of being taken down and the next act is a band the sound crew has never worked with before, does a completely different style of music with a completely different setup, may have requested a completely different lighting scheme—and everything has to be ready to go in a matter of minutes!

That is the challenge facing the people in charge of making sure the audience can

see and hear what is happening on stage, and at the Philadelphia Folk Festival it requires the hard work, expertise, and coordination of dozens of volunteers and contracted professionals.

Working on the stage crews is physically demanding, and can sometimes be hazardous: a sudden, unexpected storm appearing over the tops of the trees can send one or more crew members scurrying up the speaker towers to cover and secure the very expensive equipment, while set changes often involve maneuvering very heavy instruments —grand pianos, for example—on or off stage.

Several different companies have been hired by the Festival over the years to produce the performances, but what they all have in common is the experience and knowledge to ensure that the folks sitting on the top of the hill can hear the music just as well as those in the front row. Of course, from the top of the hill it is a bit harder to *see* exactly what's happening on the stage with the naked eye. Fortunately, for most of the Festival's history the "back row" folks have had as good a view—maybe even better —than the "down-fronters" thanks to the large video screens on either side of the Main Stage.

Paula Ballan, a longtime Chair of the Programming Committee, says those screens were an innovation pioneered at Philly Folk through the vision of a legendary figure named Bill Hanley, known as the "Father of Festival Sound." Not only was Hanley in charge of stage sound for most of the early years of the Philly Festival, he was also

behind the board at many other major outdoor music events, including Woodstock in 1969.

"Bill did all the sound at Philly for years," Paula remembers. "He invented the screens on the side of every stage of every big concert there is." She recalls Bill saying, "This [the 'Baby Boomers' of the '60s] is a generation that's used to being able to see everything on a screen, every little finger movement. They want to lie back and have it brought to them." She continues, "That's when he conceptualized [the screens]— 'How am I gonna be able to do that?' He's the one that invented [it], and the first place that he tried it out—in black-and-white, not color—was [here]. Philly was the first with the screens. [Bill] was really special."

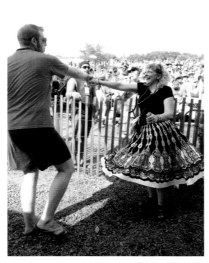

DULCIMER GROVE

A small stream runs through the Old Pool Farm that in many years is virtually dry by the time Festival weekend rolls around. It lies in the shallow valley flanked by the main performance and craft areas on one side and the campground on the other. As the stream approaches the spot where it empties into nearby Perkiomen Creek, the stand of trees on both sides of the stream widens out and begins creeping up the hillsides to form what is usually the coolest and shadiest spot on the Festival grounds. There is a path that runs from the side of the Main Stage down the hill, through the trees, and back up the opposite hill to the lower campground, "Ballad Gate."

This oasis is known as Dulcimer Grove, a place where dozens of people can be found lazing about in hammocks slung from the trees on the hillside or on the cool ground. For parents, though, Dulcimer Grove is where the entire family can go for entertainment. In any given year there are likely to be jugglers, high-wire walkers, magicians, storytellers, and folksingers whose shows are geared toward children. More than a few longtime Festival attendees can truthfully say that not only did they enjoy their first Festivals as kids in Dulcimer Grove, but so have their own kids—and grandkids.

It is in Dulcimer Grove that you can find the Give and Take Jugglers. Dave Gillies, a member of the troupe since 1982, is a native of Delaware County, Pennsylvania, and has been coming to the Festival since the years it was held in Paoli. He often laughs and

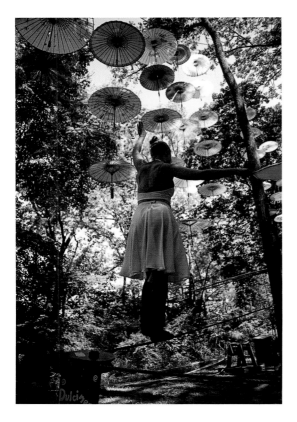

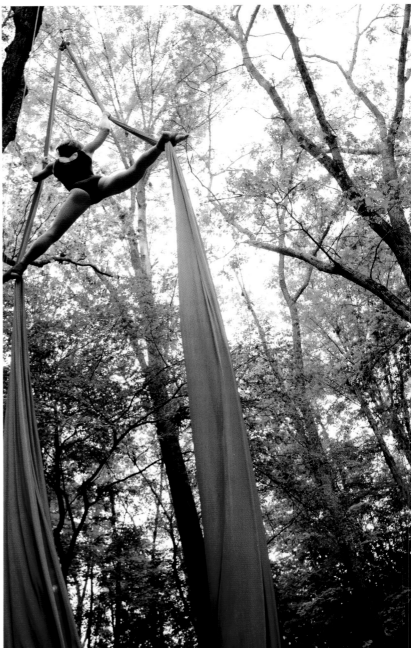

Above: "Don't try this at home!" The Give and Take Jugglers in Dulcimer Grove, 2016. Photo by Jayne Toohey

Aerial acrobatics in Dulcimer Grove, 2012. Photo by Laura Carbone

Dave Gillies (R), founder of the Give and Take Jugglers. Photo by Steve Sandick

comments that he usually got a better reaction from his juggling than he did when he played his banjo. Over the years he taught people how to juggle during the Festival weekend, bringing more and more beanbags each year, until one day someone from the Programming Committee asked Dave if he would like to do it "officially." Ever since, the Give and Take Jugglers have been a staple of the Festival.

Dave tells of visiting a ski slope with his wife in the Swiss Alps. "We went to the top of the lift," he says, "but if you wanted to go even farther up the slope you had to put money into a turnstile—but the instructions were in German!" As they tried to decipher and translate the instructions, they asked a passerby if he knew English and German. The man said, "I know you. You taught me how to

juggle at the Philadelphia Folk Festival." Although Dave was impressed to learn that his fame had spread across the oceans, he confesses he had to respond, "Wow, that's great! But do you speak German?"

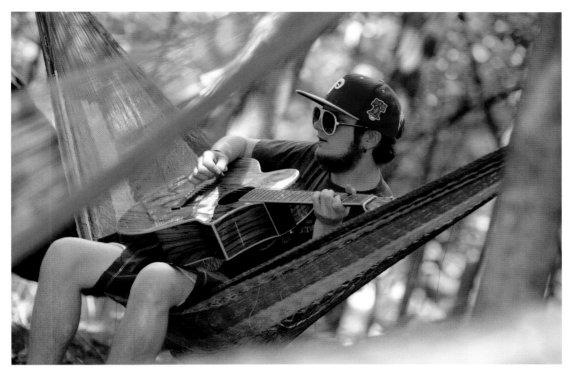

THE CAMPGROUND

During the first few years, when the Philadelphia Folk Festival was held on the Wilson Farm in Paoli, ticket holders were not permitted to camp on the grounds. This did not stop many who wanted to camp from finding creative nearby alternatives. Steve Miller, a member of the Philadelphia Jug Band, recalls a search for a campsite in one of those early years that resulted in spending the weekend sleeping in a cemetery. "People would sleep in fields and on the side of the road," he says. "It was all very makeshift, which I don't think really endeared us to the local residents."

When the Festival moved to the Old Pool Farm in 1971, there was much more

available camping space than at previous Festival sites, and it was not only the "Paying Customer Committee" (a phrase coined by longtime Festival attendee Eileen Bird of the Flamigos to describe rank-and-file ticket buyers) that took advantage of it. Many Festival volunteers have made it part of their yearly pilgrimage to group together, often in the same spot year after year, and spend the entire Festival weekend on the grounds. In the early years it was mostly "light" camping, with "tent cities" springing up all across the hillside within an hour or two of the "land rush" that commences with the opening of the campground gates.

As years went by, and many regular campers got older and less inclined to endure the rigors of tent camping, the campground evolved more and more into its current configuration of more or less

Clockwise from above left: Jammin' in a hammock, Dulcimer Grove, 2013. Photo by Alex Lowy

No, it's not Santa Claus on his summer vacation, it's "Peace Sign Dave" Finley, who travels to the Festival each year from Alabama, 2014. Photo by Jayne Toohey

Holly Wilson of the FLIDs, 2011. Photo by Jayne Toohey, reflected in sunglasses

Water fight! (2015) After trucking fresh water in for many years, a number of wells were dug on the Old Pool Farm to provide "water stations" such as this one. Photo by Lisa Schaffer

Longtime volunteers Judi Space and her late husband, Mike, 2013. Photo by Jayne Toohey

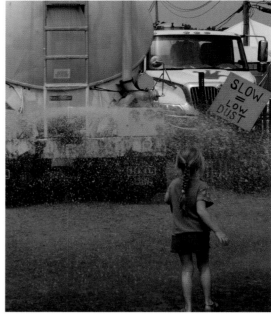

human nature to form bonds with neighbors, even if it is only for four days a year or so. The various groups—communities, actually—spread across the campground all have interesting stories about their formation, names, and even how they have changed over the years. Kids "raised" in one compound often break away as they reach adulthood (or close enough to it that their parents are happy to have them off somewhere else) and form their own new compounds. Some compounds have three or even four generations of Festival goers as part of their membership.

To truly understand the nature of the Philadelphia Folk Festival community, one must understand that it is the culture of the compounds—the family and friends who come together each August—that drives many Festival goers. It would be impossible to tell all the stories, or even identify all the compounds in the space of these few pages, but a few are chosen here to give a sense of how the 5,000 or so hardy souls who inhabit the Festival grounds each year manage to make the best of it—and then some.

Above: Kids of all ages make friends easily at Fest. (2011) Photo by Lisa Schaffer

Cooling off (undated). Philadelphia Folksong Society Archives

Hosing down the crowd, 1995. Photo by Robert Corwin

two-thirds contingent of "light" camping (tents and canvas shelters) and one-third "heavy" camping (RVs, pickup trucks, pop-up trailers, etc.). One of the campground's enduring landmarks is the "Green Bus" (see **below**), a one-time school bus that occupies an honored spot just about dead center of the campground along the main camp road that divides "heavy" from "light."

Though campers are certainly not *required* to become part of one of the various long-standing "compounds" that have evolved over the decades, it is simply

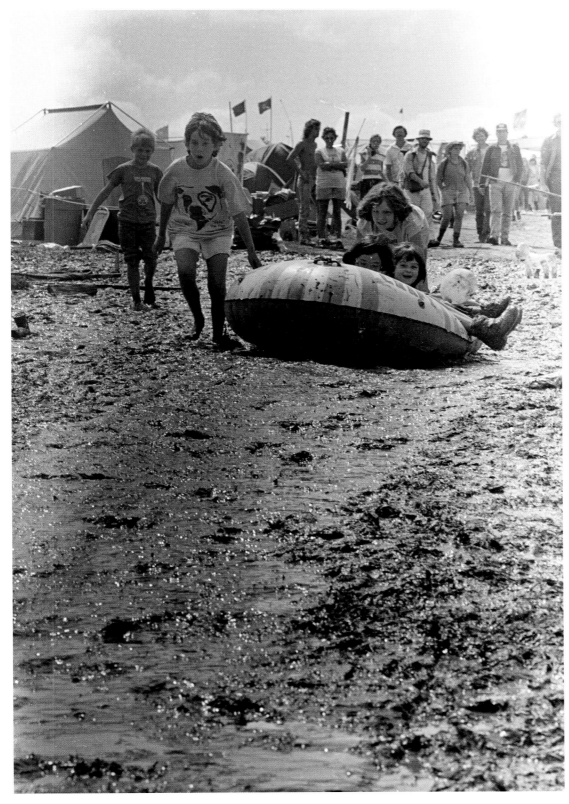

Left: "Land ho! . . ." (undated) Photo by
Jayne Toohey

Bottom left: "Slip-slidin' away . . ."
(2011) Photo by Howard Pitkow

Howard Yanks (yellow shirt) conferring
with "Stretch" Pyott, probably in 1971
("The Year of Mud"). During his term as
Folksong Society President, Howard's
handshake deal with property owners
Abe Pool and Maud Godshall brought
the Festival to the Old Pool Farm.
Philadelphia Folksong Society Archives

THE
CHAPTER SIX
CAMPGROUND
COMPOUNDS

AZZOLES

"Azzole Country"—home of the Azzoles—is among the oldest—and largest—compounds in the campground at the Philadelphia Folk Festival. An article published in the *Delaware County Times* at the time of the fiftieth anniversary Festival in 2011 quoted longtime Azzole Country citizen John Fuhr as estimating the chunk of land occupied by the group at roughly 10,000 square feet and containing approximately sixty-five individual tents, a one hundred-foot dome-tented "common area," and a fifty-foot pole complete with banner and strobe light.

"You need to get here early to get the land," John told the reporter. "I can always know where we stay based on the surrounding, like the trees and the level of the ground. I can tell this year we are fifteen feet over from usual because there is a downhill slope we usually don't have."

The Azzoles first appeared at the 1968 Festival and have been a fixture ever since. They think of themselves as "good people who like to have fun, most often in folk music-related activities. Kind of like a**holes, only

much nicer." Like most of the compounds in the campground, they have their traditions and annual activities, the best-known of which is almost certainly the "AZZOlympics," which includes Blow Pong (table tennis using mouth power instead of paddles), Human Bowling (you can be a pin or you can be the ball), and Quarter-Horse Racing (a relay race involving coins and "drinks"—beyond that, it is best to see for oneself).

BOB'S COUNTRY BUNKER

Since its establishment in 1995, the neon-lit swinging doors of Bob's Country Bunker have graced the campground's Main Street. The compound sprang into being after one

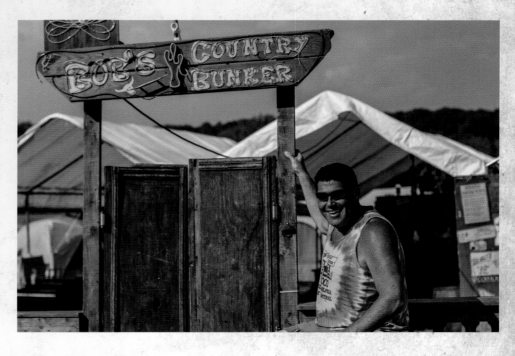

of its founders, Jeff Weinberg, was kicked out of two other groups and wanted, sensibly, to establish his own compound that no one could boot him from. He admits, to his credit, that the one time he fully deserved to get the heave-ho, but the other? Nope, definitely not his fault. If the compound's name rings a bell, it is because Bob's Country Bunker comes straight out of *The Blues Brothers* film.

A respectful visitor to the camp can count on the friendly offer to share a drink, though the group does have to occasionally remind some campers that Bob's is not a real bar, and that disorderly or rude conduct will result in immediate removal. Things do on occasion get a little rowdy at Bob's, causing Bunker dwellers to be "escorted" out of the campground one year. Overall, Bob's Country Bunker is made up of family and friends who love the impromptu music in the campground area and, most importantly, sharing a weekend together.

Bob's usually has a theme each year. One memorable theme was when they decorated for Christmas—in August —complete with a snow machine. Another favorite tale involves Bob's, the Hoagies (see p. 58), and a third compound—since disbanded, and that shall remain nameless for the purposes of this account. This third group pilfered a cardboard cutout of Clint Eastwood that had been proudly displayed in the Hoagie compound.

The details of how it came about are disputed, but it soon appeared in front of the Bunker. What, after all, could be more appropriate than Clint Eastwood swinging the doors open at the western saloon known

(see p. 58)

Previous: Jeff Weinberg welcoming you to Bob's Country Bunker, 2015. Photo by Eric Ring

The Azzoles flag flying proudly, 2011. Photo by Jayne Toohey

"Absolut Folk" at the Azzoles, 1995. The background of the banner depicts many of the flags, poles, and other distinguishing features of the many neighbouring "compounds." Photo by Jayne Toohey

The Green Bus at Sunset, 2013. Photo by Jayne Toohey

as Bob's Country Bunker? Jeff Weinberg claims not to know where the cutout came from, but needless to say, the Hoagie folks were none too happy about the theft of one of their mascots.

Over the next few years, Clint continued to find his way over to Bob's. Having had more than enough, Hoagie retaliated by stealing a Bunker decoration and branding it with a large "H." Not to be outdone, the Bob's crew absconded with the Hoagies' prized tie-dye namesake banner, replacing it with a spray-painted sheet that read, "Coming to

Keeping a watchful eye at Camp Woody, 2015. Photo by Eric Ring

Fest 2009: Bob's Hoagie Hut." Seeking peace, Hoagie brought up food and drink, pleading to have their banner returned—which it was, unharmed. Since that time the two compounds have become close friends.

In addition to cutting loose and shedding the responsibilities of everyday life at the campground gates, Bob's Country Bunker has long enjoyed hosting their own music. They do have a strict "no egg rattlers or tambourines" policy, and have enjoyed visits from Main Stage acts like the Carolina Chocolate Drops, who stopped by and played a few songs at the makeshift bar.

CAMP WOODY

Up the hill from the Camp Stage, just inside the "Ballad Gate" leading into the campground, a casual stroller will encounter a large campsite dominated by a lifeguard chair of the type very familiar to anyone who has spent time at the Jersey Shore. The reputations of many of the Fest camp compounds being what they are, the immediate suspicion that comes to mind involves some sort of furtive excursion to the beach at Margate or Sea Isle City in the wee hours of the morning to "liberate" a suitable chair, but as Mark Stevens happily finishes assembling it on Thursday afternoon of the 2016 Festival, he proudly says he built it himself in a case of necessity being the mother of invention.

Noting that Camp Woody has a direct line of sight to the Camp Stage, Mark recalls his frustration a half-dozen years or so ago that especially at the Thursday night "Campers Only" concerts on the stage, he was unable to see over the heads of the crowd. "I was like, 'if only I was eight feet tall, I could see the stage. I can't see the damn stage.'"

An eight-foot-tall chair seemed the obvious, natural solution, and it became another of the remarkable array of additions and improvements the Woodies seem to come up with every year. A stroll around the compound reveals what is likely the most elaborate kitchen setup on the entire grounds (including a full-size commercial propane stove and oven), and pulling the curtain on the bathing stall aside reveals a shower setup that would have a starring role in most any of the home improvement shows on HGTV and DIY Network.

"We have a trailer we bought in the past year that holds all the stuff," Mark says. "It's now parked in Heavy Camping, and now that

it's empty, I rigged up an air conditioner to it. So now we have an air-conditioned bedroom, and we can sleep in the afternoon—because we stay up all night! We are multi-purposing *everything*. We find more and more ways to have fun every year. That's what it's all about—so we can all be stupid and still have fun."

Greg Marshall, another longtime Camp Woody denizen, remarks that many in the compound are volunteers, and most of them try to "front load" their work shifts so that they are done by Friday night and can devote the rest of the weekend to just having a good time. He says originally they called themselves NHCA for a few years, though he never quite gets around to revealing what that stood for.

What he does reveal, as delicately as he possibly can, is that the "Camp Woody" name came about when one of the members took down a tree in his yard and found a large branch that had two large, spherical growths that resembled—"Well, I was gonna say 'dumbbells,'" Greg laughs, "but you get the idea. We mounted [the branch] to a plaque, and we would give it out to the best camper of the weekend; the camper, the guy that did most of the work, [who] was always willing to go that extra yard. We picked that as the trophy, and you could take it home with you for the year —inscribe your name on the plaque and everything. That's how we became Camp Woody."

Being opportunists as well as campground engineers, Greg recounts a Friday evening working the Main [Camping] Gate a dozen or so years ago when a newlywed couple, Brad and Betsy, approached the gate, said they had been honeymooning down south, had heard about the Festival, and decided to come up and check it out. "Is it okay," Brad called out, "if I pull my truck down and find a campsite?"

"You've never been here before, have you? There isn't much room left by Friday night."

As they chatted further, it turned out that Brad was a commercial clammer on Long Island, and "As a matter of fact, I have about three hundred clams on my truck."

The reply, Greg laughs, was about two seconds in coming—"We have a spot for you!"

"They've been coming [ever since]. That," he smiles, "is how we met Brad and Betsy."

CANADA

Sam Cohen, one of the main founders of Canada, is the nephew of Barry Brenner, onetime accountant for the Philadelphia

Canada's "Alberta" lit at night, 2015.
Photo by Sandra Dillon

Folksong Society. Sam remembers seeing Richie Havens at his first Festival, which happened to be the twenty-fifth anniversary year 1986. "I loved it and had a great time," says Sam. Two years later he brought a bunch of friends and they camped on the same spot, ultimately staking the claim for it as "Canada on the Perkiomen."

By 1990, the group felt that they needed a flag, and in spring of that year Sam was coerced to "liberate" a maple leaf flag while at a Grateful Dead concert in Hamilton, Ontario. The plan was to adopt that as the official flag, but sadly, it was reclaimed by the authorities on the return trip. Fortuitously, a group that camped next to them at the Festival that year were actually from Canada, with a maple leaf painted on their huge cabin tent. On Sunday, the camping committee made a map of the campground and listed the group as "Canada." The following year Sam went to an Army-Navy store and obtained—legally this time—a Canadian flag. The name and the flag have been at the Festival ever since.

Among the more noticeable icons in the campground is the large red-and-white canopy that can be seen marking the Canada compound. The structure is named "Alberta," after the one member of the group who actually *was* from Canada and who resided in Alberta. That member, because of family and life obligations, unfortunately no longer attends the Festival. Ironically, there are currently no genuine Canadians in "Canada." One of the group's traditions is to light the red-and-white lights that outline "Alberta" at 9:00 p.m. every night.

Another ritual, "Canadian Thanksgiving," has taken place since 1991, where members gather together to celebrate on the Saturday

following the American celebration in November (though it should be noted that our "Neighbors to the North" actually celebrate their Thanksgiving holiday in October). About sixty members from the group meet every year to cook three turkeys and bring potluck dishes. As they go around the room each person says what they are thankful for, dinner commences, followed by cleanup, and then it is playing music until the sun comes up in the morning.

FLAMIGOS

There is no typo or misprint in "Flamigos." The group's beginnings hearken back to the 1970s, when a group of friends from Delaware began attending the Festival each year. Heading up the group were Suzi Wollenberg, a longtime folk music DJ at the University of Delaware's radio station, WVUD; and Eileen Bird, along with John and Maggie Thomas. As the years went by, the group expanded to include friends from Pennsylvania, Maryland, New Jersey, Connecticut, and Virginia, numbering more than thirty in some years, and along the way they adopted the flamingo as their "token."

Each year, as various groups prepare for the traffic and camping crews to take them into the campground, many of them prepare signs to be placed on the windshields of their vehicles to assist the crews in more easily identifying group members and keeping them together. Among the "Flamingo Folks," as many referred to them then, it became the task of group member Leon Oboler to prepare and distribute these signs, which would of course feature the word "Flamingos," along with a flamingo graphic.

One year—reliable authority pegs it as 1993, give or take—Leon duly prepared the signs, but unwittingly left out the "n," resulting in "Flamigos." In a classic case of "making lemonade out of lemons," the new name was enthusiastically adopted, and the graphic in succeeding years featured a flamingo wearing, naturally, a sombrero.

As part of their annual traditions, each year saw one "lucky" Flamigo chosen as "Mr. Clean," by virtue of having gone to the greatest lengths to maintain "real world" standards of cleanliness (though in some years the winner was perversely chosen for precisely the opposite reason), and one member chosen as "Worthless Bitch of the Year" for displaying and exemplifying sheer, unadulterated laziness. It should be noted that, titles notwithstanding, these "awards" were *not* gender specific, but *were* all in good fun.

Another tradition of the camp dates to the mid-1990s, when group member Laura

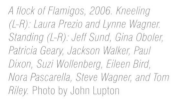

A flock of Flamigos, 2006. Kneeling (L-R): Laura Prezio and Lynne Wagner. Standing (L-R): Jeff Sund, Gina Oboler, Patricia Geary, Jackson Walker, Paul Dixon, Suzi Wollenberg, Eileen Bird, Nora Pascarella, Steve Wagner, and Tom Riley. Photo by John Lupton

Prezio, hankering for a lobster dinner, discovered a restaurant in nearby Harleysville that was willing to deliver such a dinner—for more than twenty people—to the Festival Camping Gate, where Laura and a platoon of Flamigo helpers eagerly awaited to claim and pay for it. Thus was born the annual "Friday Lobster Supper" in the Flamigo camp.

Sadly, Suzi Wollenberg passed away very suddenly a few days before Festival weekend in 2009, and for that reason, as well as other circumstances befalling the group—as has happened occasionally to compounds over the decades—the Flamigos have disappeared from the Philly Folk campground. As they say, the times they are a changin'.

Just another day with the FLIDs . . .
Courtesy of the FLIDs

FLIDS

As one of the FLIDs' founders, Bob Benner, explains, they originally called themselves the Folk Ewes because one of the themes of the festival that year was animals. In their early years at the Festival they struggled to find a name that really matched the "persona" of the group. Most of the members were from Long Island, and there was a fair amount of "hi-jinks" or "lo-jinks," Bob says.

The name finally came when Bob was with a group in upstate New York that stopped in an ice cream shop. As the woman behind the counter turned to fill their order she told her coworker, "Oh, they're FLIDs." Bob was offended, or wanted to be, but did not know what a FLID was. He asked his friend what the term meant, and "he started laughing." The friend explained that, well, the "L" is for Long and the "I" is for Island. Readers are encouraged to imagine their own "F" and "D." And thus was born the name of the group.

"We play off the fact that Long Islanders are rude," Bob says as he tells of "closing off" the camp road that runs by their compound—"we made it into the LIE [Long Island Expressway] at rush hour."

Brian Stuart chimes in to say that in 2002—the year following the 9/11 attacks—they "closed" the road and "told people we had to search their bags—and they would let us do it; they were just letting us do it!"

One year the FLIDs wanted to have a beach party, and Bob asked one of the Groundz crew supervisors if they could bring in some sand. The supervisor asked, "How much [sand] are you talking about?"

Bob responded that they wanted three yards. The supervisor agreed, but was fairly certain Bob and his fellow FLIDs did not quite realize how much sand that actually was (more than eighty cubic feet, enough to cover a fifteen-foot square area more than four inches deep), but he went and got the front-end loader and brought the sand in. It turned out, Bob remembers with a laugh, that the huge sand pile was a magnet for all the kids in the campground, and everyone had a great time. The Groundz crew would never agree to allow that much sand in the campground again, though.

Brian mentions a "special character": King Ming, a spiritual leader of the compound who, like Godot, is expected at any moment but never seems to arrive. Holly Wilson quickly produces a few of the only known photographs said to be of Ming, who is a scarecrow-like figure sitting in a chair, apparently comatose and covered with paint. "That's what happens when you fall asleep at FLIDs," Bob pronounces.

FORTISSIMO

While it is not unusual for compounds in the campground to include couples with young children, Marie Dolton of the Fortissimo clan says that their origins date back to the early 1970s, when several families began attending the Festival and camping together, including a time when their primary shelter was an old parachute. "Doltons, McGlincheys, McGees, Brysons, Laufers, and Hodges," she ticks off the names. The kids were there at the beginnings too, and more came as the years

went on—one of them almost literally becoming a "Fest Baby" (more on that in a moment).

Kids being kids, they tended to wander away toward Dulcimer Grove and the creek while the adults were trying to enjoy the shows, so a system of "crowd control" had to be developed.

"So," Marie says, "we developed the rule of the 'Holy Orange Tarp.' First of all, all the children were to consider all the adults their parents and obey the direction they gave. The Holy Orange Tarp was an old tarp with lots of holes in it. We placed it on the hill in front of the Main Stage. During the day one or more 'parents' would be sitting on the tarp, and all children had to check in with the designated parent at least every two hours. The parents would consult and decide who needed to be found."

"It worked," she laughs, "sort of. In all the years we have been going, we have never lost a child—for long."

In 1983, as they looked around at all the various compounds—and the "really cool flags," Marie remembers—it seemed like a good time to adopt a name of their own. Wanting something music-related, they discussed the matter for a while before consulting a dictionary to learn that "fortissimo" denotes a musical passage that is to be played very loudly. "Yup! We do that!" she says, and the matter was settled.

Marie was chosen to design and produce a flag, so she cut up an old pair of jeans for one of the legs and, since the entire name would not fit as one word, stitched it in as "Fort Issimo." The well-worn (and duct tape patched) flag is still flying over the compound more than three decades later.

During his interview for this book, former Groundz Crew chair John Wenino averred that, to his knowledge, there has not yet been an actual birth on the grounds during Festival (though he adds with a chuckle that many have undoubtedly been conceived), but Marie says the Fortissimos came pretty close in 1989, when Johnnie Sue McGlinchey went into labor on Saturday night. Her husband, John McGlinchey, headed off to find and retrieve their car to take her to the hospital. While they waited anxiously, a nearby parking crew member came over to help out, though Marie says he turned out to be more of a major distraction.

"He began yelling—remember, there are at least ten children asleep in our campers whom we would very much like to *stay* asleep—'Clear the table! Boil some water!' . . . So in between breathing I am trying to get this guy to be quiet!" Pausing a moment, Marie continues the story:

Johnnie Sue is a registered nurse, has worked in gynecology for years, and had three children. I would have bet that [the Parking guy]—[I think he was] about twenty—had never seen a childbirth. Clearin' and boilin' ain't gonna help! And then, because he would not be quiet, and kept on 'prepping' and yelling, Johnnie Sue and I started laughing—[she] could not continue the Lamaze breathing."

Finally, after what seemed an eternity, John McGlinchey returned with the car to find his wife and Marie still laughing, while the parking guy was still trying to "take charge." They bundled the expectant mother into the car, and Marie recalls with amazement that as they were about to pull away, the parking guy asked Johnnie Sue, "If it's not too much trouble ma'am, if it's a boy would you name him after me? And if it's a girl would you name her after my mother, Louise?"

THE FRONT PORCH

The Front Porch was established in 1986. Renette Hackett, a member of the group, says, "[It's] typical of the Folk Fest, because we all met at the Festival. It was just an accidental placement and we hit it off." She recalls the next year, as she and her friends waited to get in, the thought occurred that it would be "really cool" if they ran into the same people they had camped with the year before. Turning her head a moment later, sure enough, there they were, two places behind them in the line. Thereafter they all decided not to leave it to chance and started meeting in the parking lot of a nearby bar to caravan into the Festival together.

Many compounds have traditions, and one such tradition for Front Porch is shared with a neighboring group called the Melons: at midnight on Sunday night they all sing Dennis Leary's "I'm An A**hole" at the top of their lungs. Renette gives another example of the spontaneity that occurs at Festival. One year the Scottish band Wolfstone closed out the Sunday night concert, but the merchandise tent had closed by the end of the set, depriving the audience of the chance to buy their recordings. A short while later, two members of the band passed through the campground and sauntered past the Front Porch site holding a box of their CDs.

The Front Porch denizens told the band members that if they came in and did an impromptu concert their CDs would sell. The only problem was that the Wolfstone piper, Stevie Saint, did not have his bagpipes with him. By an incredible stroke of fate, down the path at that moment walked a camper carrying a set of bagpipes. *Only at Festival could that happen.* Accosted by one of the Front Porch residents, the owner of the pipes heard a phrase that is rarely spoken in polite company: "Come here, we need your bagpipes."

As Renette Hackett recalls it, "Within a very short amount of time we had a huge crowd of people, and the rest of us were walking through the crowd saying, 'Get your CD and they'll play another song!' They were sold out in *no time.*"

The Front Porch gets together a few times a year, camping at a Yogi Bear campground in spring, at Quaker Wood in Pennsylvania during fall, and at the Falcon Ridge Folk Festival. They have had weddings, christenings, and even funerals together. Renette says, "[This is where] my other family gets together. That's become very important. My children have grown up going to Festival, and they still come every year; they have children now that come."

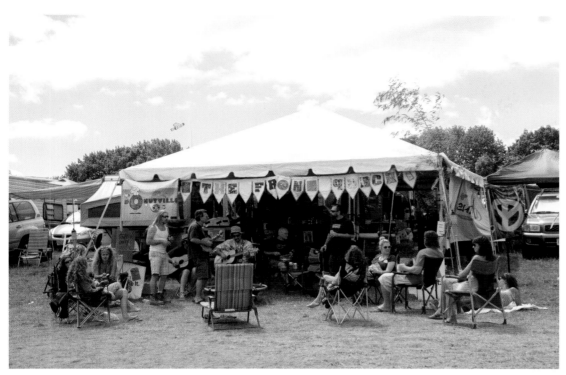

A lazy afternoon at the Front Porch.
Photo by Lisa Schaffer

*Hanging out on the "veranda" at the
Green Bus.* Photo by Laura Carbone

THE GREEN BUS

Feeling the need to camp in something bigger and more secure than a tent, Scott Anderson had always wanted a bus. He looked at an auto shopper magazine and purchased Fest's legendary "Green Bus" from a professional boxer. After buying the bus Scott discovered that he is one-eighth gypsy, and now believes he was destined to have a home on wheels. The bus debuted at the Philadelphia Folk Festival in 1984, and now occupies a spot that had previously housed an amphibious "duck" vehicle on Main Street in the campground.

Other than two trips to the races at Pocono Downs, the Green Bus has never visited any other festival-type event. Every major mechanical system on the bus has been rebuilt, and it has been quite a project for Scott and his friends. Almost everyone who walks through the campground recognizes the bus, making it an obvious choice for the cover of one of the Festival souvenir program books—and this book as well!

When Julie Leinhauser, a "Fest Baby" and volunteer on the Main Gate Committee, was asked what symbols in the campground make the Festival feel like home to her she answered, "Seeing the bus sitting at the top of the hill every single year, the exact same bus, the exact same quote, the same color green."

Visitors of all stripes have been on the Green Bus, Scott recalls. "Jian Ghomeshi from Moxy Fruvous visited and played for a very long time, singing mostly Beatles songs." Many passing the bus recognize the arched wooden sign emblazoned with the chorus from Dave Carter and Tracy Grammer's song, "Gentle Arms of Eden." The sign was originally part of the graphics that greeted Festival campers as they entered the campground in 2002. In most years, once the Festival is finished the signs are painted over and redone with a new theme the next year. In a huge shock to the folk music world, though, Dave Carter had passed away suddenly a month prior to the 2002 Festival.

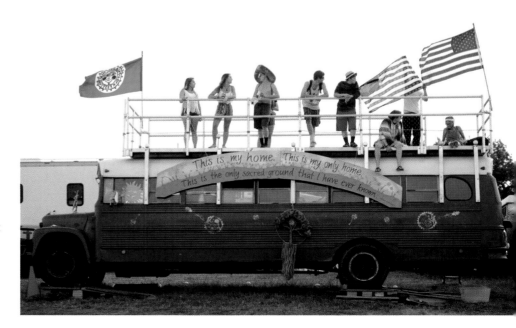

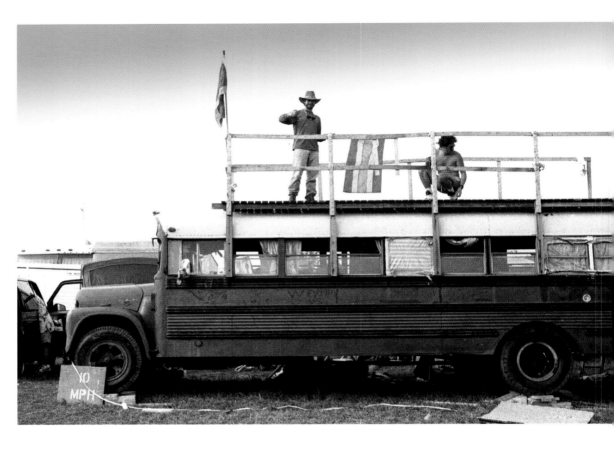

Singer-songwriter and graphic artist LisaBeth Weber, who had painted the sign, could not bear the thought of painting over Dave's words that meant so much to so many. The following year, as she and Steve "Rama" Ryan drove up the hill in a golf cart, looking for an appropriate place for the sign, they spied Scott's bus and decided it *had* to be the sign's new home. The lyrics preserved on the sign speak to and resonate with just about everyone who has made the Old Pool Farm their residence for one weekend every August:

This is my home. This is my only home. This is the only sacred ground that I have ever known.

HOAGIE

The word "hoagie," for the edification of those who are not native to or longtime residents of the Philadelphia region, refers to a type of sandwich (similar to what are called "subs" in many other parts of the country) that combines lunchmeat, fresh produce, and spices on a fresh Italian roll. The origin of the term is a matter of some dispute, but probably the most often cited story concerns Hog Island, in the Delaware River just off the Philadelphia shoreline. During World War II, the island was the site of a major shipyard, and the majority of the workers were from the surrounding Italian neighborhoods in South Philly, many having recently come directly from the "Old Country."

As the legend goes, the lunches their wives would pack for them would be these "salad and lunchmeat on a roll" concoctions, and the sandwiches came to be called "Hoggies"—except that, in the accented English of the workers, it sounded more like "Hoagies."

Whatever the true derivation is, in the case of the Hoagie compound at the Philadelphia Folk Festival, the story goes that a generous guy named Jim Boyd was offering

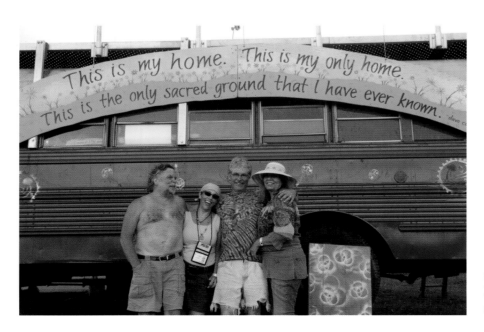

people parts of his hoagie one day. In 1982, Howard Lipson, along with some other friends from Penn State, went to their first Philadelphia Folk Festival. The group became friendly with their camping neighbors and decided to camp together the next year.

The problem was, Howard says, that there were several people named Jim. Referring to the one sharing his sandwich, someone identified him simply as "Hoagie Jim." As events turned out, Hoagie Jim moved to Colorado, and Howard agreed to pick up Jim's camping equipment from Jim's mother. When Howard arrived to retrieve the equipment, he found it had all been labeled with "Hoagie Jim."

As the group grew in size and they looked for each other during the concerts, shouting out individual names did not work well, as there were so many people in the audience. They found if they just yelled "Hoagie!" people in their group would respond. Thus was born the compound's "Hoagie" moniker.

Not long after, Howard purchased a tie-dye sheet and had their graphics committee spray paint "Hoagie" in gold metallic paint. This is the sign that meets passing campers each year as they approach the compound. It is also the very sign that was stolen one year during some back and forth pranks with Bob's Country Bunker (a tale recounted previously). Needless to say the tie-dye sheet was recovered, and each year it is folded and stored at Howard Lipson's home.

PATCHWORK

With compounds like Bob's Country Bunker whooping it up all weekend, it may seem at this point that the entire campground scene is straight out of the Wild, Wild West, but there are more than a few compounds where parents can expose their kids to the Philly Folk Festival community from an early age. Much like Fortissimo, the Patchwork clan has for the past three decades been a camp where the kids are not just there because it is too expensive to hire a babysitter; they are encouraged and taught to become a part of the "extended family."

Ian Zolitor, who took over WXPN's *Folk Show* following Gene Shay's retirement in 2015, first came to the Festival as a baby in the Patchwork camp, and treasures the memory of the entire Old Pool Farm—the campground, Dulcimer Grove, and the concert areas—as "one giant playground." Patchwork members regularly socialize throughout the year, so Ian and his brother, Rob, would get to see the "cousins" at the cookouts and holiday parties, but there were also the kids from other campsites who would be there year after year.

Music was the bond between adults and kids, and Ian remembers that his mother, an early education teacher, would sing folk songs to all the kids in the camp. Another regular in the camp was storyteller Deborah Pieri, who in many years was also part of the cast of performers in Dulcimer Grove.

"A lot of the adults at the campsite by trade and by passion were really comfortable and happy to cater toward children," Ian says, "The things that they did and the activities that they facilitated there—they really spoke our language as kids."

Ian recalls the traditions of Patchwork are a bit more sedate and reserved than in some of the other camps, but that is fine by him. He fondly recalls the "family meals" during the break between the afternoon and evening Main Stage concerts (a practice which was discontinued several years ago), but what has stayed with him through the years —and what ultimately led him to become a folk music broadcaster—was the community sing, passing around a well-worn copy of *Rise Up Singing*. "The 'folk process,'" he says, "passing songs down from generation to generation, from person to person, sharing songs with each other."

"That really had a huge impact on me, and my musical tastes and influences. I remember specific songs. I know that 'Will The Circle Be Unbroken' was always one that was sung there. As we parted ways [at the end of Fest], that was one that was always sung together, in a circle."

As many "Fest Babies" do, when he reached his high school years, Ian and several of his friends "left home" to form their own compound, the Pig Folkers. "It was just a

The Hoagie banner lit at night. Photo by Eric Ring

Patchwork, with their banner floating overhead, 1992. Photo by Jayne Toohey

Megan Hoy, daughter of Patchwork member Don Hoy, 1991. Photo by Jayne Toohey

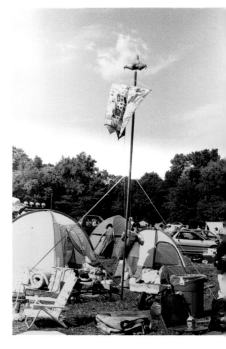

handful of people, my brother, and other friends we were playing music with throughout the year and sing songs with. A lot of the same songs that I was singing at Patchwork we now sing with the Pig Folkers."

Now that he is in his thirties, and Patchwork is starting to see a third generation coming into the camp, Ian smiles as he notes that the new camp he helped start now has its own new generation starting to appear. "In the last few years we started having kids at our site, and this past year there were two four-year-olds and a two-year-old—and it was really great. For that weekend those kids have a bunch of extra 'aunts and uncles' to play around with." It won't be long, he says, before they will be introduced to *Rise Up Singing*, and the beat will go on.

PC (POLISH COMPOUND)

Like a number of the compounds at the lower end of the campground, adjacent to Dulcimer Grove, the Polish Compound "evolved" out of other compounds that were heavily populated with Main Gate Committee members and volunteers.

Current Main Gate Co-Chair Linda Niemczura says, "When [my husband] Paul and I hooked up in the late '80s, he was camping with his committee and I was camping with my committee . . . [so] then he camped with me in E-Compound. Then we were gonna get married, and he said, 'Well, I don't want to camp with your friends, and you don't want to camp with my friends, so we have to start another campsite. So then we told everybody—and they *all* came *with* us.'"

"Originally," she continues, "when I started at E-Compound, we had a 'Polish Sector'—myself, my cousins and their kids, and our friend, John, and then my cousins' kids' friends. We're talking like the middle '80s—*way* back. So we were the 'Polish Sector,' and so that's why we are PC; we're now the Polish Compound, and you're either Polish or 'Polish by association,' and everyone agreed to it."

One of the delights of life in the campground, Linda notes, is simply watching the world go by and observing people just being people. One of the recurring amusements on the hot August afternoons is watching campers from other sites heading off on foot up the hill to get ice, only to return with a plastic bag that is mostly cold water. And occasionally, Linda admits, the joke is on themselves, when their own canopy keeps falling apart as they try to get it up and stable. But she says, "That's the mantra of this Fest—if something stupid happens, just laugh."

PHILADELPHIA JUG BAND

The Philadelphia Jug Band (PJB) has been in residence at the Philadelphia Folk Festival from nearly the beginning, having played on the festival grounds or in the campground at all but the first two festivals. PJB formed at Council Rock High School in Newtown, Pennsylvania, in the early 1960s, when a bunch of students caught up in the "folk revival" started playing together.

The original name of the band was the Ridgerunners, numbering thirteen members in all. They were playing mainstream songs at the time until Steve Miller and Dave Gauck went to the second Philadelphia Folk Festival in 1963, and heard the Jim Kweskin Jug Band. Wanting to find a more "roots-based" sound, they looked at each other and said, "This is the music we are going to play!" Steve and Dave went out and purchased a washboard, a jug, and a copy of Kweskin's first album, and the PJB has played Jug Band music ever since.

Before finally settling on PJB, they briefly were known as the Keystone County Ragtime Euphoria Jug Band. The number of members in the band has changed over time,

Relaxing at PC (the Polish Compound), 2015. Photo by Jayne Toohey

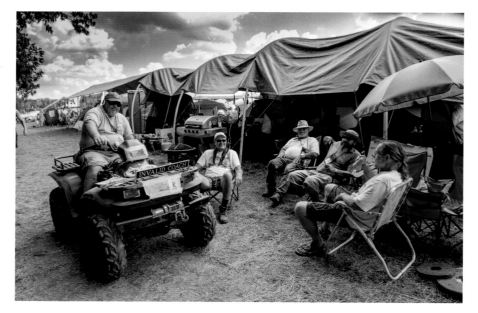

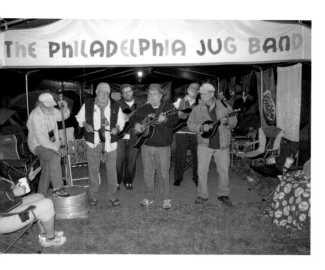

yet still has the four core founders: Dave Gauck, Steve Miller, Jim Klingler, and Frank Zemlan. The last member to join the band was Bob Beach, a blues musician and face familiar not only to Festivalgoers, but also all across the Philadelphia music scene.

Because the band members are scattered across many states, they only get together about three or four times a year. In their high school years, the band members had a New Year's Eve party, and they have continued that tradition, with each band member hosting on a rotating basis.

Though PJB has performed at many Festival workshops over the years, they have played the Main Stage only once. "*That* was the Holy Grail," Steve Miller enthuses. "It was an afternoon concert. It was *fabulous* to finally get up there. We had a lot of friends out there—it was fun. It's a different kind of setting from the Camp Stage or the little stages. You have to be kind of spread out there, and if you aren't paying attention to where the other guys are you'll be out there by yourself."

Steve reflects that the passing years have brought about much more of a separation between the "hired acts" and the Festivalgoers, and he recalls that during the Paoli years he could sit in and play with performers like Mississippi John Hurt and Roger Sprung. Although you can still meet the artists now, he says wistfully, there is not as much of the older atmosphere in which you could actually *play* with them.

SPAM HOGS

Cindy Miklos, the self-described "Grand Poobah" of the Spam Hogs, says the group has been a part of the Fest campground scene since the mid-1980s, starting in Light Camping before moving "uptown" into

Heavy Camping, where they can usually be found just a few "doors" down the main Camp Road from the Green Bus, across from the Philadelphia Jug Band.

"After the first couple [years] we realized we needed a name. Back then, I used to have a huge Groundhog Day party. We also used to have this can of Spam we brought every year—kind of an emergency thing, it didn't have to be refrigerated or whatever. We never ate it, we thought we didn't like Spam, it was just for emergencies."

It became a problem during camp setup on Thursday each year, she says, when the coolers were getting cracked open a little too early and important work was getting put off, or not done at all. Just for fun and as a "camp joke" one year they made a "Spam Altar." "So," Cindy continues, "I made this rule that nobody could have a drink until the can of Spam was on the Spam Altar, and everyone had gotten their work done."

Groundhogs and Spam being their recurring themes, she says it seemed a natural thing to combine them and become "Spam Hogs." As the years have gone by, they have become known for their annual "Gold Lamé Night."

"When we first started coming here, most women wore jeans, or shorts, that kind of thing—they didn't wear a lot of dresses or skirts. I thought how fun it would be to wear fancy dresses, glittery and sparkly, so we started doing that. And none of us were good musicians back then, but we would accompany people with 'shaky eggs' and that kind of thing. So we started 'Gold Lamé Night' on Friday, after the concert is over. We walk around to the campsites, all dressed in sequins . . . *anything* that sparkles. Our first stop is always at Philly Jug Band, and they'll stop

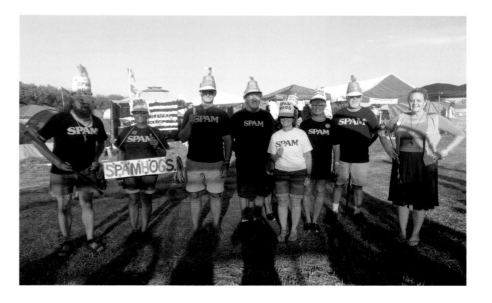

playing—'Ladies and Gentlemen, introducing the Gold Lamés!'"

Also among the annual rites in the Spam Hog camp, Cindy says, is the raising of the camp banner as they all sing "Spam, Spam, Spam, Spam" (from a timeless Monty Python sketch)—then, as they break camp on Monday and the banner is taken down, it is to a chorus of "Maps, Maps, Maps, Maps . . ."

Reminiscing about their favorite Festival performers over the past three decades and more, Cindy mentions Arlo Guthrie, John Prine, and Jackson Browne, but in the end, she says, "We don't even care who's here, it doesn't matter, we don't even check first. It's always great."

WHO HILL

Friends and acquaintances who knew each other through their love of the Grateful Dead and also from their involvement at the Philadelphia Folk Festival formed Who Hill in 1995. The core group of founders consisted of Anne Fanelli, Brian Fanelli, Gina Dinlocker and Tom Dinlocker, along with the kids of volunteers at the Main Gate who formerly camped in a group called E-Compound.

The kids of E-Compound wanted to find their own identity and were friends with the Fanellis and Dinlockers. "We had to come up with a name, and everyone is a Who," says Tom Dinlocker, when asked how they picked the name Who Hill. As to the growth of Who Hill, Eric Robbins states, "Its organic. It's a collection of friends just like every other site here. [It's] the collective conscious of people who put in so much

time and effort," he stresses, something not to be taken for granted.

The significance that the Festival has on the lives of each Who Hill member is evident in Eric's voice when he emphatically states, "This is my twenty-third straight Fest and this will be my kid's fourth straight Fest—and he's only three years old . . . It's the *one* thing on my calendar every year, no matter what, before I know what else is on the calendar. It's in my blood."

One Who Hill tradition is a yearly poker tournament. As Eric explains, though there *might* be a few "ducats" involved, nobody really cares about the money—*it's all about the trophy.* New members of Who Hill are not allowed to compete in the tournament. The right to play is earned by being an active member of the compound, with the emphasis on not taking the Festival experience for granted.

Anyone who stops by Who Hill, or even passes it while walking through the grounds, will know that the focus is on fun. They are not so much into playing music at their site as they are keen to see how far people will go in dropping their guard. As an example, Who Hill hosts the annual "Mr. Festerverse," a competition where the gents compete for the ultimate prize of being titled Mr. Festerverse for that year's Fest. Much like Whoville in the Dr. Seuss books, Who Hill is a combination of chaos, fun, and friendship.

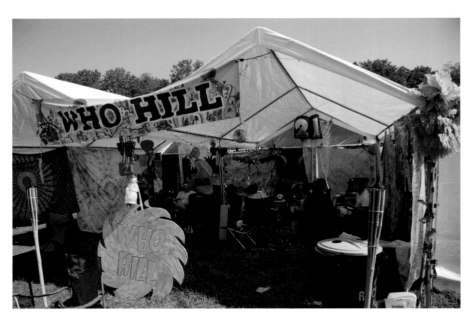

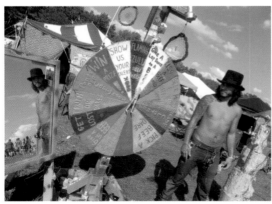

Directions and HAVOC, 2012 (The correct spelling is "Pool"). Photo by Laura Carbone

Which way to the Pig Folkers and The Festicles? (2011). Photo by Lisa Schaffer

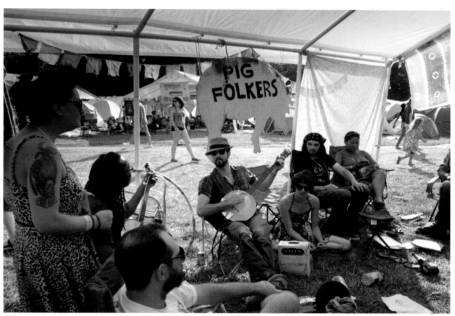

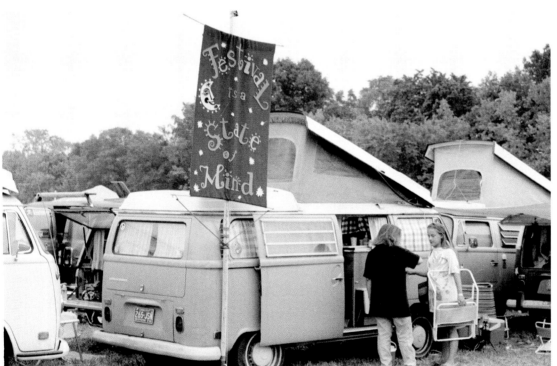

Jamming with the Pig Folkers, 2013. Photo by Jayne Toohey

VW Bus camping, 1995. Photo by Jayne Toohey

Many Faces—One Fest, 2006. Photo by Frank Jacobs III

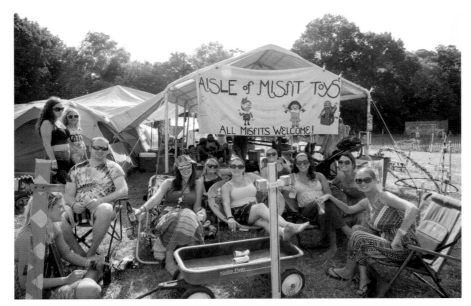

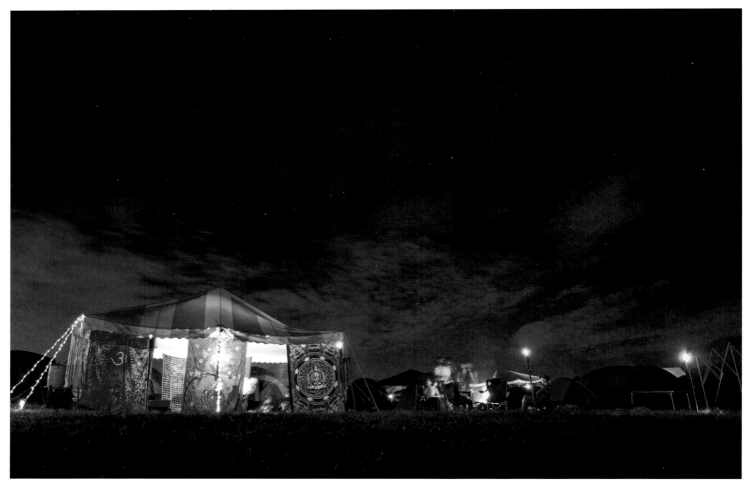

Waiting for more Misfits, 2014. Photo by
Lisa Schaffer

*One of the "extinct" compounds,
Camelot (undated).* Photo by Jayne
Toohey

Goodnight. Photo by Melissa June
Daniels

VOLUNTEERS & COMMITTEES

CHAPTER SEVEN

PRE-FEST

Few people know the amount of work that goes into making the festival grounds ready for a weekend of music and fun. Some volunteers come to the festival grounds months before the mid-August festivities to install fences, run wires, and prepare the stages and the campground. Howard Pitkow's beautiful photos show what the grounds look like prior to work being done. Slowly, over the months leading up to that one long weekend in August, the infrastructure of what some describe as Brigadoon will be laid. This period of time is aptly called Pre-Fest. Some volunteers come up for a weekend, some each weekend, and some live on-site for the months before the Festival. As the Festival approaches, more and more volunteers arrive on site to make sure that the weekend will be enjoyable for the tens of thousands of campers and concert goers. By the Sunday before Festival, "gators" (ATV-type carts), golf carts, and service vehicles zoom around—slowly so as not to kick up dust—trying to finish work prior to Wednesday, when the Friend of Festival early ticket holders start to arrive.

Pre-Fest, at the Wilson Farm, 1965. Photo by Lawrence Kanevsky, courtesy of Philadelphia Folksong Society Archives

"The Sweep," 1993. Photo by Rebecca Barger, courtesy of Philadelphia Folksong Society Archives

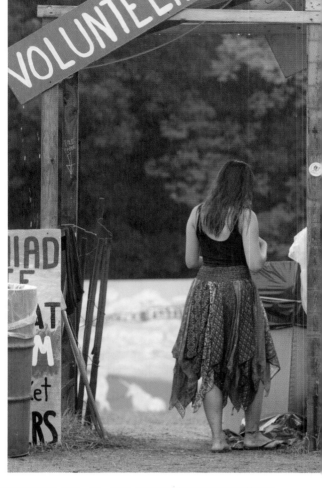

A volunteer keeps watch at Ballad Gate, at the lower end of the Campground by the Camp Stage, 2016. Photo by Eric Ring

Before the mowing, 2012. Photo by Howard Pitkow

Before the work starts, 2012: view from Dulcimer Grove, with the Martin Guitar Stage at left. Photo by Howard Pitkow

COMMITTEES

The amount of work it takes to stage an event the size of the Philly Folk Festival is staggering, ranging from administrative work like compiling budgets to negotiations with vendors, performers, and agents. It also includes a *lot* of good old-fashioned people power to prepare the site, put up the fences and tents, and keep things running as smoothly as possible while Festival is ongoing. It is a job that never ends—the work continues year-round—and on Monday morning, as the last of the campers pack up and head for home, it all starts over again.

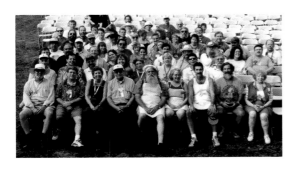

The Philadelphia Folk Festival is sponsored and operated by the Philadelphia Folksong Society under the supervision of its board of directors, and while there is a small degree of management overlap, the Festival operates separately from the Folksong Society. As often is the case with large organizations and events, the task of getting everything done on time is parceled out to a large assortment of committees, each of which focuses on a particular aspect of the Festival.

The names of the committees have changed over the years, responsibilities have been shifted, and new committees have formed, as represented in this list of committees credited in the program book for 2016 (the fifty-fifth annual Festival), which included:

Camping; Central Control; Chairman of Fun; Communicationz; Community Relations; Crafts/ Vendors; Culture Tent; Food Vendor Manager; Friend of Festival; Graphics; Groundz; Hotel Hospitality; Information/Lost & Found; Kids Creations; Legal Counsel; Lighting/Electric; Main Gate; Media Buyer; Medical; Merchandise Sales; Mobile Ticketing Support; On-Site Financial Support; On-Site Office Manager; Parking— Customer/Volunteer; Performers' Parking; Performers' Tent; Production; Program Book; Programming/Talent Buyer; Purchasing; Recording/Archives; Recycling/Cleanup; Reserved Seating; Resident Manager; Security (Rental); Security (Volunteer); Society Outreach; Tickets; Tramcart; Volunteer Food; Volunteers.

Dulcimer Grove in Winter. Photo by Howard Pitkow

Mowing the fields. Photo by Howard Pitkow

Bales of hay, 2012. Photo by Howard Pitkow

Group shot of committee chairs, 1998. Photo by Jayne Toohey

Group shot of committee chairs (undated). Philadelphia Folksong Society Archives

Longtime Festival Chairman Bob Siegel, 1995. Photo by Jayne Toohey

Longtime Festival Chairman David Baskin (undated). Photo by Jayne Toohey

Festival Chairman Andy Braunfeld, 2014. An attorney in his "day job," Andy has also handled much of the legal work for the Folksong Society and the Festival since the early 1970s. Photo by Jayne Toohey

Festival Chairman Ellis Hershman. Photo by Jayne Toohey

Lisa Schwartz, 2014. At the time, she was President of the Folksong Society, then moved over to become Festival Director in 2015. Photo by Eric Ring

Fred Kaiser and his wife Mary Lou Troy, 1998. For most of the 1990s and 2000s, Fred was Chair of both Programming and Production. Mary Lou worked closely with him on both, as well as a number of other Festival committees over the years. They were also both very helpful in compiling information and fact checking for this book. Photo by Jayne Toohey

There was also a group of dedicated interns who donated their time to help bring Fest to life.

To describe all the work these committees and their members do and tell all the great stories they have collected over the course of more than five and a half decades would fill up several books beyond this one, but let it be noted and emphasized that without the dedication of the thousands of people who work year-round to make things happen, the Festival would not and could not have lasted more than a handful of years, if that.

Many of the committees are engaged in operations that are not readily apparent to the people who stream through the Main Gate each August, but they all deserve much credit for the professional work they do—even though in most cases they serve as unpaid, or even paying volunteers. For obvious reasons, the presence and operations of some committees on Festival grounds necessarily involve close, personal contact with all the folks who visit—ticket buyers, performers, volunteers, vendors, and more. The following section highlights a few of these more visible committees and gives some insight as to just *how* the Philadelphia Folk Festival *works*, in many instances told in the words of the people who *do* the work.

FESTIVAL DIRECTOR/ CHAIR (THE POWERS THAT BE)

There always has to be someone in charge, the one person for whom "the buck stops here." This would be the Festival Director (known as Festival Chair prior to 2010). There have been many over the decades, though some have held the position for many years in a row. If you add up all the years that Robert Siegel and David Baskin held the position, it would include more than half of all Festivals. Each Festival Director, reporting directly to the Philadelphia Folksong Society board, sets the overall tone of the Festival and tries to make decisions—some not popular—that they feel will make Festival better. The work of the festival director begins the day after the previous Festival ends, but after just short of a year's worth of work, they are on site and ready to see the fruits of their labor.

Lisa Schwartz has been at the top levels of the administrative structure of both the Folksong Society and the Festival for the past decade. When asked to describe what goes on in the "Exec Trailer," she laughs and says that while in past years the activities in the Exec Trailer may have occasionally carried a bit of a "Situation Room" character, the truth is that in recent years it has simply represented the transplantation of the Society's office operation onto the site, including the switchboard for fielding calls for tickets via the Festival's 800 number. The reality, she says, is that the trailer now serves as an "information hub" rather than "command central."

She does recall the years before there were cell phones and computers to facilitate

instant communication, when the trailer would be where the quartet she fondly remembers as "The Four Horsemen of the Apocalypse"—Andy Braunfeld, Bob Siegel, David Baskin, and Ed Halpern, each with his own domain of authority and expertise—would convene to discuss and sort out whatever major issues had arisen.

After serving eight-and-a-half one-year terms as president of the Folksong Society (the "half-year," she says, came about because of a change in the date of the annual election), Lisa stepped over into the Festival side of things and began her tenure as Festival Director in 2015. She says it was something of an opportunity—and a challenge—to put her money where her mouth was.

Like so many of the "lifers" who have devoted decades to working for and with the Society and the Festival, Lisa is a Philadelphia native. Her older sister, Victoria, had become involved with the Society and the Festival, and one day, when Lisa was fourteen, her sister brought her along to a "mailing party" at the Emlen Street office. Having caught the eye of Jeanette Yanks—"you're a *hard* worker"— Lisa was invited back and has never left. "I was actually a full-blown volunteer at the ripe old age of fourteen at my very first Festival in 1974," she says proudly.

She was a paid employee—the office manager at Emlen Street in the early 1980s— before moving on to a job in the housing industry, but continued to volunteer as she took on more and more work and responsibility for the organization. When she stepped into the role of President of the Folksong Society, she took a hard look at the organization and festival event she was now ultimately responsible for and realized that, as often happens with organizations that invest so much time and resources into a single aspect of their operations, the Festival had become "the tail wagging the dog," and she set about the task of working with her colleagues to redefine and reorganize the relationship between the Society and the Festival.

"My focus as president was to help facilitate a situation where the Folksong Society wasn't so reliant on the Festival. While the Festival *is* our marquee event, over the years we had sort of abandoned the things that were really our hallmarks . . . Basically the gist of it was, we put all of our energies into the Folk Festival, albeit worthy, [but] there was so much more that the Society could do."

"I saw that we had a situation . . . where the Festival had not been prosperous. We

actually had been losing money . . . It didn't make any sense to me, and I think it just necessitated a completely different mind-set, a different leadership style."

Working with the Society board and top management of the Festival, Lisa headed up a team that, as she puts it, "could basically put the financial wheels back on the Festival bus, made up of people that were intimately familiar with the event, that had been involved with it."

She notes that the resulting Festival leadership team encompasses upwards of 175 years of experience in running the Festival, and she has come to think of them as a new version of the Four Horsemen. In addition to her work as Festival Director, Lisa collaborates with Production Chair Andy Braunfeld in Programming, Lewis

Hipkins serves as Director of Infrastructure, and Hank Voigtsberger is Director of Operations—"a 'first responder,'" Lisa says. "He's a threat assessment expert, he's a former police officer . . . he's just really quick at understanding operations and can suss things out very quickly."

"I wanted to separate the Society from the 'Festival as primary focus,'" she continues, "and have the Society be able to concentrate on the other activities—the co-op, the scholarships, all the things that the Society used to do. But whomever was in charge of the Festival needed to be completely accountable, and that had not been the case for years and years."

"Honestly," she laughs, "even though we're a 'non-profit,' I kept saying to the Board, 'non-profit' is a tax designation, *not a business plan*. We really need to recognize that this isn't being managed properly, and this is *such* a beloved event, if we don't get a handle on it, we're not gonna be able to do it anymore."

The results thus far have been more than encouraging, and as an added bonus, she says, the response from the Supervisors of Upper Salford Township to the improvement in operations and communications has been overwhelmingly positive and complimentary.

"There is so much that goes into it," Lisa finally states. "If somebody asks you, 'Why do you do it?,' the only way to answer it is, 'It's not what we do, *it's who we are.*' It is ingrained, it's part of our DNA . . . it does your heart good to recognize that you've helped build something that is so loved and so cherished that people just want it to go on and on and on, and you can see the investment that they put in —the blood, sweat, and tears—to make sure that 'Fest,' as we all lovingly refer to it, is around for the next several generations. I always say, many hands and many hearts make light work."

GROUNDZ

Probably more than ninety-nine percent of the people who descend on the Old Pool Farm each year only see it for the three or four days of Festival weekend in August, and have no idea what the "life cycle" of the property entails over the course of the other 361 or so days of the year. For example, it can be disorienting to take a walk or bike ride along the stretch of the Perkiomen Trail between Schwenksville and Green Lane in late fall, or especially winter.

At a spot just short of the crossing at Salford Station Road, the view through a locked gate along the east side of the trail will afford a view that will seem oddly familiar. Despite the tall grass or—depending on the time of year, snow—the mind will begin to fill in the vision of people on blankets spread out up and across the hillside, and a quick turn of the head will bring quick recognition of the outlines of the Martin Guitar Stage. So *this* is what it all looks like the rest of the year!

John Wenino, one of several former chairs of the Groundz Committee still on the crew, dates his tenure as a Philly volunteer back to 1969, in the midst of the years in the township park. It would take quite a bit of time and research to prove it, but it seems pretty likely that of all the committees that manage year after year to do their share to get the Festival up and running, the Groundz crew just may have the highest average "seniority" among its members. It is the kind of gig that once you get in, you never want to leave.

On a Sunday afternoon in late July, as the crew is beginning the final push before the gates swing open again in a couple weeks, John is taking a break and is joined by current chairman Lee Theis, whose length of Festival service matches John's—between them nearly a full century. Looking around him at a facility that is quickly approaching full operational status, John remarks, "A lot of the paying customers come and think this is the way it is year 'round . . . This is not a wide-open farm field through the rest of the year. They don't know that."

When it rains, it is time to bring in the gravel trucks, 1995. Photo by Jayne Toohey

Lee points out that much of what the crowd sees in August has only recently been placed there. "Anything around here that looks like it's movable, *we* put it in place. Any wooden structure, the fences, the bridges. Literally, it is like the whole Festival just grows out of the ground—there's a building there, now there's a fence line here, there's a tent there. Seriously, *it just grows out of the ground.*"

John breaks in to joke that for a small price he and Lee will grant a special pass to the underground tunnel system by which the crew raises and lowers the stages, sheds, bridges, and other structures.

"It's like Disney World in Upper Salford Township," Lee laughs.

Bert Shackerman, another of the "lifers" on the crew, explains that though he has come to be something of a "jack of all trades" through the years, he still spends much of his time at an arduous, repetitive task. "I pound [fence] posts still, which I've been doing ever since I started, really, from the days of the 'hand slammer' to now the tractor-mounted pounder."

"Last year," he continues, "when I had the heart attack, they rented a pneumatic pounder which was pretty good and all, from what I gather—but they had only one guy on site who could operate it—you need to be a *big* man. So Tom Imms is the only one that can work that at the moment."

John says having a crew that is more or less stable and cohesive from year to year greatly lessens the problem of having to learn the same hard lessons over and over, and ends up saving a lot of work for the crew and a lot of money for the Festival. As an example, he mentions that some structures in the past would be left in place throughout the year, exposed to the elements, while others would involve bringing in specialized equipment—at significant expense—such as roller trucks to jack up and load buildings for storage elsewhere.

Now they simply purchase their own trailer beds and build things directly on top of them. When time comes to move them, they back up a pickup truck and tow them off to the storage site. "In the long run," John says, "you build something that's gonna last, versus [rebuilding] it every year."

Lee Theis agrees, adding, "Sometimes spending an extra $500 saves you quadruple that amount. We spent, I think, $1,500 one year building a tool shed, about twelve years ago. That has since saved us $400 a year for a storage locker, so we have a net savings on that now . . . It reduces our overall 'footprint.'"

John points proudly to the fact that, as the Festival has become more and more an efficient, professional undertaking since

Putting up the snow fences, 1991. Photo by Jayne Toohey

Former Groundz Chair Len Lay, 2015. Photo by Eric Ring

The ceremonial chair burning, 2005. Photo by Jayne Toohey

If you work hard on Groundz you can earn your bells, 2015. Photo by Eric Ring

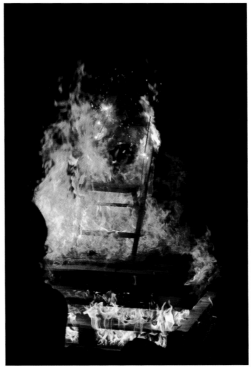

its somewhat uncertain "seat of the pants" beginnings, the Groundz operation has also kept up with the times and grown into what is, despite their outward rough appearances, a first-class outfit.

"We were just talking about how much more professional we make the place look now than the old days. The old days, you know, it was very *rustic*. It did the job, it got it done, but now it's professional, because we're dealing with a lot more of the outside world, and they look for professionalism. And that makes for a better event."

As much pride as they take in their work, it is the sense of family that keeps them coming back to their compound at the top of the hill along Salford Station Road. From early July, when preparations begin in earnest, through Labor Day, when the "take down" operations wrap up, the compound is the weekend home for upwards of one hundred crew members or more. A full on-site kitchen ensures that all are well fed as the work progresses, and a fire circle provides relaxation and community at night after the labors of the day.

Across the top of the gateway into the compound is the single word, "Groundz." John Wenino laughs as he admits he does not quite remember when the "z" displaced the "s." "Some of the things that happen here, you gotta figure, 'how did it happen? What made it change?'"

He pauses a moment, adding, "It used to be like, you come through those gates, the real world is gone. *This* is a different place, and let's not bring any of the outside in. We try to keep that somewhat here today. If somebody starts a heavy-duty discussion about politics or something —'nah, nah, *this is not the place for that*, we don't want to talk about that here. Go on Facebook if you want to rant and rave.' We just don't need all that outside stuff when we're up here. This is our way of getting away."

Lee Theis agrees, "That's what makes this place tick. It's the stupid little 'fun' games that happen, that you don't plan—it's just there. I think that's what keeps everybody coming back; you just don't know what's going to happen."

Among those bits of "fun" that continue to have a lasting presence on the Old Pool Farm can be found at the bridge that provides passage across the small creek between the campground and the Craft Area. Crossing the bridge, many may notice its designation as the "Bill Graham Bridge" and wonder if it perhaps is in honor of the legendary rock promoter and entrepreneur of Fillmore West fame in the 1960s, or possibly an irreverent reference to the famous evangelist.

The truth, as told by yet another former Groundz Chair Len Lay, is that one of the volunteers who built the original bridge was a professional carpenter whose name in fact was Billy Graham. Rather than make the deck of the bridge level, Len says, he told Billy that it should match the slope of the hillside. That offended Billy's professional sensibilities, but he did as he was told. On completing the work, he said to Len, "Don't you *ever* tell anybody I built that bridge."

"Sure," Len replied, "no problem." As soon as Billy departed, Len told another member of the crew to go down to the bridge and "carve 'Bill Graham' on it." Lee Theis smiles as he also recalls the story and adds, "That's what makes this place so much fun!"

Lee and John Wenino have both also been around long enough to remember—strange as it may seem—that for several years the Godshall family used the farm as a private airport. "The main campground road used to be a runway," Lee says. John is unsure, but thinks it was the mid-1970s that flight operations ceased when the surrounding trees grew too tall for safe takeoffs and landings.

Nina Owens is also a Groundz veteran of long service, including running the compound kitchen for several years in the early 1990s. She says being resourceful, handy people by nature, they improvised a simple, yet ingenious solution when relief was needed on those hot, sultry July and August afternoons spent preparing the grounds: line the back of the nearest pickup truck with plastic, fill it with water, and presto—instant swimming pool! For even more fun, stage mock fights flinging handfuls of glitter at each other, and before long there is a sparkling cascade when the tailgate is opened to empty it all out.

One year, Nina happily laughs, they had used a rental truck, and they were still splashing away when the Hertz man arrived to retrieve it. "We stood up, and we were covered with glitter. He just stopped and looked at us— 'Okayyyy . . .'"

Each year, as the Groundz Committee wraps up its pre-Fest work and the Festival gates are set to open the next day, an official ceremony is held as Groundz "hands off" responsibility for the site to the Security Committee. Capping off this rite is the annual "chair burning" to divine what the weekend holds in store. Len Lay says that if the chair burns straight down, falling onto itself, it will be a good year; if it falls backwards—(he makes a "raspberry" sound and gives a "thumbs down" sign); and if it falls forward, that indicates a basically good year, but with some problems.

The chair burning tradition, Len continues, began many years ago, during a time when the Festival rented folding wooden chairs for use in the reserved seating area. The Groundz crew was responsible for the chairs and, the story goes, one year the representative of the rental company told them, in a none-too-subtle fashion, he was leaving 500 chairs, and he expected *all 500 back* at the end of the Festival. Taking this as an accusation of thievery, the crew reasoned that if they were going to be punished anyway, if they were going to "do the time," they might as well do the crime, and a sacrificial chair was selected to become the first in a long line of burning victims.

Nina Owens remembers that the accounting for the chairs was never very accurate to begin with. "What's amazing is how many of those chairs *still* keep popping up. I went to look for one for this year and [was told] 'Oh, go in the barn!'" To her amusement she discovered, "There's *five* of 'em in there!" (Luckily the statute of limitations has passed.)

As is the case with many of the rituals and traditions of the compounds across the valley in the "Paying Customer" campground, the chair burning ceremony is one of the bonds that helps keep the Groundz community together and working as a team. There is another, Len Lay says, that he also brought about many years ago during his tenure as chair of the Groundz Committee, though somewhat by accident.

One afternoon, in the midst of a good-natured back-and-forth about trying to catch crew workers goofing off, Len says, he remarked (jokingly, he hastens to add), "You know, the Indians used to put bells on their women so they didn't lose them—I think that's a good idea!"

A short while later, several of the ladies on the crew ran out to a store in a nearby mall that sold Native American jewelry and trinkets, returning with a set of tiny bells attached to a thin leather strap. "The girls all decided," Len laughs, "that, no, *they'd* put bells on *me*. They wanted to know where *I* was, because that way, when they're doing something they shouldn't be doing, they'd hear me coming."

Realizing he had been outmaneuvered, Len tied the bells around his ankle, thus beginning another time-honored Groundz crew tradition. "When somebody has worked hard enough, and done their job good enough without a bunch of bulls**t, he gets the bells," he says, though it would turn out to be an honor that was not gender specific. Male or female, your bells are something that you have to *earn*, and it has nothing to do with "seniority."

"Some new guy can walk in here," Len finally says, "and all of a sudden everybody says, 'he's really good,' and he comes back the next year—we put bells on him."

Concluding his thoughts on the sense of family that is common to virtually every group of Festival attendees, whether ticket buyers, volunteers, or performers, Lee Theis says that the closeness of the bonds he and his Groundz crew peers share sometimes transcends those of actual flesh and blood.

"When I built my house eighteen years ago, we were responsible to paint the whole inside of the house. I asked around. I had *twenty-five people* from Groundz come and help paint my house." He stops, laughs, and shakes his head. "Not one single person from either my wife's or my 'real life blood' families came out."

Getting the last word in, John Wenino leans over with a laugh and says, "They knew *we* were gonna be there. They were afraid—'*I'm not going near those guys!*'"

CAMPING

Though their planning and preparation for the Festival takes place all year round, it is on Thursday that "crunch time" comes for the Camping Committee, a.k.a. the "Blue Crew" (for the shirts they wear so incoming campers can easily recognize them—not to mention keep from running them over). The area surrounding the Old Pool Farm has become more and more populated and developed over the years, but the roads leading to the farm have not changed much in that time, and are still for the most part just hilly and winding "country two-lanes."

What *has* changed to a large degree is the size and complexity of the equipment and vehicles that show up at the campground gates. In the early years of the Festival in the 1960s, there were no such things as "fifth wheels," and even if there had been, there probably was not enough room to park one in the campground. Even the tents in the Light Camping section have become larger and more ornate—some now even include porches and private shower stalls.

All of this camping gear—"heavy" and "light"—has to be brought in over the space of a few hours—usually on one of the hottest days of the year—routed over narrow roads with tight turns, and somehow shoehorned into a campground that is far from level, varying some fifty to sixty feet in elevation. This is the challenge that faces the Camping Committee on Thursday each year at the Philadelphia Folk Festival.

By the time the campground officially opens at 10:00 a.m. on Thursday, the

Campground, 1990. Photo by Jayne Toohey

Camping Gate, 1996. Photo by Jayne Toohey

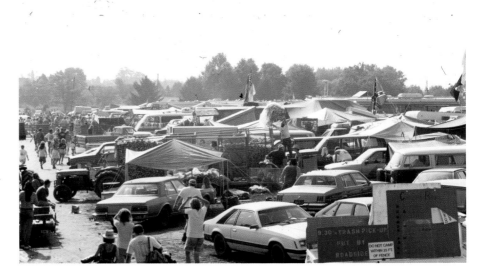

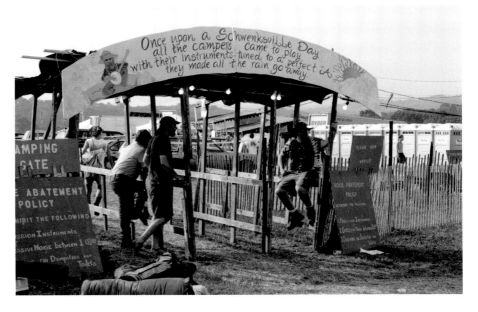

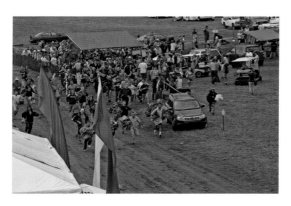

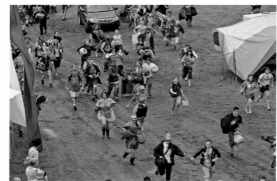

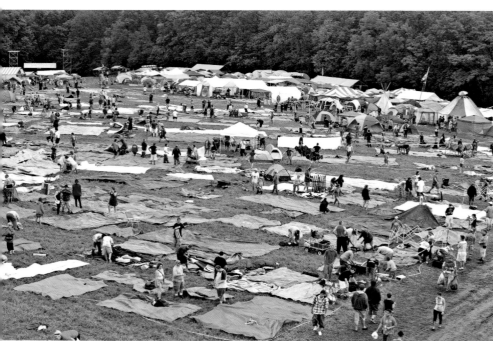

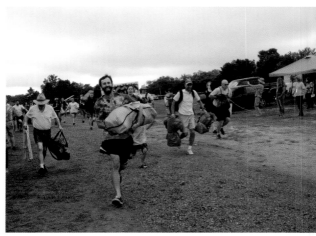

surrounding roads are already clogged as inbound campers hope to time their arrivals *just right*. With so many factors at work, it is something of a lottery to be in the right place at exactly the right time, and most early arrivals end up circling back around for another grab at the brass ring.

Tent campers heading for the Light Camping section generally get into the campground quicker, as they are carrying less gear, are usually in single, standard-sized vehicles that can be parked in regular fashion, and they can carry in everything they need on their backs and in carts. After parking and rushing up to the booth to get their camping wristbands, "light" campers who manage to arrive early congregate at the entrance and wait for the "land rush" to commence, with a mad dash to stake out the best campsites on the lower portion of the campground. Once the gates open, a runner who has been designated by his group will bolt out like an Olympic sprinter, tarp in hand or under an armpit, and run to the designated spots to quickly spread out tarps to stake a claim. Others who are part of the runner's compound will follow with the tents and Brigadoon will begin to appear.

By contrast, many of the "heavy" campers will be diverted into a holding field along Salford Station Road and wait for the call to "round 'em up and head 'em out" as

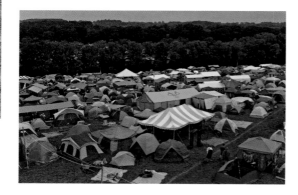

the next batch is herded toward the "triangle" lot at the entrance to the Heavy Camping section. While cooling their heels in the holding field—figuratively speaking, as it is August and there is not much shade at hand—the process begins by which those camping as groups can alert the Camping staff in the field as to who they are and how many vehicles they are coming in with. This information is relayed to the crews actually bringing the "heavy" campers in and getting them parked in an orderly fashion, and the knowledge helps those crews plan and allot the limited space they have to work with.

Once they have made it to the "triangle" like the tent campers, the RV'ers and other vehicular campers will go straight to the booth for their camping wristbands and, like climbers on Everest, wait for the call to begin the "final assault on the summit." Typically, each batch brought through the Heavy Camping gate will be comprised of one full group identified by signs placed in the windshields, along with one or two "singles" who will be shunted to a side area for an opportunity to "fill out" a row with an opening at the end.

As veteran Heavy Camping crew chiefs like Art Bonney and Scott Newmann can attest, it is something of an art form to bring the larger groups in and arrange them in a way that maximizes space and permits as many people to occupy the main campground and not be directed into the "overflow" campground (which is what the "triangle" lot eventually becomes). The groups are parked in double rows, facing each other. Safety regulations require a "fire lane" of ten feet between the facing vehicles, but each new dual row will begin with the back side of each incoming vehicle only a couple feet—or sometimes inches—from the back of the campers in the neighboring row.

The variety in size and shape of the vehicle population in Heavy Camping, Art says, can make it very difficult to make things "line up" in a way that makes everyone happy, and there are always those who will try to commandeer an extra foot or two of space wherever and whenever they can, but for the most part the communal spirit kicks in, as everyone realizes they are going to be neighbors for the next four days. Before long the tarps have been erected, the chairs have come out, the coolers have been cracked opened, and it is time to relax and enjoy being "at Fest."

Over on the Light Camping side, there is not so much of the "jigsaw puzzle" of squeezing tons of metal into small spaces, but tents are buttressed against tents to the

Home Sweet Home, 1989. Photo by Jayne Toohey

point that, unless a camper takes extra care, there may not be a path out to the road. However, there are plenty of camping staff on hand to help the tenters sort things out and get quickly established as well, and as Thursday evening settles in and the dust literally settles, the Camping crews can relax themselves and reflect on another intense but rewarding job well done.

VOLUNTEER FOOD

Alan Abercauph said to fellow veteran Festival volunteer Mike Flagg in 1968, "We really messed up." When Mike asked Alan what they had done wrong, Alan replied, "We're never going to get out of this job." Alan did remain on the Volunteer Food Committee until he passed away shortly after the 1985 Festival, while Mike still charms the ladies more than forty-five years later.

At the first Festivals on Collie Wilson's Paoli farm, Ed and Esther Halpern (then still operating The Gilded Cage coffeehouse) served food, but the Food Committee really took shape after the Festival moved from the Spring Mountain Ski Area in 1967. There are now families with three generations who are members of the committee. "Kids who used to crack eggs in the beginning are now running crews," says Naomi Kaminsky, a longtime member of the committee.

The food served by the committee to Festival volunteers has had a reputation—deserved or not—to the point that one of Alan's friends who worked as a food writer for a Philadelphia paper wrote a review that began, "Every year Alan Abercauph and a crew of repeat offenders . . ." Taking things in

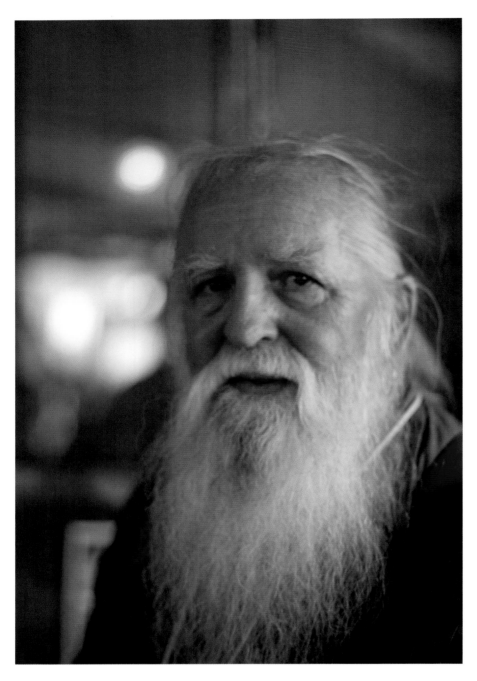

Former Food Committee Chair Mike Flagg, 2015. Photo by Eric Ring

dedication naming it in memory of one Alfred E. Packer. It is a story that readers with delicate sensibilities many may want to skip over, but as Mike Flagg came to learn, Mr. Packer was one of the few people ever convicted in court of cannibalism, having admitted to surviving being snowbound in the Colorado winter of 1874, by dining on his five deceased companions. Finding amusement in the idea, Flagg dubbed the Food Tent in Packer's "honor," and it got even more amusing when Festival Chairman David Baskin returned from a visit to the University of Colorado with a T-shirt for Mike—along with the news that the university's food service is *also* dedicated to Packer.

Most of the senior members of the Volunteer Food Committee feel that the festival is about family, whether related by blood or by sharing the Festival together. Phyllis Dennis describes how being at the Festival, especially in the beginning years, provided a place that shared her philosophy on how the world should be, and being at the festival gave her a comfort level to let her be herself. "That foundation," she says, "gave me that sense of family."

Claudia Reid notes, "The Festival is my family reunion. It is my family vacation where I get to see people who I don't see for the rest of the year. Oh, and there is this *great* music too!"

SECURITY (MONSOONS AND BIKERS)

stride, the Food Committee made the statement their own, and Naomi created a banner that read "Repeat Offenders."

Some time later, a few of the committee members took the sign along with them to the Great Hudson River Revival, which featured a cleanup of the river by inmates from a local prison. Seeing the banner, the inmates approached and asked, "What were you in for?"

All joking aside, the Volunteer Food Committee is very proud of the job they do, and as Eileen Graham says, "It can't be forgotten that the committee serves 14,000 meals from Wednesday through Sunday from a makeshift kitchen in the middle of a field."

Those who roam the Festival grounds and pass by the Food Tent may notice the

Gene Shay recalls walking around the Festival grounds at the second Festival in 1963. He had become the Chairman, and as he strolled around he discovered that, after having headlined the inaugural Festival the year before, Pete Seeger was back. As Gene walked up to say hello, he realized that Pete was talking with George Wein, founder of the Newport Folk Festival, which had started up only a few years previously. Pete, who was a member of the Newport board, had induced Wein to accompany him so that they could both observe how Gene and his colleagues were operating their new festival, particularly when it came to the matter of security.

They were impressed with the fact that the Philly operation relied heavily on unpaid volunteers who wore no uniforms and no

insignia of identification other than a small button. As Gene quickly learned, a large part of the security and crowd control issues Newport had been experiencing stemmed from the fact that they had been hiring uniformed Pinkerton guards to patrol the grounds and enforce order. That information left Gene dumbfounded.

"The Pinkertons have a bad name in folk music," he begins, shaking his head sadly. "Many years ago, when the unions were organizing down south, the Pinkerton men were the thugs that would beat on them and say 'Get back to work or we're gonna kill you,' and like that. They were the ones in the famous song by Woody Guthrie."

Woody's "1913 Massacre" relates the story of a strike in that year by copper miners in Calumet, Michigan, and the events resulting in what came to be known as the Italian Hall Disaster, in which seventy-three miners and their family members— including children—were killed in a stampede during a Christmas Eve party after someone—falsely as it turned out—shouted that the building was on fire.

There is some dispute as to the involvement and responsibility of Pinkerton operatives in that incident, but the famous detective agency's history of violence on behalf of management during labor actions in the US is well documented back to at least the Homestead Strike of 1892. Given the inborn pro-labor sympathies of the overwhelming majority of the folk music community, Gene was far from the only "folkie" who recognized the disconnect in having Pinkerton personnel enforcing order at a folk festival.

Mike McGrath is a nationally known horticulturalist, largely through his long-running weekly broadcasts of National Public Radio's *You Bet Your Garden*, which originates from Philadelphia's NPR affiliate, WHYY-FM. Each week he fields phone calls from across the country and dispenses gardening advice with wit and wisdom. In the late 1960s, though, he was a typical Philly area teenager, working a summer job at the Post Office that was coming to an end and with a weekend to kill before going back to school.

"Come on, we've got some money now," he recalls a buddy and coworker saying. "Let's go to the Folk Festival!" As it often is with teenage boys, part of the lure of the Festival was the prospect of spending an unsupervised weekend among a freewheeling crowd, many of whom were young females of about the same age.

They did meet some girls, Mike wistfully reminisces, but the reality, in that regard at

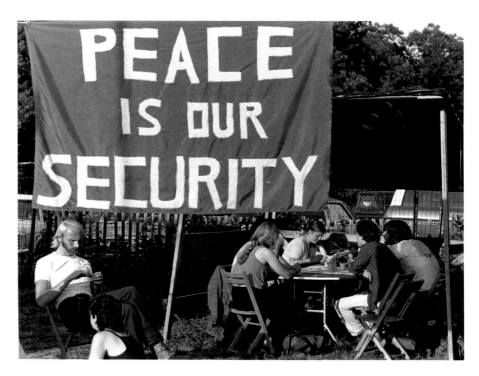

least, sadly fell far short of the fantasy. It was still a great experience, and he resolved that not only would he return next year, but he would somehow wrangle himself a spot on one of the volunteer crews and save himself a little money.

The Security team keeping the peace, 1985. Philadelphia Folksong Society Archives

The Monsoon

Mike's introduction to life as a Philly Folk volunteer came in 1971, the first year at the Old Pool Farm. "The 'Year of the Mud,'" he says of the nearly seven inches of rain dumped on the site by a tropical storm. Thanks to a buddy already on the crew, he had landed a spot on the security team headed up by Marty Singleton.

Because of the disastrous weather, Mike recalls, "Most of the security crew abandoned ship. But me and my friends, we were like 'too dumb to leave' . . .—there were times when five or six of us made up half the security force—so we stayed, and we had quite a bit to do."

At one point, Mike was trudging along the roadside through the mud when a Pennsylvania state trooper drove up behind him and hit his siren and lights briefly to get Mike's attention. The trooper had been able to see Mike's identification as a security volunteer, and as Mike approached him he rolled down his window and said, "I need you to drive my car."

Astonished to the point of speechlessness, Mike listened as the trooper explained that there was an ambulance a short distance behind that needed to get out

with a patient, but the driver was unable to navigate and handle the ambulance in the conditions. The trooper's plan was to drive the ambulance himself, but he needed someone—Mike, as it turned out—to drive the patrol car and lead the way out. Feeling the weight of responsibility and duty as part of what little of the security crew remained, Mike agreed, got in the police car, and began leading the procession away from the Festival grounds.

The roads were lined with campers and other Festival attendees trying to make their way to someplace—any place—that was dry and warm, and Mike discovered with deep satisfaction that the best way to clear the road ahead was to make use of the siren and lights. As he slowly passed the rain-soaked pedestrians, he suddenly realized that they could see that he was not a uniformed policeman, and soon he was hearing shouts of, "Hey, man—you stole a police car! *Way to go!*"

The ambulance finally got to a spot where the driver could take over, the trooper reclaimed his cruiser, and in his first year as a volunteer, Mike had an amazing story to tell for the rest of his life, though he would end up with many more before he finally "retired" from the Festival—the first time. (He now laughs that, like Frank Sinatra, he is currently on his "fourth retirement.")

Mike and the Bikers

Many longtime volunteers keenly recall the "Year of the Bikers," though as often happens with the passage of time, many are uncertain as to exactly what year it was. Longtime Cleanup Committee member "Trashy Dave" Rutkowski says with authority that it was 1972—"the first year I volunteered."

Whichever year it was, Mike McGrath recalls that Security Chair Marty Singleton approached him Saturday morning with the news from the state police that a large contingent of bikers was en route to the Festival. As with the date, there is some confusion as to which gangs were involved. Mike recalls that some were Hell's Angels, but veteran Groundz crew member Lee Theis says it was a mixture of members from two notorious regional clubs: the Warlocks and the Pagans.

It was not of urgent importance to Mike which particular gangs were about to roll through the gates when he says Marty told him, "When they get here, I want you to go out and talk to them. You're a good talker."

"I was, like, nineteen," Mike recalls with wonder. "'Marty, what do you want me to say?'"

"You'll figure it out."

The phalanx of bikers showed up around noon, Mike remembers. "They had a ritual where they would all arrive together and pull up in these straight lines. And at some unseen signal—I was standing right there—they turned their bikes off, all at the same time, and it went from this deafening roar to a deafening silence."

"They were very impressed with me," he continues. Walking up to the leaders, Mike introduced himself as a representative of the Festival Security operation and was pleasantly surprised—and relieved—at the reaction he got when he added, "What can we do for you?"

"It's probably the smartest thing I've ever said in my life," he laughs, "because it took them totally off guard. They were obviously prepared to be confronted, to be threatened, to be chased off. It took them a minute, and then they said, 'Oh, some of us have been here, some of us haven't. We wanted to show the new guys what it was like to hang out a little bit.'"

"I said, 'Well, it's Saturday afternoon, there's not much happening now, but the afternoon concert will start at four, and if you guys want to wander around, you know, get something to eat, visit the craft booths, just walk around, stuff like that, you can be our guests—*but we would need you to leave at three.*' And then I started the lie that we needed that parking lot—which we probably *did*—but also, you know, I'm trying to do damage control, and I'm making it up as I go along."

"And they agreed! They agreed, and they split up into small groups, and they go around, and every small group had, like, four of *our* guys keeping an eye on them. They were all well behaved. We didn't let them into the campground; I told them the campground was *off limits.*"

Mike pauses a moment to breathe a sigh of relief as he continues. "I go back to the trailer, and we get the *wonderful* news that most of the [bikers] had turned back, because the state police had announced over the radio that they [the police] had this great master list of stolen bike part numbers, serial numbers—and that was like the perfect 'veiled threat.' So most of them turned away. I went back to the trailer, Marty asked me all the facts, and congratulated me and all that. Marty sat down at his desk, looked at me, and says, 'what are you going to do if they don't leave the grounds? What are *you* going to do?'"

"*That* was the longest three hours of my young life."

True to the bargain, though, at three o'clock, "They were *mostly* gone—we *thought* it was all of them."

As they "saddled up," he remembers, "It was the same thing . . . they started all their bikes up at once. And it's amazing. It was like The Rockettes, with 'colors.' And they went off! Then we started to get reports of these isolated incidents, and it turns out that during those three hours they had kicked about a dozen guys off the club. So now, with this, we had these 'rogues' wandering around and they gave us trouble all night long."

"I can remember putting out a lot of fires that night, and I was *not* one of the 'tough guys.' See, the way we did things back then, you had a crew chief, and the crew chiefs had, like, ten, twelve, or twenty people underneath them, depending. They would work a sector, and the crew chief had a radio, and maybe one or two other people had a radio, and if they got in trouble, or didn't like what they were seeing, they called in, and we would send out one of the 'special teams'—*my* team."

Usually, all it would take to get things quieted down would be for a half-dozen or so of the bigger guys on the "special team" to appear, but if a situation still threatened to spiral out of control, Mike says, "The state police had a wonderful relationship with us. They would sit right outside, and they had a couple guys inside on the grounds—we knew that. But they would not come in, in uniform, unless we called them. They were [showing] a lot of confidence [in us]."

Later on that Saturday evening, the radio crackled with a call about a trio of the remaining "rogue" bikers causing trouble at one of the bridges into the campground. Mike hurried over, maneuvered himself into a position at the center of the bridge, and brandishing a quarterstaff he had become accustomed to carrying around, told the bikers they would not be allowed into the campground, and that they needed to leave the grounds—"period."

As one of the bikers began to come toward him, the thought ran through Mike's mind that taking a swing at him with the staff might not be such a good idea—"I can't hurt this guy, we'll get sued, you know, all this stuff is going through my head."

Fortunately, like in a script out of a Hollywood western, the cavalry arrived.

"The truth is," Mike quietly says, "a lot of our guys [back in those days]—the 'heavy hitters'—were professional security people, or were part-time cops, or full-time cops. So as this guy starts to come toward me, you could hear through the night air [from a short distance around] they went to 'firing mode'—and that was all it took. *That was all it took.*"

"I think one [biker] wet himself," he laughs, "and then we're fine after that . . . But we did it. All these [Security] guys—they never saw them. You never saw them. And they never came out. *They just made that sound.*"

Any gathering involving thousands of people—even a "folk festival"—runs the risk of good times getting a little too far out of hand, or as any veteran of the Philly Folk Security crew can tell you, bad actors from outside the Festival sneaking onto the grounds to commit burglary, vandalism, or simply to see the shows for free. From the beginning, the Festival has relied year in and year out on a combination of friendly, non-uniformed, low-key volunteers backed up by experienced security professionals, who in turn can rely on local law enforcement in emergencies.

Mike McGrath is philosophical, as he acknowledges that, in the midst of a community that is as instinctively anti-authoritarian as the Philly Folk crowd, anyone walking around wearing a badge with "Security" on it is likely to be viewed with suspicion and hostility, no matter how harmless and non-threatening they appear to be. It simply comes with the territory. The folks on the Security crew will frequently overhear grumblings along the lines of "Why does there have to be so many? Why do they have to be so prominent?"

But Mike concludes the tune changes when the cavalry arrives, as it did for him, to defuse a tense confrontation, or when a stolen guitar is located and returned to its owner.

"You know the Folk Festival, although it had this reputation for being raucous, and crazy, it was probably the safest place to be that weekend. Those are some of the greatest people I have ever worked with, and it was really part of my growing up. Security seemed like fun. You know, I never really got a straight answer when I asked what we did—'Oh, what do you do on Security?'"

"Ahhh, you just check people's credentials, this and that.'"

"Nobody said," Mike finally laughs, "'you'll be sent out to confront a gang of bikers on a beautiful Saturday afternoon.'"

But Mike's adventures with the Security crew included the much happier—and safer—opportunity to be one of the few people to hang out with Bob Dylan when the "King of Folk Music" visited the Philadelphia Folk Festival in that same year, 1972 (story to follow in a later chapter).

MERCHANDISING COMMITTEE

When you go to festivals and concerts these days, the merchandising booths, tables, and tents are a big part of the experience, and often part of the financial success of the event. The Philadelphia Folk Festival is very proud of its Merchandising Committee, whose efforts contribute a great deal to the bottom line year after year. However, there was definitely a time when concerts and festivals did not focus on selling commemorative items. Recently stepped-down Merchandising Committee Chair Rob Bralow comments, "The Merchandising Committee really started when a woman named Esther Halpern drove her truck up to the Festival full of T-shirts, and sold shirts out of the back of her truck. I believe that was during the second or third Festival ever."

Esther Halpern was intricately involved with the formation of the Philadelphia Folksong Society, and along with her husband Ed owned and operated The Gilded Cage, an important venue for folk music in Philadelphia during the peak of the American folk music revival period. Esther's enterprising initiative became the genesis of the Merchandising Committee, known then as Society Sales. As Rob explains:

> Esther did so much for the Folksong Society and the Folk Festival. She would go to T-shirt distribution companies and purchase blank, white T-shirts at the lowest cost, would then take them to a printer and have the design printed on the shirts, and then take them to a dyer and dye the different shirts different colors. She spent an incredible amount of time before the business of printing T-shirts was a thing.

Not all of Esther's projects turned out to be as successful. "In the mid-'90s she purchased 3,000 stick-on tattoos, but maybe sold about 200," Rob recalls. It shows how difficult it can be to choose the right products to sell at a festival, but more often than not Esther got it right.

Society Sales moved from the back of Esther's truck to a wooden booth at the top of the hill on the Festival grounds, and now occupies a huge reception-style tent full of T-shirts, artist CDs, and various other products that carry the Festival logo. Rob notes, "It's always interesting to find something strange to sell that [makes] people say 'Hey, I never thought about buying that here. I'm so glad it has the Festival logo on it.'"

"One of the more unique and popular items that was sold at the Festival was an adult 'onesie' with a seat drop," Rob laughs as he explains trying to keep the traditional items in the marketing mix, yet bringing in new items that are interesting and cool.

Merchandising Committee Chairman John Wilson, who succeeded Esther, was the one who started to really expand the different types of items sold at the Festival, such as button-down and casual shirts. Jim Klingler, also known as a member of the Philadelphia Jug Band, took over the committee from John and was always looking for that "one thing to sell," Rob elaborates.

The Merchandising Tent really took off , Rob continues, when Jim's successor, John McGlinchey, "brought in a ton of technology and moved us from scratches on a piece of paper to our current POS [Point Of Sale] system." It was an important step, Rob explains, because, "Data starts to matter, and helps us to focus on what we are selling and how we can sell it better," thus increasing the success of the committee's efforts. Rob credits John McGlinchey for changing the way the Merchandise Committee ran. "It was no longer a booth, no longer a place where people walked up, got their item, and left. It was now a *mall*. It was now a place where people could actually enter, and shop, and look around, and *enjoy themselves*. John changed the way people shopped at the Festival."

When asked what made him want to become a member of the Merchandising Committee, Rob smiles and delivers a two-word answer: "Glow Sticks!" Yes, the little plastic sticks that glow in the dark when you break the capsule and shake it, causing the phosphorescent chemicals to combine—and shine. The committee recruits kids to go up and down the hill of the Festival grounds, waving the sticks and yelling to get people to buy them, a marketing tactic that has worked for years. Rob was of course naturally drawn to the glow sticks. From there Rob was recruited to take more and more responsibility until, one year, he suddenly found himself chairman of the committee. Now that Rob is a parent himself and has started bringing his own kids to the Festival, he felt it was time to pass the chairman's baton to another.

"I love that my mother (Lisette) was a part of this," he reflects. "My dad (Andy) was a part of it, and my children are going to be a part of it. It's an exciting thought that my two-year-old and my child who hasn't even been born yet will be a part of it the way I have."

Among the funnier moments Rob remembers from being a part of the committee came during one of the "Mudfest" years. "This was maybe 2009 [or] 2008; it just poured at the Festival, the whole week before, and then let up the Saturday night of the Festival. The place was a muddy mess. People had mud up to their mid-calves." Rob continues, "Some of the middle managers came into the sales tent just soaked and muddy and saying loudly, 'So does anyone have any socks?' And we thought . . . *maybe we should invest in some socks*!" You just never know where the next big idea will come from.

The Merchandising Committee, although incredibly hardworking, is not without its fun. "Back in the days of the big wooden booth there would be lots of yelling and laughing. Then someone would call from one side to the other, 'Hey, I need a green banjo shirt,' and whomever was closer to the green banjo shirt would pick it up and throw it as hard as they could to the other side—and if it hit someone, all the better! It was just a fun, raucous time," Rob reflects with a smile. The committee would also hold a luau the Thursday night before the Festival, complete with open mic. Since the Thursday night campground concerts started, the committee has shifted to a Thursday afternoon barbecue, and the open mic is now gone. Rob

displays notable pride in his committee as he remarks, "We are a committee that loves to get it done and find different ways to do it."

Realizing the impossibility of mentioning every member who has contributed to the ongoing success of the Merchandise Committee, Rob nonetheless makes a point of mentioning two in particular. The first is "Doc Terry" McGrath, a well-known Chester County veterinarian and longtime member of the folk music community who year after year plays music in the tent as "filler." Like the music that is played at retail stores, Rob says, "[Terry] brings a hammered dulcimer into the center of the tent and gathers artists who want to jam with him for two, three, four, five, or six hours at a time as entertainment. He has been a staple of the merchandising committee long since I've been there."

Rob also fondly mentions Steve Hammond. "[Steve's] nickname is 'Builder Bob.' He puts the place together every year and takes it down every year. He makes sure everything works. If we have a problem, he fixes it. [He is] one of the very few people where we wouldn't know what to do if he wasn't there."

MAIN GATE

"Tickets and Smiles" is the greeting usually heard upon entering the Main Gate of the Festival each day for those who are day-trippers. The Main Gate itself has changed over the years, but then, so has the process of buying and paying for tickets. As time has passed, tickets ordered by mail, printed on heavy stock paper, and physically collected at the gate have given way to "print at home" tickets on standard letter-sized paper with barcodes that can be electronically scanned—or, more and more, scanned directly from the screen of a smartphone.

And while we are all used to the "canned" greetings we encounter wherever we go—"How may I help you?" or "Have a nice day!"—that may or may not be sincere, when the volunteers at the Festival Main Gate ask for "tickets and smiles," it is not out of a section in a corporate training manual; it is a simple reminder that you have entered a happy place. It is, after all, *Fest*.

As with many of the other Festival committees, working the Main Gate can be a "family tradition" that may now extend into as many as four generations. What has remained the common thread for more than fifty years is the understanding that, for many Festival attendees, the Main Gate staff are the "first line," the first "employees" they encounter. All understand that making that first good impression will go a long way to making sure the customer comes back next year.

Before the days of scanning, a ticket would be punched to show it had been used. Then, if a customer needed to leave the Festival grounds, a "return pass" would be issued. To gain re-entry, it would be necessary to present *both* the return pass and the original punched ticket.

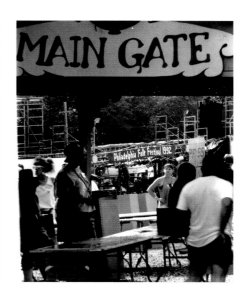

Old Main Gate, 1985. Philadelphia Folksong Society Archives

Hat showing images of old, including the "return pass." Photo by Jayne Toohey

Old Main Gate, 1992. Philadelphia Folksong Society Archives

"Tickets and Smiles!" at the Main Gate, 2015. Photo by Lisa Schaffer

"SWEEP" AND "THE CRUSH"

At the conclusion of the afternoon concert, there would be a "sweep," in which the concert area would be completely cleared with a themed parade orchestrated by Groundz and Security, with "day trippers" ushered back through the Main Gate, while campers would return to the campground for a dinner break. During that interim, the grounds would be cleared of trash (as well as any blankets and chairs that had been left behind) while the stage crews prepared for the evening concert.

For those concertgoers who were in the "corral," some arriving hours early so they could be the very first to re-enter, the term "crush" might have been literal. Scott Segan, a veteran of the Main Gate, was one of those in charge of moving the large group forward toward the ticket takers. Scott recalls, "We're always trying to balance the great 'Folk Fest attitude' at the same time with some resistance from some of the crowd and some tension with people that don't want to be involved with it, or who felt like they were being treated like animals."

"It was exciting for people and enjoyable for people," he continues, "because it was an *event*." At the same time, Scott remembers people who were annoyed because they had to pick up their stuff and possibly lose a good spot they had in the afternoon concert. It was also a safety concern moving so many people, with Scott adding that they tried to, "do it with as much friendliness and love as possible."

When the time came to reopen the gates, Scott and his fellow brave volunteers on Main Gate and Security would walk up and down the corral with a megaphone, telling jokes and giving instructions on how people would move forward to finally give their ticket . . . and smile. Scott would tell the first row, "You are going to take two steps forward and then *stop*." The crowd would naturally fill in the space behind those first rows. He did not know if this was the wisest way of handling things, but he did not have many other choices. The doors to the Main Gate would close and the committee would

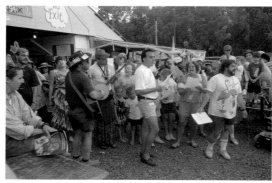

take a collective breath and get ready for the crowd to come through the gates. Then the doors would open.

The crowd outside, waiting with their tickets, much like the "land rush" in the campground on Thursday morning (see the "Camping" section), poured through the gate when it finally did reopen, becoming an avalanche of people cascading down the hill in a dash to claim (or reclaim) their "turf." Eric Ring (one of the authors) was a Main Gate volunteer for several years, and he recalls that while his fellow committee members were shouting at people to slow down he would be calmly saying, "Don't run, all the good spots are already gone and it's not worth getting hurt!" People would

smirk, Eric says, slow down to a trot, and once safely past him break into another hundred-yard dash again.

Yes, things are simpler and more streamlined now with electronically scanned tickets, the use of bracelets, and the fact that there is no "sweep" anymore. But those same volunteers who used to punch your tickets and tell you to slow down still cheerfully say, "Tickets and Smiles please."

CLEANUP AND RECYCLING

For those inhabiting the campground over the Festival weekend, one of the first sounds to enter their consciousness in the morning hours is the shout of "Bring out your dead! Bring out your dead!" No, a time warp has not opened up and transported the campground back to the Medieval era of the black plague, or even to the set of a Monty Python movie. It is the sound of the dedicated volunteers from the Cleanup and Recycling crew as they cruise the grounds while campers frantically stuff the remains of the previous day's partying into plastic bags (black for garbage, clear for recyclable plastic and cans), haul them out to the road for the "trash people" to throw in the back of the truck as they pass by, and receive new bags for their efforts.

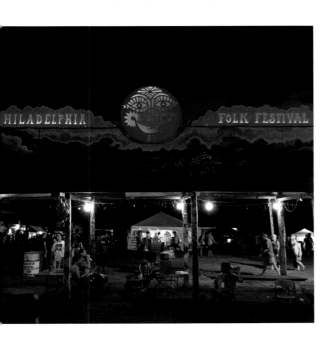

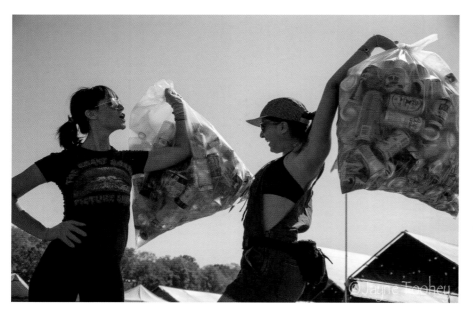

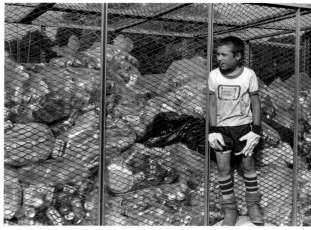

"Bring out your dead!"—Cleanup and Recycling teams cruise the campground. Photo by Jayne Toohey

Teaching to recycle when they are young, 1992. Photo by Jayne Toohey

Former Chair of Cleanup (then Trash and Recycling) "Trashy Dave" Rutkowski, 2002. Photo by Jayne Toohey

And it takes more than the usual amount of volunteer dedication and enthusiasm to do the work of cleaning up after everyone else's parties. Like the Parking Committee volunteers who stand in the hot sun (or cold rain), waving cars into small spaces, one after the other, working cleanup and recycling is not generally considered among the most pleasant and desirable "gigs" at the Festival.

"Trashy Dave" Rutkowski has been working on the crew for decades, for many years as the committee chair, and he recalls with a deep laugh that it took quite a while to build the current crew of seventy-five or so who sacrifice late-night party time to get up at 7:00 a.m. and tidy up the entire Old Pool Farm before the workshops and other daily activities kick off. A moniker like "Trashy Dave" conjures up images of the famous "Pigpen" character from Charles Schulz's *Peanuts* comic strip, but now in his sixties, with flowing white hair and beard, Dave presents more the appearance of a Biblical prophet than a walking cloud of dirt and dust, and the more he talks, the more that comparison seems apt.

Noting the historically close relationship and interaction between Cleanup and Groundz, Dave says they spend a lot of time together, and since there will inevitably be instances of more than one person with the same name—Dave, for instance—nicknames will be used to differentiate. Since he was the one on the "trash crew," he naturally became "Trashy Dave."

A native of the Bridesburg neighborhood of Philadelphia, one of Dave's teenage friends and neighbors was Richie Pyott, whose parents were Howard "Stretch" Pyott and his wife Teresa. Among the many other

things he did at and for the Festival over the years, Stretch was president of the Folksong Society, and also called square dances during the Festival. Teresa Pyott had been Ken Goldstein's secretary in the Folklore Department at Penn, had joined him in helping to run the Festival in the early years, and when Ken relinquished the job of programming chair in the 1970s, Teresa stepped in and handled booking the Festival for a few years.

Richie Pyott was already in charge of the grounds cleanup as a teenager ("Because no one else wanted it," Dave says), and he got Dave to come to the Festival to help out. After an interlude of a couple years in the Army Dave returned, became part of the cleanup crew, and before he knew what had happened, found himself in charge a few years later. He quickly discovered that he was in command of an operation that had become notoriously unreliable, and he set about recruiting a more stable and dependable crew.

"We tried Boy Scouts, and this and that," he remembers, but achieved little long-term success. "Then we hit all the bars in our [Bridesburg] neighborhood and said, 'Look, we'll give you free food, free beer, and we'll pay you fifteen bucks a day.'—and that was it, we had a crew. But we had a lot of problems," he admits.

It took a few years to clear out the "driftwood" and get down to a core of people who would produce more work than trouble, and Dave says it was a major turning point when the kids of some of his better workers became old enough to join the crew—including his own. When Dave stepped down as chair in 2011, his son Josh, and daughter Jes, took over as co-chairs.

"I wanted to change that whole image," Dave finally says, "and it's become a great crew since then. I'm really proud of the people."

It is Cleanup and Recycling who get to inspect and pick up the pieces *after* the party is over on Monday afternoon, after the last RV has pulled out and the last tent has been taken down and carted away. Well, *almost* the last tent. Josh Rutkowski shakes his head in amazement at some of the things they find scattered across what just a few hours before were thriving, active campsites.

"Money, drugs, alcohol," he says, though it is quickly apparent that he's joking. He does add that it is pretty common to find tents, clothes, air mattresses, and other discarded gear. "If Sunday is gonna be wet," he laughs, "Monday is gonna be fun. Some people are gonna feel, 'Yeah, it's wet—screw it, I'm not taking it home. I'll buy another one next year.'"

Dave relates that occasionally someone will return to retrieve property left on the site. One Monday afternoon a few years ago, he says, a car pulled up and the driver got out and approached the crew. Dave asked him, "Can we help you?"

"Yeah," the driver said, "I left my gear out there in the field. I put it in trash bags, so no one would steal it."

As Dave and his colleagues dissolved into laughter, Dave pointed to the "packer" (trash compressor) truck they had been chucking bags into and said, "See that 'packer?' You can follow it to the dump— *that's where it's going.*"

Dave notes all those mounds of trash and stacks of bottles and cans are handed off to a local trash company contracted by the Festival, and the money from the recycling is deducted from the bill. The overwhelming majority of Festival goers, be they campers or "day trippers," are ecologically conscious and do the right thing when it comes to keeping the Old Pool Farm as clean as possible, but Josh is quick to note, "There are still some slobs."

Dave points out that a few years back, the Groundz Crew created a Facebook page with the slogan, "Leave Nothing But Footprints." "I'm glad they did it, rather than us doing it," he says, "because now it's another committee besides us who's saying, 'Let's keep the place clean.' And that's really helped; it's changed a lot of people's attitudes."

Still, there is no getting around the fact that the Cleanup and Recycling Committee is charged with literally the dirtiest and least glamorous job at the Festival. In particular, Dave recalls, in the years when campers could obtain lids from fifty-five-gallon drums to build their campfires on top of, it was his crew's job to retrieve them at the end, and it was not until Wednesday that they could be confident that all the embers had burned out. After collecting and stacking the lids, the entire crew would be covered head to toe in ashes. But, he laughs, they would usually finish ahead of the others and get first crack at the showers.

Above: Hauling cans. Photo by Don Hoy

Left: Kurt Grotz from Trash and Recycling, 1996. Photo by Jayne Toohey

CENTRAL CONTROL

Right: Winifred "Winnie" Otto from Central Control showing off her new Tee. Photo by Eric Ring

Below, left: Co-Chair of Central Control George Calvert with his son, Najah (L), and Andrés Mordecai (R) from El Caribefunk, 2015. Photo by Eric Ring

Below, right: Backstage: Central Control becomes "weekend roadies," 2015. Photo by Eric Ring

If something needs to be done and nobody knows who is supposed to do it, "Call Central Control." During Pre-Fest, the committee is tasked with delivering chairs and tables around the festival grounds. Once the Festival begins, the fun starts. You may see Co-Chair George Calvert delivering ice to the various stages to help keep the artists cool in the August heat. However, most of the tasks come from calls received from a telephone situated outside the Exec Trailer. Mary Ann Volk answers those calls and determines what the problems are and how much immediate attention they need. Central Control tries to fix those problems. It could be artists and their instruments need to be escorted from the backstage to the Camp Stage, or a neighbor has complained that people are using their driveway—or worse, their lawn—to turn around and would like a fence put up to protect their property. Mary Ann calls her husband Greg Frost, who can be seen zipping around the grounds in a "gator" with a trailer hooked on the back, "Greg, can you?" Central Control heads out to keep things moving.

The other task Central Control is charged with is to help unload, and then load, the performers' trucks. Becoming weekend roadies, they move boxes full of instruments and equipment, assisting the professional roadies to get to the point where they can begin setting everything up.

"It's amazing to see, and to help load one of the big bands, like when Lyle Lovett was at the Festival," says Eric Ring, co-author of this book. He continues, "The Roadies have it down to a science, and it's like watching them play Tetris, but with real boxes." Once the concert is over and people are either headed home or back to the campground to enjoy a night of music and campfires, the members of Central Control are backstage, rolling boxes up and down ramps and onto trucks so the artists can get to their next gig and start all over again.

SPECIAL STORIES

"FEST BABIES"

There are many who, like Gene Shay, have attended every Philadelphia Folk Festival since that first hope-filled edition in 1962. But there are also many who have attended every year that they have been alive. Julie Leinhauser, now in her mid-twenties, was just three months old when she attended her first Philadelphia Folk Festival. She says, "It's like coming home to family every time I come to Festival." The Festival is one of the special times each year that she gets to vacation with her father.

If there is any one person who can claim to be the "Original Fest Baby," a likely candidate might be Tim Britton, whose father George Britton is widely regarded as the founder of the Philadelphia Folksong Society. Tim followed his father's footsteps into a career as a folk music artist, though in Tim's case it is as a highly regarded piper and flute player who has performed and recorded with Mick Moloney, Eileen Ivers, Seamus Egan, and many others.

Though Tim recalls that they did not come *every* year in his childhood years, the Festival was an important part of the musical upbringing he and his siblings received. It was Kenny Goldstein, another early member of the Society and Festival

Father and "Fest Baby" daughter, Bob and Julie Leinhauser. Photo by Eric Ring

management, he says, who got him hooked on Irish music, inviting Tim to sample and make recordings of albums from his extensive collection.

Tim remembers one year he and his brother were playing in a nearby frog pond as the show on the Main Stage was taking place. His father seemed disappointed that the boys appeared to be paying little attention to the music, but Tim says he remembers everyone he heard on the stage that day.

Father and son having fun near the Tank Stage. Photo by Howard Pitkow

Thea Shoulson (Full Frontal Folk) backstage at Fest. Photo by Jayne Toohey

"Where are the keys?" Sylvie Braunfeld, daughter of Michael Braunfeld and granddaughter of Festival Chairman Andy Braunfeld.. Photo by Jayne Toohey

Diana Esposito—the "Hershey's Kiss Girl"—handing out kisses. Photo by Eric Ring

"Even if you think your kids aren't taking it in, they're completely taking it in, much more than you'd ever guess, or may ever know," he smiles.

There is a clear, lasting legacy, Tim concludes, of being raised in a folk music environment:

The love, the joy, and the unique experience we have here playing folk music as an extended family—the 20,000 of us, whatever—is very real, and tangible, and those kids are absolutely fed by that at a very deep level, I firmly believe. The fact that I can get on a stage and feel comfortable in front of people, and people are sort of, "How do you do that?"—I saw my father do that, like, thousands of times. It's just normal. Doesn't everybody do it?

Aaron Essen, when asked when his first Festival was, says, "Technically, it would be when my mom was pregnant."

Aaron and his brother Avrom have been coming to the Festival their entire lives. Asked what keeps him coming to the Festival now that he is older, Aaron says he wants to bring his friends to the Festival and share the experience. "I wanted to keep that tradition going."

Some Fest Babies have made a name for themselves at the festival—literally. Starting at the age of ten, Diana Esposito, also known as the "Hershey's Kiss Girl" and who has taken the last name "Kiss" during the Festival, started wearing a Hershey's Kiss hat. For more than twenty years she has worn the symbol of that little piece of chocolate, and is frequently recognized outside the Festival, such as when attending concerts by the Celtic folk-rock band Tempest—and yes, the band recognizes her, too.

Diana also gives out Hershey Kisses as she walks around the Festival grounds. Exemplifying the spirit in youngsters who have been attending the Festival their entire lives, she says that when she got married, she had two weddings: a "real" wedding and, as she relates it, "We got 'Folk Fest married'—because if it doesn't happen at Festival, *then it's not real.*"

During Fest Week, Diana's husband takes his wife's "Festival last name," and they are now known as "Mr. and Mrs. Kiss."

A number of Fest Babies have gone on to musical and entertainment careers of their own, either part-time, such as Michael Braunfeld has done (like his dad, Andy, he is a lawyer in his "day job"); or full-time, such as John Gallagher Jr., whose credits include a Tony Award for his role in Broadway's *Spring Awakening*, appearances on major network TV shows like *The West Wing*, and a starring role in HBO's *The Newsroom*.

Asked what the Folk Festival means to him, Michael looks at the digital tape recorder and says, "I don't know how many hours you have on this thing." He first performed at the Festival at age sixteen, when he met Native American folksinger and flute player Bill Miller. Bill took Michael under his wing and asked him to open some shows for him. At the 1993 Festival, Bill asked Michael to join him on the Main Stage to play "Geronimo's Cadillac," a Michael Martin Murphey song that Bill had adopted as one of his standards. "Seeing that hillside come alive was something I'm never going to forget," Michael fondly recalls.

In much the same vein, John Gallagher Jr. ("Johnny," as he is more widely known in his musical alter ego) agrees, "I really did grow up a lot in a sense here [at the Folk Festival]. Every summer this was a big deal for my family." His father John Sr. is a longtime volunteer who manages the Tank Stage, and who, with his wife June, has performed at folk music venues around the region for many years.

Following their dad around at the Festival gave Johnny and his big sister Joni the chance to not only see, but also meet musicians like Arlo Guthrie, Richie Havens, Janis Ian, and others. It gave Johnny a sense—unconsciously perhaps—of what art, and specifically performance art, was about. He ponders, "Without all of those experiences, would I have been so inclined to [be creative] myself?"

Other Fest Babies have formed professional bands together. Full Frontal Folk came together at the Spring Thing, an offshoot event of the Festival. Wendy Fuhr, Courtney Malley, Jen Schonwald, and Thea Shoulson got

Fest Kids enjoying bubbles. Photo by Lisa Schaffer

Photographer Lisa Schaffer with her daughter, Julia, 2013. Photo by Mark Smith

Catching raindrops. Photo by Eric Ring

Hitting the road, 2015. Photo by Steve Sandick

Full Frontal Folk, 2011 (L-R): Jen Schonwald, Wendy Fuhr, Courtney Malley, and Thea Shoulson. Photo by Jayne Toohey

"The Great Groove Band," 2012. Photo by Frank Jacobs III

together and began harmonizing and exploring their common musical talents. Following an "open mike" session at which he happened to be in the audience, Gene Shay encouraged them to keep going, telling them, "You guys should be a band."

Eager to get started, they first came up with the "O Canada Girls" as a band name, from their mutual ties to the "Canada" compound in the Festival campground. Thea, now with more than forty Festivals under her belt, says she had always wanted to play the Main Stage at Philly, and it came true for her and her bandmates in 2004. When she came off the stage she got a hug from her father

and started to cry, thinking to herself, "Well, what do I do now? I played Philly Folk Fest—*I've played Main Stage!* That's the peak of existence for someone who grew up here!"

She continues, "We're a real shining example of . . . growing up in this amazing community of musicians, music lovers, supporters of folk music, and supporters of the Folksong Society . . . We are products of that nurturing environment; we lucked into something special. We would not have been the band that we were if it weren't for this community."

And any discussion of Fest Babies also has to include Shannon Lambert-Ryan, who likewise roamed the Festival grounds throughout her coming-of-age. Blessed with a beautiful voice, she appeared on the Main Stage in the early 2000s as part of Guy Mendilow's band, then again a few years later as lead singer of the exciting young Celtic-American band RUNA.

Some of the Fest Babies are now having babies of their own. Diana Esposito Kiss now brings her daughter, whom has gone by the subtitled name of first "Micro Kiss" and now "Mini Kiss." Michael Braunfeld concludes,

"This is one of the few places I can go and feel relatively young, because so many people are there to remind me that I *still* am the kid . . . From the second my [own] kids were born I knew we were going to look forward to August and giving them the same memories of being out in this magical place."

"DYLAN IS HERE! DYLAN IS HERE!"

Mike McGrath states on Saturday morning of the 1972 Festival, his boss on the Security crew, Marty Singleton, called him to the office and told him to go backstage for a special assignment. "Don't tell anybody," Marty said. "Nobody's supposed to know, but Bob Dylan's here."

Mike responded, "Cool, when's he gonna go on?' And Marty said, 'Well, they're trying to get him to go on, but I don't think he's *gonna* go on.'"

As in many years throughout the Festival's history, David Bromberg was among the headliners that year. He had performed often with Dylan, and they had become good friends, so when Dylan expressed interest in visiting the Festival and hanging out for the day, a "conspiracy" was hatched to bring him in without causing an uproar.

"He hid in our equipment truck. I mean, there is no way he could have shown his face," David smiles as he confesses he snuck Dylan into the Festival in the back of the "Duck Truck," so named because of the large yellow duck painted on the back.

Dylan spent the afternoon and evening enjoying the backstage camaraderie, and Janis Ian remembers being bowled over when he approached her after she came off stage and complimented her on the song she had just closed her set with. At one point he expressed the desire to walk around the

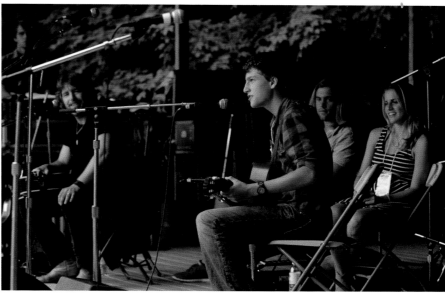

grounds for a while, and it became Mike's job to escort him and try to keep him from being recognized and besieged by fans. Dylan had a bandana around his head and was wearing a pair of sunglasses, and Mike says Dylan looked more like Stevie Van Zandt than himself. "He looked pretty good," Mike laughs, "in terms of 'not looking like Bob Dylan.'"

As they headed out from backstage toward the Food Tent, though, they were conversing, and quickly realized that while the "disguise" was holding up from a visual standpoint, they had not counted on one thing.

"[Bob's] asking me questions," Mike says, "and we're talking, and then people started to recognize his voice. But we came up with a *great* routine. People would come up and go, 'Are you—*are you?*' And I would, like, hit [Bob] in the shoulder and go, 'Somebody *else* thinks you're Bob Dylan!' And he would laugh and go, 'I wish, I wish.'"

Rumors of the presence of the single biggest name in the folk music world shot through the crowd all day. Paula Ballan, who was in charge of booking and stage operations that year, lowers her voice and imitates the "Dylan is here! Dylan is here! Dylan is here!" half-whispers that echoed across the grounds. Although everyone in the Festival management structure grasped that his visit was an important event, and an honor for the Festival, the question of whether or not to arrange an impromptu stage appearance by Dylan raised issues that were not only logistical—when, how?—but political, as well.

The previous year had been the first at the Festival's new home, the Old Pool Farm, and the awful weather had forced a lot of changes to the schedule. The auxiliary stages

The "Full Frontal Fathers" re-create the debut album cover of their daughters' band, Full Frontal Folk (L-R): John Fuhr, Frank Malley, Steve Schonwald, and Joel Shoulson, 2002. Photo by Jayne Toohey

Proud dad John Flynn watches his kids Ethan, Sean, and Sarah perform, 2013. Photo by Alex Lowy

Reverend TJ McGlinchey, son of longtime volunteers John and Johnny Sue McGlinchey, 2012. Photo by Lisa Schaffer

were unusable, and all performances had to take place on the Main Stage. Paula recalls that this forced her to make hard decisions about which workshops would still take place and which would have to be cut. One of the longstanding workshops over the years had been the "Bawdy Songs" session that was usually held at one of the smaller side stages in a more secluded, "adult friendly" part of the grounds using a sound system geared to a smaller, more localized audience.

For obvious reasons it was also one of the more popular workshops, and Paula was determined that it should go on as planned, even if it would have to be on the Main Stage with the full sound system. As had been the case at previous sites, the neighbors were uneasy about having the Festival taking place so close to their homes, and when some of them found they could hear the workshop's often ribald and risqué lyrics, they complained not only to the Festival, but to the Township, as well.

As preparations for the '72 Festival commenced, it became imperative to minimize complaints and convince the surrounding communities that the Festival could—and would—indeed be a "good neighbor." An important part of this effort would be to strictly adhere to the local carnival ordinance, part of which specified that musical performances must end by midnight. In short, allowing the stage shows to go on too long into the night might result in withdrawal of permission to hold any future Festivals at all. (This curfew is actually still in place.)

Also on the minds of the directors as they debated what to do were the events of the previous month, when Dylan had made a similar unannounced appearance at the Mariposa Folk Festival, which that year was held on one of the small islands off the Toronto shoreline in Lake Ontario. As the same word spread as at Philly—"*Dylan's here!*"—he had been mobbed by fans, and though he had been very gracious and accommodating to all, the disruption lasted until a special boat was brought out to ferry him off the island.

As afternoon became evening, the question of whether or not to invite Dylan to perform was being hotly debated. It was not that anyone truly did not *want* to see Bob Dylan on the Philly stage. The problem was, once they got him on the stage, would they be able to get him off? Would the crowd response be so overwhelming that "one or two" songs would become an entire set? And if that turned out to be the case, could the entire show be concluded in time for the midnight curfew?

Gene Shay was the emcee who would have to take control in such a circumstance, and as he recalls it, "Ellis Hershman came to me with directors Esther Halpern and somebody else, and they said, 'Gene, we have a question to

ask you. Do you think that if we get Dylan to agree to play two songs—*two songs*—at the Festival, do you think you can quiet the crowd afterward and get them to quiet down?'"

"I said I could." After pausing a moment to reflect, Gene continues, "If I started off by saying to them 'I've got something *very* special, but the *only* way we're gonna do this is if you make a bond with me that at the end of the two songs you're gonna hear'—yeah, I think that little by little they'll get the feel of what I'm talking about. I said to [the directors], 'I think I can control them, and I think that they [the Philly audience] are a sincere enough and honest crowd that they would stick to it, they would shut up.'"

Gene remembers that as the day went on, although the rumors were rampant, it seemed on the whole that the crowd was unaware of the drama swirling around backstage. As the Georgia Sea Island Singers took the stage, though, he thought their leader, Bessie Jones, had let the cat out of the bag when she told the audience, "Well, I tell you, I was just talking to Bobby Dylan backstage . . ."

"And then all of a sudden," Gene says, "I hear, 'Did I hear her right? What? *Bob Dylan's backstage?*' She blew his cover, you know."

Noting though that Bessie and her fellow Sea Islanders were native Gullah speakers, Gene says he realized, "[Most of the audience] didn't understand what was going on— they could barely understand her accent."

Paula Ballan says the discussions and communications between the Executive Tent and the Main Stage went on all afternoon and into the evening. Though she would have enjoyed seeing Dylan perform as much as anyone, she remembers thinking, "Oh my God, if he gets on that stage they're never gonna let him off."

Finally, a runner came down from the top of the hill with the instructions to "tell Paula *right now*, she has *got* to tell that man that he *cannot* get up on that stage!"

"So," Paula says with a laugh, "I had to walk over to *Bob Dylan*—'Welcome to the Festival! Really nice to see you! We're gonna be partying pretty hearty at the motel later on, I hope you're up for a party."

After a moment's pause she got to the heart of the matter. "The old folks up in the Executive Tent, they're kind of panicked about [you being here]. Nobody knows you're here, and if you go up to do one song, [the crowd is] never gonna let you get off, and we're gonna lose the site and the possibility of another Festival. So, I feel *really* stupid, but I have to ask you to just please enjoy yourself —but *not* take the stage."

Paula remembers having the impression that Dylan had been going back and forth in his own mind about it, and seemed relieved that she had offered him a graceful way to resolve the issue in a way that was satisfactory to both sides.

"No problem," he said. "I'm having a great time."

As she walked away from the encounter, Paula came upon another messenger from the hilltop with the news of a course reversal, "[they've] finally figured out that BOB DYLAN IS AT OUR FESTIVAL! How can we *not* have him do at least *one song*?"

"They sent someone down to ask me to ask Bob Dylan, would he *please* do just *one song*? I turned my back on that person—I can't even remember who it was—and I walked over to where Dylan is [still] standing, with him facing me, and my back to whomever that person was."

"I said, 'Well, you know the world is just full of—it's the music business, Bob. They just figured out Bob Dylan is here, and how could they *not* have you do one song? But [you and I have] already figured this out, so I'm going to look like I'm pleading, and do me a favor—just shake your head 'no,' and smile, and shake my hand."

Dylan smiled, shook his head, shook Paula's hand, and they turned and walked away from each other. "End of story," she concludes—at least, as far as the question of whether or not Bob Dylan has ever appeared on the Philly Folk stage. But in a sense, he did play the Festival when he took the suggestion to join the party at the performers' motel later in the evening and early morning hours.

"[Bob] got hold of Bonnie [Raitt], John Prine, Steve Goodman, Maria Muldaur, and Bobby Neuwirth," David Bromberg says, noting that they made a circle in David's room, with two guitars and a Dobro on hand. "One guitar started at one end of the room and made a circuit around," while David filled in with the other guitar and, occasionally, the Dobro.

When the song circle came around to Bob, the guitar stopped and "[Bob began] playing tune after tune, and nobody minded," David smiles. "At one point he was doing 'Mr. Tambourine Man' and I was playing the Dobro. It just slipped out of my hand, and I sat there with my jaw open. It was *wonderful*."

Gene Shay looks wistful as he recalls that—though he can't remember exactly why—he did not make it to the motel in time for the jam session. "I missed that," he sighs.

He agrees with Paula Ballan, though, saying, "[Bob] decided it would not be a good idea [to perform on stage]. It would cause pandemonium, and he was probably right about that . . . everybody who didn't know he was there would be going for his autograph, and all the volunteers would want to mob him."

Gene smiles, though, as he remembers that he had not been fooled for a moment. "He wore a bandana, he wore sunglasses, and I remember as he passed by I said, 'There's Bob Dylan, right there.'"

THE MAIN ACTS

In 2005, Emmylou Harris broke her wrist two weeks before the Festival and was forced to cancel. Nevertheless, someone perusing a copy of the program book from that year would see her listed among the lineup and likely not remember, or know at all, that she was not actually there.

Not all of the artists listed in the lineup and the program book appear on the Main Stage. Many are booked to participate in workshops on the auxiliary stages, provide music for dances, perform in Dulcimer Grove as part of the children's portion of the Festival, and more. To give *all* the incredibly talented artists who have graced the Festival over the decades their due would take many more pages than this book could possibly provide, but the following sections will highlight many of those whom have made lasting impressions through their many appearances. Or, in some cases, an artist who has made only one or two visits that has acquired historical or other special significance.

THE PIPERS (BRUCE MARTIN AND DENNIS HANGEY)

The announcement of the lineup at the Festival each year is an occasion that is eagerly anticipated throughout the folk music community, and not just in the Philadelphia area. As one of the premier events—the longest continually operating music festival in North America—the answer to the question "who's playing Philly this year?" carries importance not only for the fans who want to know if their favorites have been booked, but for the performers who will try to fill out their touring schedules with additional gigs in the area.

In the appendix of this book is an index that attempts to present a record of the performers over the years that is as accurate as possible,

but it is virtually impossible to get such a compilation one hundred percent right. David Bromberg, for example, made an unannounced—and unexpected—appearance at the 1980 Festival, and while the list can be "adjusted" for that, there are many other instances of performers who come to the Festival as regular guests, or even paying customers, and get invited by a friend who is performing to come on stage and "sit in" on a set. Tom Smothers famously surprised John Hartford one year by strolling out onto the stage doing yo-yo tricks.

There are also occasions when performers who have been booked and scheduled are unable to appear, sometimes at almost the last minute.

It could not be more fitting than to open the performers section of this book with Bruce Martin and Dennis Hangey (pronounced "HAN-jee"), because collectively they have started the evening performances every year since the second Festival in 1963 (with the exception of 1988). As soon as the distinctive sound of Highland bagpipes drifts down from on top of the hill, the audiences seated in reserved seating chairs in front of the Main Stage or stretched out on their blankets on the hillside know a great night of music is about to begin. Dennis, recognizing the tradition he is part of, proudly states, "It sets the mood for all to follow."

Bruce Martin opened every evening performance as part of a

tradition started by Bob Siegel, longtime festival chairman. Bruce played the bagpipes for thirty-five festivals and was a staple. At the Festival following Bruce's passing, the Cameron Highlanders Pipe Band marched with pipes and drums in a tribute to him, and the job of Festival Piper was passed to Dennis Hangey. Although Dennis had been a longtime resident of the Philadelphia area, he decided the winters were too much and moved out west. Nevertheless, he and his wife continue to drive in from Nevada for the Festival. "I drive 2,500 miles every year for it," he smiles, "and as long as I can do it, I will continue to do that. I just love the people."

Dennis' wife purchased his first set of bagpipes as a Christmas gift for him, and he promptly put them under his bed for about four years. He went to Las Vegas and saw a show starring Glen Campbell. When Campbell—famous as a country/pop singer and guitarist—came out on stage playing a set of pipes Dennis said, "This is me, I'm going to do it." He located a teacher named Jim Ross, an old Scotsman who lived in Springfield, Pennsylvania, and learned how to play. Dennis has played for queens,

presidents, and at more prominent funerals than he can keep track of anymore.

Dennis comments often on how nice it has been to meet performers such as Kevin Bacon and Emmylou Harris at the Festival, but a highlight came in 2015, when he was invited onto Arlo Guthrie's bus for a quick tour. Arlo asked him to play a tune, and Dennis happily responded with "Scotland the Brave." Dennis admits that one of the most embarrassing moments during his years at the Festival—yet also among the funniest—came as he marched down the hill to open the evening show at a particularly muddy Festival weekend, slipped, and landed on his rear end.

"The ladies always ask, what do I wear under that kilt?" he laughs. "Well, I think they all know now!"

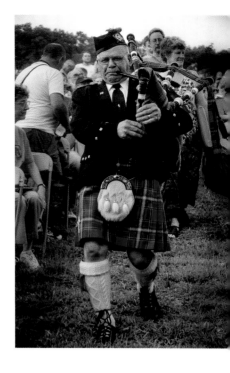

Bruce Martin, circa 1967. Photo by Diana Davies

Dennis Hangey, 2004. Photo by Jayne Toohey

Pete Seeger, 1991. Photo by Jayne Toohey

THE SEEGER FAMILY (1991)

Charles Seeger was a prominent ethnomusicologist, folklorist, and field collector in the early years of the twentieth century, and the love of music by the people for the people was infused in his children, several of whom would go on to have noted careers as folk music performers and folklorists. Pete Seeger was his son by his first wife, Constance Edson. Another of their sons, John, was the father of Tony Seeger, now retired from a career as a professor of ethnomusicology at UCLA. By his second

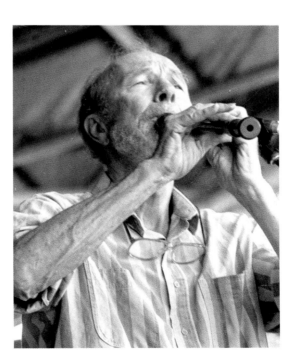

wife, Ruth Crawford, he had another son, Mike, and daughters Peggy and Penny.

The Seeger Family (Pete, Mike, Peggy, and Penny) appeared together one time at the Philadelphia Folk Festival, and in fact, it was a first for them as well. Although they had all performed in various combinations with each other, it was not until the thirtieth Philadelphia Folk Festival in 1991, that all four appeared together on the same stage. Joining the four Seeger siblings on stage that day were Peggy's sons Kevin and Calum MacColl (by her husband, the late, great Scottish folksinger Ewan MacColl) and Pete's grandson Tao Rodriguez.

Renette Hackett, a Festival goer since 1983, reflects, "Whenever you see a dynasty, I guess you would say, or group that are related like that . . . [It's] amazing and it's so cool that I'm getting to experience this."

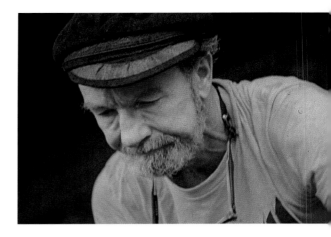

PETE SEEGER
(1962, 1967, 1978, 1991)

The emergence of "folk music" as a separate and distinct form of American popular music—spoken of with the same respect as jazz, blues, country, and rock—probably could not have taken place without the presence and influence of Pete Seeger. His entry in the *Encyclopedia of Folk, Country, and Western Music* describes him as a "father figure whose contributions as an artist and writer were highly valued by people of all ages in and out of the music field."

As war swept over Europe in the early 1940s, Pete and his friend Lee Hays, founded the Almanac Singers, much of whose music supported pacifist causes and opposition to American involvement in the rapidly spreading conflict. Following the war, Pete helped found *Sing Out!* magazine, again in conjunction with Hays, as well as with Woody Guthrie, Paul Robeson, Alan Lomax, Irwin Silber, and Earl Robinson.

In the late 1940s, he and Hays joined with Ronnie Gilbert and Fred Hillerman to form The Weavers, a group that enjoyed a successful run until 1955, when Seeger and Hays were accused of membership in the Communist Party by an FBI informant (who later recanted). Under subpoena to testify before the House Un-American Activities Committee Pete refused to answer questions, citing his rights under the First Amendment.

Pete was eventually convicted on charges of contempt, and though it was overturned a year later, he and his Weavers bandmates were blacklisted throughout much of the 1950s, barred from recording or having their existing records played on radio. Nevertheless, Pete continued to write and perform, turning out folk classics like "If I Had

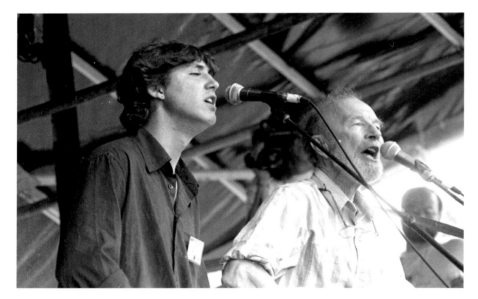

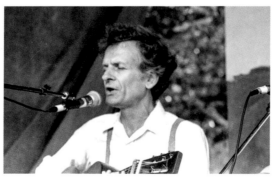

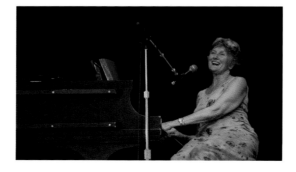

A Hammer" (with Lee Hays) and "Where Have All The Flowers Gone?" (with Joe Hickerson).

By the time the newly formed Philadelphia Folksong Society settled on the Wilson Farm as the site for their new festival and started looking for talent to put on the stage, Pete Seeger had become the very icon of the American folk singer. When Gene Shay got the news from David Hadler that Pete had been booked as the headliner, his intuition that it almost guaranteed the Festival's success—at least for that first year—proved to be on the mark.

In addition to the recollection of seeing Pete's breath as he performed on that chilly September evening in 1962, Gene remembers that each performer at that first Festival was paid $150. A short time later, he says, Pete sent his check back to the Folksong Society with a note saying, "Why don't you use this money for next year's festival?"

That following year, now installed as Festival chairman, Gene was walking the grounds and came upon Pete and George Wein (founder of the Newport Folk Festival, which had held its first edition four years previously). Gene recalls thinking, "What is Pete doing here?" As it turned out, Pete was on the Newport board and had brought Wein with him to observe how the "new kids on the block" operated their upstart festival, and particularly how they managed security. (More discussion of this can be found in the Security section).

Pete Seeger remained a vital force in the folk music world until his passing in January 2014, at age ninety-three.

MIKE SEEGER

(SOLO: 1963, 1964, 1971, 1972, 1983, 1991)

(WITH NEW LOST CITY RAMBLERS: 1966, 1967, 1988)

Pete's half-brother Mike Seeger was so much more than a stellar musician: he was also a scholar, field collector, record producer, and promoter of traditional folk music. Mike and Pete both joined their father Charles Seeger and his second wife, Ruth Crawford Seeger, in assisting John and Alan Lomax at the Archive of American Folk Song in the Library of Congress.

Mike also did his own field work, collecting songs over the course of several decades, and was very focused on preserving traditional music. When the music of Bill Monroe and his followers started to be called "bluegrass" in the late 1950s, Mike produced what is widely credited as one of the very

first "bluegrass" record albums, featuring early regional bands like Earl Taylor and The Stoney Mountain Boys.

In 1958, Mike joined up with John Cohen and Tom Paley (and later Tracy Schwarz) to form the New Lost City Ramblers, known for playing authentic string band music from the 1920s and 1930s. Mike was also an important advocate for and promoter of traditional musicians, especially from rural areas, who did not have the opportunities for exposure and bookings available to musicians from the "folk music scenes" in the major cities.

In particular, when a revival of the "old time" music of Appalachia and the South took place during the early 1970s, Mike was a critical resource in locating many of the "source" musicians who became models and mentors for an emerging new generation of talents. He was also very active as a performer in those years, frequently appearing as part of the Strange Creek Singers with Tracy Schwarz, Hazel Dickens, Lamar Grier (father of superb contemporary guitarist David Grier), and Alice Gerrard (to whom Mike was married for several years).

In an interview published in the August 26, 1988, *Morning Call*, prior to a Festival appearance with the Ramblers Mike said, "The thing about the Philadelphia Folk Festival is that it has everything, from people who play traditional music to more popular acts who play and write contemporary songs. You don't have that at too many festivals anymore."

Though stricken with cancer, Mike continued to study, tour, and perform into the final months of his life, including a farewell tour with the New Lost City Ramblers before passing away in August 2009, just short of his seventy-sixth birthday.

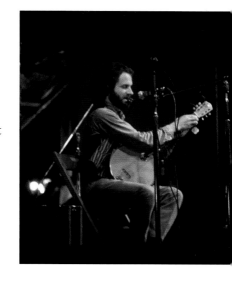

Mike Seeger, 1970s. Photo by Wanda Fischer

New Lost City Ramblers, 1968 (L-R): Tracy Schwarz, Mike Seeger, and John Cohen. Photo by Diana Davies

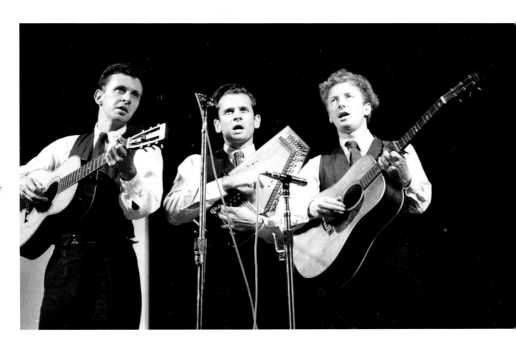

ARLO GUTHRIE
(1974, 1979, 1984, 1995, 1996, 1998, 2001, 2005, 2011, 2015)

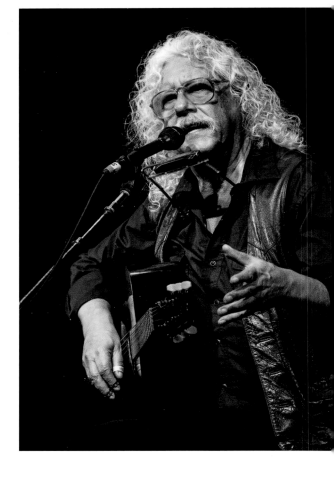

Right: Arlo Guthrie, 2011. Photo by Mark Silver

Below: Arlo Guthrie and "Ramblin' Jack" Elliott, 1984. Photo by Ellen Nassberg

Bottom, left to right:
Arlo Guthrie and band joined on stage by David Bromberg, 2011. At left are the Burns Sisters (L-R): Marie, Annie, and Jeannie. Photo by Lisa Schaffer

Arlo Guthrie, 1974. Photo by Richard Nassberg

Arlo Guthrie, 2011. Photo by Jayne Toohey

Though he is often associated with Oklahoma—birthplace of his legendary father Woody Guthrie—and with Massachusetts—the setting for his best-known musical story, "Alice's Restaurant"—Arlo Guthrie has long had personal connections to Philadelphia and, by extension, the Philadelphia Folk Festival. His mother Marjorie Mazia Guthrie had grown up in Philadelphia, and Arlo proposed to his wife Jackie in the basement of the Main Point in suburban Ardmore, a premier folk music venue in the region for many years.

He bought his first car (from Pete Seeger) and drove it in Philadelphia, a red 1957 MG-A. And not too long after his "Alice's Restaurant" experience, Arlo and a few friends were arrested and jailed for playing ring-around-the-rosy in Rittenhouse Park in a "disorderly" fashion (though he got another popular song out of it, "Ring-Around-A-Rosy Rag"). Arlo has a long history with and fondness for Philly, and a visit to the city or the Festival is always a chance to catch up with old friends.

Gresham Lowe, who co-chairs the Performer's Parking Committee, remembers the early years she and her family came to the Festival from their home in the Washington, DC, area, and would stay at an inn in the vicinity of Plymouth Meeting that they fondly dubbed the "Fleabag Hotel." One year when Arlo was playing the Festival, they went down to the restaurant one morning and discovered that not only was Arlo staying there as well, he was busily eating a bowl of spaghetti for his breakfast.

Arlo paused to say hello and have a brief, friendly chat with them, and Gresham recalls, "he was fabulous with children, the nicest man, unbelievable," but she laughs, as she says her kids were soon asking her, "Why can't we have spaghetti for breakfast? Arlo does!"

Renette Hackett explains Arlo's stature and appeal to Folk Festival "lifers" like her with perhaps the ultimate compliment, that when he is on stage, the whole compound clears out of the campground and heads for the Main Stage—"It's like an old friend coming back to visit with great stories."

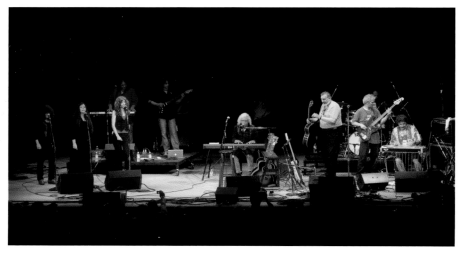

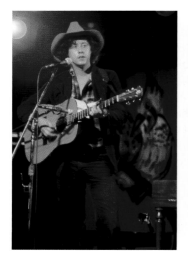

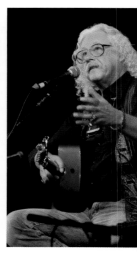

DAVID BROMBERG

(1969, 1970, 1971, 1972, 1973, 1974, 1975, 1976, 1985, 1986, 1989, 1991, 2001, 2005, 2006, 2011, 2013, 2014)
(WITH JERRY JEFF WALKER: 1968)
(IMPROMPTU VISIT: 1980, 2017)

If the Folksong Society is considered the "father" of the Philadelphia Folk Festival, David Bromberg could be considered its "son." He was born in Philadelphia, but was raised in Tarrytown, New York, and learned much of his music from Reverend Gary Davis during his college years. With the exceptions of Roger Sprung and Michael Cooney, David has performed at the Festival more often than any other professional musician (including his performance backing up Jerry Jeff Walker in 1968, and his "impromptu" visit in 1980).

Early in his career, David was often sought after to play backup for an array of top headliners that, in addition to Walker, included Bob Dylan and George Harrison, to name just a couple. Recalling his first time leading his own ensemble on the Main Stage, David remembers the surprise of seeing John Hartford, Erik Frandsen, and Tom Paxton walking out on stage in "turning the tables" fashion to back him up for a change.

With a chuckle, David recalls he had the last laugh, making Tom—who would be the first to say no one will ever mistake him for Doc Watson—play a guitar solo. Although the Philadelphia Folk Festival did not launch David's solo career, it was his lively and entertaining stage performances, along with the jam sessions at the performers' hotel after the concerts, that made the Philadelphia Folk Festival a special place for David personally.

About that "impromptu" appearance: In 1980, David had decided to stop touring, and his last official touring concert was held Friday, August 22, at the Wollman Skating Rink Theater in Central Park, New York City. Coming offstage following that show, he says that he had an irresistible urge to come to the Philadelphia Folk Festival because he wanted to be someplace that was *important* to him. He performed that Saturday on the Craft Stage, during the

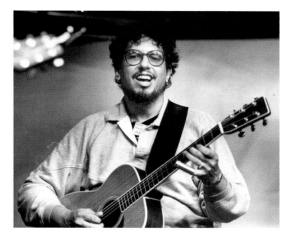

David Bromberg. Photo by Frank Jacobs III, courtesy of Philadelphia Folksong Society Archives

David Bromberg. Photo by Mark Silver

David Bromberg. Photo by Mark Silver

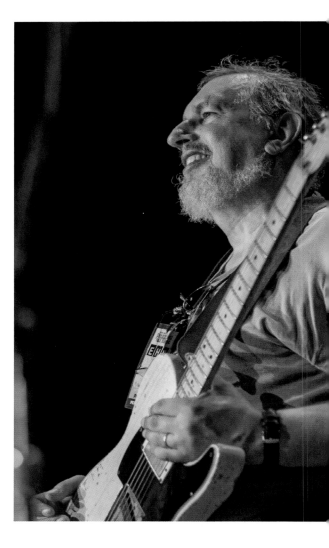

day, even though he had not been booked for the Festival that year.

After living in Chicago for several years, David and his wife Nancy Josephson made a move in 2002, that, while not quite making Philly their actual home, got them a whole lot closer. Seeking to give the local arts and music scene a shot in the arm, the city government of Wilmington, Delaware, proposed a deal that would provide David a downtown building for his renowned violin store, as well as a residence for the family.

In return, David would become the city's "Music Ambassador," a role that he has filled with gusto, frequently appearing (often in "cameo" fashion) at music venues in the city, such as the Grand Opera House and World Café Live at the Queen, as well as hosting a long-running series of bluegrass and blues jams. With the Folk Festival now little more than an hour's drive from home, David and Nancy have continued to be familiar faces at the Old Pool Farm, highlighted by their work in assembling the star-studded cast that joined the late Levon Helm on stage for the closing concert of the fiftieth annual Festival in 2011.

David Bromberg will always be a fan favorite at the Philadelphia Folk Festival, and David Dye of Philadelphia's WXPN puts it best, saying, "David Bromberg, to me, is the quintessential Philadelphia Folk Festival musician, because he plays with everybody, he's been there so often, and he is one of the best performers anywhere."

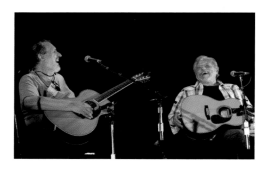

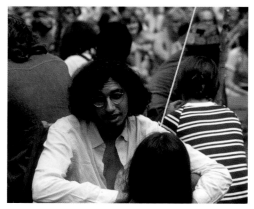

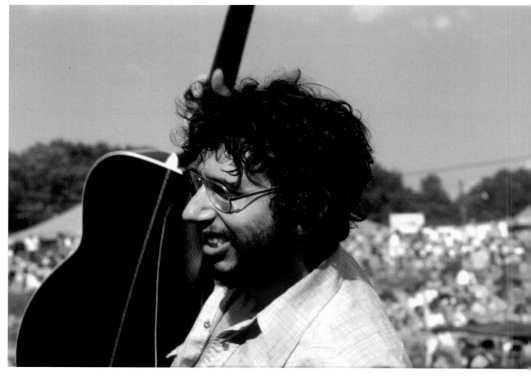

TOM RUSH

(1965, 1966, 1969, 1974, 1977, 1979, 1980, 1981, 1984, 1986, 1988, 1990, 1991, 1995, 2001, 2009, 2011)

Tom Rush was a student at Harvard in 1961, when he first began performing at local coffeehouses, particularly the legendary Club 47 (now known as Club Passim). By the time he graduated, he had released his first two albums, and over the course of the next five decades would become not only among the most sought-after performers in the emerging folk music scene, but his own

songs would be covered by a wide variety of artists spanning most of the music business. But he also sought out and recorded the works of other up-and-coming singer-songwriters, helping to popularize artists like Joni Mitchell and James Taylor in the early years of their careers.

In the 1980s, Tom continued to help introduce new talents through his work with the ongoing Club 47 Series of concerts in Boston, including teenaged sensations like Alison Krauss and Mark O'Connor. Tom has been among the most frequent guests on the Philly Folk stage. His relaxed and comfortable style, along with his wry sense of humor, are always a welcome treat, and though now in his seventies, he is still going strong and hopefully has a few more visits in store.

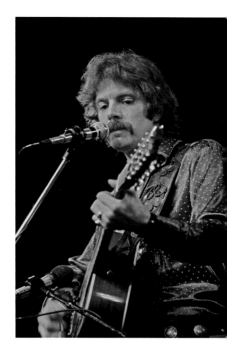

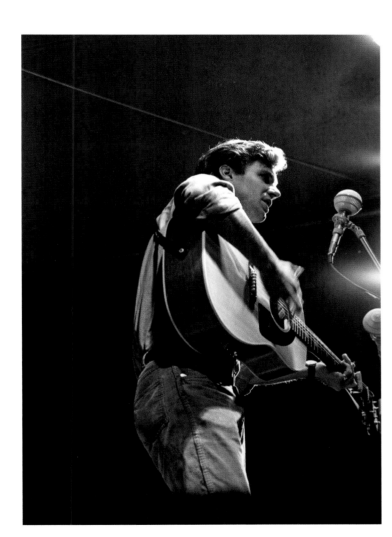

Above: Tom Rush, 1979. Photo by Robert Corwin

Bottom, clockwise from left:
Tom Rush, 1965. Photo by Lawrence Kanevsky, courtesy of Philadelphia Folksong Society Archives

Tom Rush, 2011. Photo by Steve Sandick

Tom Rush, 1995. Photo by Ellen Nassberg

TOM PAXTON

(1964, 1965, 1966, 1967, 1969, 1970, 1975, 1977, 1978, 1983, 1985, 1986, 1988, 1991, 1994, 1998, 2001, 2008, 2011, 2015)

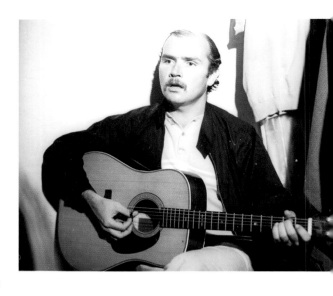

Tom Paxton, 1967. Photo by Diana Davies

Tom Paxton, 1967. Photo by Diana Davies

Tom Paxton, 2011. Photo by Steve Sandick

To say that Tom Paxton was among the most consequential of the singer-songwriters to come out of the turbulent folk music scene of the early 1960s would be something of an understatement. The late Dave Van Ronk wrote in his memoir that, even more than Bob Dylan, "the person who started the whole thing was Tom Paxton . . . he tested his songs in the crucible of live performance, and he found that his own stuff was getting more attention than when he was singing traditional songs or stuff by other people."

Undoubtedly among Tom's best-known songs is "The Last Thing On My Mind," which he recorded as part of his 1964 release "Ramblin' Boy" (the title track is also among the songs most treasured by his fans). But to gauge how much of an impact Tom's work has had all across the music business, consider that a very partial list of the artists who have covered the song in the past half-century and more includes Neil Diamond, Porter Wagoner and Dolly Parton, Harry Belafonte, Flatt and Scruggs, Pat Boone, José Feliciano, and Judy Collins.

Though born in Chicago, Tom moved with his family to Oklahoma at a young age, and considers that his true home state—the same as Woody Guthrie. And like Woody, as Tom came of age and began to write his own songs, his work reflected not only the heartache of parting ("The Last Thing On My Mind") and the joy of roaming free ("Ramblin' Boy"), but also humorous and often pointed commentary on political issues, such as education ("What Did You Learn In School Today"), war ("Lyndon Johnson Told The Nation"), and culture ("One Million Lawyers").

By the time Tom took the Main Stage for his 2015 appearance, he had already announced that, at age seventy-eight, he planned to stop touring. Hopefully, though, he will still pencil in Philly Folk and make the trip down to visit with several thousand of his closest friends.

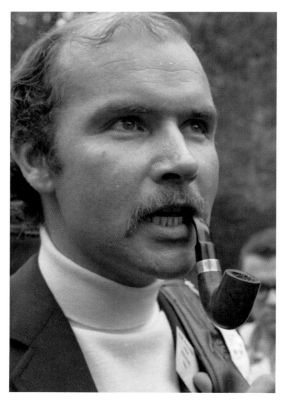

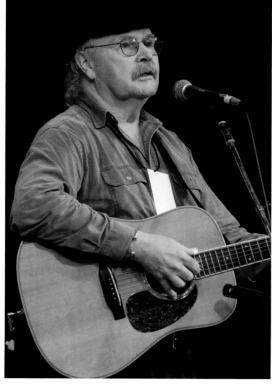

JANIS IAN

(1968, 1971, 1972, 1973, 1976, 1990, 1995, 1999, 2001, 2008, 2014)

Janis Ian's entry into the folk music limelight came at age fourteen, with the release of her 1965 hit "Society's Child," a song about what was still, in those years, the "taboo" subject of interracial love. She was still a teenager when she sang her iconic song "At Seventeen" on the *Smothers Brothers Comedy Hour*, and in 1975, she was one of the musical guests (along with Randy Newman) on the very first edition of NBC's *Saturday Night Live.* She has enjoyed much success over the past five decades, but has also had to deal with personal challenges, inept and deceptive management, and some very difficult times.

Through it all she always had her music, and proclaimed in her autobiography that nobody could take that away from her. A resilient person who is also an author, and among the first in the business to grasp the power of the Internet, Janis believes her online auction to organize and raise funds for her charity, the Pearl Foundation (named for her late mother), was among the very first events of its kind. (The foundation provides scholarships to students returning to school after an absence of more than five years.)

Ironically, Janis was seventeen when she first performed at the Philadelphia Folk Festival in 1968, and she remembers the Festival being small enough that you could really know the audience members and the volunteers—many of whom, she pauses to reflect, she has now known most of her life. Janis has performed at the Festival in every decade but the 1980s. Scheduled to appear in 1986, she was felled by an emergency medical issue and remembers telling the surgeon in the hospital, "I really have to get out of here, because I have a commitment."

Some of Janis' more memorable Festival moments include watching as a teenaged Bonnie Raitt, only a couple years older than Janis herself, learned to play slide guitar from someone at the Festival—which turned out pretty well all the way around—and hanging out at the post show parties in David Bromberg's room, where artists would sit around and share songs.

Never afraid to speak her mind, Janis says one aspect of folk festivals—Philly included—that she regards as having changed for the worse over the decades is the evolution of the workshops that take place during the mornings and early afternoons from what were truly "teaching sessions"—to watch up close, for example, as Earl Scruggs carefully demonstrated how he did many of his banjo "licks"—into what often turns out to be what might be called a "round robin concert."

"I also have my own issues with the idea of a workshop being for people to just get up and sing songs and then sit back down. To me, a workshop is supposed to give the audience something that they can't get anywhere else."

Noting that at her last two Festival appearances she has insisted on inclusion of workshop appearances—including a Master Guitar class—as part of her contract, Janis says, "I personally love it when I'm on [a workshop stage] with someone like Jean Ritchie, and then I get to introduce Jean to Kathy Mattea, who had never met her before. And then I get to play on Jean's songs, when I've known Jean since I was in my twenties!"

"Philly is a folk festival," Janis concludes, "that most of us keep coming back to because it's *home* in a lot of ways. A lot of us have been doing it since we were kids, we've watched the next generation, and then the generation after that coming up."

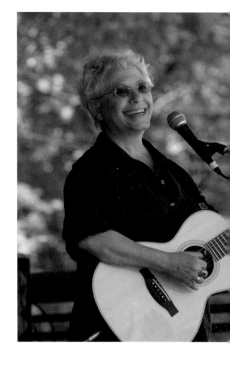

Above: Janis Ian, 2008. Photo by Jayne Toohey

Below, left to right:
Janis Ian, 1995. Photo by Jayne Toohey

Janis Ian with Tommy Emmanuel, 2014. Photo by Jayne Toohey

Janis Ian, 2014. Photo by Jayne Toohey

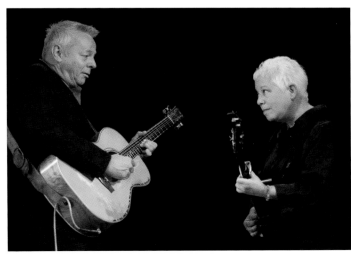

JOAN BAEZ
(1968)

Joan Baez, 1968. Photo by Mike Marmel

Joan Baez, 1968. Photo by Mike Marmel

Joan Baez has (so far) performed only once at the Philadelphia Folk Festival, but her presence was significant in the year 1968, which marked a watershed in the political and cultural history of the United States. The assassinations of Martin Luther King Jr. and Robert Kennedy had sparked rioting and unrest in many cities. Richard Nixon had secured the Republican presidential nomination and shocked the nation by choosing the infamous Spiro Agnew as his running mate. Among the Democrats, the insurgent candidacy of Eugene McCarthy against the establishment, represented by Hubert Humphrey, produced the chaos of the Chicago Democratic convention, with rioting in the streets flickering on televisions in living rooms across the country.

The events of Chicago were fresh in the minds of the crowd at Philly, and few performers could more poignantly voice and address their concerns than Joan Baez. Daughter of a Mexican father and a Scottish mother, her family had converted to Quakerism in her childhood, setting her on a course toward the pacifism and struggle for social justice and workers' rights that would be a hallmark of her career. Her sister Mimi Fariña also achieved notable success as a folk singer.

At Woodstock—almost exactly a year after her Philly appearance—Joan's soaring rendition of "Joe Hill" in the cool evening air would become imprinted in the consciousness of millions and immortalized in the landmark film documentary released in the wake of that festival.

In the late 1950s, Joan was among the rising new wave of folk singers who had cut their professional teeth at Club 47, a landmark Boston venue. In the early 1960s, she was among the first to bring Bob Dylan's songs to the attention of folk audiences, and she and Dylan were a couple for a time. Her 1975 hit "Diamonds and Rust" was a warm recollection of their relationship, though it had ended by the time she appeared at Philly in 1968.

In the early years of her career she was given the nickname "Madonna," inspired by her astonishing voice—a clear, haunting soprano that is as powerful and resonant as the peal of a cathedral bell. Now in her seventies, her voice is still as thrilling as ever, and perhaps the opportunity for Philly Folks to be overwhelmed by it will come around again.

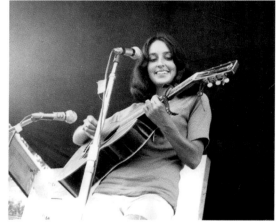

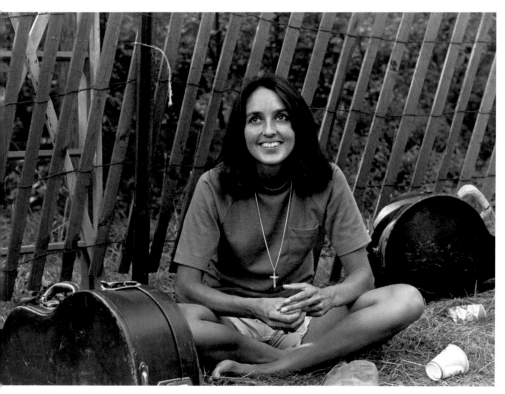

JUDY COLLINS
(1964, 1965, 1966, 1986, 2001, 2008)

Like many of her contemporaries, Judy Collins debuted on the folk music scene in the early 1960s. She was born in Seattle, but moved with her family to Denver at age ten. She began taking classical piano lessons from Antonia Brico, an early pioneer among women who have risen to lead symphony orchestras, about whom Judy co-directed a biographical documentary in 1974.

When Judy expressed an interest in the folk music she was hearing by artists like Woody Guthrie and Pete Seeger, Brico was unimpressed and discouraged her from following that path. Judy gave up the piano lessons, though, picked up a guitar, and charted a new course. While she quickly gained popularity at festivals and in coffeehouses—as witnessed by her three visits to Philly in the mid-1960s—it was her hit recording of Joni Mitchell's "Both Sides Now" in 1968, and the Grammy it brought her that thrust her into the national spotlight.

Later in her career, Judy has recalled, she returned to Denver for a concert that Antonia Brico attended. Still not convinced that "folk music" was a worthy calling, Brico grasped her hands and told her, "Little Judy . . . you *really* could have gone places!"

But of course Brico was wrong. Judy Collins did go places, and not just in folk music. Her crystal-clear, multi-octave soprano has served her well in pop and musical theater settings too, as evidenced by her iconic recording of Stephen Sondheim's "Send In The Clowns." Though her famously brown hair has turned to silver, her eyes are still the same famous shade of blue they were when Stephen Stills wrote his "Suite: Judy Blue Eyes" about her, and she continues to be a welcome guest at theaters, music halls, and, yes, folk festivals.

Above, left: Judy Collins, 1986. Photo by Robert Corwin

Above, right: Judy Collins, 2008. Photo by John Lupton

Below, left: Judy Collins, 1965. Photo by Lawrence Kanevsky, courtesy of Philadelphia Folksong Society Archives

Below, right: Judy Collins, 2001. Photo by Jayne Toohey

JIM CROCE
(1970, 1973)

Born and raised in Philly, Jim Croce's coming-of-age included schooling at Upper Darby High School, Malvern Prep, and Villanova University. He got involved with music while in college, and released his first album, "Facets," in 1966. As the story goes, on the occasion of Jim's marriage to his musical partner, Ingrid Jacobson, his parents had given the couple a gift of $500 on the condition it be used to produce and market the album.

Fully expecting that the record would be a flop that would convince their son to give up folk music for a more "appropriate" career, it was a shock when the entire production run sold out and Jim continued his career, though he went through a couple periods when, disillusioned, he left the business and did odd jobs to make a living.

Jim was back in the business in time to make his 1970 appearance at the Festival, and two years later, had achieved national Top 40 radio success with "Operator (That's Not The Way It Feels)," followed by "Time In A Bottle" and "Bad, Bad Leroy Brown," both of which reached number one on the charts.

Many people believe that Jim's appearance at Philly over the last weekend in August 1973, was the final public performance he gave before his death with six other people in the crash of a small plane in Natchitoches, Louisiana, on September 20. As many sources confirm, the plane was carrying him away shortly after he and his sideman, Maury Muehleisen, had finished a show at nearby Northwestern State University. Still, it was a tremendous shock to lose a locally grown talent who had so recently made a triumphant return in front of his hometown fans.

JOHN DENVER
(1969, 1970)
(WITH MITCHELL TRIO: 1965, 1966)
(WITH DENVER, BOISE, AND JOHNSON: 1968)

Born John Henry Deutschendorf Jr., son of a career Air Force officer, John Denver took his stage name from the capital of his beloved Colorado after Randy Sparks of the New Christy Minstrels suggested that

"Deutschendorf" might be a tad too long to fit on a marquee. John rocketed to international fame and success in the early 1970s, with his chart-topping recording of "Take Me Home, Country Roads" (co-written with Bill Danoff and Taffy Nivert, both later of Starland Vocal Band fame), kicking off a run of hits that included "Rocky Mountain High," "Calypso," "Back Home Again," and many more. With all that success, it was easy to forget or overlook the fact that John's musical roots were in the folk music scene of the 1960s, including the Philadelphia Folk Festival.

By the time the 1965 Festival took place—the final one at Collie Wilson's farm in Paoli—Chad Mitchell had left the popular trio act he had founded that bore his name—it had been re-christened the "Mitchell Trio"—and twenty-two-year-old John Denver had signed on as his replacement. The trio returned the following year for an encore appearance as the Festival relocated to Spring Mountain. When further changes left Denver and David Boise as the sole remnants of the "trio" and contractual considerations prevented continued use of the Mitchell name, they added Michael Johnson and returned to the Festival in 1968 as Denver, Boise, and Johnson.

John Denver made his final appearance at the Philadelphia Folk Festival in 1970. Five months later he recorded "Take Me Home, Country Roads," and the rest, as the saying goes, is history. Tragically, his life was cut short at age fifty-three when a small plane he was piloting crashed into Monterey Bay, California, in 1997.

RICHARD THOMPSON
(1994, 2002, 2010, 2013)
(WITH FAIRPORT CONVENTION: 1970)

London-born Richard Thompson was only eighteen when he became one of the founding members of Fairport Convention, the band widely credited with having virtually invented what has come to be known as "folk rock." Though other British bands of the late 1960s had made some use of electric instruments in arrangements of traditional material (as Bob Dylan had on the other side of the Atlantic), it was Fairport Convention that unabashedly brought a rock-and-roll approach to folk music. Though the band's lineup in those early years boasted sterling talents such as Sandy Denny, Simon Nicol, and Ashley Hutchings, much of the band's appeal was drawn from the jaw-dropping guitar talents (electric and acoustic) of Richard Thompson.

Richard's only Philly Folk appearance as part of Fairport Convention came in 1970, a few months before he departed the band. For the next decade and a half, he performed and recorded with his wife, Linda Thompson, until they separated in the mid-1980s. By the time he returned to Philly as a solo act in 1994, he had acquired worldwide acclaim not only for his groundbreaking guitar work, but also for his powerful and distinctive singing and songwriting. That his songs resonated with and were enjoyed by music fans across a wide range of genres was amply demonstrated when a cover version of Richard's iconic motorcycle ballad "1952 Vincent Black Lightning" performed by bluegrass master Del McCoury was chosen as IBMA Song of The Year in 2002.

Though many writers and reviewers over the years have noted that Richard's songs and performances sometimes tend toward the dark and somber side of things, LisaBeth Weber says that each time he returns to Philly—and she has seen every one of them—he is the epitome of dynamic stage presence, making the audience feel that they are up on stage with him. "He really connects with the audience," she says. "He's really having a hell of a time, he's having so much fun and it really shows."

Below, left: Richard Thompson, 2010. Photo by Jayne Toohey

Below, right: Richard Thompson, 2013. Photo by Steve Sandick

Next page: Richard Thompson. Photo by Mark Silver

Mark Silver Photograph

STEVE GOODMAN
(1970, 1971, 1972, 1973, 1976, 1978)

It has come to be a cliché to say, "Today is the first day of the rest of your life," but for Steve Goodman it had more immediate meaning and impact than for most of us. A native of Chicago (and a high school classmate of Hillary Rodham Clinton), he was diagnosed with leukemia while in college and immediately quit school. Setting out to spend as much time as he had left making music and living life to its fullest, he was a regular at Chicago's Old Town School of Folk Music, where he met and became close friends with John Prine.

The story is told that on one particular evening, Steve went to see Arlo Guthrie perform at a local club and asked him to listen to a new song Steve had just written. Hesitant at first, Arlo agreed on the condition that Steve had to buy a round of beer. Steve's new song was "City Of New Orleans," and to say that Arlo was impressed is more than a little of an

understatement. Arlo's subsequent recording of it was a chart-topper around the country and remains a staple of his stage shows to this day.

A few years later Steve wrote "You Never Even Called Me By My Name" with John Prine (though Prine has claimed over the years not to have had that much to do with it). A good-natured parody of the stereotypes often found in country songs, the version recorded by David Allan Coe just may have ended up on more jukeboxes in more roadhouses and bars across the country than any other song in history.

It was not just his audiences that came to know and love Steve Goodman for his music, good humor, and humanity. Many Philly volunteers recall him showing up far ahead of the Festival to help with the setup and other Pre-Fest tasks. For a man who knew time was running out all too fast for him, it was another way to meet and make as many friends as possible.

When Steve Goodman died in September 1984, at age thirty-six, the number of friends who mourned him was in the millions.

Above: Steve Goodman, 1978. Photo by Barry Sagotsky

Below: Steve Goodman, 1976. Photo by Robert Corwin

Left: Steve Goodman (L) with Gamble Rogers. Photo by Robert Penneys, courtesy of Philadelphia Folksong Society Archives

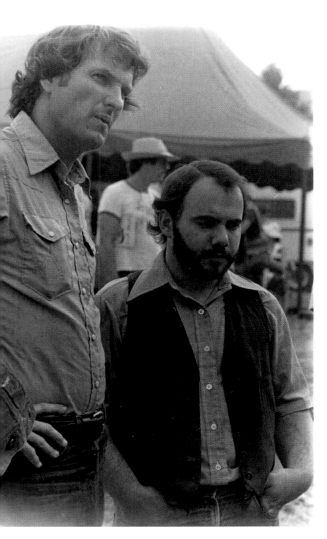

BUDDY GUY
(1968, 1982)

Junior Wells (center) with Buddy Guy (right, with guitar), 1982. Photo by Daniel C. Hulshizer/Omega News Group, courtesy of Philadelphia Folksong Society Archives

The words "best guitarist alive" usually tend to come from the mouths of publicity agents or overenthusiastic reviewers, but when it is Eric Clapton talking about Buddy Guy, well, that's a different story. Buddy has often been described as the "bridge" between the classic "Chicago blues" of Muddy Waters and the blues/rock of the late 1960s, that brought stellar guitar talents like Clapton, Jeff Beck, and Jimmy Page to fame.

A native of Louisiana, George "Buddy" Guy moved to Chicago in the late 1950s, and quickly fell under the influence of Muddy Waters. As time passed, though, he began to work elements of jazz, rock and roll, and other strains into his music, eventually developing a style and sound all his own, which was often described as "flamboyant"—though not for any reason relating to stage attire or behavioral quirks. He simply plays his guitar with a sense of élan and joy that is unmatched. More than his blues predecessors, his use of distortion, feedback, and variations in volume set Buddy apart, inspiring a new generation of guitarists. As *Guitarist Magazine* once put it, "Without Buddy Guy, there would be no Stevie Ray Vaughan."

Now in his eighties, Buddy Guy still maintains a full touring schedule and shows no sign of slowing down.

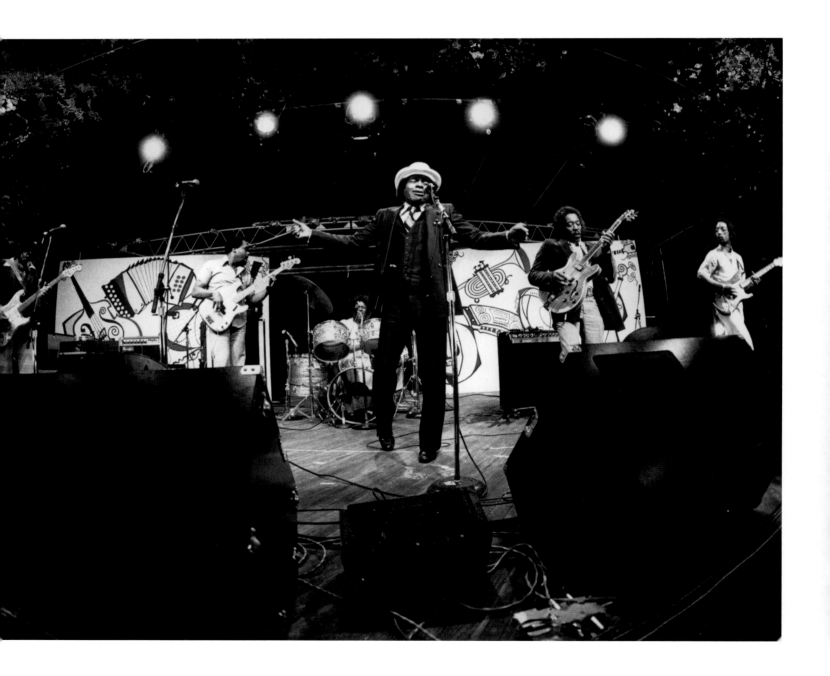

EMMYLOU HARRIS
(1968)
(WITH BUDDY MILLER, 1997)

Her birth certificate may say Birmingham, Alabama, but as the daughter of a career military officer, Emmylou Harris spent her growing up years in a number of towns across the map. After dropping out of college, she moved to New York City and began performing in various coffeehouses and other folk venues. At the time of her 1968 visit to the Philadelphia Folk Festival, she was a folk singer much in the style of her contemporaries, Joan Baez and Judy Collins.

In the early 1970s, she came to the attention of Chris Hillman and Gram Parsons, both former members of The Byrds. She became a protégé of Parsons', joining his band and thrilling audiences with their harmonies on stage and in the studio. In the aftermath of Parsons' death in 1973, Emmylou was soon heard singing backup on

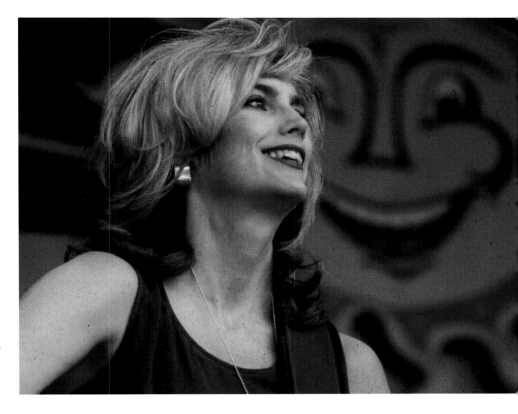

a number of major folk/country releases, notably Linda Ronstadt's *Heart Like A Wheel*.

By the middle of the '70s she had brought together her legendary Hot Band, which would come to include major talents such as Rodney Crowell, Ricky Skaggs, Barry Tashian, and James Burton. Gram Parsons had introduced her to the timeless country and bluegrass music of Hank Williams, Bill Monroe, the Louvin Brothers, and many more, and for the next twenty years she led a resurgence of the "classic country" sound, battling against the currents that were causing Nashville to drift more and more toward the emerging "country rock" sound.

Endlessly curious and adventurous, by the 1990s, Emmylou had begun to branch out from the country music that had made her famous, and as before, she became a leading figure in the development of what is now known as the "Americana" genre. Teaming with diverse talents like producer Daniel Lanois and guitarist Buddy Miller (with whom she performed at Philly in 1997), she recorded a string of albums that represented a clear departure from her earlier work. For her legions of fans, however, it was still the same golden, soothing voice that had drawn them to her decades before.

Emmylou Harris, 1997. Photo by Jayne Toohey

Emmylou Harris, 1997. Photo by Robert Corwin

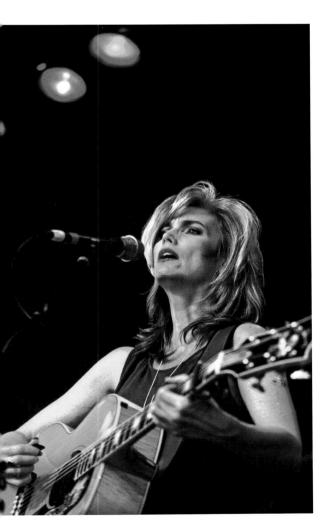

JOHN HARTFORD

(1969, 1970, 1971, 1972, 1974, 1976, 1983, 1985, 1987, 2000)

Right: John Hartford and surprise guest "Yo Yo Man" (Tom Smothers), 1985. Photo by Robert Corwin

Below: John Hartford, 2000. Photo by Jayne Toohey

It will probably surprise many who enjoyed the music and artistry of John Hartford—his fiddling, banjo playing, flatfoot dancing, storytelling, and singing—over the course of his nearly forty years in the public eye that his surname at birth was actually Harford— no "t." He changed it early in his career at the suggestion of legendary guitarist (and RCA Records chief) Chet Atkins.

John's music sprang into the American consciousness when Glen Campbell's 1967 recording of John's "Gentle On My Mind" became a major hit (garnering Hartford a Grammy), igniting not only Campbell's career, but John's as well. John made several appearances in the late 1960s, on the *Smothers Brothers Comedy Hour* and reunited with Campbell on *The Glen Campbell Goodtime Hour*, a summer "replacement" series for the Smothers Brothers show.

In the early 1970s, John pulled together the Aereo-Plain Band, featuring, in addition to himself, a quartet of the most acclaimed and accomplished acoustic country and bluegrass musicians of the time: guitarist Norman Blake, fiddler Vassar Clements, flat pick Dobro wizard Tut Taylor, and bassist Randy Scruggs.

Their *Aereo-Plain* album is widely credited as the inspiration and foundation for what eventually became known as "newgrass," a fusion of the classic bluegrass of Bill Monroe, Flatt, and Scruggs, and other pioneers with the musical sensibilities of a new generation raised on rock and roll, exemplified by startling new talents like Sam Bush, John Cowan, and Béla Fleck.

As time went on, though, John seemed to gravitate back toward the more traditional side, including a widely acclaimed release of fiddle tunes in 1996, on the Rounder label *Wild Hog In The Red Brush*. At his final appearance at the Philadelphia Folk Festival in 2000, his band included longtime sidemen Bob Carlin on banjo and Chris Sharp on guitar, joined for the evening by the stellar young mandolin player Chris Thile from up-and-coming band Nickel Creek.

Less than a year later, John succumbed to the non-Hodgkin's lymphoma he had been fighting for several years. Carlin and Sharp would carry on his music by forming the John Hartford Stringband, appearing at the Festival in 2011.

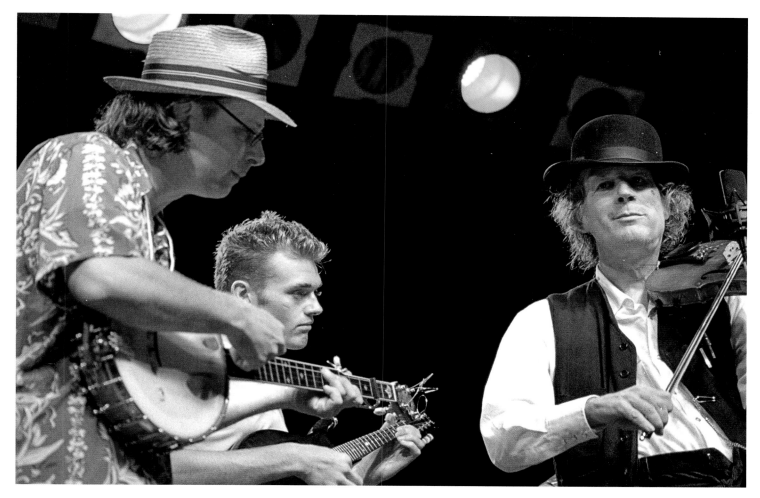

Renette Hackett remembers, "[John's] banjo playing was just so amazing. We have friends that play banjo who say 'I've never seen anyone doing what he's doing.'" Renette was among the thousands of fans who were delighted one year when Tom Smothers made an unannounced visit, walking on stage doing yo-yo tricks as John performed his set.

"All of a sudden," she says, "you see this movement on the side out of the corner of your eye. Here comes Tommy Smothers, very casually strolling out on the stage, playing with a yo-yo . . . He just moved closer and closer. Tommy was right next to John when one of them said, 'It's Yo-Yo Man!'"

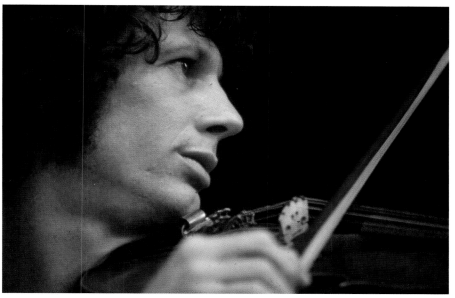

John Hartford (R) with Bob Carlin (L) and Chris Thile, 2000. Photo by John Lupton

John Hartford, 1974. Photo by Barry Sagotsky

RICHIE HAVENS
(1981, 1982, 1986, 1991, 2001, 2005)

Richie Havens would have to be one of the premier examples of the old adage about the advantages of "being in the right place at the right time." He entered the Greenwich Village folk scene in the early 1960s, and by summer 1969, had recorded more than a half-dozen highly regarded albums. He was known for his powerful voice, compelling songs, and distinctive guitar style marked by innovative open tunings and his habit of using the thumb of his massive left hand to form barre chords across the entire neck. Still, he was not well-known outside the relatively insulated folk music world of that time.

That all changed when Richie led off the Friday afternoon concert at the legendary Woodstock Festival in August 1969. With a crowd much larger than had been anticipated still trying to reach the Yasgur Farm where the festival was taking place, the surrounding roads—including the New York Thruway—were so clogged that many of the performers scheduled to follow Richie were unable to get to the site on time, even by helicopter.

What had been scheduled to be a normal set of forty-five minutes or so turned into a three-hour showcase for Richie, as the producers implored him to keep playing because there was no one available to follow him. Not that the crowd minded; they happily called him back for encore after encore.

"I'd already played every song I knew and I was stalling . . . trying to think of something else to play," he would later say, "and then it just came to me . . ."

Working off the old spiritual "Motherless Child," he began a lengthy improvisation that would eventually become his signature tune, "Freedom." When the full-length feature film of the Woodstock experience hit theaters the following year, Richie and "Freedom" were front and center in the opening sequences. It was a huge turning point in his career that led to much wider public exposure for his music, including appearances with Johnny Carson on *The Tonight Show*.

But Richie remained a treasured guest and friend at folk festivals, Philly included. Forced to retire from touring in 2012, due to health concerns, he passed away in April 2013, at age seventy-two. At his request, his ashes were scattered over the Woodstock site, now part of the Bethel Woods Center for the Arts.

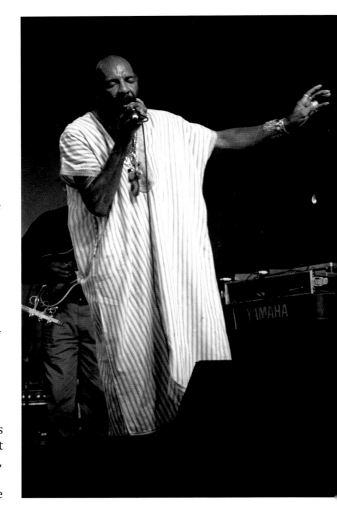

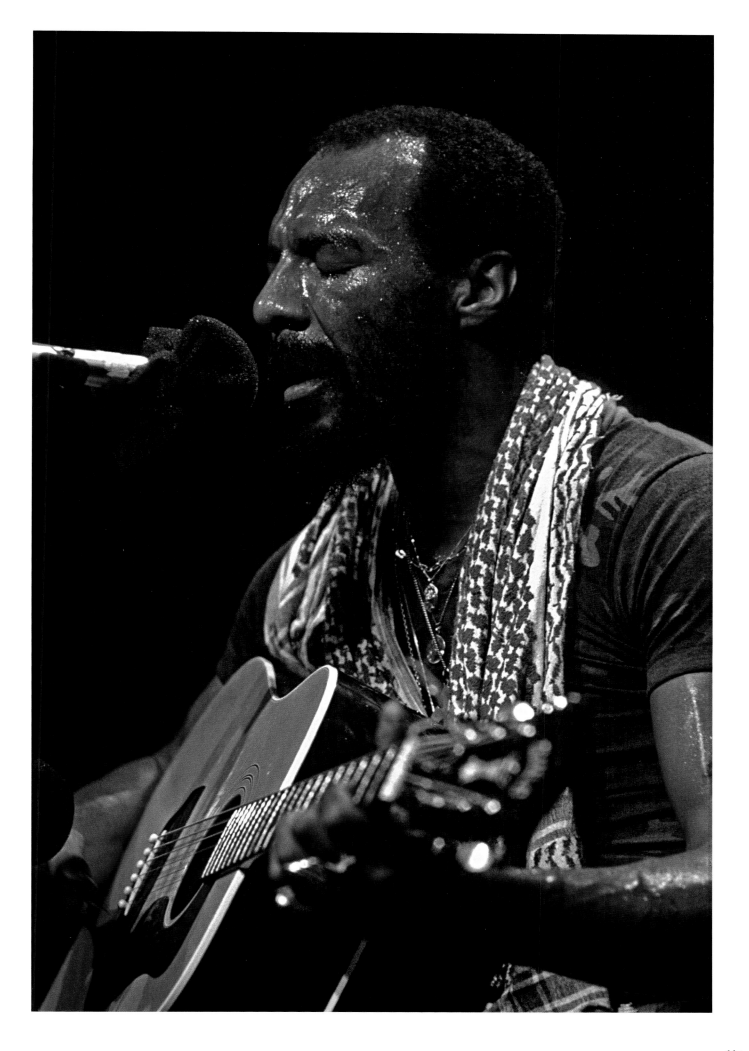

LEVON HELM/THE BAND
(2011)
(WITH THE BAND: 1995)

Right: Levon Helm with The Band, 1995. Photo by Jayne Toohey

Below (L-R): Teresa Williams, Larry Campbell, David Amram, and Levon Helm, 2011. Photo by Steve Sandick

Levon Helm, a founding member of The Band (so named for having been Bob Dylan's backup band in the 1960s), performed at the Festival only twice. The well-known musician and actor appeared in 1995, as part of The Band, in which Levon was lead singer and drummer. Surprisingly, it was an unscheduled appearance. Bo Diddley had been booked, but had to cancel on short notice, so The Band stepped in to "pinch hit." The second visit is remembered as one of the most emotional performances ever to take place on the Philadelphia Folk Festival stage. It was Levon's 2011 appearance that put smiles and tears in the eyes of many in the audience.

Levon appeared as part of the lineup that David Bromberg had helped put together for the fiftieth anniversary edition of the Festival. Levon had been battling throat cancer for a little more than a decade, and as it came to pass, he succumbed the following April. On that final tour guitarist

Larry Campbell would put together the set list and determine if Levon was well enough to sing each night.

When the Philly gig rolled around, an all-star cast that included David Bromberg and David Amram joined in on The Band's iconic song "The Weight," with Levon belting out a verse in fine style. Although none could know for certain how much longer Levon Helm would live, all who saw him that night knew it was almost certainly the last performance by him they would see, and even though it was raining, *no one* left the hill in front of the Main Stage! As if by divine

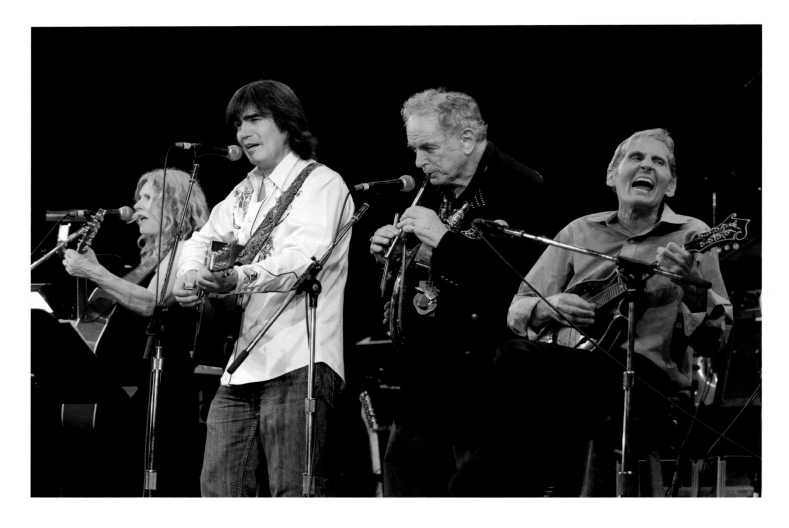

intervention, the rain stopped during Levon's performance. As the crowd filed out at the end and the lights came up, it was clear that there was not a dry eye in the house.

David Bromberg commented, "It's always fun to play with Levon. I loved Levon and still love Levon. It was a privilege and a pleasure to play with him, and I can't put any more feelings into words; I don't have the words."

Lee Bowers, host of the local Musical Lairs house concert series and a Festival volunteer of long standing, remembers an SUV pulling up backstage. Levon sprang out, accompanied by a pit bull. The dog was not on a leash, and Lee recalls people in the vicinity edging away out of fear. Recognizing that the dog was friendly, she approached and asked Levon if she could pet "Muddy"— named for Muddy Waters. Muddy turned out to be enthusiastically affectionate, and as they communed Lee noticed a scar on the dog's head.

Levon explained that Muddy had been "rescued" from a shelter, and Lee excitedly told him she was the owner of a rescued pit bull as well. Levon gave Lee an affectionate hug and said, "You and I know one of the best secrets in the whole world."

For Lee, it was an incredibly intimate, personal moment, perhaps the most memorable Festival experience she has ever had. Unlike many musical performance environments, folk festivals afford much better and more frequent opportunities for all in attendance—audience, volunteers, hired staff—to meet and interact with the performers, and many forge bonds with the musicians who touch them, not only through their music and art, but through their simple humanity. Levon Helm, by all accounts of those who met him at Philly, was as down-to-earth as they come.

Above: Levon Helm and a few close friends, 2011. Photo by Jayne Toohey

Below: Levon Helm, 2011. Photo by Jayne Toohey

TAJ MAHAL

(1979, 1980, 1982, 1985, 1988, 1990, 1992, 2004, 2010, TAJMO WITH KEB' MO': 2017)

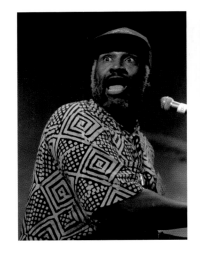
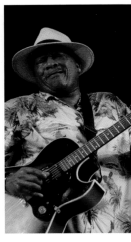

Top left: Taj Mahal, 1992. Photo by Jayne Toohey

Top right: Taj Mahal, 2010. Photo by Lisa Schaffer

Below: Taj Mahal, early 1980s. Philadelphia Folksong Society Archives

Among the most beloved performers in the long history of the Festival, Taj Mahal never fails to get the crowd on its feet and dancing—and that is exactly why he prefers festival gigs. As he told a writer for *straight. com* in 2008, "The music was designed for people to *move*, and it's a bit difficult after a while to have people sitting like they're watching television. That's why I like to play outdoor festivals—because people will just *dance*. Theatre audiences need to ask themselves, 'what the hell is going on? We're asking these musicians to come and perform and then we sit there and draw all the energy out of the air.'"

Taj Mahal is of course a stage name, but Taj came to realize, much as John Denver did, that using your birth name can present something of a challenge—in Taj's case, it is Henry Saint Clair Fredericks Jr. The decision in the late 1950s to adopt the name of the monumental palace in India as his performing moniker, he has said, resulted from dreams that came to him about Mohandas (Mahatma) Gandhi and the struggle in India for social tolerance. His mother sang in the church choir, and his Caribbean-born father was a jazz pianist. Taj absorbed these influences, as well as the "world music" (though that term would not come into vogue for several decades) he heard as a boy via the family's shortwave radio.

He was fascinated by legendary blues greats like Thelonius Monk, and after moving to California in the mid-1960s, he met and began making music with Ry Cooder and others. Over the years, Taj would collaborate (often including Cooder) with many, many artists from the worlds of blues, rock, jazz, and more—among them the Rolling Stones. Amazingly, it all almost didn't happen. Concurrent with the early days of his musical career, he had enrolled in agricultural school and seriously considered giving up music as a profession in favor of farming.

Fortunately for all who have enjoyed his music and followed his career, he chose the musical path that has included nearly three dozen albums over the past fifty years or so. Though he is generally thought of as a blues master, that description does not take into account the Caribbean, African, Indian, and other strains he has forged into a sound that is unique and completely his own. Each visit he makes to the Philadelphia Folk Festival further establishes him as one of the most creative and dynamic artists ever to take the stage there.

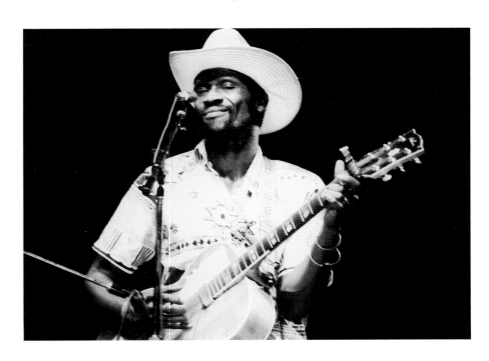

JONI MITCHELL
(1968)

Like Joan Baez, the only appearance Joni Mitchell has made at the Philadelphia Folk Festival thus far came in 1968, at the end of a summer that had been tumultuous and roiled by politics and culture shock. Both women are regarded as iconic artists in the folk music world, but while Baez was well established by that time, Joni was a relatively new face. Her debut album *Songs To A Seagull* (featuring David Crosby and Stephen Stills) had been released in March, and though it was well received, it would not be until the following year and the release of *Clouds* that she would become a much more widely recognized figure.

A native of Canada, Joni Anderson was born in Alberta in 1943. She gravitated toward art and music in her high school years. She had studied piano, and when she also took up the guitar, she found that as a result of a bout with polio in childhood it was difficult for her to finger the chords in standard guitar tuning. She began to devise her own open tunings and what she came to call "Joni's weird chords," and as she turned to writing and composing her own songs, she discovered that her creative abilities opened up as well.

She performed around Canada during the early 1960s, and met and performed with Chuck Mitchell, whom she married in 1965. Though they parted company two years later, she retained his name and continued as a solo act. Though her recording career was still over the horizon, the literacy and imagery of her songs were beginning to attract the attention of other artists. Tom Rush, for example, heard "Urge For Going" and suggested to Judy Collins that she record it.

When Judy declined, Tom recorded his own popular version. None of the people interviewed for this book could recall for certain what Joni performed in that 1968 show, and if a set list was recorded no one admits to having it, but it is very likely that she tried out some of the songs for her next album, which would earn her a Grammy: "Chelsea Morning," "Tin Angel," and "Both Sides Now" (which Judy Collins *did* record, getting herself a Grammy as well).

In addition to producing her own records, Joni also produced the artwork on all her albums and has often described herself as a "painter derailed by

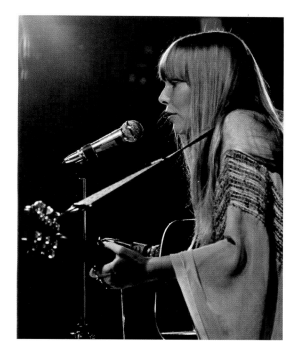

Joni Mitchell, 1968. Philadelphia Folksong Society Archives

Natalie MacMaster, 2000. Photo by John Lupton

circumstance." Though there has been some controversy, it was reported in 2015, that she had been injured in a fall that some sources would attribute to a brain aneurysm that had also impaired her ability to speak. Later in the year, though, Judy Collins visited her and was able to report that Joni was walking, talking—and painting.

NATALIE MACMASTER
(1994, 1997, 2000, 2004, 2014)

Fiddling is so deeply embedded in the culture of Cape Breton, at the northern end of Nova Scotia, it is said that visitors with fretted instruments are viewed with skepticism and suspicion. The niece of Cape Breton legend Buddy MacMaster, Natalie had already gained a reputation as a teen sensation by the time she debuted on the Festival Main Stage at age twenty-two. Her fiddling was impeccable and dynamic, echoing all the finest traditions of her culture. Like most Cape Breton youths, she had also been taught to step dance, and she learned to incorporate this into her vibrant stage persona in a way that brought the house down everywhere she performed. She was, and still is, simply irresistible.

Fred Kaiser, Chair of the Programming Committee during the 1990s and into the new century, recalls trying to book Natalie a few years before he finally landed her for the

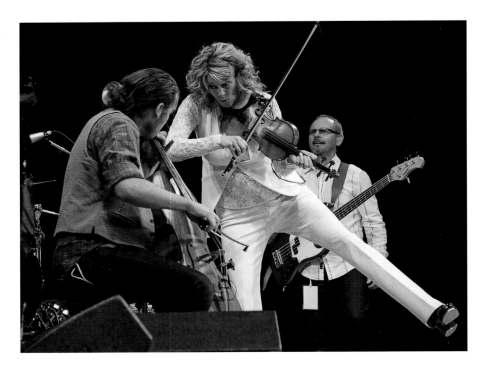

did, and Fred put her on in the middle of the Saturday night lineup. "Nobody knew her," he laughs as he recalls the moment, "and I watched people getting up to get food or whatnot until she started, and everyone came right back. She tore it up."

Natalie was glad Fred finally got through as well. "I have incredibly fond memories of the Philadelphia Folk Festival," she says, as she enjoys her return to the Festival in 2014. "I [first] came here when I was twenty-two, and it was [my] biggest performance up to that date. The greatest part of any festival is the crowd, *that* is who you are playing for . . . Years and years ago people in the audience would make a noise—'*Whert*'—and just last night when I was signing autographs, someone went '*Whert.*'"

Natalie was a single woman when she first lit up the Philly stage, but a few years later she married Donnell Leahy, of Canada's Leahy family and himself a virtuoso fiddler. If anyone doubted that she fully understood that the Philadelphia Folk Festival is not just another gig, it is a family reunion, those doubts were dispelled when she arrived for her 2014 appearance carrying her sixth child in her arms, four-month-old Sadie.

Above: Natalie MacMaster with cellist Nathaniel Smith, 2014. Photo by John Lupton

Below, left: Natalie MacMaster with Tracey Dares on the Camp Stage, 1994. Photo by Ellen Nassberg

Below, right: Natalie MacMaster, 2000. Photo by Jayne Toohey

1994 Festival. "I saw her at a Vermont festival when I was working stage management," he says, "and she just blew everyone away." He pauses a moment and laughs, "It didn't work out that time."

He tried again a few years later while Natalie was in college, and the only contact information he had for her at the time was the phone number at her dormitory, which turned out to be a common phone at the end of the hall for all the residents to use. Not having much luck reaching her directly, he did some research and managed to locate the number of her home in Cape Breton. When he dialed the number, Natalie's mother answered.

Fred explained who he was, that he was calling about a booking for her daughter, and that he was having trouble reaching her. Mrs. MacMaster listened politely, immediately grasped the situation, and very firmly told Fred, "Natalie *will* give you a call back." She

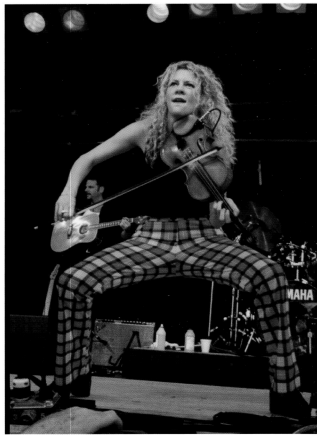

ARTHUR HALL AFRO-AMERICAN DANCE ENSEMBLE

(1969, 1970, 1971, 1972, 1973, 1975, 1986)

The Arthur Hall Afro-American Dance Ensemble was a unique experience at the Philadelphia Folk Festival. In addition to the amazing performances from this Philadelphia-based national and international dance company, it had an audience participation component that got people up and moving.

Nana Korantema Ayeboafo, who was a performer with the ensemble and also an administrative assistant for Arthur Hall, says, "Arthur had a lot of names, but one was the 'Appleseed of Dance.' He was very open and accommodating. Allowing people who were not performers or dancers to get involved was something that made him happy. He believed that everyone should dance, from a young elementary school child to a senior citizen. Arthur could invite people off the street and work with them, and within a week get them ready to do a performance."

"It was always exciting for me," Nana continues, "people just needed to have a desire to get up and be a part, it didn't matter if they had dance training. [To] see what it feels like to move to the drums. It was rewarding to see how much enthusiasm the African dance and drumming provided to people."

Nana describes Arthur as having "created a track record of being excellent, being evocative, and intriguing." The Arthur Hall Afro-American Dance Ensemble performed at festivals like Philly and at Woodstock, made an appearance on *Mister Rogers' Neighborhood*, and was highly sought after not only to entertain, but also to share and teach people about the culture of African music and dance.

Asked what she wants people reading about the Philadelphia Folk Festival to know about Arthur Hall, Nana says, "Arthur was a person who supported folk art. He was able to grow his company from a local company to have a national and international artistic component. But the folk art and its importance to people is what really motivated him to grow his company—that African-Americans *also* had a beautiful folk art that needed to be preserved."

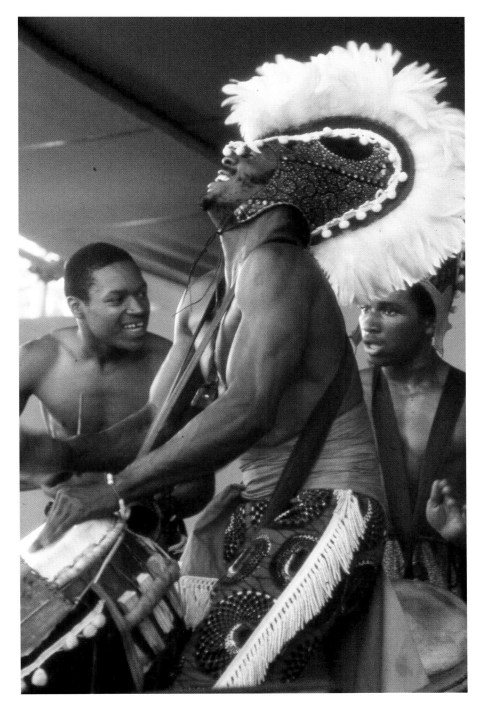

Arthur Hall Afro-American Dance Ensemble, 1975. Photo by Barry Sagotsky

Arthur Hall Afro-American Dance Ensemble. Photo by Barry Sagotsky

KIM AND REGGIE HARRIS

(1986, 1995, 2001, 2011)

Kim Harris, 2011. Photo by Mark Smith

Reggie Harris, 2011. Photo by Mark Smith

Kim and Reggie Harris—two of the nicest people one could ever meet—were both born and raised in Philadelphia and began singing together in 1974 and 1975. They are an example of performers who became involved with the Philadelphia Folksong Society's Odyssey program, an outreach project that sends musicians to schools in the Delaware Valley to enhance teaching culture and history through music. Through that experience they were then invited to become part of the Philadelphia Folk Festival.

One of their favorite moments at the Festival was in 2011, when they were doing the "Gospel Sunday" workshop on the Camp Stage with the Campbell Brothers, the iconic Sacred Steel band. It had rained all the previous night, but the skies magically cleared during the sound check, allowing the check to be completed just ten minutes before show time.

Reggie started playing a riff of "Wade in the Water" and the Campbell's' drummer picked it up. Reggie and Kim's bass player picked it up and then, says Reggie, "[Pedal steel player] Chuck Campbell started playing licks behind it, and then we started humming and then it was *on.*"

The sound check guy, Reggie continues, said, "'You got ten minutes,' and we said 'never mind'—and we never stopped." It seemed like everything clicked and it was a magical moment where two groups of musicians who do not know each other very well clicked and made amazing music together.

Another memorable moment for Kim and Reggie came when they first appeared on the Main Stage at Philly. They had played to large arenas prior to their Main Stage performance, and the "thrill of being on a big stage had been reduced," but this was their hometown in Philadelphia, and Reggie was in the middle of recovering from a liver illness that almost took his life. He explains, "Here we are in Philly on the Main Stage of the Philadelphia Folk Festival. They announced our names and there was this huge ovation. You kind of go, 'Oh Wow, someone's been really paying attention.'" Kim chimed in, "We are Philly kids, [Reggie] went to Olney, I went to Girls High, and we both went to Temple University. We are Philly people—to be with the hometown crowd is *wonderful.*"

SHEMEKIA COPELAND
(2002, 2006, 2014)

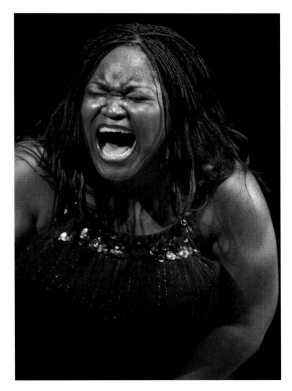

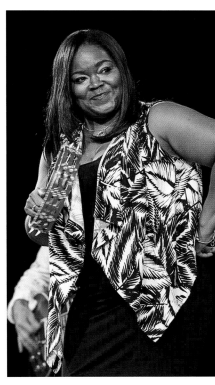

Though she has performed only three times (so far) at the Philly Festival, Shemekia Copeland's brand of high octane, knock-your-socks-off blues vocals have made her a hands-down favorite with the Philly crowd. The daughter of late Texas blues guitarist and singer Johnny Copeland, Shemekia was raised in North Jersey, and was already performing at Harlem's legendary Cotton Club by the time she was ten.

At the Chicago Blues Festival in 2011, she was officially named to succeed the late Koko Taylor as "Queen of the Blues," with the crown literally handed to her by Koko's daughter. Still in her thirties, Shemekia Copeland promises to be a major force on the scene for decades to come, and undoubtedly there will be a few more stops at Philly along the way.

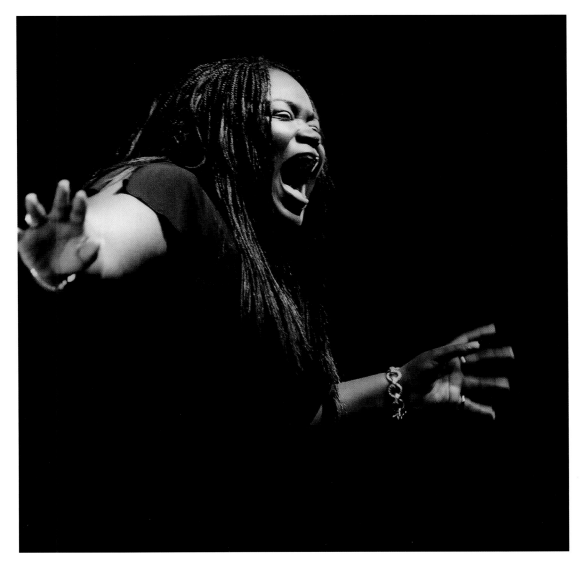

Above, left: Shemekia Copeland, 2006.
Photo by John Lupton

Above, right: Shemekia Copeland, 2014.
Photo by John Lupton

Left: Shemekia Copeland, 2002. Photo by Jayne Toohey

TEMPEST

(1995, 1997, 1999, 2001, 2003, 2005, 2008, 2011, 2014, 2016)

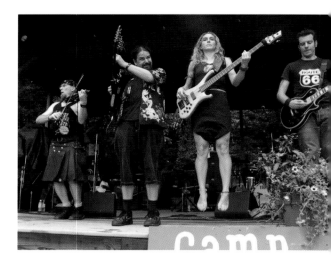

Tempest on the Camp Stage, 2005.
Photo by Jayne Toohey

Lief Sorbye (Tempest), 2011. Photo by
Jayne Toohey

Adolfo Lazo (Tempest), 2011. Photo by
Jayne Toohey

Ariane Cap (Tempest), 2005. Photo by
Jayne Toohey

Michael Mullen (Tempest), 2011. Photo
by Jayne Toohey

In 1994, Norwegian-born Lief Sorbye, lead vocalist and mandolin player for Tempest, met Program Chair Fred Kaiser at a Folk Alliance conference, where they discussed booking Tempest for the 1995 Festival. It would not be Lief's first time at the Festival, however. In 1978, when he was twenty-one, Lief visited the United States for the first time, and while traveling around he attended the Philadelphia Folk Festival. He remembered the Festival and was excited at the chance to play there.

That year turned out to be very memorable for Lief. Tempest was such a hit with the audience that their merchandise flew off the tables, and Lief remembers several urgent requests to bring more of their CDs, T-shirts, and other wares up to the sales tent. During the last trip up to the tent on Sunday night he heard "The Weight" being played by The Band. They were one of Lief's favorite bands, and they had not been scheduled to play—they filled in when Bo Diddley became ill and could not make his scheduled appearance. It was, Lief says, one of his more memorable moments at the Philadelphia Folk Festival, a feeling of personal success made all the sweeter by also getting to see one of his favorite bands perform.

"Playing the Philly Folk Festival," Lief says, "is like playing in a very large living room with all your best friends. It's all about

the intimacy. You can create a very nice intimacy here with the audience." When he and his wife produced their own festival in California for three years, Lief readily confesses he used the Philadelphia Folk Festival as a model of what they hoped to aspire to.

"The Philly Folk Festival," he explains, "has its own personality and its own place in the world. It stands on its own." He wanted to capture that feeling at his own festival.

Though often described as a "Celtic rock band," Lief says Tempest's roots are solidly in traditional folk music. "Especially here [at Philly] on Main Stage, we try to feature traditional music played our way. That's what keeps tradition going. If you keep it like it always was it ends up a museum piece and it dies. The point of having folk festivals is being open to the natural evolution of folk music, and I think we have our own place in the world on that level."

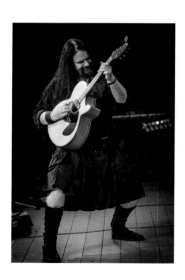

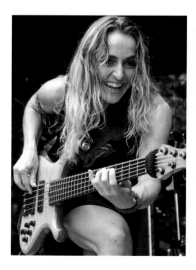

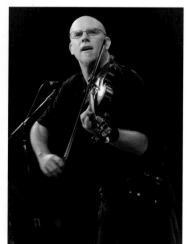

ELIZABETH COTTEN
(1963, 1972, 1979, 1986)

Elizabeth Cotten (usually known as Libba) was already seventy years old when she first appeared on stage at the Philadelphia Folk Festival in 1963. Born Elizabeth Nevills in the Chapel Hill, North Carolina, area, she began playing music at age seven, started writing her own songs within a year, and by eleven had already written what would become probably her best-known composition, "Freight Train."

A self-taught guitarist, she was left-handed but maintained the "right-handed" stringing, so that she played with the bass strings at the bottom of her strum instead of at the top. This led her to develop a distinctive style that became known as "Cotten picking."

Libba worked as a maid with her mother until age seventeen, when she married and had her first child. She gave up music for nearly three decades. As the story is told, she was working in a department store when a lost child approached her. Libba helped the little girl find her mother who, it turned out, was Ruth Crawford Seeger, and the girl was her daughter, Penny. The Seegers hired Libba as their maid, and once again in a musical environment, she picked up her guitar. By the late 1950s, Mike Seeger had produced her first recordings.

Among the all-time most memorable moments of the Philadelphia Folk Festival were the workshop sessions in which Libba appeared along with other pioneering women of folk music like Hazel Dickens, Alice Gerrard, and Janis Ian. Festival graphic artist and singer-songwriter LisaBeth Weber says, "I feel so lucky I got to see [Libba]. I knew what a legend she was, she held her guitar flat, and she did her best—she *brought* it!"

Libba Cotten passed away at age ninety-four less than a year after her final appearance at the Festival in 1986.

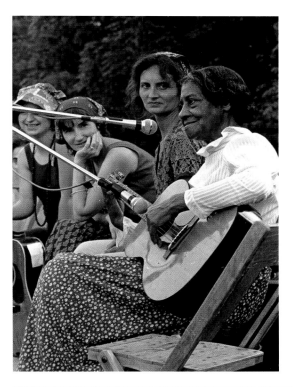

Libba Cotten in a workshop with Hazel Dickens (L) and Alice Gerrard (center), 1972. Photo by Peter Cunningham

Libba Cotten, 1972. Photo courtesy of Philadelphia Folksong Society Archives

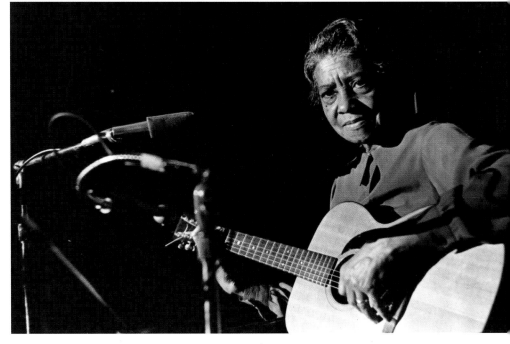

BILL MONROE
(1964, 1966, 1967, 1968, 1969, 1971)

Bill Monroe was born and raised in Rosine, Kentucky, a small town in the central western part of the state that features rolling farmlands—which is ironic, given that he is known in American music as the "Father of Bluegrass," a style that many people think of as "mountain music." The youngest of eleven children, he often told how he ended up playing the mandolin as a boy because by the time he was old enough to learn to play, "all the good instruments had already been taken."

As he grew into adulthood, it became clear that he had mastered the instrument to the point that he had developed his own innovative, "rapid fire" style of playing that would make him famous in the decades to come. By the 1930s, he had teamed up with his brother Charlie, a guitar player, and as the Monroe Brothers they became one of the most successful duets in the early years of the country music business. Both were temperamental and strong-willed, they clashed repeatedly on how the act should be run, and by the end of the decade they had gone their separate ways.

Bill formed his own band—the Blue Grass Boys, named for his home state—and set about the task of developing a style and sound that would set him apart from the crowd of Nashville sound-alikes. After several failed experiments finding the "right" sound (one of which included an accordion), he struck gold in 1946, when he welcomed into his band a smooth-voiced baritone singer and guitar player from Tennessee named Lester Flatt and a young banjo player from North Carolina, Earl Scruggs, whose blazing three-finger picking style literally brought audiences out of their seats.

Strangely enough, it would be another decade or so before the term "bluegrass" came into common usage to describe the music that Bill Monroe had brought to the American consciousness, and in those years there were plenty of imitators—"poachers," as Bill tended to regard them—but he eventually came to understand that imitation is the sincerest form of flattery, and that he had legitimately earned his title as the "Father of Bluegrass."

Although the impact of Elvis Presley on the country music industry had made life difficult for many more traditional artists (though one of Elvis' early hits was a cover of Bill's "Blue Moon of Kentucky"), by the time the early folk festivals like Newport and Philly came looking for Bill in the early 1960s, he had come to be viewed as an "elder statesman." The emergence of the bluegrass festival circuit a few years later gave him an even wider audience, and he continued to be an iconic figure until passing away in 1996.

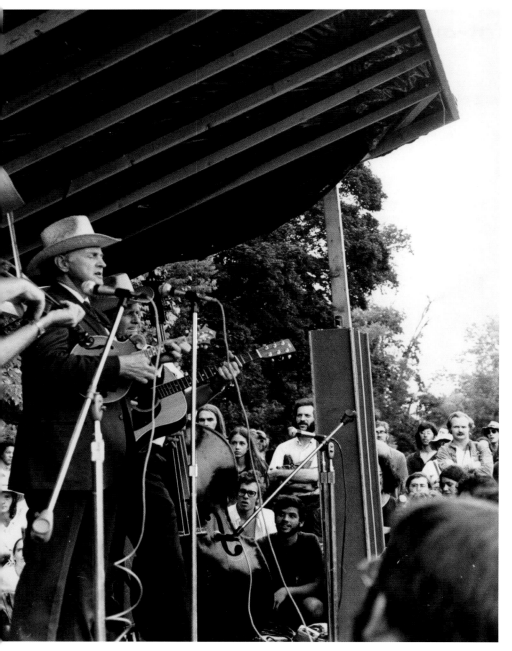

NICKEL CREEK

(2000, 2001)

Although bluegrass is often thought of as a style of folk and country music indigenous to the American South, the fact is, there have been hotbeds of the music all around the country for more than a half-century, including major cities like Boston and Washington. Southern California in particular has been the home not only of many great pickers and singers like Tony Rice and the father-and-son duo Don and David Parmley, but a number of the country and folk-rock legends of the 1960s and 1970s as well, like Chris Hillman and Herb Pedersen.

Growing up in the San Diego area, Sean Watkins, his younger sister Sara, and Chris Thile were not yet teenagers when they began bugging their parents to take them to a local pizza parlor where a frequent attraction was a band called Bluegrass Etc., featuring the highly respected mandolin player and singer John Moore. Inspired to become musicians themselves, it turned out in a "perfect storm" kind of way that all three were prodigies on their instruments: Chris on mandolin (he began taking lessons from Moore), Sean on guitar, and Sara on fiddle.

Before he was even old enough to drive Chris had released a critically acclaimed solo

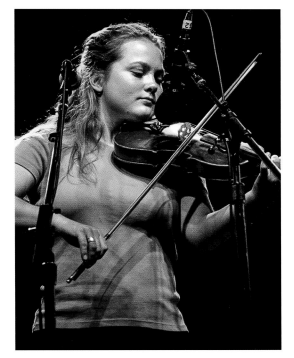

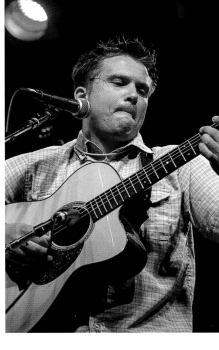

instrumental album, the Watkins siblings had likewise demonstrated a phenomenal grasp of the music, and by the early 1990s, they were performing around San Diego as Nickel Creek, occasionally in the same pizza parlor where they had first met. As they grew older and their voices matured, they discovered that their vocal talents were substantial as well, and they set about the task of melding their bluegrass roots with their own progressive ideas about the musical paths they wanted to explore.

By the time they debuted on the Philly Folk stage in 2000, they had already gained a reputation as one of the most astonishingly creative and accomplished acoustic bands on the scene, pioneers in what was coming to be known as "Americana." Remarkably, at twenty-three Sean Watkins was the senior member of the trio, while Chris and Sara were still only nineteen. That visit became even more memorable for Chris when John Hartford invited him to join his band for the evening.

The reception for Nickel Creek in 2000, was so overwhelming they became among the relatively few acts in the more recent era of the Festival to be invited back the next year, and were received no less enthusiastically in 2001. Though they parted company a few years later to pursue separate careers, the trio has occasionally reunited. In 2013, when Garrison Keillor announced he would retire from hosting his long-running radio show *A Prairie Home Companion*, it was not long before Chris Thile was named to succeed him.

Sara Watkins (Nickel Creek), 2000.
Photo by John Lupton

Sean Watkins (Nickel Creek), 2000.
Photo by John Lupton

Below, left: Chris Thile with Byron House on bass (Nickel Creek), 2000. Photo by John Lupton

PHIL OCHS
(1964, 1965, 1968)

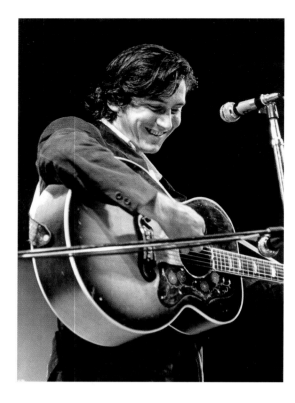

Along with his "friendly rival" Bob Dylan, Phil Ochs was one of the major young, dynamic talents to emerge on the national folk music scene in the early 1960s. His father, Jacob "Jack" Ochs, was a physician who practiced at a series of hospitals around the United States (his mother, Gertrude, was Scottish-born), and Phil, the middle child of three, was born in El Paso, Texas, during his father's tenure there. Phil's musical talents were evident at an early age, and by the time he was sixteen, he was a solo clarinetist with the Capital University Conservatory of Music in Columbus, Ohio.

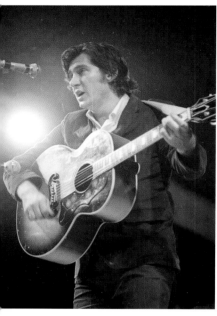

Phil enrolled at Ohio State, where he met Jim Glover, a fellow student who was active in the emerging folk music scene. Sonny Ochs, Phil's older sister and herself a well-known figure in the folk music world since the 1960s, recalls that "[Phil] was at Ohio State as a journalism major, and he wrote articles there. He quit college because Jim kept saying, 'Come to New York, this is where it's happening.'"

"This is the early '60s," she continues, "and [Phil] was writing articles favorable to Castro, and they weren't getting printed, they were being censored. So [Phil's] thing was, 'Why should I be a journalism major if they won't [print] what I'm saying?' And that's why he decided to go to New York . . . Jim taught him the guitar, so he put his thoughts to the guitar, and he wrote his songs from the headlines of the *New York Times*, and from *Newsweek*. He was a prolific writer; he just knocked 'em out, one-two-three."

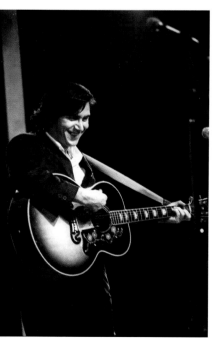

Reviewing the 1965 Festival at which Phil was among the headliners, *Billboard* magazine described him as the "Angry Folksinger." It is a description Sonny takes issue with. "He was angry at what was going on, of course, like everybody else was, but no, I wouldn't call him an 'angry folksinger' . . . He was known as a topical songwriter, basically a musical journalist, if you will. He considered himself more of a journalist than a songwriter—which is how he really started out. Because of Jim Glover he realized he could put his writing to good use."

Sonny credits her longtime friend Gene Shay, with reminding her of an episode at the 1968 Festival that capped off a summer of historic unrest and controversy across the country. Phil had been in Chicago during the famously turbulent Democratic Convention of that year and had not only witnessed in person the riots and arrests that were shown to national television audiences, but he had been among those arrested. It was an event that profoundly affected him personally and professionally.

"Gene sent me a recording of Phil's Main Stage performance [that year]," Sonny says, "and I had forgotten that when [Phil] came up on stage, he said something about just coming from jail. I wondered, 'why was he in jail?' Then I remembered he had just come from the Chicago convention. So that was kind of momentous. And he did his set, and he got such an amazing round of applause they wanted an encore . . . and they didn't want him to get off stage."

Due next on stage was Bill Monroe, the "Father of Bluegrass," a man who was probably as far to the right on the political spectrum as Phil was to the left, and who was never keen on being upstaged by anyone, regardless of their music or politics. Gene, of course, was the emcee, and Sonny laughs, "Poor Gene had to calm down the audience and Bill Monroe was on next," adding, "Poor Bill!"

ODETTA
(1968, 1969, 1977, 1993, 2003)

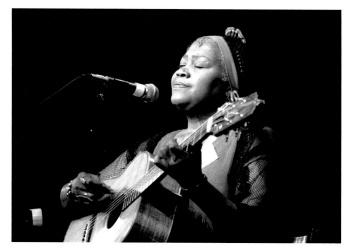

Before there was Cher, and before there was Madonna, Alabama-born Odetta Holmes was a powerful presence on the American music scene, an artist who did not need to have her surname on marquees, posters, and album covers to make sure people knew who she was—simply "Odetta" was more than enough. She was one of a kind; not only a performer of remarkable depth and flexibility, be it folk, jazz, blues, or spirituals, but also a lifelong crusader and advocate for civil rights and social justice.

Still a teenager in the late 1940s, she was a star in musical theater, including a nationally touring company of *Finian's Rainbow*, when she encountered a troupe of street musicians performing folk songs in San Francisco and was inspired to make a course change in her young career. Throughout the 1950s, she immersed herself more and more into the emerging folk music genre, and when the following decade saw the rise of the civil rights movement, Odetta was invited by Dr. Martin Luther King Jr. to perform at the epochal March on Washington in 1963, at which she sang "O Freedom." It was Dr. King who anointed her the "Queen of American Folk Music."

It is doubtful Odetta ever thought of herself as royalty, but it was impossible not to be impressed with what can only be described as her regal presence on stage—charming, serene, self-assured, and always dignified. But when she asked the audience to sing along, and she thought they weren't holding up their end of the deal, she always made it clear that significant improvement would be expected the next time the chorus came around—and she *always* got it.

Odetta continued to perform in the years following her last visit to the Philly Festival in 2003, despite declining health. Her final show came in October 2008, two months before she passed away at age seventy-seven.

Odetta, 1993. Photo by Jayne Toohey

Odetta, 2003. Photo by Jayne Toohey

"UTAH" PHILLIPS
(1970, 1971, 1972, 1975, 1978, 1979, 1990, 2001)

Although throughout his career in folk music he was known as "Utah," Bruce Duncan Phillips was a Cleveland, Ohio, native. Both his parents were active in the Industrial Workers of the World—a.k.a. the "Wobblies"—and Bruce would grow up and remain committed to the cause of unionism and workers' rights throughout his life. Drafted as a teenager into service in the Korean War, he returned to civilian life vowing never again to let anyone else tell him who his enemies were, and his pacifism led him to join Ammon Hennacy's Catholic Worker Movement, a group devoted to anarchism and nonviolence. Phillips often quoted Hennacy, "An anarchist is a person who doesn't need a cop to make him behave."

In 1968, at the height of the Vietnam War, Bruce was an employee in the Utah State Archives when he ran for the US Senate as the candidate of the Peace and Freedom Party. He garnered all of about 2,000 votes (a mere 223,000 behind the winner, Republican incumbent Wallace F. Bennett) and lost his job in the process. He had been writing songs, was a popular storyteller, and had become friends with folksinger Rosalie Sorrels, who encouraged him to give up "day jobs" and turn his talents into a profession. He acquired a VW minibus, christened it "Hitler's Revenge," and headed to Saratoga, New York, to begin his new career at the legendary Caffé Lena.

In his youth he had become enamored of the country music he heard coming over the

Utah Phillips, 2001. Photo by Jayne Toohey

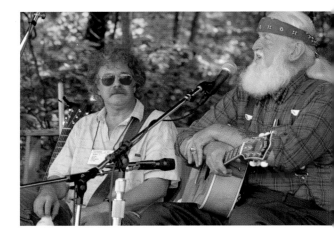

airwaves, particularly from the high-powered AM stations in Mexico just across the Rio Grande that could reach just about every part of the United States. Among his favorites was a crooner who went by the stage name T. Texas Tyler, a Missouri-born singer whose real name was David Myrick. As he embarked on his own career in the music business, Bruce Phillips quickly transformed himself into "U. Utah Phillips, the Golden Voice of the Great Southwest." Many fans who acquired autographs or letters from him over the years would come to particularly treasure the "GVGSW" he would scribble along with his name.

Utah Phillips was one of those rare performers who could hold an audience spellbound not only by singing one of his insightful and beautifully crafted songs in his comfortably craggy voice, but also by launching into a lengthy and usually hysterically funny monologue. Possibly his most famous story relates an attempt to

improve his employment situation by baking moose manure into a pie and serving it to his fellow employees. On the surface it is an outlandish and unbelievable tale, but in his telling it would always make perfect sense and be perfectly hilarious. He was quick with one-liners, too: "An empty car pulled up to the White House . . . and Ronald Reagan got out."

Forced by heart disease to end his touring, Utah Phillips passed away in 2008. Fondly remembered by Philly Folk audiences for his wit, charm, storytelling, and simple humanity, his true legacy can be found by walking around the campground jam sessions late at night, where close listening will invariably bring the strains of one of his timeless songs: "Room For The Poor," "Orphan Train," "Green Rolling Hills," "Starlight On The Rails," and many, many more.

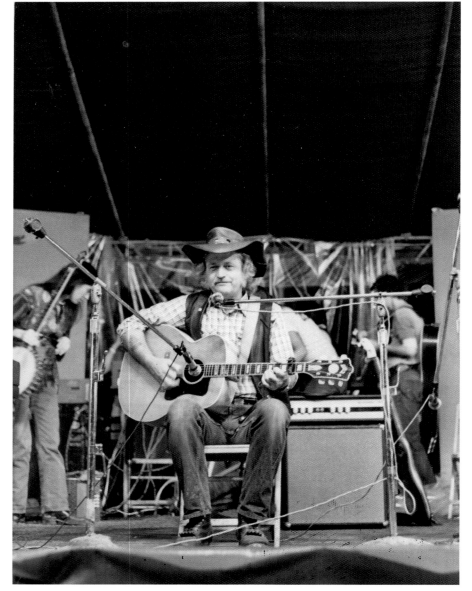

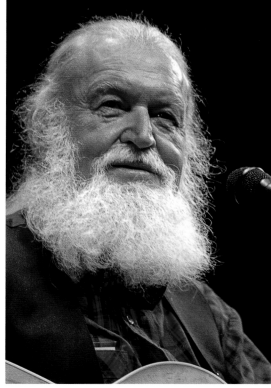

JOHN PRINE
(1972, 1974, 1999, 2004)

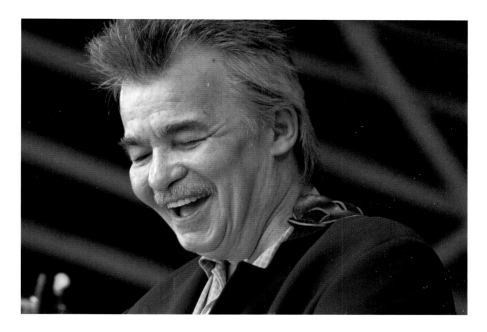

John Prine was a Vietnam veteran in his early twenties and working as a mail carrier in the late 1960s, when he began visiting open mike nights at a Chicago folk club that was not far from his Maywood hometown in the suburbs on the city's western side. He quickly became fast friends with another local singer-songwriter, Steve Goodman, and as his career gained steam he caught the notice of Kris Kristofferson, who joked that John's songs inspired so much professional jealousy, "we'll have to break his thumbs." Before long, the long list of folk and country greats who admired John's work would come to include Bob Dylan and Johnny Cash.

In 1998, John underwent neck surgery and chemotherapy for squamous cell cancer, and though he recovered, it left his voice deeper, with more of a gravel tone. In the minds of many, though, it simply added a bit more "character" to his vocals, and he has continued to be a top draw.

Like Utah Phillips, John Prine is one of those writers whose songs will echo throughout the night in the campground, where at just about every campfire session someone will sing at least *one* "Prine": "Angel From Montgomery," "Sam Stone," "Souvenirs," "Illegal Smile," "Your Flag Decal Won't Get You Into Heaven Anymore," and dozens of others.

But perhaps the best testament to the power of his artistry lies in what is possibly his best-known song, "Paradise," the story of his parents' Kentucky hometown that was strip-mined out of existence by, as the song relates, the Peabody Coal Company. In the course of a lawsuit, the now-bankrupt company attempted to keep the song's lyrics from being introduced into the court record—"I'm sorry, my son, but you're too late in asking/Mister Peabody's coal train has hauled it away."

Above: John Prine, 1999. Photo by Jayne Toohey

Below, left: John Prine, 1974. Photo by Barry Sagotsky

Below, right: John Prine, 1974. Photo by Steve Ramm

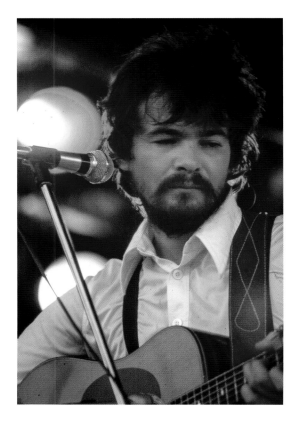

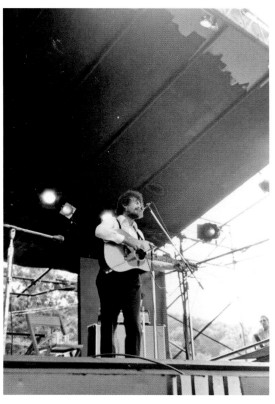

BONNIE RAITT

(1970, 1971, 1972)

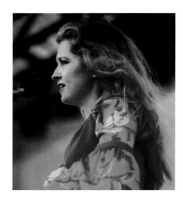

Returning to the Philadelphia area in a show at the Mann Music Center in 2016, Bonnie Raitt spoke warmly of the city she considers her "professional hometown," reminding the audience that it was in the Philly folk music scene, at venues like The Main Point, that she got her first "paying gigs." Coincidentally, opening for her that evening at The Mann was Richard Thompson, whom she had met when both made their first appearances at the Philadelphia Folk Festival in 1970.

Born in California, Bonnie is the daughter of Broadway musical star John Raitt and singer/pianist Marge Goddard. She got her first guitar at age eight, and during her college years in Boston she became obsessed with the blues, learning the "bottleneck" style played by masters like "Mississippi Fred" McDowell, whom she also got to meet at that 1970 Philly Festival.

Though her first several albums were critically acclaimed, her national breakthrough did not come until the release and overwhelming popular success of her tenth (*Nick Of Time*, 1989) and eleventh (*Luck Of The Draw*, 1991) albums. Bonnie has garnered (to date) ten Grammys over the course of her career of nearly five decades, and has achieved the distinction of being named by *Rolling Stone* to both their "100 Greatest Singers of All Time" and "100 Greatest Guitarists of All Time" lists.

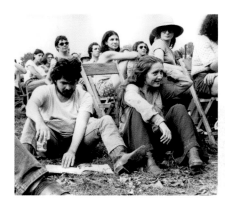

JOHN ROBERTS AND TONY BARRAND

(1970, 1971, 1972, 1973, 1975, 1978, 1985, 1989, 1992, 1998, 2004)

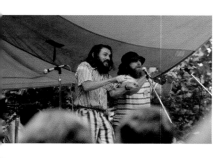

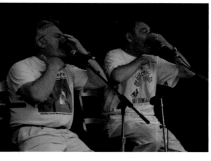

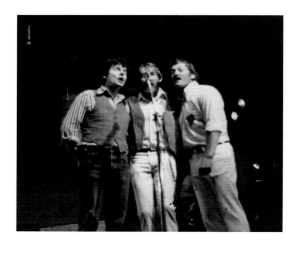

Though both English-born, it was as students at Cornell University in New York State that John Roberts and Tony Barrand first met and began singing together. Performing a cappella, or occasionally with John playing a concertina, their stock in trade since the early 1970s has been the ballads and comic songs of the English music halls in the nineteenth and early twentieth centuries. They are both accomplished storytellers, and adept at mimicking American accents, as they demonstrated in the later stages of their careers by doing the "full Hoboken" in singing a favorite from their repertoire, "The Rolling Mills Of New Jersey."

Afflicted with multiple sclerosis, Tony Barrand's ability to travel and perform declined steeply in the late 1990s, and into the new century, and he and John made their final appearance together at Philly in 2004. Tony now lives in retirement in Vermont. John is still active, performing as a solo act and as a member of Ye Mariners All and the Broken String Band. Over the course of their many visits to the Festival, John and Tony were always welcomed as old friends who just happened to drop by to share a few old songs and tell a few good stories.

CHRIS SMITHER

(1967, 1968, 1969, 1979, 1990, 1992, 1994, 1996, 1999, 2001, 2004)

Chris Smither grew up in New Orleans, the son of a professor of romance languages at Tulane University. He has credited his mother's brother with opening the door to the wide world of music for him at a young age. "Uncle Howard," he has said, "showed me that if you knew three chords, you could play a lot of the songs you heard on the radio. And if you knew *four* chords, you could pretty much rule the world."

He appeared to be on his way to following in his father's footsteps as an academic, studying anthropology at Mexico City University when his life course was irrevocably altered after he heard Lightnin' Hopkins' *Blues In My Bottle* album. Not long after, he met folk/blues artist Eric von Schmidt, who encouraged him to leave school and make his way to the burgeoning folk music scenes of Boston and New York in the late 1960s.

Nearly a half-century later, Chris is regarded not only as one of the premier acoustic blues artists of his generation, but an iconic writer whose songs have been covered by Bonnie Raitt, Emmylou Harris, Tim O'Brien, Diana Krall, and Loudon Wainwright III, among many others.

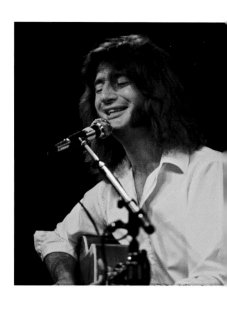

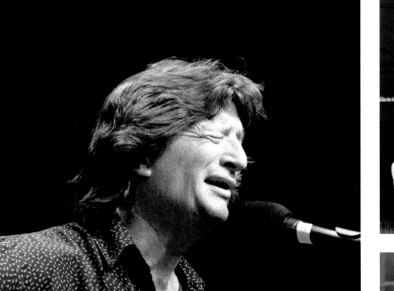

Above: Chris Smither, 1979. Photo by Robert Corwin

Clockwise, from left:
Chris Smither, 1999. Photo by Jayne Toohey

Chris Smither, 1990. Photo by Neal Pressley, courtesy of Philadelphia Folksong Society Archives

Chris Smither, 1967. Photo by Diana Davies

MERLE TRAVIS
(1976)

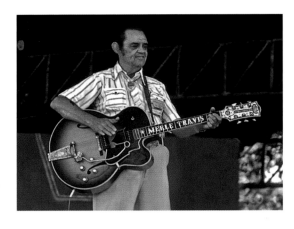

Merle Travis, 1976. Photo by Robert Corwin

Merle Travis, 1976. Photo by Barry Sagotsky

Though he only visited the Philadelphia Folk Festival one time in a career that spanned almost fifty years, Merle Travis had a profound impact in not only country and folk music, but in American popular music as well. Renowned for a thumb-and-forefinger guitar style that came to be known as "Travis picking" (frequent Philly guest Gamble Rogers was among his disciples), he was also a powerful singer, masterful songwriter, and consummate stage performer.

Born in the deepest, most remote parts of Kentucky coal country, Travis learned the basic elements of his guitar style from a number of local musicians, one of whom was Ike Everly, whose sons, Phil and Don, would become rock and roll immortals as the Everly Brothers. By his early twenties, Travis was performing regularly on radio in Cincinnati with "Grandpa" Jones and the Delmore Brothers as the Brown's Ferry Four.

Following a brief period of military service during World War II, he headed for California and a career that would include not only radio and studio recording, but also movies and early television. As the story has been told, he was called into the offices at Capitol Records one day in 1946, and was asked to record an album of "folk songs."

"I don't know any," Travis responded.

"Then write some," came the reply.

In the era before the advent of the 33¹/₃ rpm record, the term "record album" meant literally that—a collection of 78 rpm discs in separate sleeves bound together in similar fashion to a photograph album. When Travis emerged from the studio, his *Folk Songs of the Hills* album contained several traditional songs (it turns out he *did* know some "folk songs" after all), but also four original tunes that would become standards of the American folk and country canon: "Over By Number Nine," "That's All," "Dark As A Dungeon," and especially "Sixteen Tons."

Like many of his contemporaries in the mainstream country music business of his time, Merle Travis' career was negatively affected when Elvis Presley ushered in the rock and roll era, but he got a huge boost in 1955, when Tennessee Ernie Ford's recording of "Sixteen Tons" became a multi-million seller (surprisingly, as it had been released as a "B" side). The fame—and royalties—came as a godsend for Travis, and for years afterward he showed his appreciation in wry fashion when singing the song by changing the last line of the final chorus to "I owe my soul to Tennessee Ernie Ford." He died in 1983 at age sixty-five.

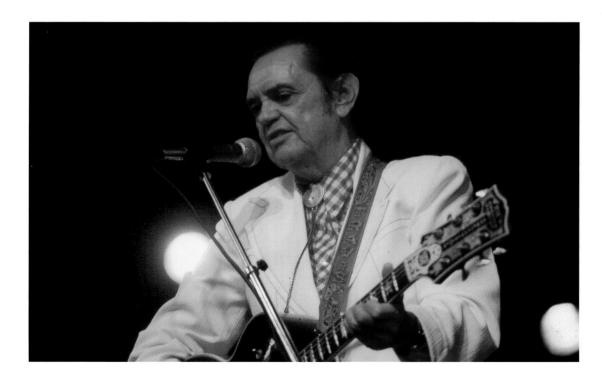

ARCHIE FISHER
(1975, 1976, 1985, 1987, 2014)

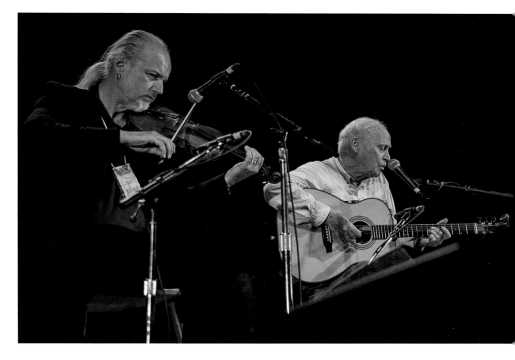

Along with his contemporaries Dick Gaughan, Andy M. Stewart, and Davy Steele, Glasgow native Archie Fisher has come to be regarded over the past half-century as among the quintessential Scottish folk singers, not only of their own original songs and those of their peers, but of traditional Scottish songs and ballads. Archie was born into a large, musical family in 1939, the only son among seven children. His sisters, Cilla and Ray, both became noted folksingers, and Archie appeared with them regularly in the 1960s, on the BBC counterpart of the American *Hootenanny* television show.

The opportunities for North American audiences to see Archie in live performance became limited beginning in 1981, when he signed on as host of BBC Radio Scotland's long-running *Travelling Folk* broadcast, and it is not too much of a stretch to say that in many ways Archie might be thought of as Scotland's version of Gene Shay. He retired from the show in 2010, and though he says he sometimes contemplates retirement from touring to his beloved horse farm, in the past few years he has been traveling much more often to this side of the Atlantic, including a long overdue return visit to the Festival in

2014, during which he was joined on stage by his longtime friend and frequent partner, Garnet Rogers.

Archie is possibly best known for his song "The Final Trawl," a melancholy lament of the declining fishing industry, but he is also credited with introducing Eric Bogle's "And The Band Played Waltzing Matilda" to US and Canadian audiences. (The song is an emotionally charged tale of a young Australian soldier who marches into the carnage at Gallipoli in World War I.) Andy Braunfeld, a longtime fan of Archie, says the "most poignant moment" he can remember throughout his decades as part of Festival management came when he first heard Archie do the song on the Main Stage.

"The power of the song, and the way he performed it, just shut the place up. I had *never* seen that crowd *silent*. You could have heard a pin drop."

After that, Andy says, "Archie became one of those people who, for me—I even remember posting on Facebook a couple years ago, when the 'noise quotient' got out of hand for my taste—the antidote for what happened last weekend was you go home, and you pull out your music, and you listen to any five Archie Fisher songs. It doesn't matter what they are, but it'll fix *everything*."

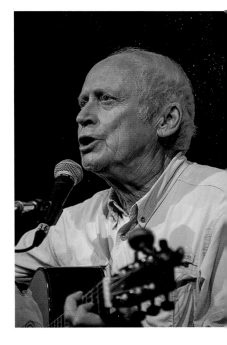

Top: Archie Fisher (R) with Garnet Rogers, 2014. Photo by John Lupton

Above: Archie Fisher, 2014. Photo by John Lupton

Left: Archie Fisher taking a break, 2014. Photo by Jayne Toohey

TROMBONE SHORTY
(2011, 2012)

Troy Andrews plays trumpet, drums, and keyboards, and hails from New Orleans, Louisiana, but as a young boy he would walk around his Tremé neighborhood toting his trombone. It was larger than he was, earning him the nickname "Trombone Shorty." Troy was a member of the Stooges Brass Band and attended the New Orleans Center for Creative Arts when he was a teenager. In 2005, Troy was a member of Lenny Kravitz's horn section and toured the world. Prior to his album *Backatown* reaching No. 1 on *Billboard* magazine's Contemporary Jazz Charts he worked with a variety of other artists, including U2 and Green Day, and appeared on numerous television shows on both NBC and HBO.

There is no doubt that when Trombone Shorty played the main stage at the Philadelphia Folk Festival he became a fan favorite. Playing jazz, rock, funk, and hip hop, Troy and his band had the entire hillside up and grooving. Photographer Laura Carbone was in just the right place at exactly the right time to snap this shot (**at right**) of Shorty in 2011, one of the most striking performance images captured in the entire history of the Festival.

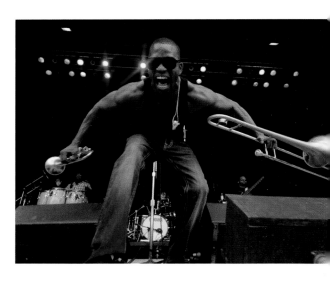

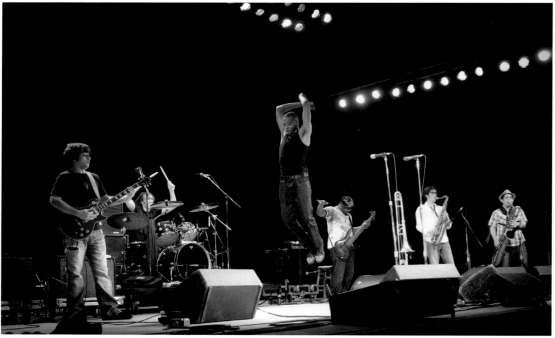

RALPH STANLEY
(1970, 2003)

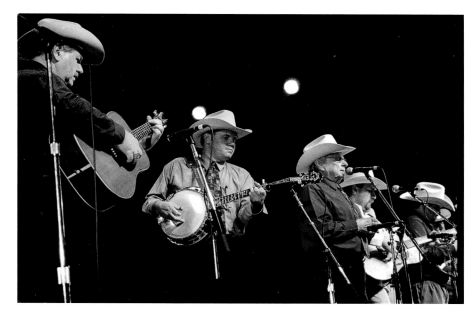

As Ralph Stanley returned from military service in Europe in 1946, he stepped off the bus in his southwest Virginia homeland to find his older brother Carter waiting, not to take him home for a family reunion, but straight to a local radio studio for a show that would mark the beginning of a twenty-year partnership as pioneers of the emerging brand of music that had not yet even begun to be called "bluegrass." When Carter Stanley passed away in 1966, the historic run of the Stanley Brothers came to an end. Though he briefly considered retiring from music, Ralph revamped their band, the Clinch Mountain Boys, and resumed course on a career in which he would eventually come to be regarded as a national treasure.

In contrast to the brand of music that Bill Monroe, Flatt and Scruggs, and others were making in the early bluegrass years, the "Stanley Sound" was much more heavily imbued with the ancient, haunting echoes of the mountains. Raised in the Primitive Baptist tradition, their vocals were strongly influenced by the "shape note" singing of their youth. Ralph's initial exposure to the banjo came with the "clawhammer" style taught to him by his mother. The earliest Stanley Brothers recordings feature Ralph playing a two-finger style, but before long he had developed his own idiosyncratic three-finger style that set him apart from contemporaries like Earl Scruggs and Don Reno.

Again like Monroe and Flatt and Scruggs, the emerging folk festival circuit (and later bluegrass festivals) gave the Stanley Brothers an opportunity to bring their music to a wider audience. In the years following Carter's passing, Ralph's stature continued to grow up to the eve of the new century and millennium. In his early seventies, Ralph was considering retirement when he was asked to perform his signature song "O Death" for the soundtrack of the wildly popular Coen Brothers film *O Brother, Where Art Thou?* Though it was John Goodman on the screen, it was Ralph's overdubbed, otherworldly vocal that became a national sensation.

With a short "make hay while the sun shines" and a quick check of the tires on the tour bus, Ralph set aside his retirement plans and enjoyed more than another decade of accolades as the Elder Statesman of Bluegrass, and after an absence of thirty-three years, made his second and final appearance at Philly in 2003. He passed away in 2016, at age eighty-nine.

Ralph Stanley and the Clinch Mountain Boys, 2003 (L-R): James Alan Shelton, Steve Sparkman, Ralph Stanley, Ralph Stanley II, and John Rigsby. Photo by John Lupton

Ralph Stanley, 2003. Photo by John Lupton

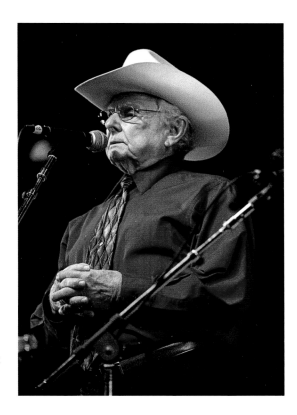

DAVE VAN RONK
(1963, 1968, 1969, 1970, 1971, 1977, 1979, 1981, 1985, 1990, 1995)

Above: Dave Van Ronk, 1981. Photo by Robert Corwin

Right: Dave Van Ronk. Photo by Richard Nassberg, courtesy of Philadelphia Folksong Society Archives

Below, left: Dave Van Ronk with Janis Ian, 1995. Philadelphia Folksong Society Archives

Below, right: Dave Van Ronk, 1968. Photo by Diana Davies

In reading about the careers of artists like Bob Dylan, Phil Ochs, Tom Paxton, and others, it is easy to draw the conclusion that the modern era of folk music begins with their arrival on the New York City scene in the early 1960s. But by that time Dave Van Ronk was already well-established as a widely known and respected singer, guitarist, and storehouse of songs, stories, and sage advice, especially among the denizens of Greenwich Village—"The Mayor of MacDougal Street," as the title of his memoir co-written with Elijah Wald famously described him.

Born in Brooklyn, Dave took up jazz and blues at a young age. He dropped out of high school, and after spending some time as a merchant seaman, he moved to The Village and devoted his career to music. Over six feet tall, bearded, and with a gravelly voice (that nonetheless could achieve surprising delicacy at times), he was an imposing figure who, to most of his peers, seemed older than he actually was. Born in 1936, he was only five years older than the struggling young Minnesota kid he befriended and helped when that kid—Bob Dylan—arrived in New York in 1961.

After becoming part of the famous Washington Square gatherings of the 1950s, the focus of Dave's music began shifting toward the folk music that was growing in popularity in the city and beyond, though he would continue to weave jazz and blues threads throughout his performances and recordings for the remainder of his life. As influential as Dave was to the careers of Dylan, Joni Mitchell, and others, the fates seemed to conspire to prevent him from achieving the kind of breakthrough that propelled the fame of his protégés. Janis Ian, another who benefited from his friendship and tutelage, frankly describes Dave as among the most underrated and underappreciated performers of all time.

Dave Van Ronk passed away in 2002. A decade later, he received a measure of the national attention due him when the Coen Brothers released *Inside Llewyn Davis*, the title character of which was loosely—but clearly—based on Dave. Personality wise, the fictional Llewyn Davis was not all that much like him, but Dave's peers remember the true character of the man. Arlo Guthrie still treasures the memory of sitting with Dave at Philly and cracking up at Dave's ongoing pointed (and often salty) commentaries on the shows.

LOUDON WAINWRIGHT III

(1972, 1973, 1981, 1986, 1989, 1993, 1999, 2003, 2014)

Journalist Stephen Holden, writing in the *New York Times*, described Loudon Wainwright III as "far and away the most candid diarist among the singer-songwriters," and an artist who "wrings more human truth out of his contradiction than any other songwriter of his generation." Certainly the thousands who have seen Loudon perform at the Philadelphia Folk Festival over the course of more than four decades will attest to that. Though his material often comes with heavy doses of irony and humor, there is also the realization that he is opening a window into his psyche

and soul that few other writers dare to attempt. Loudon's lyrics can be intensely personal and sometimes discomfiting, but always command attention.

Then again, he is also the guy who debuted in the American consciousness in 1972, with "Dead Skunk (In The Middle Of The Road)," followed a couple years later with a brief stint on *M*A*S*H* as "singing surgeon" Capt. Spaulding (a wry nod to the Marx Brothers). His father, Loudon Jr., was a nationally known columnist for *Life*, and though not a professional musician, he was a piano player who introduced his son to the work of musical satirists like Stan Freberg and Tom Lehrer.

Experiencing Loudon III ("LW3") on stage is more like watching an extended monologue with occasional musical accompaniment than a concert performance. It is sometimes manic, sometimes calm, but always a stream of consciousness that demands close attention. No one chats with the person in the next seat while Loudon is in the house.

Below, left to right:
Loudon Wainwright III, 1986. Photo by Ellen Nassberg

Loudon Wainwright III, 2003. Photo by Jayne Toohey

Loudon Wainwright III with Kate McGarrigle. Photo by Barry Sagotsky

DOC WATSON

(1964, 1966, 1967, 1968, 1970, 1971, 1980, 1982, 1983, 1986, 1988, 1994, 1999, 2007)

Right: Doc Watson, 1967. Photo by Diana Davies

Below, left to right:
Doc Watson with Jack Lawrence, 1999. Photo by John Lupton

Doc Watson, 2007. Photo by Jayne Toohey

Doc and Merle Watson, 1967. Photo by Diana Davies

Arthel Lane "Doc" Watson was a native of the deep hollows of the Blue Ridge Mountains in western North Carolina. He was blinded in infancy by an eye infection, and often spoke of how his father, General Watson (his actual given name, not a military title), put him to work on the farm at an early age, helping with sawing and other chores to instill in his son the sense that blindness should not prevent him from making it through life on his own. General also gave Doc his first musical instrument—a homemade banjo—and Doc began to absorb the early country music that was becoming available on primitive gramophone discs of the day.

Upon being sent to a state-run school for the blind, Doc began studying the guitar in earnest. In an era when the dominant guitar style was the rhythmic backup popularized by early country stars of the 1920s and 1930s like Maybelle Carter, Doc began to demonstrate a remarkable ability, using a flat pick to duplicate on guitar the intricate fiddle tunes heard throughout the Appalachian regions.

On reaching adulthood, Doc discovered he could make a living as a musician, in particular by playing electric guitar in the rockabilly bands that sprang up throughout the South in the 1950s, in the wake of the Elvis Presley phenomenon. Then in his thirties, and with a wife and two young children to provide for, Doc settled down to what he expected would be a reasonably stable life as a working "rock and roll" musician, but his true love remained the traditional music and early country songs of his youth.

In the late 1950s, folklorist and musician Ralph Rinzler came to the North Carolina mountains to track down and make field recordings of Clarence "Tom" Ashley, a fiddler who had recorded a number of 78 rpm sides in the 1930s. Ashley was happy to oblige, and as legend has it, on wrapping up the session he remarked to Rinzler, "You should meet my neighbor down the road, Doc Watson." Rinzler immediately recognized Doc as a major talent, became his manager, and by 1961, had booked Doc into major folk music venues like Gerde's Folk City in New York and the Ash Grove in Los Angeles.

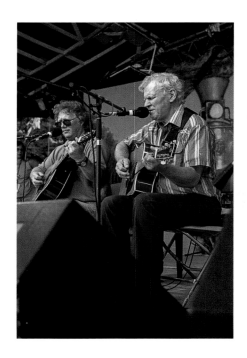

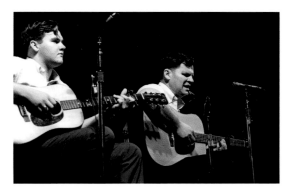

It was difficult for a blind musician to undertake and endure the traveling requirements and hardships for a touring musician of that time, but it became much easier for Doc in the mid-1960s, after his teenaged son Merle (named for Merle Travis) partnered up to become not only Doc's accompanist, but his road manager as well. They were an inseparable pair until Merle was killed in a tragic farm accident in 1985. Though he considered retirement, Doc continued touring in the company of exquisitely talented sidemen, including Jack Lawrence, T. Michael Coleman, Mark O'Connor, his own grandson Richard Watson (Merle's son), and, in the final years of his life (and at his final appearance at the Festival in 2007) with David Holt.

Doc Watson was eighty-nine when he passed away in 2012. He was an "old school" gentleman, and was always approachable to the many fans wanting to meet and talk with him at the thousands of festivals and concerts where he appeared. Amusing as it could be to those who saw the episodes take place, it was a frequent occurrence for fans to walk up to Doc—a blind man—and ask for an autograph. Always gracious and humble, Doc would invariably stick out his hand and say, "My handshake is my autograph!"

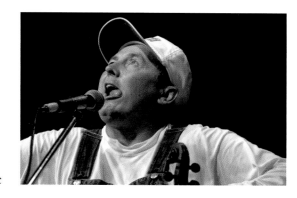

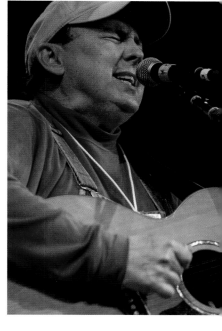

Above, left: Mike Cross, 1996. Photo by Jayne Toohey

Above, right: Mike Cross, 2012. Photo by John Lupton

Below: Mike Cross, 1982. Photo by Ellen Nassberg

It would come as no surprise to his fans to learn that Mike was born in 1946, in Maryville, Tennessee, a small town a few miles south of Knoxville. Though raised in a region that is a hotbed of American traditional music, it *is* something of a surprise that Mike was not steeped in that music as a child. In fact, he initially attended college on a golf scholarship, with the intent of becoming a doctor.

After breaking up with his girlfriend and giving up his scholarship, Mike says, "I got stuck in a snowstorm during my junior year and ended up spending the night in a friend's dormitory room. It turned out his roommate played the guitar." Over the next two days Mike learned his first songs and guitar chords, finding what he describes as "a new passion in life." He has often brought that passion to the Philly stage, and with any luck will return many more times.

MIKE CROSS
(1982, 1983, 1984, 1985, 1986, 1988, 1989, 1991, 1992, 1994, 1996, 2000, 2012)

In his trademark bib overalls, long-sleeved white turtleneck, and "feed store gimme" baseball cap, Mike Cross has been a familiar presence on the Philly Folk stage for more than three decades. A born storyteller, his on-stage monologues have often drawn comparisons to such iconic humorists as Mark Twain and Will Rogers, and he never fails to leave his audiences in stitches. Mike's talents go far beyond the realm of comedy. His singing and songwriting demonstrate an ability to resonate with listeners across a wide range of genres— folk, country, bluegrass, blues, old time, Celtic, and more—and he is among the finest instrumentalists to be found in folk music: an extraordinary fiddler and world-class flat pick guitarist.

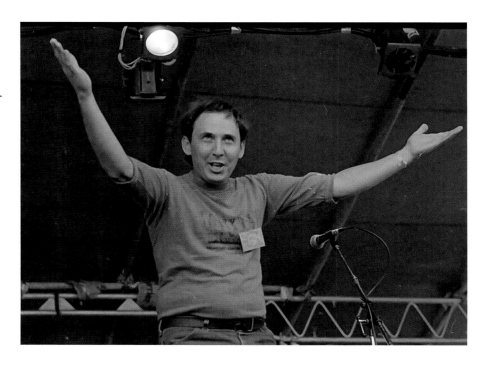

ROGER SPRUNG

(1964, 1965, 1966, 1967, 1968, 1971, 1974, 1975, 1977, 1978, 1979, 1980, 1981, 1982, 1983, 1984, 1985, 1986, 1987, 1988, 1989, 1990, 1991, 1992, 1993, 1995, 2016)

Roger Sprung. Philadelphia Folksong Society Archives

Roger Sprung (banjo) with Hal Wylie (guitar). Photo by Richard Nassberg, courtesy of Philadelphia Folksong Society Archives

Who has played the Main Stage at Philly Folk more often than any other performer? The answer to that bit of trivia is Roger Sprung, the banjo master whose version of progressive bluegrass has echoed through the grounds at no less than twenty-six of the first thirty-four Festivals (including the entire decade of the '80s). Roger is also among the very few who have performed at each of the four locations where the Festival has been held, including the single year (1966) at Spring Mountain Ski Area.

Roger combines his talented banjo picking with jokes and banter to make his performances especially entertaining. One of his favorite jokes explains the way banjo players count to eight: "One . . . two . . . three . . . four . . . five . . . six . . . sev . . . en . . . eight." He recalls a pair of especially treasured moments while at the Festival. One was when the crowd of eight to ten thousand people sang happy birthday to him. "It blew my mind," he says.

The other moment involved the impromptu jam sessions he would have with Festival goers. He would just start to play and other people would take out their guitars and banjos and jam with him. One of his impromptu jam sessions got so big that the whole crowd was asked to move outside the Festival grounds.

A native of New York City, Roger was a teenager in the late 1940s, when he began to attend the folk music gatherings in Washington Square Park, near Greenwich Village in Lower Manhattan. He learned to play banjo by ear, listening to records by Earl Scruggs. In 1953, in his early twenties, he formed the Folksay Trio with Erik Darling and Bob Carey, and recorded a popular version of "Tom Dooley," which Kingston Trio leader Dave Guard would admit some years later they had modeled their 1957 hit version after.

Often joined by guitarist Hal Wylie, Roger and his Progressive Bluegrassers were mainstays at Philly for more than three decades. Now well into his eighties, he is still performing, and following an absence of more than twenty years made a return visit to the Festival in 2016.

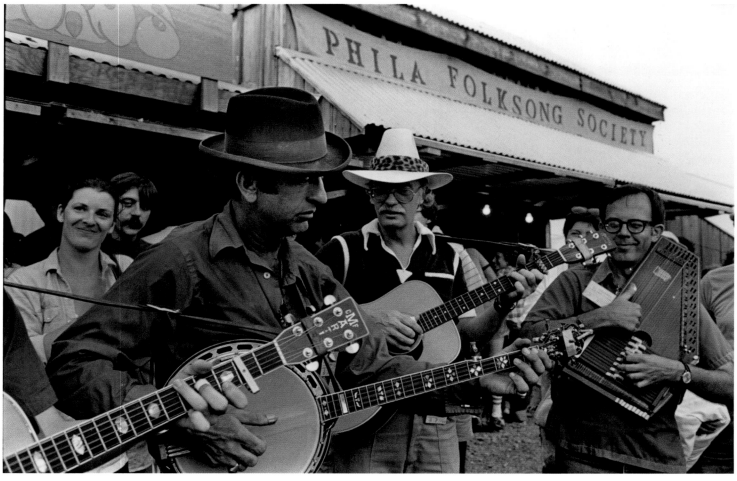

ROBIN AND LINDA WILLIAMS

(1978, 1979, 1981, 1983, 1986, 1988, 1990, 1992, 1995, 2002, 2004, 2016)

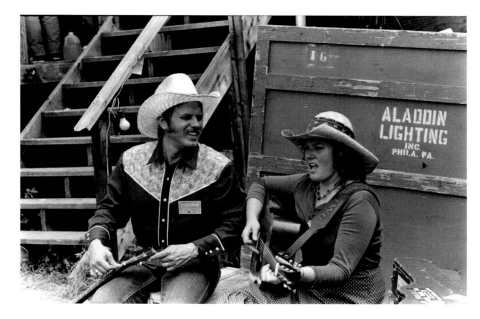

It would be easy to assume that the invitation to their first Philly Folk appearance in the late 1970s came as a result of the national profile they had gained as regular cast members of Garrison Keillor's long-running public radio broadcast *A Prairie Home Companion*, but Robin Williams is quick to point out that although he and his wife Linda first played "PHC" in 1975 (he mentions that they were among the first "non-Minnesota" performers booked for the show), it was not until 1980 that the show aired nationwide.

While Robin recalls their appearance at the '78 edition of the Festival was only for one day to do a single workshop, the opportunity to be introduced to the audience at a major festival quickly led to more bookings at a wider variety of venues.

"I remember after our set we had to drive home. We drove all the way back from Philadelphia, and we were just on cloud nine to *finally* play the Philadelphia festival, because at that point in time it was already a legendary festival. There weren't all that many folk festivals happening there in the early seventies, and since then, in the last forty years, festivals have proliferated. But back then Philadelphia was really *singular*; it was like, if you got on *that* stage it was *important*."

Linda notes that, though she and Robin are not "strictly bluegrass," they would often appear on the Main Stage as part of the late Saturday afternoon country and bluegrass concerts that were a mainstay of the Festival for many years, and it gave them a chance to meet and become friends with many of the "old time standard bearers" of bluegrass— "the icons," she reminisces, "they always wore suits—there were no T-shirts and tennis shoes—it was always suits and they were always dressed to *perfection*."

One particular year, she continues, "It was *so* hot and we came off stage just *dripping* in sweat." Getting ready to follow them were the legendary McReynolds brothers, Jim and Jesse, and their band, the Virginia Boys. "Here they were dressed in these suits," Linda laughs, "and [Jim and Jesse] both had these kind of big,

Robin and Linda Williams, 1978. Photo by Richard Nassberg, courtesy of Philadelphia Folksong Society Archives

Linda Williams, 2004. Photo by John Lupton

Robin Williams, 1986. Photo by Ellen Nassberg

Robin and Linda Williams joined on stage by Tim O'Brien (L), 1995. Photo by Jayne Toohey

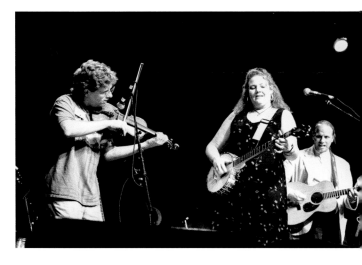

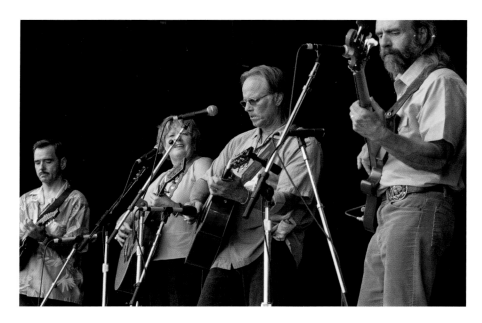

Robin and Linda Williams and Their Fine Group, 2004 (L-R): Jimmy Gaudreau, Linda Williams, Robin Williams, and Jim Watson. Photo by John Lupton

Michael Cooney, 1999. Photo by Jayne Toohey

pompadour hairdos—and there was not a hair out of place, and there was not a drop of sweat on these people, and I thought 'these people are *professionals*, they're in another league.'"

Playing the Philly Folk Festival, Robin says, "put us on the same stage and in the same rooms with these iconic performers that we never thought we would ever get to meet. And not only did we get to meet them, we became friends with them. It gave us legitimacy, and it all started with the Philadelphia Folk Festival."

"Of course," he continues, "legitimacy only gets you so far. You have to keep producing, which we have done for forty-three years. But in a very real way, the Philadelphia Folk Festival helped 'spring us out,' helped get us out of what we were doing then and get us into the legitimate folk music business." He pauses and laughs. "If that's not an oxymoron."

Linda agrees, "[Philly Folk] has always been a welcoming place to us, and then to go back year after year—the staff, the people who book, the sound people, the volunteers that come and set up three months before the festival—you get to feel like you are part of the family that gets together year after year."

Festival volunteer Anne Stevenson Smith wrote, "Michael Cooney was 'Fest' to me for years, please, come see us again!" in a post on the Facebook page that was established for this book. Again, with the exception of Roger Sprung, Michael Cooney has played the Festival more often than any other musician.

Trading turns as emcee with Gene Shay in between sets, Michael would tell stories and play songs, filling time during the sometimes ten to fifteen minutes between acts. He recalls one memorable time when he started to sing a Beatles song.

"I don't know why it popped into my head, I didn't really know it terribly well— 'With A Little Help From My Friends.'" The band setting up was English folk rock legends Steeleye Span, and at a certain point Michael says, "The whole band immediately started playing the other parts. That was a bit of fun."

than go back to the performers' hotel. Only a couple days following the 2016 Festival, Facebook was awash in comments and shared posts about Michael's reported sudden passing, though subsequent inquires clarified it was another Michael Cooney—a well-known Irish piper—who had died. Surveying all this from his New England home, and still very much alive, it must have brought to Michael's mind the famous comment of another great humorist, Mark Twain, when his obituary was prematurely published, "Reports of my death have been greatly exaggerated."

Michael Cooney, 1967. Photo by Diana Davies

Michael Cooney chills out in the Groundz compound, 1994. Photo by Jayne Toohey

JACKSON BROWNE
(2006)

Which performer has drawn the biggest crowd in the history of the Philadelphia Folk Festival? That is a natural question to ask, but for many reasons a very difficult one to answer. Venues that promote concerts featuring a single artist at each performance, perhaps with a lesser-known opening act, have a relatively easy way to look at sales figures and number of tickets sold to make one-on-one comparisons.

By their nature, folk festivals like Philly book many individual acts to perform over a three- or four-day period (the program book each year at Philly usually features upwards of one hundred), and the question of audience draw is generally computed along the lines of "the whole being more than the sum of the parts." It is generally felt that relatively few people make the decision to attend the Festival

Jackson Browne, 2006. Photo by Jayne Toohey

On more than one occasion Festival weekend coincided with the full moon, and as it rose into the night sky above the Main Stage concert area, Michael would lead the audience in a sing-along of "Shine On Harvest Moon." Michael also remembers being in charge of a "Humorous Songs Workshop" which musicians would eagerly try to worm their way into: "I know a funny song; can I be in your workshop?"

"Well," he laughs, "they would get up and sing songs that weren't the *least bit* funny. They just wanted to play their hit song." At one point, Michael recalls, a guy sang a song about going to town and cutting people up, laughing between each verse. Michael saw the audience grimace as the song progressed.

"[Production Chair] Paula Ballan came," he says, "and whispered to me, 'I have a guy here who's *really* funny, and if you were to put him on we would at least have *one* funny song.' So I put him on because I had such poor representation on stage—and that guy was Steve Goodman, who nobody had ever heard of at that time!"

Michael also enjoyed interacting with the volunteers, so much so that he preferred to camp with the Groundz Committee rather

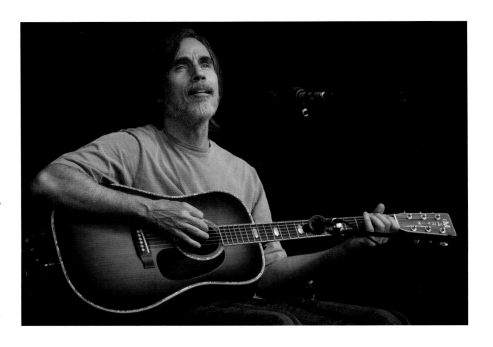

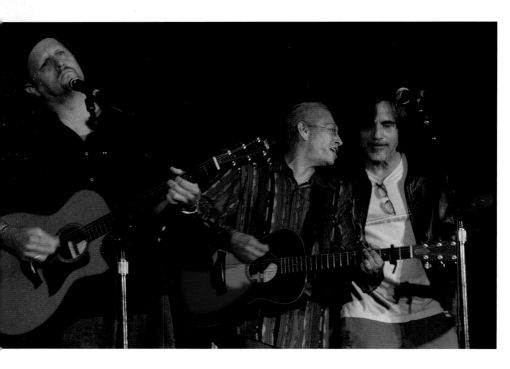

(L-R): Jimmy LaFave, Joel Rafael, and Jackson Browne, "Ribbon of Highway, Endless Skyway" at the Camp Stage, 2006. Photo by Jayne Toohey

Jackson Browne, 2006. Photo by Jayne Toohey

just to see a single performer. And as has been highlighted throughout these pages, thousands of longtime attendees come no matter *who* is going to be on stage.

All that said, former Programming and Production Chair Fred Kaiser says that ticket sales for the Saturday afternoon in 2006, when Jackson Browne took the stage in the company of his sideman, superlative guitarist David Lindley, outstripped any previous occasion in his experience.

"There could have been more," Fred recalls, noting that overflow conditions in the parking areas kept many people from reaching the stage in time. Though he agrees exact numbers of how many people saw that show—not only the single-day ticket buyers, but how many came over from the campground to watch—are difficult to accurately assess, but by his estimation it was certainly the largest crowd in memory.

Jackson Browne has been a major force on the American music scene—folk and pop—since the early 1970s. While living in Los Angeles, he became friends with Glenn Frey and Don Henley, soon-to-be founders of The Eagles. Jackson co-wrote "Take It Easy" with Frey, and when it became one of the band's first major hits Jackson's star began to rise rapidly as well.

Before that Jackson had been one of many emerging singer-songwriters whose travels brought him on occasion to The Main Point, the legendary folk music venue in Bryn Mawr operated for many years by Jeanette and Bill Campbell. (In the club's origins Folksong Society founder George Britton and his wife Charlotte had also been partners).

It was at the annual Folk Alliance conference in Austin, Texas, earlier that year, Fred recalls, that he found himself in a four-way conversation that included Festival Chairman David Baskin and Gene Shay. The fourth person in the chat was Jackson's manager, Cree Miller, whose high-profile clientele also includes the various combinations of Crosby, Stills, and Nash—not to mention her own father, folksinger Joel Rafael, who has appeared at Philly Folk twice.

The trio from Philly knew full well that bringing Jackson to the Festival for his regular fee would be a major budget buster, but they agreed to pursue the matter to see what could be done. It turned out that Jackson's fond memories of the Philly folk music scene and The Main Point were special to him, and he was more than willing to make a special arrangement to appear at the Festival.

"Cree and I worked on it," Fred says. "Jackson and David [Lindley] were returning from a European tour right before the Festival in 2006. While we could not afford his regular rate . . . Jackson agreed to do the show for expenses—not a small amount, since it included travel and rehearsal time in New York, but *certainly* a gift to the Festival."

On top of the two-hour Main Stage performance that afternoon (a length rarely seen at the Festival), Fred notes that Jackson also took part with Cree's dad, Joel Rafael, in the "Ribbon of Highway" Woody Guthrie salute on the Camp Stage on Thursday, two nights before.

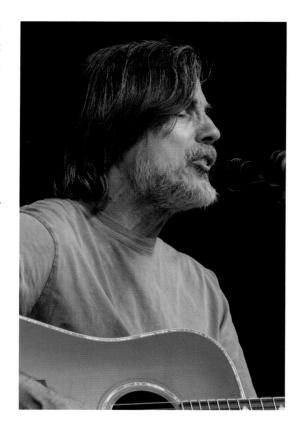

CHAPTER TEN

BY THE DECADES

PHILADELPHIA FOLK FESTIVAL PERFORMERS 1962-2017
(Listed by Year)

The following section provides a list of performers at each Philadelphia Folk Festival from 1962 through 2017. This list is based on best available records and resources. No attempt has been made to parse out the names of individual band members from the bands they appeared with, and in many cases that information may no longer be possible to ascertain with any accuracy. Similarly, many individual performers listed below may also have appeared in other years as members of a band shown in this list. Following the publication of this book, updates to this list will be published on the Festival website at www.folkfest.org.

THE 1960S

1962
Bonnie Dobson
Clarence Johnson and Mabel
 Washington
Gene Shay
Greenbriar Boys
Ken Goldstein
Obray Ramsay
Paul Cadwell
Pete Seeger
Ralph Rinzler
Ramblin' Jack Elliott
Reverend Gary Davis
Sonny Miller
Tossi Aaron

1963
Alix Dobkin
Almeda Riddle
Bart Singer
Bates McClean
Bill Keith

Bill Vanaver
Bob Grossman
Bob Yellin
Bonnie Dobson
Dave Van Ronk
Elizabeth Cotten
Esther Halpern
Folk Dance Leaders Council
Gene Shay
George Britton
Gospel Choir
Hedy West
Hobart Smith
Jean Redpath
Jim Kweskin Jug Band
JimmyMartin and the Sunny
 Mountain Boys
John Hurt
Judy Roderick
Ken Goldstein
Lonnie Johnson
Mike Seeger
Moravian Group
Pennsylvania Dutch Cloggers
Ralph Rinzler
Raun MacKinnon

Roger Abrahams
Sonny Miller
Suzanne Gross
Theodore Bikel
Tony Saletan
Tossi Aaron

1964
Andrews Balalaika Orchestra
Beers Family
Bernice Reagon
Bill Monroe and the Blue
 Grass Boys
Bill Thatcher
Bonnie Dobson
Doc Watson
Franconia Chorus
 (Mennonite)
Gene Shay
Germantown Bagpipe Band
Gil Turner
GTV Almrausch Tyrolean
 Dance
Hedy West
Hopezar Mid East Band

Ishangi Dance Group
Judy Collins
Judy Roderick
Ken Goldstein
Kilby Snow
Koerner, Ray, and Glover
Mike Seeger
Mitch Greenhill
Murv Shiner
Paul Cadwell
Phil Ochs
Roger Sprung
Tom Paxton
Tracy Schwarz

1965
Ali Akbar Khan
Arnold Keith Storm
Bagpipers
Beers Family
Buffy Sainte-Marie
Charlotte Daniels and Pat
 Webb
Dave Sear
Deirdre O'Callaghan

Gene Shay
Glenn Ohrlin
Grant Rogers
Greenbriar Boys
Ishangi Dance Group
Jackie Washington
Jean Redpath
Jean Ritchie
Judy Collins
Ken Goldstein
Kerr's Bal Caribe Dancers
Margaret Barry and Michael
 Gorman
Mitchell Trio
Moving Star Hall Singers
Patrick Sky
Paul Butterfield Band
The Pennywhistlers
Phil Ochs
Roger Sprung
Skip James
Theodore Bikel
Tom Paxton
Tom Rush

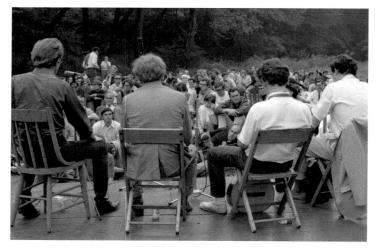

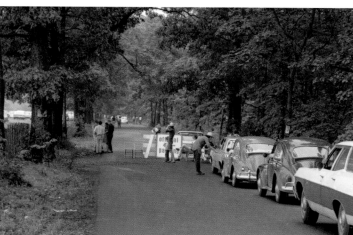

1966

Alec Campbell and Ola Belle
 Reed
Babatunde Olatunji
Beers Family
Bill Monroe and the Blue
 Grass Boys
Bob Yellin
Bonnie Dobson
Buddy Moss
Buffy Sainte-Marie
Carol Hunter
Dick Waterman
Doc Watson
Gene Shay
Grant Rogers
Ishangi Dance Group
Joe Heaney
John Hurt
Judy Collins
Judy Roderick
Junior Wells and Buddy Guy
Ken Goldstein
Len Chandler
Mabel Hillery

Mighty Kings
Mitchell Trio
Mount Nebo Gospel Choir
New Lost City Ramblers
Patrick Sky
The Pennywhistlers
Reverend Gary Davis
Robert Pete Williams
Roger Sprung
Russell Fluharty
Sara Grey
Shoshana Damari
Steve Gillette
Theodore Bikel
Tom Brandon
Tom Paxton
Tom Rush

1967

Art Rose
Beers Family
"Big Boy" Crudup
Bill Monroe and the Blue
 Grass Boys
Bob Davenport

Bob Goldman
Bonnie Dobson
Bruce Martin
Carolyn Hester
Charles Perdue Jr.
Chris Smither
Connie Williams
Dick Waterman
Doc Watson
Eric Andersen
Gene Shay
Gordon Bok
Guitar Wilson
Hedy West
Jackie Pack
Jerry Ricks
Jesse Fuller
Joe Heaney
John Basset
John Burke
John Dildine
Junior Wells
Ken Goldstein
Lanie Melamed
Len Chandler

Clockwise from left:
Louis Killen, 1967. Photo by Diana Davies

Norman Kennedy, 1967. Photo by Diana
Davies

Buddy Guy, 1968. Photo by Diana Davies

Gone swimmin', 1968. Photo by Diana
Davies

Swimming in Perkiomen Creek, 1968.
Photo by Diana Davies

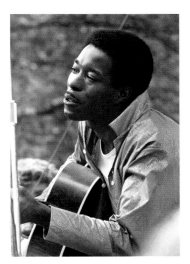

Leonda
Louis Killen
Margot Kurtz
Marty Singleton
Michael Cooney
Mike Miller
New Lost City Ramblers
Norman Kennedy
Old Reliable String Band
Oscar Brand
Owen McBride
The Pennywhistlers
Pete Seeger
Roger Sprung
Rooftop Singers
Rosalie Sorrels
Roy Berkeley
Sara Grey
Saul Broudy
Son House
Sons of the Birds
Steve Gillette
Tom Paxton
Tossi and Lee Aaron

Washboard Slim
William Brooks

1968

Andy Robinson
Beers Family
Bill Monroe and the Blue Grass Boys
Bill Vanaver
Bonnie Dobson
Bruce Martin
Buddy Guy
Carol Hunter
Charles River Valley Boys
Chris Smither
Dave Van Ronk
Denver, Boise and Johnson
Dick Waterman
Doc Watson
Emmylou Harris
Gene Shay
Gordon Bok
Hedge and Donna Capers
Henry Crow Dog

IGRA
Janis Ian
Jerry Jeff Walker
Joan Baez
Jody Stecher
Joe Heaney
John Jackson
Joni Mitchell
Ken Goldstein
Larchmont Sid Dermis
Louis Killen
Michael Cooney
Mike Miller
Norman Kennedy
Odetta
Oscar Brand
Patrick Sky
Paula Ballan
Penny Lang
The Pennywhistlers
Phil Ochs
Roger Sprung
Sara Cleveland
Skip James

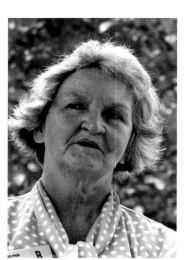

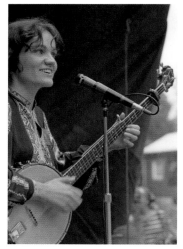

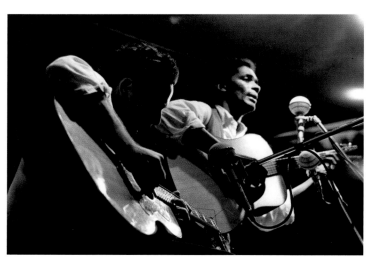

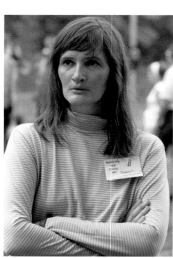

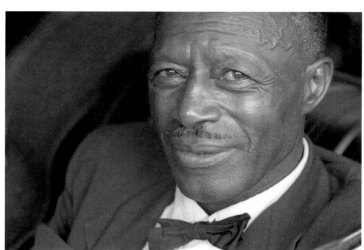

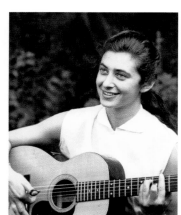

Son House
Steve Gillette
Sweet Stavin' Chain
William Brooks
Young Tradition

1969

Andy Robinson
Andy Wallace
Arthur Hall Afro-America
 Dance Ensemble
Balkan
Bill Brooks
Bill Monroe and the Blue
 Grass Boys
Bob Messenger
Bonnie Dobson
Bruce Martin
Bunky and Jake
Chicago Blues All Stars
Chris Smither
Danny Starobin
Dave Van Ronk
David Bromberg

Dick Waterman
Doc Watson
Eric Andersen
Frank Wakefield
Gene Shay
George Britton
Hamza El Din
Hedge and Donna Capers
Hoyle Osborne
Incredible String Band
Jean Redpath
Jerry Jeff Walker
Joe Heaney
John Basset
John Denver
John Hartford
John Jackson
Josh Dunson
Ken Goldstein
Leonda
Lloyd Miller
Louis Killen
Michael Cooney
Mike Miller

Norman Kennedy
Odetta
Oscar Brand
Patrick Sky
Paul Cadwell
Paul Geremia
The Pennywhistlers
Reverend Gary Davis
Richard Hughes
Rosalie Sorrels
Sara Grey
Sir Douglas Quintet
Stars of Faith
Sweet Stavin' Chain
Tanner Bros
Theodore Bikel
Tom Paxton
Tom Rush

Clockwise from top left:
The Young Tradition, 1968 (L-R): Peter Bellamy, Heather Wood, and Royston Wood. Photo by Diana Davies

Eric Andersen does an impromptu performance, 1967. Photo by Diana Davies

The Beers Family, 1968 (L-R): Martha Beers, Evelyne Beers, and Bob "Fiddler" Beers. Photo by Diana Davies

Main Stage, 1967. This was the debut of the Festival at Rahmer Park in Upper Salford Township. Four years later, it moved to the adjacent Old Pool Farm. Photo by Diana Davies

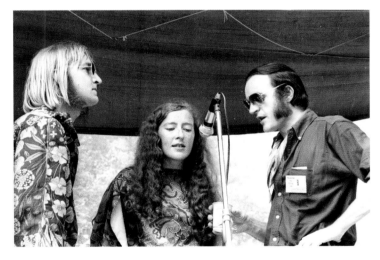

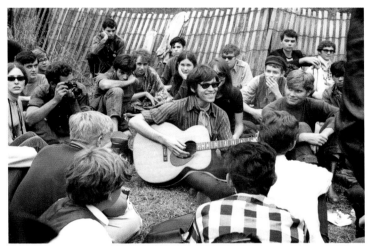

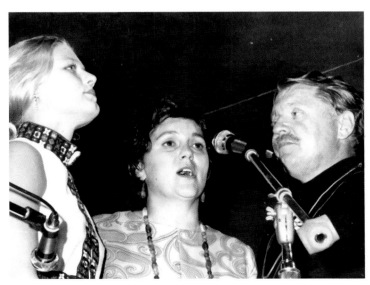

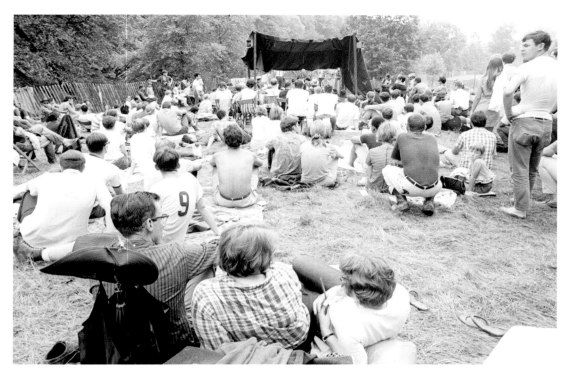

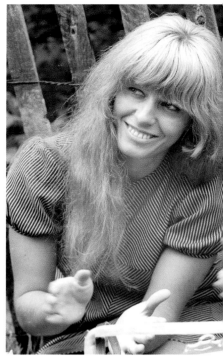

Top left: *A 1967 workshop.* Photo by Diana Davies

Top right: *Carolyn Hester, 1967.* Photo by Diana Davies

Center left: *Bernice Johnson Reagon with daughter Toshi, 1967.* Photo by Diana Davies

Center right: *Waiting out the rain, 1967.* Photo by Diana Davies

Bottom left: *Hedy West, 1967.* Photo by Diana Davies

Bottom right: *View from the Main Gate (1967), the first of four years the Festival was held at Rahmer Park.* Photo by Diana Davies

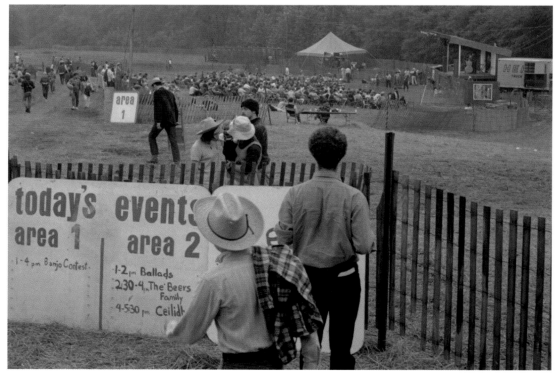

THE 1970S

1970
Allan Fraser and Donna
 DeBolt
Anne Byrne
Arthur Hall Afro-American
 Dance Ensemble
Artie and Happy Traum
Beers Family
Bonnie Raitt
Bruce Martin
Dave Cooper
Dave Van Ronk
David Bromberg
Doc Watson
Fairport Convention
Fred McDowell
Gene Shay
Hedge and Donna Capers
Hedy West
Sara Grey
Stars of Faith
Steve Goodman
Tanner Brothers
Tom Paxton
Tony Hughes
Tossi and Lee Aaron
Utah Phillips
Wildweeds

1971
Al Bluhm
Alan Stowell
Allan Fraser and Donna
 DeBolt
Allan Taylor
Arthur Hall Afro-American
 Dance Ensemble
Artie and Happy Traum
Battering Rams
Beers Family
Bessie Jones
Bill Danoff and Taffy Nivert
Bill Monroe and the Blue
 Grass Boys
Bill Vanaver
Bob Tanner
Bob White
Bonnie Raitt
Bruce Martin
Calvary Gospel Chorus
Chuck Klein
Dave Van Ronk
David Bromberg
Dewey Balfa Freres
Doc Watson
Doug Kershaw
Erik Frandsen
Flying Burrito Brothers
Gene Shay
Hedy West
Ian Campbell and Caroline
 Mitchell
J. B. Hutto and Hawks
Jack McGann
Janis Ian
Jeff and Gerret Warner
Jim Brewer
Joe Heaney
John Hartford
John Jackson
John Roberts and Tony
 Barrand
Johnny Morris
The Johnstons
Josh Dunson
Ken Goldstein
Kurt Anderson
Liam O'Flynn
Linda Morley
Louis Killen
Mac Wiseman
Martha Radcliff
Martin, Bogan and Armstrong
Michael Cooney
Mike Cohen
Mike Seeger
Nano Riley
Norman Kennedy
Oscar Brand
Owen McBride
Patrick Sky
Patty Nunn
Paul Cadwell
Paul Geremia
Paul Siebel
Paula Ballan
R. Paul Bergsman
Raun MacKinnon
Reverend Dan Smith
Richard Rachelson
Robin Roberts
Roger and Joan Sprung
Rosalie Sorrels
Saul Broudy
Steve Goodman
Tony Hughes
Topper Carew
Utah Phillips
Walter Scott and Rich Hughes
Wildflowers
Wilfred Guillette

1972
Alice Seeger (Alice Gerrard)
Arthur Hall Afro-American
 Dance Ensemble
Beers Family
Bessie Jones
Bill Jackson
Bonnie Raitt
Boys of the Lough
Bruce Martin
Captain Bob Tuesday Nite
 Band
Chuck Klein
Country Gentleman of
 Virginia
David Bromberg
Dewey Balfa and Freres
 (Balfa Brothers)
Diana Markovitz
Dianne Davidson
Dietrich Odes
Don McLean
Doris Abrahams
Elizabeth Cotten
Erik Frandsen
Fairport Convention
Gene Shay
George Houvardis
Hazel Dickens
Janis Ian
Jean Redpath
Jeff and Gerret Warner
Joe Heaney
John Hartford
John Herald
John Prine
John Roberts and Tony
 Barrand
John Vesey Ceilidh Band
Jose Borges
Josh Dunson
Keith Sykes
Ken Goldstein
Ken Kosek
Larry Packard
Leo Arons
Loudon Wainwright III
Louis Killen
Mance Lipscomb
Margaret MacArthur
Maria Muldaur
Marshall Dodge
Martin, Bogan and Armstrong
Mike Seeger
Norman Kennedy
Otis Rush Blues Band
Owen McBride
Paul Cadwell
Peter Yarrow
Princeton Ethnic Dancers
Raun MacKinnon
Reverend Dan Smith
Sara Cleveland
Sara Grey
Saul Broudy
Steve Goodman
Strange Creek Singers
Topper Carew
Trinidad Steel Band
Utah Phillips

1973
Arnie Solomon
Arthur Hall Afro-American
 Dance Ensemble
Bai Konte
Benny Kalanzi
Bessie Jones
Bill Dicey
Bob Gibson
Boys of the Lough
Breakfast Special
Bruce Cockburn and Bernie
 Brothers
Bruce Martin
Bryan Bowers
Children of Skymont
Chuck Klein
Dan Stover
David Bromberg

Diana Markovitz
Doris Abrahams
Downchild Blues Band
Eric and Justin Kay
Erik Frandsen
Frankie Armstrong
Fred Holstein
Freddie Moore
Gene Shay
Hamilton Camp
Heidi Barton
Highwoods String Band
Holly Tannen
Homesick James
Ile-Ife
Jake and Family Jewels
Janis Ian
Jeff Gutcheon
Jim Croce
Joe Heaney
John Davis
John Roberts and Tony
 Barrand
Kate McGarrigle
Ken Goldstein

Kendall
Leon Redbone
Leslie Berman
Lilly Brothers
Los Quinchamali
Loudon Wainwright III
Louis Killen
Louisiana Red
Maria Muldaur
Mark Ross
Marshall Dodge
Mick Moloney
Murray McLaughlan
Norman Kennedy
Owen McBride
Patrick Chamberlain
Paul Berliner
Paul Cadwell
Paula Ballan
Raun MacKinnon
Sara Cleveland
Saul Broudy
Sippie Wallace
Sonny Terry and Brownie
 McGhee

Steve Burgh
Steve Goodman
Tex Logan
Topper Carew Group
Victoria Spivey
Wilf Wareham

1974
Abby Newton
Alan Wolfersberger
Alistair Anderson
Arlo Guthrie
Arnie Solomon
Barbara Barrow
Bruce Cockburn
Bruce Martin
Buffalo Gals
Caryl P. Weiss
Chuck Klein
Dan Ruvin
David Amram
David Bromberg
Deadly Nightshade
Dennis Brooks
Diana Markovitz

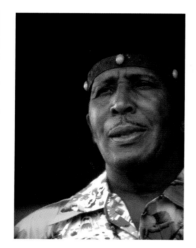
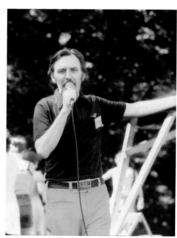

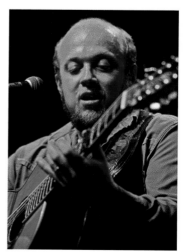
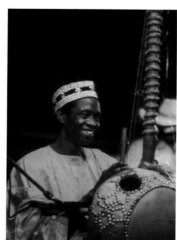

Diane Davidson
Don Lange
Don Pedersen
Don Reno
Doug Freeman
Edith Wilson
Elizabeth Corrigan
Eric Jensen
Eugene O'Donnell
Fabulous Torpedoes
Frankie Armstrong
Gamble Rogers
Gene Shay
Giles Losier
Glenn Ohrlin
HannyBudnick
Holly Tannen
Jack McGann
James Jesse Boozer
Jay Ungar
Jean Carignan
Jim Couza
John Hartford
John Prine
Johnny Morris

Ken Goldstein
Kevin Roth
Larry Johnson
Leo Arons
Leon Redbone
Leslie Smith
Little Brother Montgomery
Lynn Ungar
Martin Carthy
Mick Moloney
Mike Smith
Murray McLaughlan
Nano Riley
Norman Blake
Patrick Chamberlain
Patrick Sky
Paul Cadwell
Peg Leg Sam
Peter Eckland
Putnam String County Band
Roger Sprung
Sailor Bob Schmidt
Sandy Zerby
Saul Broudy
Skookill Express

Snuffy Jenkins and Pappy
 Sherrill
Steve Mandell
Tarheel Slim
Tom Rush
Victoria Spivey

1975

Alanis Obomsawim
ArchieFisher
ArthurHall Afro-American
 Dance Ensemble
Bertilla Baker
Bill Vanaver
Boys of the Lough
Bruce Martin
Bryan Bowers
Colleen Peterson
Dan Ruvin
David Amram
David Bromberg
Elizabeth Corrigan
Eric Jensen
Esther Halpern
Eugene O'Donnell

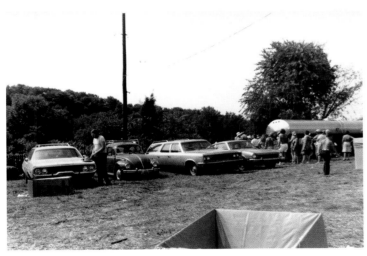

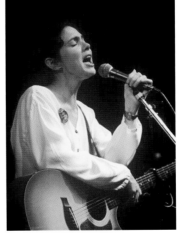

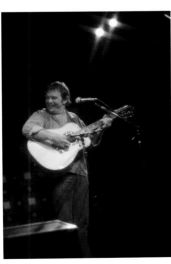

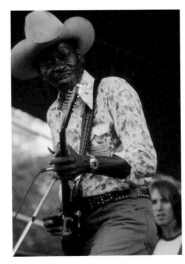

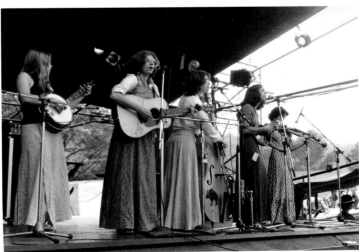

Fats Kaplin
Gamble Rogers
Gene Shay
Green Grass Cloggers
Hedy West
Highwoods String Band
Hirten Family
Jack McGann
Jackie Pack
Jean Ritchie
Jim Couza
Joey George
John Peterson
John Roberts and Tony
 Barrand
John Roussos
Kate and Anna McGarrigle
Ken Bloom
Ken Goldstein
Leo Arons
Leslie Smith
Lewis Brothers
Martin, Bogan and Armstrong
Michael Cooney
Mick Moloney
The National Recovery Act
Ola Belle Reed
Pat Alger
Patrick Chamberlain
Paul Cadwell
Paul Siebel
Paula Ballan
Princeton Ethnic Dancers
Professor Longhair
Regis Mull
Roger Sprung
Rosalie Sorrels
Roy Book Binder
Saul Broudy
Slippery Elm
Star Spangled Washboard
 Band
Steve Burgh
Sue White and Cathy Ramos
Suzanne Gross
Sweet Honey in the Rock
Tambo
Tom Paxton
Utah Phillips
Vin Garbutt
Willa Ward Gospel Group

1976
Archie Fisher
Arthur Argo
Bruce Martin
Charlie Chin
Clarence "Gatemouth" Brown
Claudia Schmidt
Clyde Bernhardt
Coteau

Dan Ruvin
David Amram
David Bromberg
Diane Davidson
Doris Abrahams
Eugene O'Donnell
Gamble Rogers
Gene Shay
Green Grass Cloggers
Harlem Blues and Jazz Band
Heather Wood
Hedy West
Hickory Wind
Hirten Family
Homer and Jethro
Hotmud Family
How to Change a Flat Tire
Janis Ian
Jeff Pollard
Jim Couza
Jim Post
John Allan Cameron
John Hartford
Johnny Morris
Julie Lieberman
Ken Bloom
Leo Arons
Lew London
Marilyn Quine
Mark Ross
Marshall Dodge
Martin Harris
Martin, Bogan and Armstrong
Merle Travis
Mick Moloney
New Grass Revival
No Relation
Patrick Chamberlain
Paul Cadwell
Peter Eckland
Pullin' Teeth
Richard Fegy
Robbie MacNeill
Robin Williamson
Roosevelt Sykes
Royston Wood
Saul Broudy
Stephen Wade
Steve Burgh
Steve Goodman
Susie Monick
Winnie Winston

1977
Alan Jabbour
Aly Bain
Arwen Mountain String Band
Bally Hoo String Band
Beverly Robinson
Bluegrass Cardinals
Bodie Wagner

Bruce Martin
Bruce Yasgur
Cathy Fink
Charles Sayles
Dave Gillies
Dave Van Ronk
David Amram
De Dannan
Don Cogan
Don McLean
Duck Donald
Eugene O'Donnell
Flying Cloud
Folk Tellers
Fred Holstein
Gene Shay
George Gritzbach
Green Grass Cloggers
Highwoods String Band
J.P. and Annadeene Fraley
Jackie Pack
Jean Ritchie
Jim Couza
Jim Post
Jim Ringer
Jim Six
John Herald
John Jackson
Juggernaut String Band
Kalanit Dancers
Kate Wolf
Ken Goldstein
Kevin Roth
Lew London
Louis Killen
Louisiana Red
Mary Faith Rhoads
Mary McCaslin
Michael Cooney
Mick Moloney
Mickey Clark
Norman and Nancy Blake
Northern Lights
Odetta
Ola Belle Reed
Outward Bound
Owen McBride
Priscilla Herdman
Red Clay Ramblers
Reverend Dan Smith
Roger and Gail Casey
Roger Sprung
Sacred Harp Group
Sara Grey
Saul Broudy
Scrub-Board Slim
Star Spangled Washboard
 Band
Stephen Wade
Steppup Puppets
Stretch Pyott

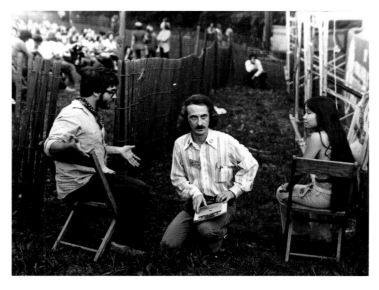

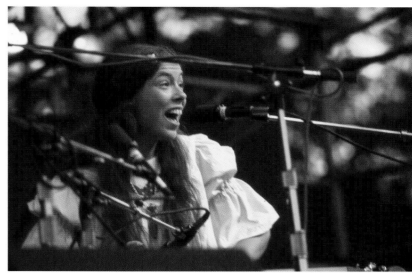

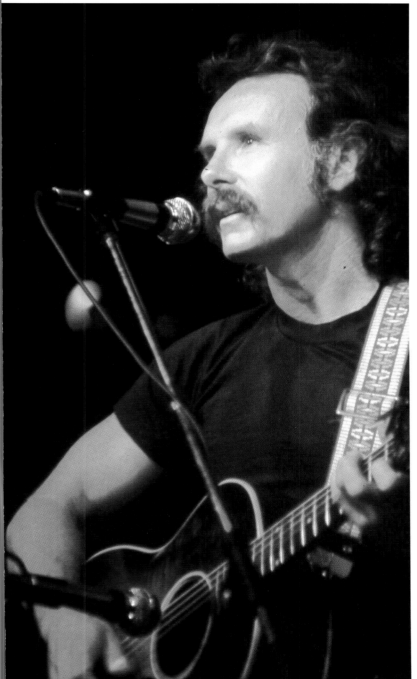

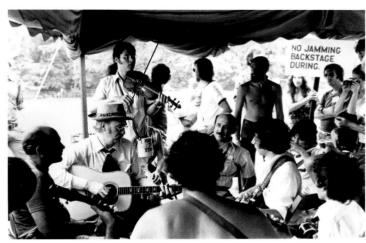

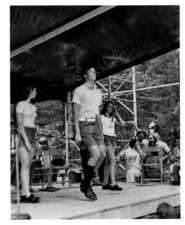

Clockwise from top left:
Volunteer conference, 1973. Philadelphia Folksong Society Archives

Claudia Schmidt, 1976. Photo by Barry Sagotsky

Backstage jam, early 1970s. At center right with banjo is John Hartford. Philadelphia Folksong Society Archives

The Hirten Family, circa 1975. Philadelphia Folksong Society Archives

Henry Crow Dog, circa 1970. Philadelphia Folksong Society Archives

Jim Post, 1978. Photo by Barry Sagotsky

Simon St. Pierre
Skyline
Sparky Rucker
Stan Rogers
Steve Goodman
Stretch Pyott
Suni Paz
Ted Lundy and Bob Paisley
Tim Britton
Tom Paxton
Tom Winslow
Trapezoid
Utah Phillips
Wendy Grossman
Winnie Winston
Zenith String Band

1979
Al McKenney
Alhaji Bai Konte
Apple Chill Cloggers
Arlo Guthrie
Backwoods String Band
Barbara Reimensnyder
Barde
Bill Staines
Blind John Davis
Bob Gibson
Bruce Martin

Buck White
Chicken Spankers
Chris Smither
Cindy Mangsen
Dan Ruvin
Dave Gillies
Dave Swarbrick
Dave Van Ronk
David Amram
Don McLean
Elizabeth Cotten
Esther Halpern
Fennig's All-Star String Band
Gamble Rogers
Gary Mehalick
Gene Shay
Hamilton Camp
Hang The Piper
High Level Ranters
Honolulu Heartbreakers
Jim and Jesse and the Virginia
	Boys
Jim Couza
Jim Craig
Josh White Jr.
Ken Goldstein
Koko Taylor and Her Blues
	Machine
Liverpool Judies

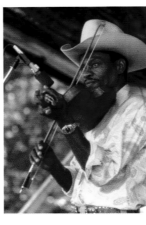

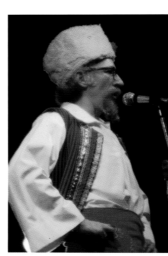

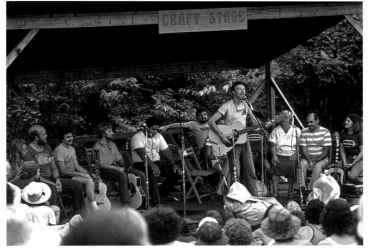

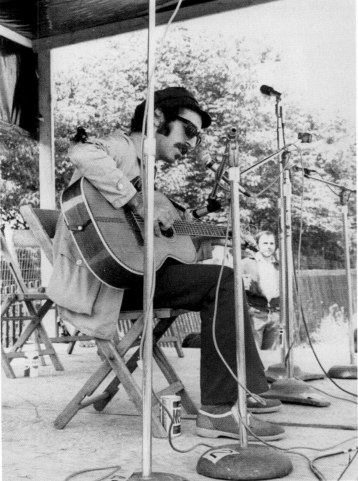

Clockwise from top left:
Dave Swarbrick, circa 1979. Photo by Wanda Fischer

Pete Seeger leads a workshop on the Craft Stage, 1976. At far left are Garnet and Stan Rogers. Louis Killen is behind Pete in the gold shirt. Photo by Robert Corwin

Howard Yanks, a longtime President of the Folksong Society, 1973. Philadelphia Folksong Society Archives

Maria Muldaur, circa 1973. Photo by Barry Sagotsky

Stephen Wade, 1978. Photo by Barry Sagotsky

Cooling off in the Perkiomen, 1973. Photo by Barry Sagotsky

Jim Croce (R) and Maury Muehleisen, 1970. Philadelphia Folksong Society Archives

Leon Redbone, circa 1974. Philadelphia Folksong Society Archives

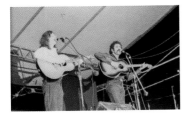

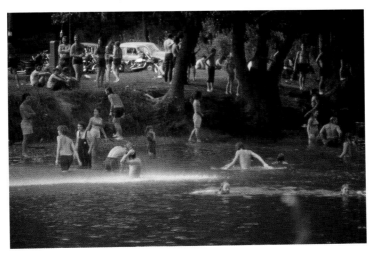

159

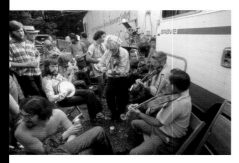

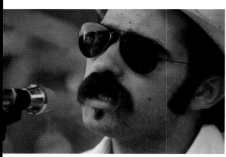

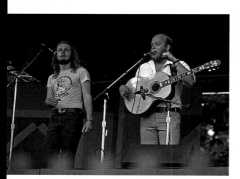

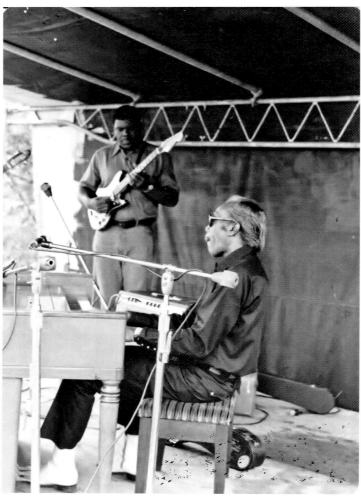

Above, top to bottom:
Backstage jam, 1974. The standing fiddler is Eugene O'Donnell. The banjo player is Mick Moloney. Philadelphia Folksong Society Archives

Roy Book Binder, 1975. Photo by Barry Sagotsky

Brothers from Nova Scotia Garnet (L) and Stan Rogers, 1976. Photo by Robert Corwin

Above, center: Professor Longhair (Henry Byrd), 1975. Photo by Steve Ramm

Right, top to bottom: Dianne Davidson, circa 1974. Photo by Wanda Fischer

Jaime Brockett, 1970. Photo by Wanda Fischer

Alhaji Bai Konte, 1973. Photo by Barry Sagotsky

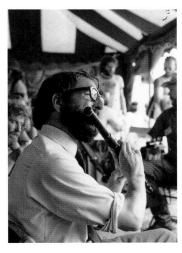

Clockwise from top left:
Ken Goldstein (L) and Utah Phillips, 1979.
Photo by Robert Corwin

Gene Shay (L) with veteran volunteer Bert Shackerman, 1975. Photo by Steve Ramm

Cathal McConnell (Boys Of The Lough), circa 1975. Photo by Steve Ramm

Howard Armstrong (Martin, Bogan, and Armstrong), 1974. Photo by Barry Sagotsky

Don McLean, circa 1977. Photo by Barry Sagotsky

The Star-Spangled Washboard Band, circa 1977. Philadelphia Folksong Society Archives

Reverend Dan Smith, circa 1971. Photo by Barry Sagotsky

Maria Muldaur, 1973. Photo by Barry Sagotsky

161

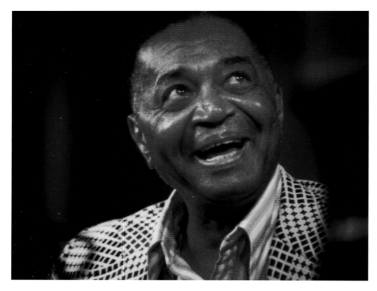

Clockwise from top left:
Archie Edwards, 1978. Photo by Barry Sagotsky

Norman Blake, 1974. Photo by Barry Sagotsky

Green Grass Cloggers, 1978. Photo by Barry Sagotsky

1974 workshop, "Wind Instruments, Real and Imagined," featuring David Amram (red shirt), Saul Broudy (center, blue shirt) and "Peg Leg Sam" (Arthur Jackson). Photo by Barry Sagotsky

Gene Shay and an unidentified audience member share a moment, 1970s. Photo by Barry Sagotsky

Murray McLaughlin, 1974. Photo by Barry Sagotsky

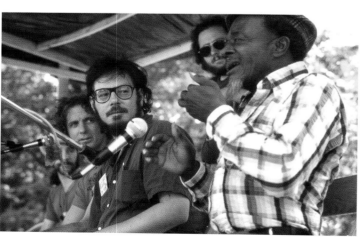

Clockwise from top left:
Roy Book Binder (L) and Fats Kaplin, 1975. Photo by Steve Ramm

Koko Taylor, "Queen Of The Blues," 1979. Photo by Barry Sagotsky

Eugene O'Donnell, 1978. Photo by Barry Sagotsky

Peter Paul Van Camp, 1979. Photo by Barry Sagotsky

Owen McBride, circa 1971. Photo by Wanda Fischer

"Bawdy Songs" workshop, early 1970s. Owen McBride is at left with guitar, Dave Van Ronk is at center, and John Roberts and Tony Barrand are at far right. Photo by Wanda Fischer

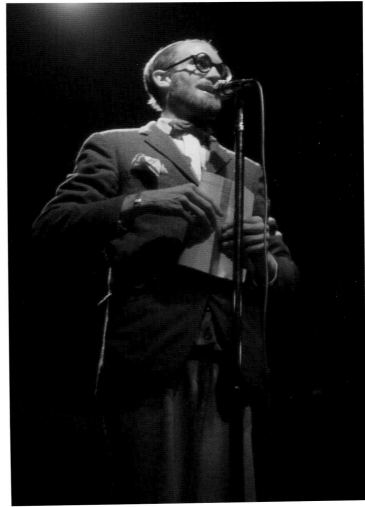

THE 1980S

1980

Andy Breckman
Backwoods String Band
Beverly Cotton
Bill Staines
Bob Zentz
Bruce Martin
Cabin Fever
Dan Crary
Dan Ruvin
Dave Gillies
David Amram
David Mallett
Debbie McClatchy
Doc Watson
Don and Barb Golden
Ed Henderson
Eric Andersen
Erik Frandsen
Eugene O'Donnell
Fiddle Puppets
Figgy Duff
Folk Tellers
Gene Shay
Guy Van Duser and Billy
 Novick
Hot Rize
James Cotton
James Turner
Jim Albertson
Jim Couza
Johnny Morris
Johnston Brothers
Juggernaut String Band
Katie Laur
Ken Goldstein
Linda Cohen
Lisa Null and Bill Shute
Liverpool Judies
Liz Carroll
Louis Killen
Mary Travers
Maryland Pace Steel
 Orchestra
Michael Feldman
Michael, McCreesh and
 Campbell
Mick Moloney
Mike Miller
Na Cabarfeidh (Rare Air)
Nick Seeger
Nova
Oscar Brand
Persuasions
Priscilla Herdman
Rob Peck
Roger Sprung

Ron Evans
Saul Broudy
Sean McGlynn
Sonny Terry and Brownie
 McGhee
Spencer Nelson
Stretch Pyott
Taj Mahal
Tim Britton
Tim Harrison
Tom Rush
Tony Bird
Tracy Family Band

1981

Aztec Two-Step
Battlefield Band
Bill Harrell and the Virginians
Bo Diddley
Bosom Buddies
Bruce Martin
Buck White
Buskin and Bateau
Cabin Fever
Caryl P. Weiss
Charlotte Micklos
Dan Ruvin
Dave Gillies
Dave Van Ronk
David Jones
David Mallett
De Dannan
Duke Brier Patch Puppets
Eclectricity
Ed Stivender
Erik Frandsen
Esther Halpern
Fiddle Puppets
Gene Shay
George Britton
Hotmud Family
Jackie Pack
Jim Albertson
Jim Couza
Jim Mageean
Jim Ringer and Mary
 McCaslin
Jimmy Johnson Blues Band
Joel Shoulson
John Pearse
Johnny Cunningham
Jonathan Edwards
Ken Goldstein
Leo Arons
Loudon Wainwright III
Mary Faith Rhoads
Michael Cooney
Mike Miller
Murray Callahan
Pepe Castillo-Criolla
Persuasions

Philadelphia Tap Dancer
Polish American String Band
Ray Gray
Red Clay Ramblers
Richie Havens
Riders in the Sky
Robin and Linda Williams
Roger Sprung
Rolly Brown
Rosalie Sorrels
Saul Broudy
Scott Alarik
Spencer Nelson
Stretch Pyott
The Roches
Toby Fagenson
Tom Gala
Tom Rush
Tom Winslow
Twelve Moon Storytellers
Wareham Family

1982

Andy Breckman
Ar Log
Bonnie Dobson
Bruce Martin
Bryan Bowers
Buddy Guy
Caryl P. Weiss
Dan Ruvin
Dave Gillies
David Massengill
Dewey Balfa
Disco Queen and King
Doc Watson
Doyle Lawson and
 Quicksilver
Eclectricity
Eric Andersen
Eric Bogle and John Munro
Esther Halpern
Fiddle Fever
Frankie Armstrong
Gamble Rogers
Gene Shay
George Gritzbach
Gerry Hallom
Huxtable, Christensen and
 Hood
Jean Ritchie
Joe and Antoin McKenna
John McEuen
Johnny Morris
Johnston Brothers
Judith Fox
Ken Goldstein
Kevin Roth
Klezmorim
Leo Arons
Linda Goss

Mike Cross
Mike Miller
Mike Seeger
Mill Creek Cloggers
Mock Turtle Marionette
 Theater
Nevard Barrelhouse
Oscar Brand
Outward Bound
Priscilla Herdman
Queen Ida
Quilt
Rob O'Connell
Robin and Linda Williams
Roger Sprung
Sally Rogers
Saul Broudy
Scott Alarik
Skyline
Son Seals Band
Spencer Nelson
Spoons Williams
Steve Cormier
Stretch Pyott
Swallowtail
Sweet Accord
Toby Fagenson
Tom Paxton
Tracy Family Band
"Washboard Slim" Young

1984
Albert Collins
Annie and Lynn
Arlo Guthrie
Baltimore Consort

Bob Brozman
Bob Carlin
Bonnie Phipps
Bruce Martin
Buskin and Bateau
Canebreak Rattlers
Claudia Schmidt
Critton Hollow String Band
Dan Ruvin
Dave Gillies
David Mallett
Don Merlino
Doug Dillard Band
Ed and Joe Reavy
Faith Petric
Fiddle Puppets
Folk Tellers
Fred Small
Fry Yellow Moon Jamb
Gamble Rogers
Gene Shay
Hall and Peabody
Jackie Pack
Jim Ringer and Mary
 McCaslin
Joel Mabus
John Hammond
John Herald
John Sebastian
Johnny Morris
Josh White Jr.
Josh White Singers
Judy Small
Ken Goldstein
Kinvara
Klezmer Conservatory

Leftwich, Higginbotham and
 Ritchie
Leo Arons
Magpie
Mike Agranoff
Mike Cross
Mike Miller
Moira O'Casey
Nick Plakius
Otis Bros
Patrick Sky
Ramblin' Jack Elliott
Red Clay Ramblers
Reilly and Maloney
Roger Deitz
Roger Sprung
Roy Book Binder
Saul Broudy
Si Kahn
Sonny Terry
Spencer Nelson
Stretch Pyott
Swallowtail
Tom Rush
Touchstone
Trapezoid
Washington Square

1985
Aileen and Elkin Thomas
Archie Fisher
Artie and Happy Traum
Battlefield Band
Belle Stewart
Bill Morrissey
Bob Carlin

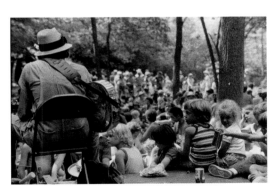

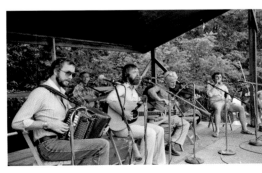

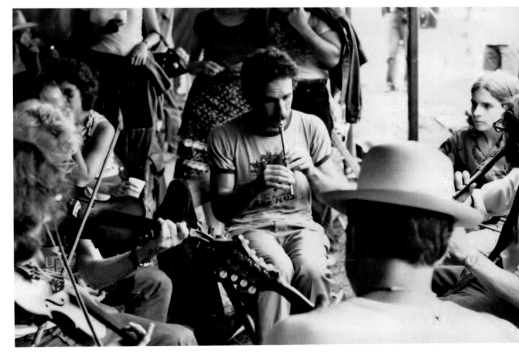

Bruce Martin
Buskin and Bateau
Caryl P. Weiss
Cathy Fink
Dan Ruvin
Dave and Kay Gordon
Dave Gillies
Dave Van Ronk
David Bromberg
Deborah Pieri
Duke Brier Patch Puppets
Frank Christian
Garnet Rogers
Gene Shay
George Gritzbach
George Russell
Ian and Mary Kennedy
Jane Gillman
Jim Post
John Gorka
John Hartford
John McCutcheon
John Roberts and Tony Barrand
Johnny Morris

Judy Small
Ken Goldstein
Ken Perlman
Kevin Roth
Koko Taylor and Her Blues Machine
Leo Arons
Louis Killen
Lucille Reilly
Margaret MacArthur
Michael Cooney
Mike Agranoff
Mike Cross
Mike Miller
Nanci Griffith
Pierre Bensusan
Queen Ida
Reel World Band
Reilly and Maloney
Robin Moore
Roger Deitz
Roger Sprung
Rory Block
Saul Broudy
Seldom Scene

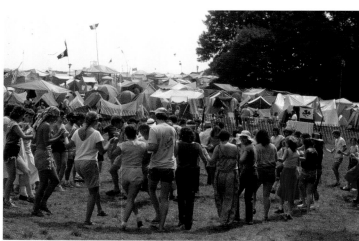

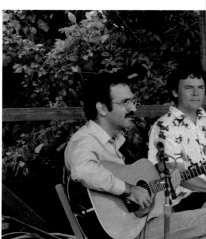

Dan Ruvin
Dave Gillies
Dave Sear
David Amram
David Bromberg
De Dannan
Doc Watson
Elizabeth Cotten
Eric Andersen
Esther Halpern
Eugene O'Donnell
Frankie Armstrong
Gamble Rogers
Gene Shay
Greenbriar Boys
Hamish Moore
Jackie Pack
Jonathan Edwards
Judy Collins
Junior Wells
Kevin Roth
Kim and Reggie Harris
Leo Arons
Liverpool Judies
Lo Jai

Loudon Wainwright III
Michael Cooney
Mick Moloney
Mike Agranoff
Mike Cross
Mike Dugan
Mike Miller
Mountain Laurel
Orlando Puntilla
Orrin Star
Oscar Brand
Patty Larkin
Paula Lockheart
Peter Alsop
Polish American String Band
Ray Kamalay
Richie Havens
Robin and Linda Williams
The Roches
Rod MacDonald
Roger Deitz
Roger Sprung
Ruth Pelham
Saul Broudy
Spencer Nelson

Steve Gillette
Stretch Pyott
Tom Chapin
Tom Coughlin
Tom Dahill
Tom Paxton
Tom Rush

1987
Aileen and Elkin Thomas
Archie Fisher
Big Night Out
Bill Staines
Bob Carlin
Bob Franke
Bob Pasquarello
The Bobs
Bruce Martin
Bryan Bowers
Cathy Fink
Christine Lavin
Cindy Mangsen
Dan Ruvin
Dave Fry
Dave Gillies

Clockwise from top left:
John Jackson, 1989. Photo by Jayne Toohey

Eric Andersen, 1986. Photo by Ellen Nassberg

Paula Lockheart, circa 1986. Photo by Barry Sagotsky

Suzanne Vega, 1985. Photo by Robert Corwin

Alison Krauss and Union Station, 1988 (L-R): Mike Harman, Alison Krauss, John Pennell, and Jeff White. Photo by Robert Corwin

Riding on Mom's shoulders, circa 1984. Photo by Barry Sagotsky

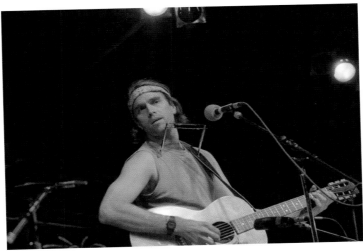

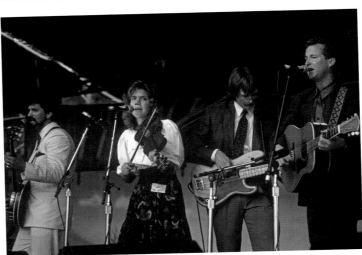

Fiddle Puppets
Free Hot Lunch
Garnet Rogers
Gene Shay
George Gritzbach
Hans Theessink
Holly Near
Janet Peters
Jay Ansill
Jemma Walsh
Jim Albertson
John Hartford
John Sebastian
Ken Goldstein
Leo Arons
Leon Redbone
Livingston Taylor
Louis Killen
Marian Barnes
Mary Chapin Carpenter
Michael Cooney
Mike Agranoff
Mike Miller
Moses Rascoe
Ned Bachus
Norman and Nancy Blake
Queen Ida
Ray Kamalay
Red Clay Ramblers
Reilly and Maloney

Roger Deitz
Roger Sprung
Roy Book Binder
Saul Broudy
Scartaglen
Sechaba
Seldom Scene
Skyline
Spencer Nelson
Steeleye Span
Stretch Pyott
Tim Britton
Tuckers Tales Puppets
Uncle Bonsai
Walt Michael and Company

1988

Alistair Anderson
Allison Krauss and Union
 Station
Bill Miller
Bob Carlin
Bruce Martin
Clarence "Gatemouth" Brown
Cliff Eberhardt
Dan Ruvin
Dave Gillies
Doc Watson
Ed Stivender
Esther Halpern

Eve Rantzer
Filé
Free Hot Lunch
Gene Shay
George Neff
Glen Morningstar
The Horse Flies
Jay Ansill
Jim Albertson
John Renbourn and Stefan
 Grossman
Jug Band
Just Friends
La Bottine Souriante
Leo Arons
Magpie
Marcy Marxer
Maria Muldaur
Mary Chapin Carpenter
McLain Family Band
Melanie
Michael Cooney
Mickie Singer-Werner
Mike Agranoff
Mike Cross
Mike Miller
Moses Rascoe
New Lost City Ramblers
New Saint George
Ossian

Patty Larkin
Paul Geremia
Paula Lockheart
Plywood Cattle Company
Quilt
Robin and Linda Williams
Roger Deitz
Roger Sprung
Rolly Brown
Shawn Colvin
Skye Morrison
Sotavento
Spencer Nelson
Stewarts of Blair
Stretch Pyott
Taj Mahal
Tom Gala and Richard
 Drueding
Tom Paxton
Tom Rush
Tom Winslow

1989
Anne Hills
Ashley Cleveland
Bill Miller
Bob Brozman
Bob Carlin
Bruce Martin
Buskin and Bateau

Carolyn Hester
Caryl P. Weiss
Claudia Schmidt
Dan Ruvin
Dave Gillies
David Bromberg
David Jones
Deborah Pieri
Dry Branch Fire Squad
Eddy "The Chief" Clearwater
Fairfield Four
Fred Koller
Gene Shay
George Gritzbach
Guy Clark
Hanny Budnick
The Heartbeats
The House Band
Ira Bernstein
Jackie Pack
Jay Ansill
Jerry Jeff Walker
Jim Albertson
Joe Heukerott
John Jackson
John Roberts and Tony
 Barrand
Jonathan Edwards
Judy Gorman
Katie Webster

Ken Goldstein
Kimati Dinizulu
Kingsessing Morris Men
Leo Arons
Lewis Brothers
Linden Sherwin
Lisa Pack-Miller
Lou and Peter Berryman
Loudon Wainwright III
Louise Sherman
Michael Cooney
Mike Agranoff
Mike Cross
Mike Miller
Original Hurdy Gurdy Man
Patrick Street
Peggy Atwood
Percy Danforth
Priscilla Herdman
Queen Ida
Robert Earl Keen
Robin Williamson
Roger Deitz
Roger Sprung
Rory Block
Sally Rogers
Sileas
Spencer Nelson
Stretch Pyott

Clockwise from top left:
At the Camp Stage, 1980. Photo by Ellen Nassberg

The "Groundz Signal Mast" with Paul "Indian" Antonini, late 1980s. Philadelphia Folksong Society Archives

John Sebastian, 1984. Photo by Robert Corwin

Jay Ungar (Fiddle Fever), 1982. Photo by Ellen Nassberg

Workshop with (L-R) Priscilla Herdman, Oscar Brand, Tom Paxton, and Michael Cooney, 1983. Photo by Ellen Nassberg

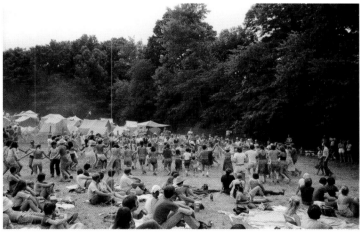

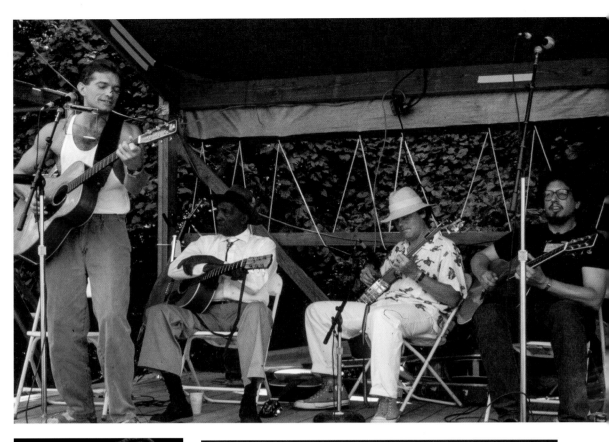

Clockwise from top:
Blues workshop (1989) with (L-R) George Gritzbach, John Jackson, Michael Cooney, and David Bromberg. Photo by Jayne Toohey

Guy Clark, 1989. Photo by Robert Corwin

Ruthie Foster, 1986. Photo by Ellen Nassberg

George Gritzbach, 1982. Photo by Ellen Nassberg

Junior Wells, 1986. Photo by Barry Sagotsky

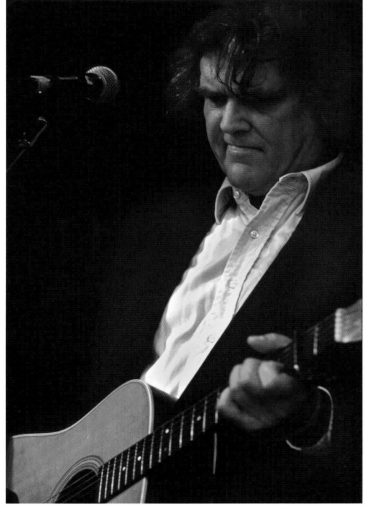

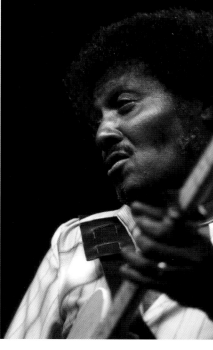

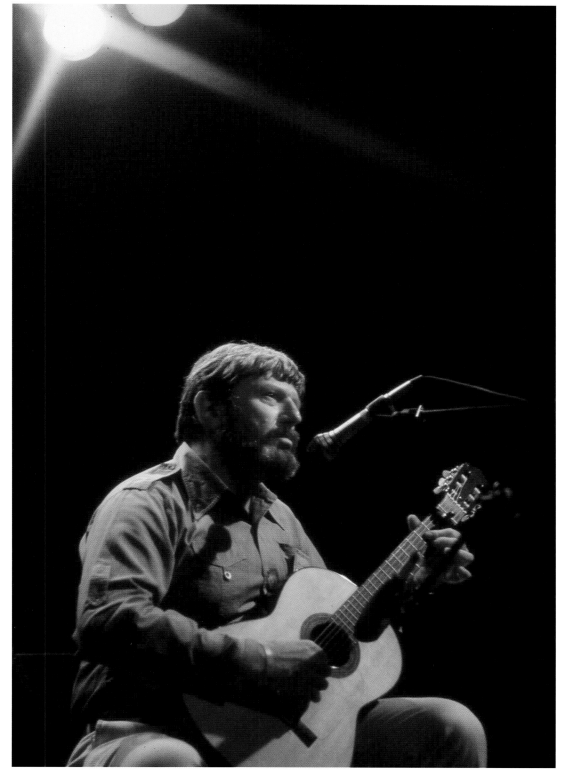

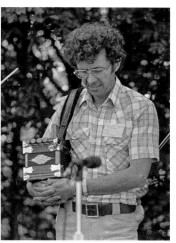

Clockwise from top left:
Albert Collins, 1984. Photo by Barry Sagotsky

Dewey Balfa, 1982. Photo by Ellen Nassberg

Albert Collins, 1984. Photo by Robert Corwin

Tracy Schwarz, 1982. Photo by Ellen Nassberg

Theodore Bikel, 1981. Photo by Barry Sagotsky

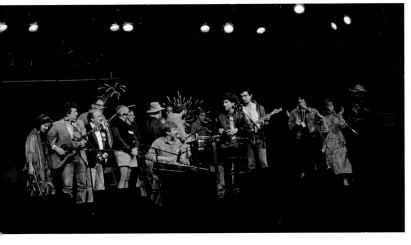

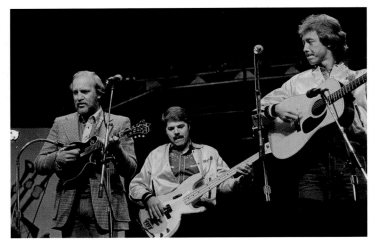

Clockwise from top left:
Tom Rush and friends, 1986. Photo by
Jayne Toohey

Doyle Lawson (L) and Quicksilver, 1982.
Photo by Ellen Nassberg

Brownie McGhee, 1980. Photo by Robert
Corwin

Jay Ansill, 1982. Photo by Ellen Nassberg

Queen Ida, circa 1985. Philadelphia
Folksong Society Archives

Saul Broudy, 1982. Photo by Ellen
Nassberg

Tom Chapin, 1986. Photo by Ellen Nassberg

Clockwise from top left:
Saturday afternoon at the Craft Stage,
1986. Photo by Jayne Toohey

David Buskin and Robin Batteau, circa
1985. Photo by Richard Howard

The Upper Salford Fire Company to the
rescue on a sweltering afternoon, early
1980s. Philadelphia Folksong Society
Archivesv

Brownie McGhee, 1980. Photo by Barry
Sagotsky

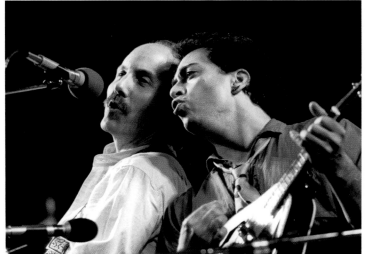

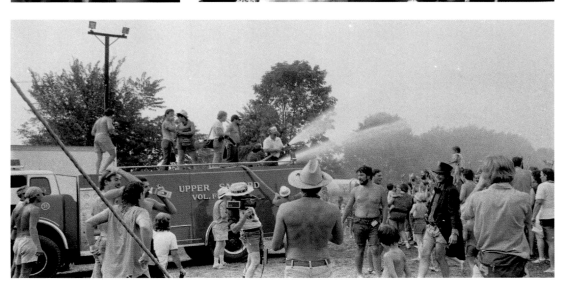

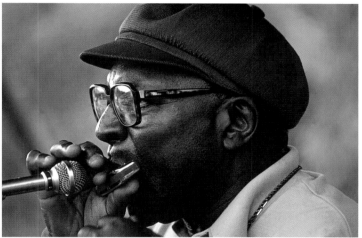

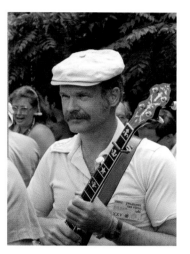

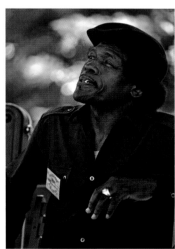

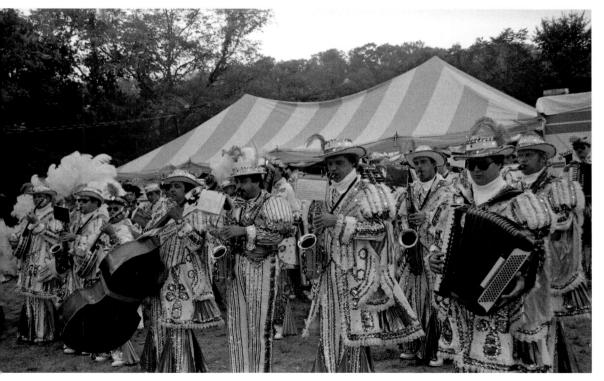

THE 1990S

1990

Anndrena Belcher
Anne Hills
BeauSoleil
Bob Gibson
Bruce Martin
Carnloch
Cathy Fink and Marcy Marxer
Cheryl Wheeler
Chris Smither
Christine Lavin
Cindy Mangsen
Cliff Eberhardt
Dan Ruvin
Dave Gillies
Dave Van Ronk
David Amram
David Roth
Eddy "The Chief" Clearwater
Fred Koller
Gene Shay
Good Ol' Persons String Band
Green Fields of America
Hans Theessink
Ira Bernstein
Janis Ian
Jay Ansill
Jean Farnworth
Jim Albertson
Jim Hale
John Gorka
Judith Casselberry and Jackie DuPreé
Ken Goldstein
Kevin Welch
Leo Arons
Livingston Taylor
Los Afortunados
Mac Parker
Mamou
Mark Silber
Mary Chapin Carpenter
Megan McDonough
Michael Cooney
Mike Agranoff
Mike Miller
Patty Larkin
Pete Sutherland
Peter Bellamy
Priscilla Herdman
Radney Foster and Bill Lloyd
Robin and Linda Williams
Roger Deitz
Roger Sprung
Sally Fingerett
Si Kahn
Stewed Mulligan

Stretch Pyott
Taj Mahal
Tom Rush
Utah Phillips
Wayne Toups and Zydecajun
The Whites

1991

Abdou Rahm Mangara
Ad Vielle Que Pourra
Angel Chiango and Dan Liechty
Ari Eisinger
Barry Rabin
Battlefield Band
Bill Miller
Brave Old World
Bruce Martin
Caryl P. Weiss
Cindy Mangsen
Dan Ruvin
Dave Gillies
Dave Orleans
David Bromberg
The Dixie Hummingbirds
Don Henry
Eileen McGann
Esther Halpern
Flor De Cana
Gamble Rogers
Gene Shay
George Gritzbach
Hazlewood
Jah Levi and Higher Reasoning
Jamal Koram
Jay Ansill
Jean Farnworth
Jim Albertson
Jim Femino
John Jennings
John Sebastian
Juggernaut String Band
Just Say No Traveling
Ken Goldstein
Koko Taylor and Her Blues Machine
Laurie Lewis
Leo Arons
Martin and Jessica Simpson
Michael Braunfeld
Michael Cooney
Mike Agranoff
Mike Cross
Mike Miller
Mike Seeger
Noel and Sarah McQuaid
Oscar Brand
Patrick Sky
Peggy Seeger
Penny Seeger

Pete Kennedy
Pete Seeger
Richie Havens
Roger Deitz
Roger Sprung
Saffire, the Uppity Blues Women
Saul Broudy
Spencer Nelson
Stephen Wade
Steve Forbert
Steve Gillette
Steve Key
Stretch Pyott
Sun Rhythm Section
Terry Garland
Tom Paxton
Tom Rush
Tommy Makem

1992

Alison Krauss and Union Station
Ani DiFranco
Archie Roach
BeauSoleil
Ben Arnold
Bill Morrissey
Boukman Eksperyans
Bruce Martin
Catie Curtis
Christine Lavin
Christopher Shaw
Cindy Mangsen
Dan Ruvin
Darden Smith
Dr. Joe
Fairfield Four
Gene Shay
Give and Take Jugglers
Guy and Candie Carawan
Hal Wylie
Hanny Budnick
Hard Travelers
Heather Mullen
Iain Matthews
Iris DeMent
Jackie Pack
Jay Ansill
Jean Farnworth
Jim Albertson
Jim Femino
John Gorka
John Roberts and Tony Barrand
Johnny "Clyde" Copeland
Ken Goldstein
Killbilly
Kingsessing Morris Men
Laurie Freelove

Leo Arons
Leon Rosselson
Lucinda Williams
Magenta Music
Michael Miles
Mike Agranoff
Mike Cross
Mike Miller
Mock Turtle Marionette Theater
Patchwork: A Storytelling Guild
Peter Alsop
Peter Rowan and Jerry Douglas
Pierce Pettis
Quilt
Ranch Romance
Red Clay Ramblers
Robin and Linda Williams
Roger Sprung
Roger Deitz
Rory Block
Saffire, the Uppity Blues Women
Spencer Nelson
Steve Gillette
The Story
Stretch Pyott
Sukay
Susan Werner
Taj Mahal
Terry Garland
Winnie Winston
Zulu Spear

1993

Amy and Jenny
Ben Arnold
Beth Williams
Bill Miller
Bruce Martin
Chenille Sisters
Chuck Brodsky
Craobh Rua
Dan Ruvin
Dave Fry
David Massengill
David Wilcox
Dougie MacLean
Dry Branch Fire Squad
Ed Stivender
Four Bitchin' Babes
Gene Shay
Give and Take Jugglers
Hanny Budnick
Holmes Brothers
James Miller
Jane Gillman and Darcie Deaville
Jean Farnworth

Jim Albertson
John Flynn
Joseph Parsons
Karen Farr
Kate and Anna McGarrigle
Kathy Mattea
Ken Goldstein
Lee-Ellen
Leo Arons
Leon Redbone
Libana
LisaBeth Weber
Loudon Wainwright III
Low Road
Luke Daniels
Margaret Christl
Michael Cooney
Mike Agranoff
Mike Miller
Nat Reese and Howard
 Armstrong
Odetta
Patty Larkin
Paul Ubana Jones
Peter Ostroushko and Dean
 Magraw
Pint and Dale

Robin Moore
Roger Sprung
Satan and Adam
Schuylkill Bayou Ramblers
Seldom Scene
Shetlands Young Heritage
So's Your Mom
Spencer Nelson
Stretch Pyott
Susan Werner
Tannahill Weavers
Ted Fink
Tish Hinojosa
Trout Fishing in America
Tuckers Tales Puppets
Walt Michael
Zachary Richard

1994
Altan
Ani DiFranco
Ari Eisinger
The Billys
Bridget Ball
Bruce Martin
Burns Sisters
Carrie Newcomer

Caryl P. Weiss
Cathy Fink and Marcy Marxer
Chris Smither
Cosy Sheridan
Cris Williamson and Tret
 Fure
Dan Ruvin
David Buskin
Elias Ladino Ensemble
Freyda and Acoustic AttaTude
Gene Shay
Give and Take Jugglers
Jamie Watson
Jason Eklund
Jean Farnworth
Jean Redpath
John Flynn
John Gorka
John Hammond
The House Band
Killbilly
Kingsessing Morris Men
Leo Arons
Lesley Mitchell and Kelly Ray
Livingston Taylor
Los Lobos
Maddy Prior

Michael Cooney
Michael McNevin
Mike Agranoff
Mike Cross
Mike Miller
Mustard's Retreat
Nashville Bluegrass Band
Natalie MacMaster
The Nields
Patchwork: A Storytelling
 Guild
Paul Kaplan
Quilt
Ranch Romance
Richard Thompson
Rick Ilowite
The Roches
Roger Deitz
Rolly Brown
Spencer Nelson
Stretch Pyott
Susan Herrick
Tom Paxton
Tom Prasada-Rao
Tracy Dares
Trout Fishing in America
Two of a Kind
Vance Gilbert

Voices of the Folk
Winnie Winston

1995
Amy and Jenny
Arlo Guthrie
The Band
Barbara Kessler
Battlefield Band
BeauSoleil avec Michael
 Doucet
Big Blow and the
 Bushwackers
Bob Zentz
Bruce Martin
Cathy Fink and Marcy Marxer
Christine Lavin
Chuck Brodsky
Dan Ruvin
Dave Fiebert
Dave Van Ronk
The Dixie Hummingbirds
Fred Koller
Fred Small
The Freedom Sound
Gene Shay
Gillian Welch and David
 Rawlings

Give and Take Jugglers
Janis Ian
Jean Farnworth
Jem Moore and Ariane Lydon
Jerry Brown
Jim Albertson
Joseph Parsons
Kathy McMearty
Ken Kaplan
Kim and Reggie Harris
The Klezmatics
Koko Taylor and Her Blues
 Machine
Leo Arons
Les Sampou
Liverpool Judies
Louis Killen
Louise Taylor
Magpie
Margo Hennebach
Mary McCaslin
Michelle Shocked
Mike Agranoff
Mike Miller
Moxy Fruvous
Nancy Tucker
New Saint George
Pat Donohue

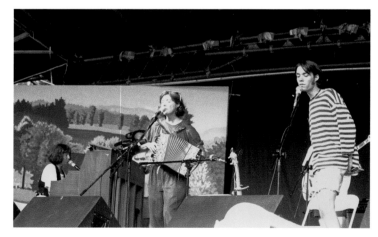

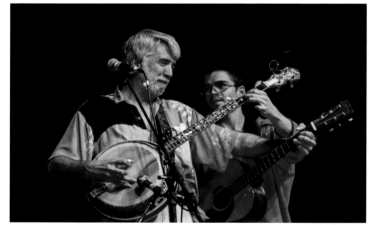

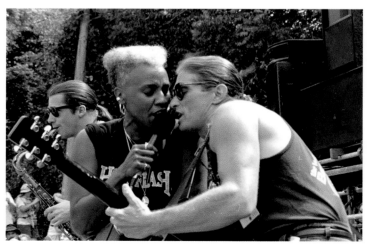

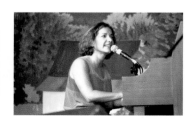

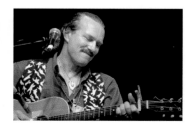

Pete and Maura Kennedy
Raelinda Woad
Robin and Linda Williams
Roger Sprung
Shirley Lewis
Spencer Nelson
Steve Earle Group
Steve Pullara
Steve Riley and The Mamou
 Playboys
Stretch Pyott
Susan Piper
Susan Werner
Tempest
Tim and Mollie O'Brien and
 The O'Boys
Tom Lewis
Tom Rush

1996
Ad Vielle Que Pourra
Anne Hills
Arlo Guthrie
Artisan
Beth Williams
The Blind Boys of Alabama
Brooks Williams
Bruce Martin

Buckwheat Zydeco
Burns Sisters
Caryl P. Weiss
Charlie Zahm
The Chenille Sisters
Chesapeake
Chris Smither
Christine Kane
Christopher Shaw
Craobh Rua
Dan Ruvin
Dar Williams
Dave Sherman
David Wilcox
Dick "Richard" Albin
Duke Robillard Band
Ferron
Frank Malley
Fred Kaiser
Gene Shay
Give and Take Jugglers
Greg Greenway
Hans Theessink and Blue
 Groove
Heather Eatman
The House Band
Jackie Pack
Jay Ungar and Molly Mason

Jim Albertson
Jimmie Dale Gilmore
Jimmy Landry
John Wesley Harding (Wesley
 Stace)
Johnny Morris
Juggernaut String Band
June Rich
Katy Moffatt
Kelly Joe Phelps
Kingsessing Morris Men
Koerner, Ray, and Glover
Lou and Peter Berryman
Louise Sherman
MartinSexton
Mary Roth
Melvin Wine and Gerry
 Milnes
Michael Cooney
Mike Agranoff
Mike Cross
Mike Miller
The Nields
Nightingale
Norman Blake
Poor Old Horse
Ricky Skaggs and Kentucky
 Thunder

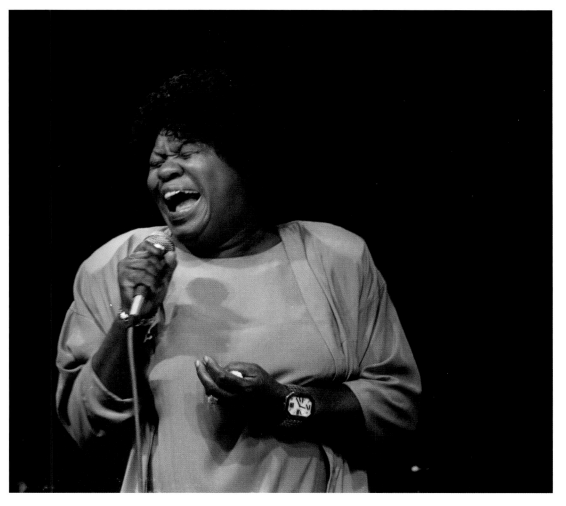

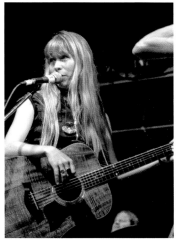

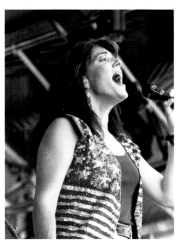

Roy Book Binder
Small Potatoes
Steve Gillette and Cindy
 Mangsen
Steve Schonwald and Jennifer
 Schneck
Stretch Pyott
Sue Dupre
Teresa Pyott
Tom Gala
Wendy Beckerman
Wolfstone

1997
Beats Walkin'
Belinda Balloon
Bill Miller
Bob Franke
Broadside Electric
Bruce Martin
Bryndle
Chuck Brodsky
Cordelia's Dad
Dan Bern
Dan Ruvin
Dave Sherman
David Olney
Debra Shaw
Dick Gaughan
Don Edwards
Ed Stivender
Elaine Silver
Emmylou Harris
Fred Kaiser
Gene Shay
Geno Delafose and French
 Rockin' Boogie
Give and Take Jugglers
Greg Brown
Griffith and Mealy
Jerry Brown
Jim Albertson
Joel Mabus
John Flynn
John McEuen
Kate and Anna McGarrigle
Kate Campbell
Keb' Mo'
Kristina Olsen
Laura Love Band
Les Sampou
Lucy Kaplansky
Mac Benford and the
 Woodshed All-Stars
Mark Cosgrove

Michael Jerling
Mike Agranoff
Mike Miller
Moxy Fruvous
Natalie MacMaster
Nomos
Pele Juju
Ray Naylor
Robin Moore
Rolly Brown
Rory Block
Rosanne Cash
Saffire, the Uppity Blues
 Women
Salamander Crossing
Si Kahn
Solas
Steve Blackwell and Friends
Stretch Pyott
Susan Piper
Suzzy Roche
Tempest
Teresa Pyott
Trout Fishing in America
Two of a Kind
Voices of the Folk

1998
Annie Wenz
Arlo Guthrie
Barachois
Battlefield Band
BeauSoleil avec Michael
 Doucet
Belinda Balloon
Bob Davenport
Bryan Bowers
Burns Sisters
Cameron Highlanders Pipe
 Band
The Cassidys
Christine Lavin
Clandestine
Clarence "Gatemouth" Brown
Claudia Schmidt
Colonel Mike's Dance Band:
 Bob Pasquarello, Bob
 Stein, John Krumm
Dana Robinson
Dave Orleans
David Hamburger
David Perry
Dayna Kurtz
Debi Smith
Donna Hunt

Eddie from Ohio
Fred Kaiser
The Freight Hoppers
Front Range
Garnet Rogers
Gene Shay
Give and Take Jugglers
Guy Davis
Hanny Budnick
International Folk Sounds
Jack Williams
Jerry Ricks
John Roberts and Tony
 Barrand
John Whelan Band
Josh White Jr.
June Rich
Karen Terri Ludwig
Koko Taylor and Her Blues
 Machine
Les Barker
Louise Taylor
Lui Collins
Mad Pudding
Magpie
Michael Braunfeld
Michael Cooney
Mindy Simmons
Mustard's Retreat
The Nields
Owen McBride
Pete and Maura Kennedy
Pitz Quattrone
Planete Folle
Rosemary Woods
Sadie Green Sales
Samite of Uganda
Simple Gifts
Slaid Cleaves
Small Potatoes
Stretch Pyott
Susan Werner
Timoney Irish Dancers
Tom Paxton

1999
Alvin Youngblood Hart
Andy Kimbel
Aunt Peggy and Jay Smith
Balfa Toujours
Barbara Kessler
Bio Ritmo
Broadside Electric
Chris Smither
Colleen Sexton

Cordelia's Dad
Cry Cry Cry
Dar Williams
Dave Fry
David Olney
Deb Pasternak
Deborah Pieri
Debra Shaw
Dennis Hangey
Doc Watson
Dry Branch Fire Squad
The Eileen Ivers Band
Four Shadow
Fred Kaiser
The Freedom Sound
Gene Shay
Give and Take Jugglers
Great Big Sea
Handsome Molly
Hazel Dickens, Ginny Hawker
 and Carol Elizabeth Jones
Hot Soup
Janis Ian
Jennifer and Hazel Wrigley
Jenny Reynolds
Jerry Brown
Jim Albertson
Jim Femino
John Prine
Karan Casey
Loudon Wainwright III
Lucy Kaplansky
Michael Cooney
Moxy Fruvous
Old World Folk Band
Ray Wylie Hubbard
Rik Palieri
So's Your Mom
Stacey Earle
Steve Forbert
Steve Gillette and Cindy
 Mangsen
Still on the Hill
Stretch Pyott
Suzy Bogguss
Tempest
Teresa Pyott
Terri Allard
Toucan Jam
Vance Gilbert
White Water
Willy Porter

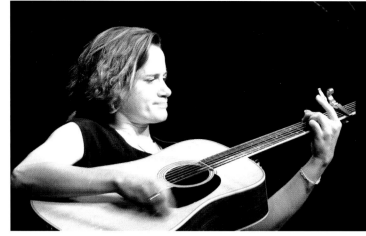

Clockwise from top left:
Ray Wylie Hubbard, 1999. Photo by Jayne Toohey

Susan Werner, 1993. Photo by Jayne Toohey

Kingsessing Morris Men, 1996. Photo by Jayne Toohey

Eileen Ivers, 1999. Photo by Jayne Toohey

Jerry Douglas (L) and Peter Rowan, 1992. Photo by Jayne Toohey

Megan McDonough, 1990. Photo by Jayne Toohey

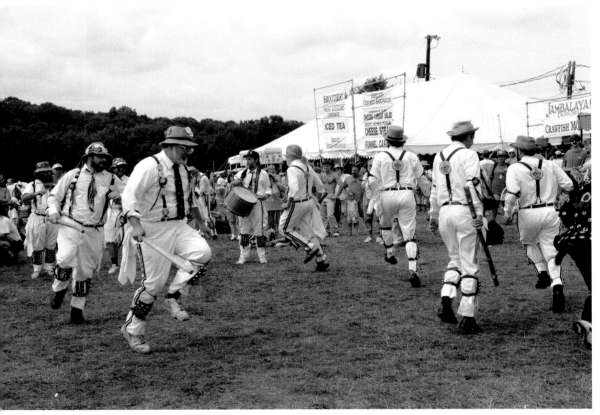

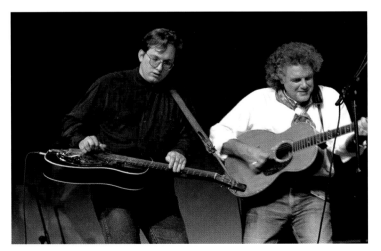

Clockwise from top left:
Gaye Adegbaiola (Saffire, the Uppity Blues Women), 1991. Photo by Jayne Toohey

Sarah McLachlan, 1994. Photo by Robert Corwin

Guy Davis entertains the crowd near the Main Gate, 1998. Photo by Jayne Toohey

Keith Grimwood (L) and Ezra Idlet (Trout Fishing In America), 1997. Photo by Jayne Toohey

Steve Forbert, 1999. Photo by Jayne Toohey

Rory Block, 1997. Photo by Jayne Toohey

Rick Danko (The Band), 1995. Photo by Jayne Toohey

Katryna Nields (The Nields), 1996. Photo by Jayne Toohey

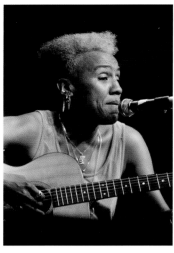

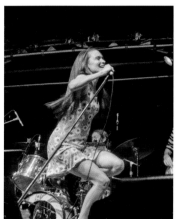

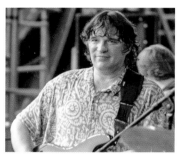

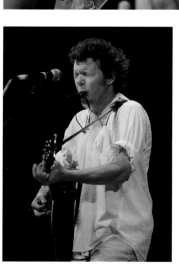

182

Clockwise from top left: Suzy Bogguss, 1999. Photo by John Lupton

Bob Franke, 1997. Photo by Jayne Toohey

Roy Gullane (Tannahill Weavers), 1993. Photo by Ellen Nassberg

Ali Thelfa (performing with Hans Theessink), 1996. Photo by Jayne Toohey

Ron Thomason (Dry Branch Fire Squad), 1999. Photo by John Lupton

Bill Miller, 1997. Photo by Jayne Toohey

Ray Wylie Hubbard, 1999. Photo by Jayne Toohey

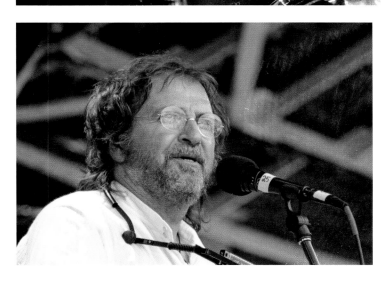

Clockwise from top left:
Theresa Pyott and Frank Malley, 1996.
Photo by Ellen Nassberg

(L-R) Anna McGarrigle, Suzzy Roche, and Kate McGarrigle, 1997. Photo by Jayne Toohey

Bill Miller (R), 1993. Photo by Jayne Toohey

Kingsessing Morris Men, 1996. Photo by Jayne Toohey

Michael Doucet (BeauSoleil), 1992. Photo by Jayne Toohey

Cindy Mangsen (L) and Anne Hills, 1991. In the background (L-R): Michael Cooney, Eileen McGann, and Gaye Adegbaiola. Photo by Jayne Toohey

Mike Miller and Dan Ruvin, 1990s. Philadelphia Folksong Society Archives

Dougie MacLean and Kathy Mattea, 1993. Photo by Jayne Toohey

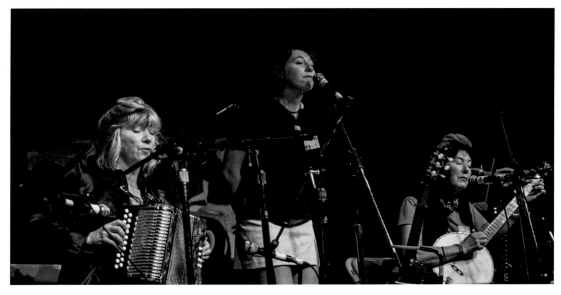

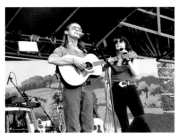

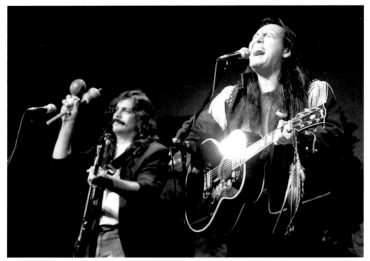

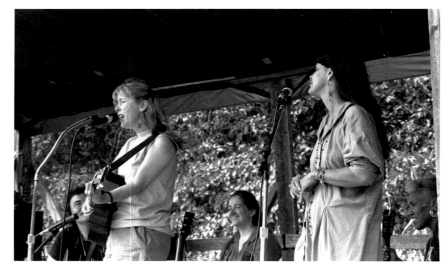

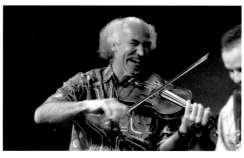

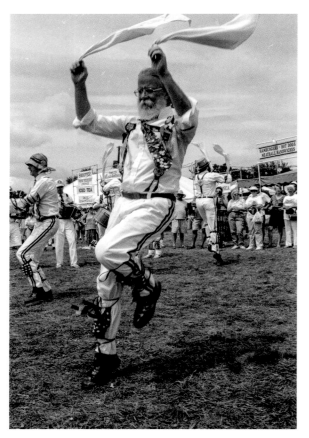

THE 2000S

2000

Amy Fradon
Bacon Brothers
Barbara Barrow
Beats Walkin'
Beverly Smith
Boys of the Lough
Cary Fridley and Friends
Caryl P. Weiss
Craobh Rua
Dave Carter and Tracy
 Grammer
Dennis Hangey
Eddie From Ohio
Entrain
Eric Bibb
Finger Pyx
Fred Kaiser
Gene Shay
Give and Take Jugglers
Hanny Budnick
Harmonia
Inti Illimani
Irene Farrera
Jack Williams
Jeff Lang
Jive 5 minus 2
John Gorka
John Hammond
John Hartford
Juggernaut String Band
Kala Jojo
Liz Bradley
Mad Pudding
Mark Dvorak
Mary Gauthier
Michael Smith
Mike Agranoff
Mike Cross
Mollie O'Brien
Moving Cloud
Mustard's Retreat
Nanci Griffith
Natalie MacMaster
Nickel Creek
The Nields
One Drum
Oscar Lopez
Patty Larkin
Pitz Quattrone
Rosalie Sorrels
Sadie Green Sales
Saw Doctors
Scott Alarik
Sharon, Bram and Friends
So's Your Mom
Terry McGrath

Timoney Irish Dancers
Tom Dundee
Two of a Kind
Weavermania
Women's Sekere Ensemble
Zima

2001

4 Way Street
Anne Hills
Annie Wenz
April Verch
Arlo Guthrie
Ben Arnold
Billy Jonas
Charivari
Charlie Sweeney
Chris Smither
David Bromberg
Dennis Hangey
Doug Tilgham
Eileen Ivers
Erin McKeown
Esther Halpern
Gene Shay
Give and Take Jugglers
GrooveLily
Hanny Budnick
International Folk Sounds
Jackie Pack
Janis Ian
Jay Ungar, Molly Mason and
 Swingology
Jim Boggia
Jimmy Johnson
John Krumm
Johnny Irion
Joseph Parsons
Judy Collins
Kat Eggleston
Kim and Reggie Harris
Laura Love Band
Laurie Lewis
Lila Downs
Liverpool Judies
The Mammals
Michael Cooney
Nickel Creek
Richie Havens
RIG
Rik Palieri
Roy Book Binder
Ruthie Foster with Cyd
 Cassone
Sarah Lee Guthrie
Scott Bricklin
Small Potatoes
Solas
SONiA
Steve Blackwell and Friends
Strauss and Warschauer Duo

Stretch Pyott
Tao Rodriguez-Seeger
Tarbox Ramblers
Tempest
Terry McGrath
Tom Paxton
Tom Rush
Utah Phillips
Wayfaring Strangers
Whirligig

2002

Alice Gerrard, Brad Leftwich
 and Tom Sauber
Alice Peacock
Blue House
Bob Beach
Bruce Cockburn
Dave Fry
David Jacobs-Strain
David Perry
DaVinci's Notebook
Deborah Pieri
Dennis Hangey
Diane Ponzio
Don Edwards
Donna the Buffalo
Ed Stivender
Eric Schwartz
Finest Kind
Flatlanders
Fortissimo
Frank Malley
French Toast
Fruit
Full Frontal Folk
Gene Shay
Give and Take Jugglers
Greenbriar Boys
Hanny Budnick
Huun-Huur-Tu (Tuvan Throat
 Singers)
Jan Alter
The Jay Ansill String Section
Jim Albertson
John Flynn
John Lilly
Karen Shaw
Kris Delmhorst
Lucas Rivera and Grupo
 Huracon
Lunasa
Mahotella Queens
Marty Stuart
Mike Agranoff
Mike Miller
Nashville Bluegrass Band
Pete and Maura Kennedy
Philadelphia Jug Band
Providence
Railroad Earth

Raise the Roof
Richard Thompson
Robin and Linda Williams
 and Their Fine Group
Roger McGuinn
Sandy Pomerantz
Scott Alarik
Sharon Katz and the Peace
 Train
Shemekia Copeland
Shooglenifty
Silk City with Dede Wyland
Stretch Pyott
Susan Werner
Tommy Emmanuel
Tracy Grammer
Tuckers' Tales Puppet
 Theatre
Vince Masciarelli
Zima

2003

Alison Brown Quartet
Ani DiFranco
Anne Hills
April Verch
Baka Beyond
BeauSoleil avec Michael
 Doucet
Bob Brozman
Bob Franke
Carol Mahler
Dennis Hangey
Disappear Fear
DonnaHunt
Eddie From Ohio
Fiddlekicks
Finger Pyx
Fourtold
Freebo
Gene Shay
Give and Take Jugglers
Hanny Budnick
Holmes Brothers
International Folk Sounds
Jay Smar
Jennifer Schonwald
Jerry Brown
John Gorka
John Matulis and Friends
Joyce Andersen
Kathleen Edwards
Kevin Roth
Led Kaapana
Loudon Wainwright III
Magpie
Mark Erelli
Mary Chapin Carpenter
Michael Smith
Mustard's Retreat
Nerissa and Katryna Nields

Odetta
Pieta Brown with Bo Ramsey
Pinmonkey
Plena Libre
Ralph Stanley and the Clinch
 Mountain Boys
Robin Moore
Roger Deitz
Run of the Mill String Band
Sons of the San Joaquin
Spirit Wing
Steve Gillette and Cindy
 Mangsen
Steve Schonwald
Stretch Pyott
Tempest
Terri Hendrix
Todd Snider
Tom Gala
Two of a Kind
Xavier Rudd

2004
Adrienne Young and Little
 Sadie
Andy M. Stewart and Gerry
 O'Beirne
Antje Duvekot

Bill Kirchen
Bob McQuillen
Brave Combo
Cathy Fink and Marcy Marxer
Charlie Miller
Cherish the Ladies
Chris Smither
Cindy Cashdollar and the
 Silver Shot Western
 Swing Review
David C. Perry
David Olney Band
DaVinci's Notebook
Deanna Stiles
Dennis Hangey
Echoing Heart
Eliza Gilkyson
Essra Mohawk
Fitzgerald and Beach
Full Frontal Folk
Gene Shay
George Wilson
Girlyman
Give and Take Jugglers
Green Grass Cloggers
Hickory Project
John Flynn
John Prine

John Roberts and Tony
 Barrand
Juggernaut String Band
Kala Jojo
Kris Kristofferson
La Bottine Souriante
LisaBeth Weber
Mike Agranoff
Mike Miller
Mindy Smith
Natalie MacMaster
Okefenokee Joe
Ollabelle
Pat Humphries and Sandy O
Phil Roy
Rob Lutes
Robert Hazard
Robin and Linda Williams
Sones de Mexico
Taj Mahal
Teresa Pyott
Time for Three
Tom Russell
Uncle Earl
We're About Nine
Wild Asparagus
Wishing Chair
Zydeco a-go-go

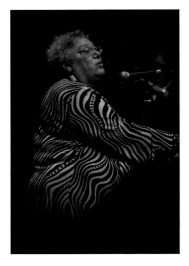
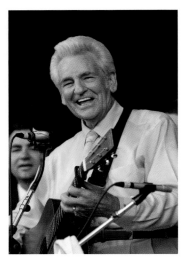
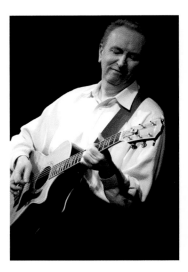

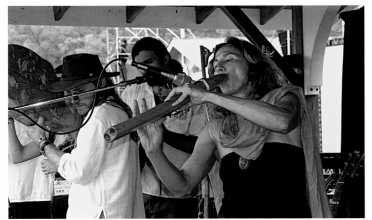

2005

Air Dance
Angel Band
Ann Rabson and the
 Annimators
Arlo Guthrie
Artisan
Avett Brothers
Beaucoup Blue
Beth Williams
Bethany and Rufus
Birdie Busch
Campbell Brothers
Charlie Miller
Cheryl Prashker
Chinua Hawk
Chuck Brodsky
Courtney Malley
Crooked Still
Darcie Miner
Darol Anger
Dave Fry
David Bromberg
David Grisman Quintet
David Surette and Susie
 Burke
Debra Shaw
Dennis Hangey

Donna Hunt
Footworks
Frank Malley
French Toast
Gandalf Murphy and the
 Slambovian Circus of
 Dreams
Gene Shay
Give and Take Jugglers
The Glengarry Bhoys
Hanny Budnick
Hazmatt
Helen Leicht
International Folk Sounds
Jim Albertson
Joel Rafael
John Francis
John Jorgenson
The Johnson Girls
Kate Gaffney
Lester Chambers
The Mammals
Marcia Ball
Moch Pryderi
Modern Man
Orpheus Supertones
Pat Wictor
Peggy Seeger

Pete LaBerge
Quetzal
Ray Gray
Red Stick Ramblers
Rik Palieri
Sadie Green Sales
Sian Frick
Spirit Wing and Friends
Stretch Pyott
Svitanya
Tempest
Tori Barone
Two of a Kind
Wailin' Jennys
Wolfstone
Zima

2006

Alex DePue
Amos Lee
Andrew Lipke
Angel Band
Annie Wenz
Antje Duvekot
Arrogant Worms
Avett Brothers
Beau Django
Beth Molaro

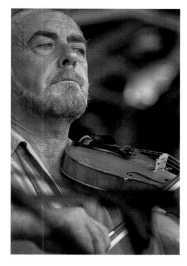
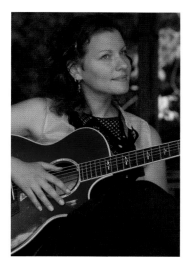
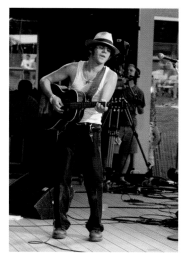
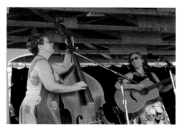
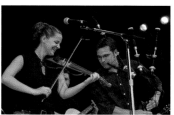
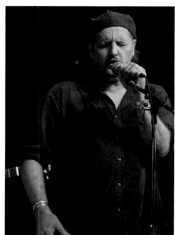
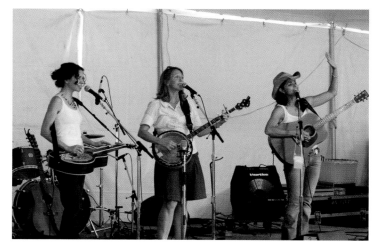
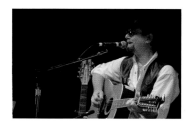
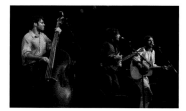

Boris Garcia
Bryce Milano
The Burns Sisters Band
Caryn Lin
Charles Nolan
Charlie Miller
David Bromberg
David Jacobs-Strain
David Lindley
Deborah Pieri
Dennis Hangey
Dennis Stroughmatt and
　　Creole Stomp
Dog on Fleas
The Duhks
Ed Stivender
Eliza Gilkyson
Elizabeth Mitchell
Fiddlers' Bid
Finger Pyx
Gandolf Murphy and the
　　Slambovian Circus of
　　Dreams
Gene Shay
Give and Take Jugglers
Groovemama
Guy Mendilow

Helen Leicht
Hoots and Hellmouth
The Horse Flies
Hot Tuna
Huun-Huur-Tu (Tuvan Throat
　　Singers)
Jackson Browne
James Hunter
Janine Smith
Jay Smar
Jimmy LaFave
Jody Hughes
Joel Rafael
Lizanne Knott
Matt Duke
Melody Gardot
Mum Puppet Theater
Natalia Zukerman
Pipeline
Raul Malo
Ribbon of Highway, Endless
　　Skyway
Robin Moore
The Roches
Rodney Crowell
Run of the Mill String Band
Santa Cruz River Band

Saul Broudy
Shemekia Copeland
Terri Hendrix

2007
Angel Band
Back of the Moon
Baka Beyond
Bettye LaVette
Bob Beach
Bob Carlin
Carolina Chocolate Drops
Carsie Blanton
Chanterelle
Charlie Miller
The Coyotes
Dan May
David Dye
David Holt
Dennis Hangey
Diana Jones
Doc Watson
Echoing Heart
Fennig's All-Star String Band
Freebo
Gene Shay
Give and Take Jugglers

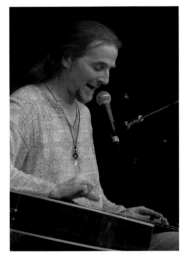

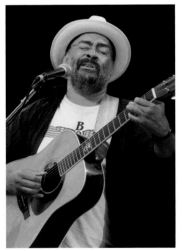

The Greencards
Groovemama
Helen Leicht
Jack Williams
James Leva
Jess Klein
John Flynn
Johnny Duke and the Aces
Jonathan Edwards
Jud Caswell
Kala JoJo
Kathy O'Connell
Les Yeux Noirs
Liz Longley
The Lovell Sisters
The Lowlands
The Mammals
Mavis Staples
Mike Craver
Old Springs Pike
Pat Wictor
The Pine Leaf Boys
The Quebe Sisters Band
Quiet Riot
Rik Palieri
Ron Buchanan
Sam Bush

Son Volt
Stephen Wade and Friends
Toby Walker
Tori Barone
Unlikely Cowboy
Vance Gilbert
Zan McLeod

2008
Al Stewart
Allison Moorer
Amy Speace
Anthony DaCosta
Baird Sisters
Bearfoot
BeauSoleil
Ben Arnold
Bob Beach
Box 5
Charlie Miller
Chris Pureka
Compadres
Craig Bickhardt
David Dye
David Massengill
Eilen Jewell
Ellis

Espers
Felice Brothers
Gadji-Gadjo
George Stanford
Give and Take Jugglers
Great Big Sea
Groovemama
Helen Leicht
Hezekiah Jones
Hoots and Hellmouth
Jack Rose
Jake Shimabukuro
Janis Ian
J. D. Crowe and the New
 South
Jean Ritchie
Jeremy Fisher
Jim Bianco
John Francis Maher
Judy Collins
Kathy Mattea
Kenny White
Kierstan Gray
Kimya Dawson
Lee Boys
LisaBeth Weber
Matt Duke

Clockwise from top left:
"Doc Terry" McGrath, 2008. Photo by Lisa Schaffer

Led Kaapana (L), 2003. Photo by Jayne Toohey

The Mammals, 2007. Photo by Jayne Toohey

Red Stick Ramblers, 2005 (L-R): Chas Justus, Kevin Wimmer, Glenn Fields, Linzay Young, and Eric Frey. Photo by Jayne Toohey

Anne Hills, 2003. Photo by Jayne Toohey

Tony Trischka Band, 2009. Photo by Bob Yahn

Jessica Lovell (Lovell Sisters), 2007. Photo by Jayne Toohey

Uncle Earl, 2004 (L-R): Eric Thorin, Rayna Gellert, KC Groves, Kristin Andreassen, and Abigail Washburn. Photo by John Lupton

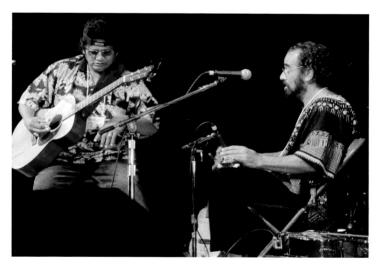

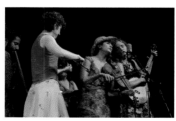
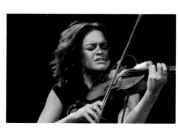
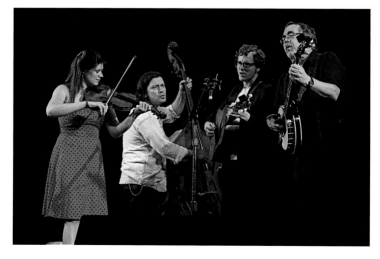
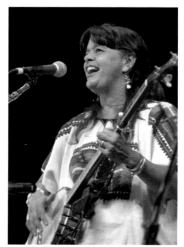

Nicole Reynolds
Peasant
PG Six
Red Molly
The Refugees
Ryan Montbleau
Samuel James
Sharon Van Etten
Sisters 3
Stephen Cohen
Stephen Kellogg and the
 Sixers
Steve Earle
The Strangelings
Tempest
Terrance Simien
Tin Bird Choir
Tom Paxton
Trout Fishing in America
Ursula Rucker
Vanaver Caravan
Vinx

2009
Adam Swink
Adrien Reju
Alela Diane
Andrea Carlson
Angella Irwin
Austin Lucas
Bob Beach

Boris Garcia
Burning Bridget Cleary
Buskin and Batteau
Caravan of Thieves
Cathy Fink and Marcy Marxer
Charlie Miller
Chris Kasper
Cresson Street Vibration
Danaher and MacCloud
Dante Bucci
David Dye
Dawn Iulg
The Decemberists
Deer Tick
The Del McCoury Band
Dennis Hangey
The Derek Trucks Band
Donna Hunt
Ellis Paul
Enter the Haggis
Erik Mongrain
Folk Brothers
Fraction Theory
Frog Holler
Gene Shay
Get the Led Out
Give and Take Jugglers
Groovemama
Heartless Bastards
Helen Leicht
Iron and Wine

Jay Ansill
Jill Hennessey
Jill Sobule
Joe Pug
John Flynn
Justin Townes Earle
Kelly Ruth
Kerri Powers
Langhorne Slim
The Lewis Brothers
The Low Anthem
Marissa Nadler
Melissa Martin and The
 Mighty Rhythm Kings
Rebirth Brass Band
Rolly Brown
Ron Buchanan
Sara Hickman
Shannon Lambert-Ryan and
 RUNA
Slo-Mo featuring Mic Wrecka
Sonny Landreth
Tom Rush
Tony Trischka
West Philadelphia Orchestra
Wissahickon Chicken Shack
Works Progress
 Administration
Zach Djanikian

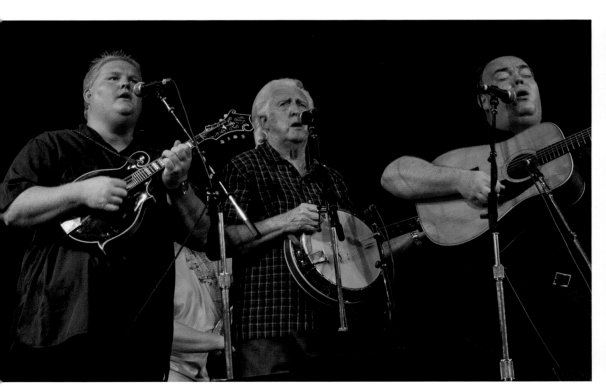

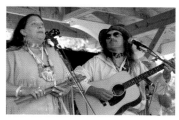

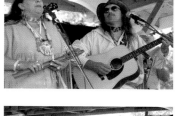

Clockwise from top left:
David Tamulevich (Mustard's Retreat), 2003. Photo by Jayne Toohey

Michael Doucet (BeauSoleil), 2008. Photo by John Lupton

Lester Chambers, 2005. Photo by John Lupton

Spirit Wing, 2003. Photo by Jayne Toohey

"Workshop Compadres," 2008. Seated: James Keelaghan. Standing (L-R): LisaBeth Weber, Maggie Marshall, Alan Doyle, Brent Gubbel, Craig Bickhardt, David Massengill, and Oscar Lopez. Photo by Lisa Schaffer

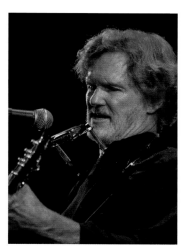

Kris Kristofferson, 2004. Photo by John Lupton

(L-R): Toby Walker, Bob Beach, and Freebo, 2007. Photo by Frank Jacobs III

Marie Burns (Burns Sisters), 2008. Photo by Jayne Toohey

Bet Williams, 2005. Photo by John Lupton

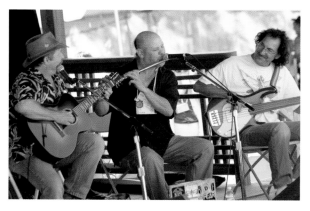

Bacon Brothers (2000): Kevin Bacon (L) and Michael Bacon. Photo by Jayne Toohey

Kathy Mattea, 2008. Photo by Lisa Schaffer

Kathy Mattea and Craig Bickhardt, 2008. Photo by Lisa Schaffer

Jack Casady (Hot Tuna), 2006. Photo by John Lupton

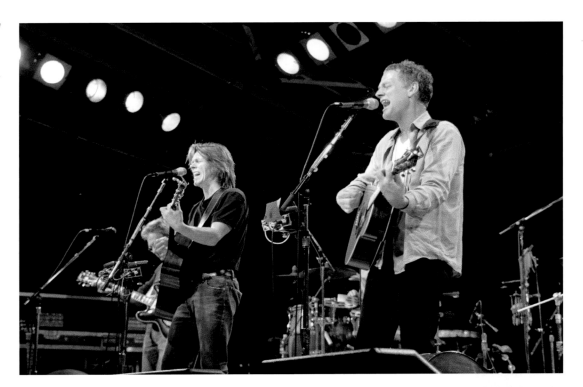

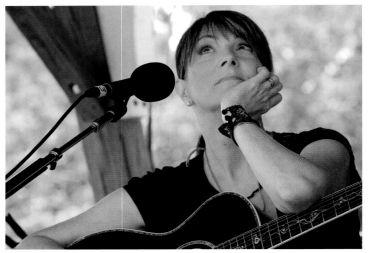

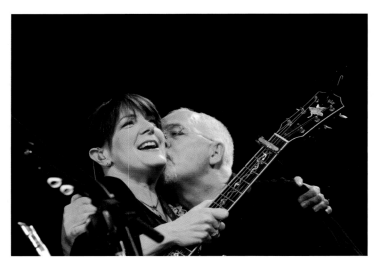

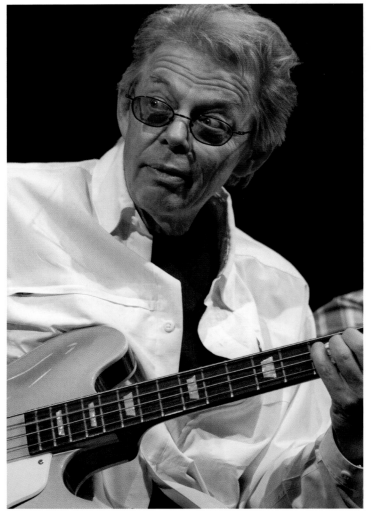

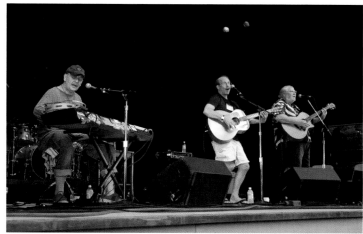

The Strangelings, 2008. Photo by Jayne Toohey

Sara Hickman, 2009. Photo by Jayne Toohey

Josh White Jr., 2003. Photo by Jayne Toohey

Modern Man, 2005 (L-R): Rob Carlson, David Buskin, and George Wurzbach. Photo by Jayne Toohey

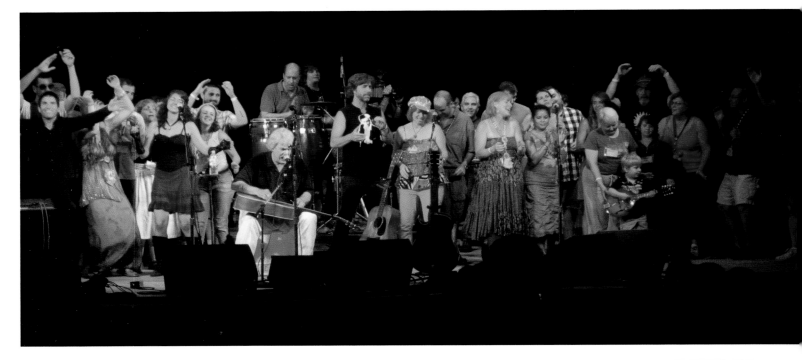

Clockwise from top:
Tom Rush (seated) and John Flynn (center) with a few of their closest friends, 2009. Photo by Frank Jacobs III

Sara Watkins (Nickel Creek), 2001. Photo by Steve Sandick

Jen Schonwald, 2005. Photo by Jayne Toohey

David Jacobs-Strain (R) with Tania Elizabeth of The Duhks, 2006. Photo by Jayne Toohey

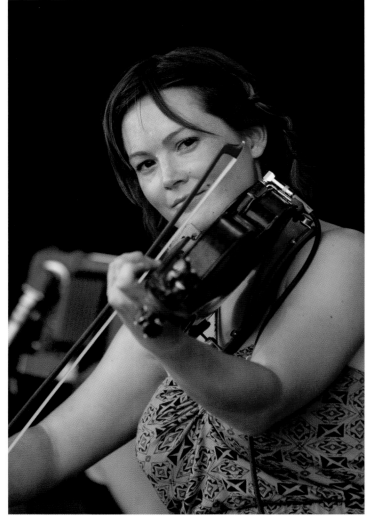

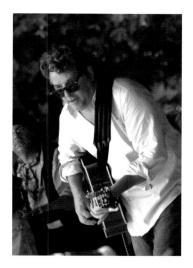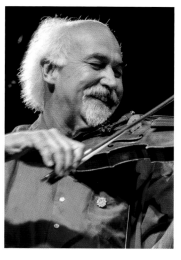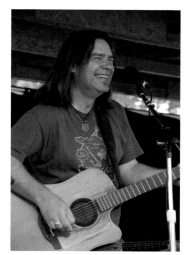

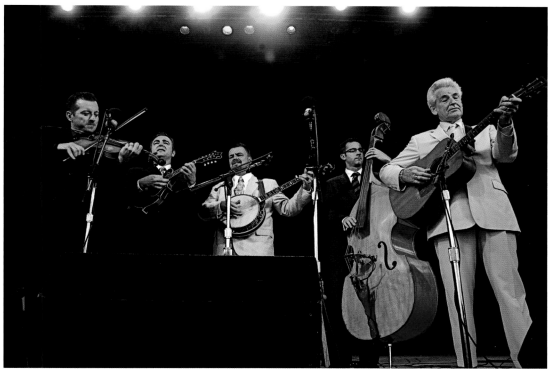

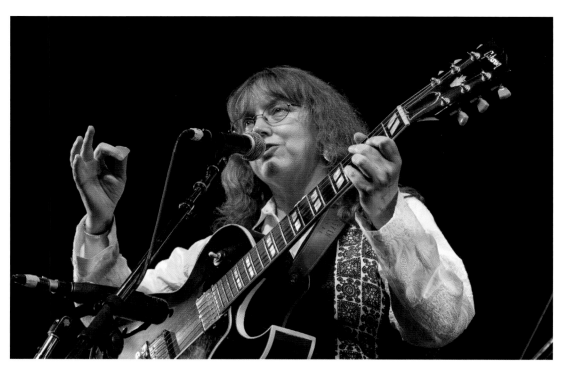

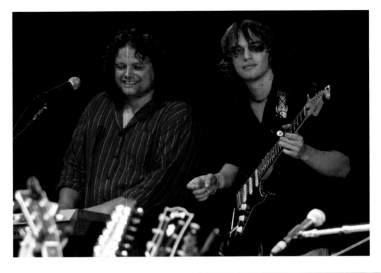

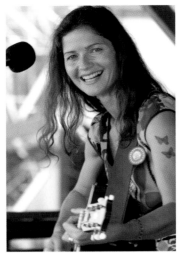

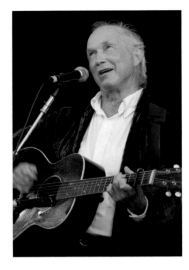

Top, left to right:
Grandson and great-grandson of Woody Guthrie: Abe Guthrie and his son, Krishna Guthrie, 2001. Photo by Mark Smith

Jill Hennessy, 2009. Photo by Jayne Toohey

Jack Hardy (Folk Brothers), 2009. Photo by Jayne Toohey

Center: Greg Liszt (Crooked Still), 2005. Photo by Jayne Toohey

Bottom, left to right:
D. C. Fitzgerald (R) and Bob Beach, 2004. Photo by Jayne Toohey

Eileen Ivers, 2003. Photo by Jayne Toohey

Top, left to right:
Bill Kirchen, 2004. Photo by Jayne Toohey

Amos Lee, 2008. Photo by Jayne Toohey

Jonathan Edwards with Cheryl Prashker, 2007. Photo by Jayne Toohey

Center, left to right:
Jean Ritchie, 2008. Photo by Lisa Schaffer

Member of the Vanaver Caravan troupe, 2008. Photo by Jayne Toohey

Bottom, left to right:
Darol Anger and Republic of Strings, 2005 (L-R): Brittany Haas, Darol Anger, Rushad Eggleston, Aoife O'Donovan, and Scott Nygaard. Photo by Jayne Toohey

Burning Bridget Cleary, 2009. Photo by Jayne Toohey

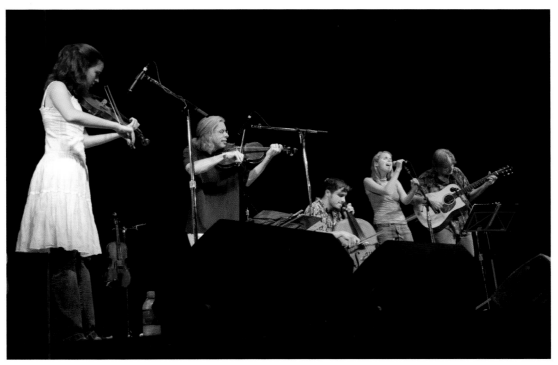

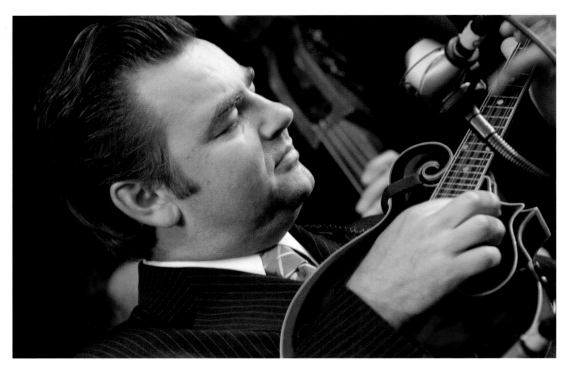

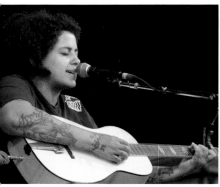

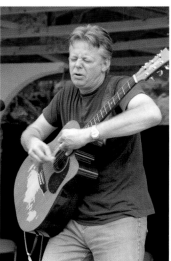

Clockwise from top left:
Rob McCoury (Del McCoury Band), 2009.
Photo by Jayne Toohey

Ronnie McCoury (Del McCoury Band),
2009. Photo by Jayne Toohey

Tommy Emmanuel, 2002. Photo by Jayne
Toohey

Michael Hough (Mustard's Retreat),
2003. Photo by Jayne Toohey

Guy Mendilow, 2006. Photo by Bob Yahn

Kimya Dawson, 2008. Photo by Lisa
Schaffer

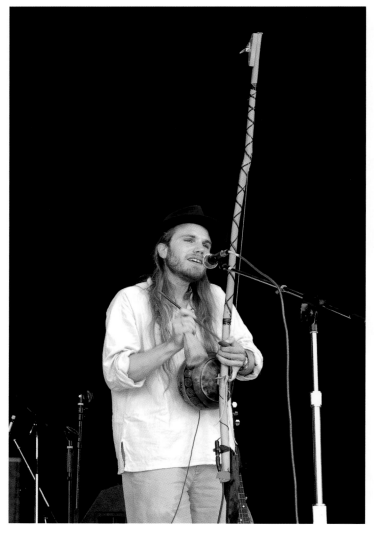

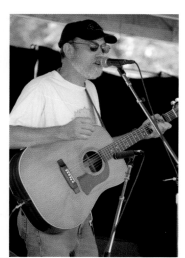

198

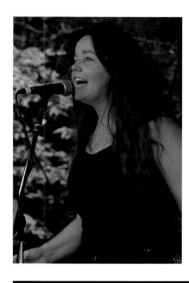
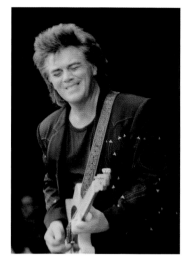
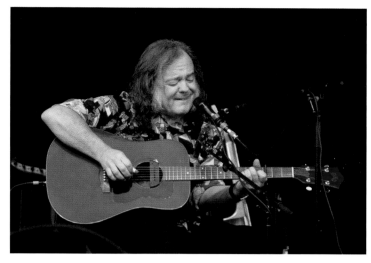

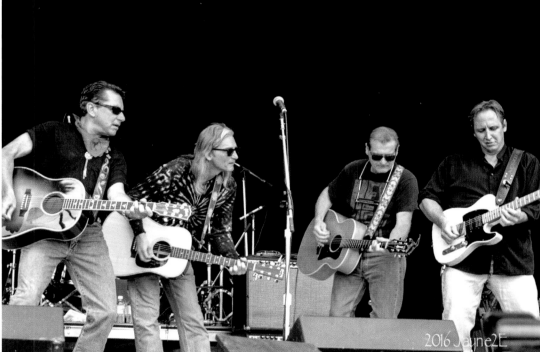

Top, left to right:
Annie Burns (Burns Sisters), 2008. Photo by Jayne Toohey

Marty Stuart, 2002. Photo by Jayne Toohey

David Lindley (performing with Jackson Browne), 2006. Photo by Steve Sandick

Center: The Flatlanders, 2001. Photo by Jayne Toohey

Bottom, left to right:
(L-R): Jay Ungar, David Bromberg, Molly Mason, and Ruth Ungar, 2001. Photo by Jayne Toohey

Derek Trucks, 2009. Photo by Steve Sandick

John Jorgensen, 2005. Photo by Jayne Toohey

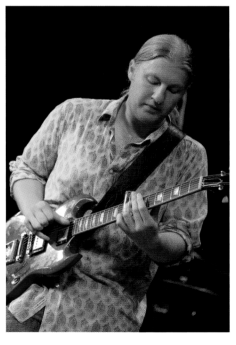

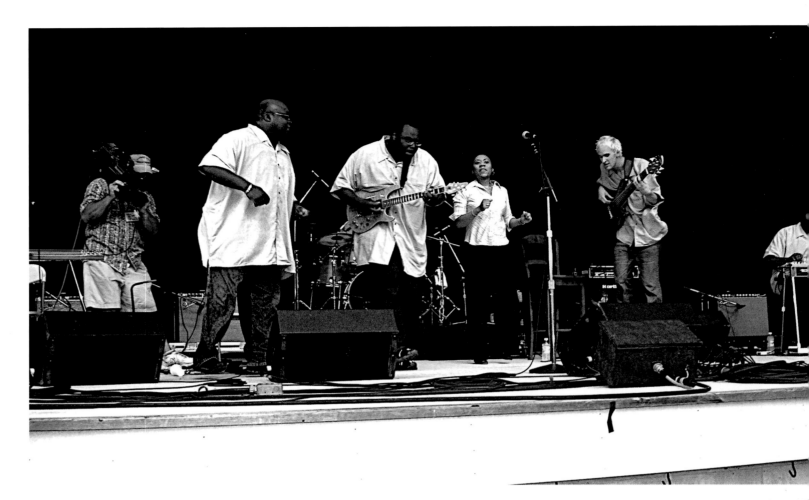

Top: The Campbell Brothers, 2005. Photo by Bob Yahn

Above: Patty Larkin, 2000. Photo by Jayne Toohey

Right: Willie "Popsy" Dixon (Holmes Brothers), 2003. Photo by Jayne Toohey

Clockwise from top left:
Eliza Gilkyson, 2006. Photo by John Lupton

John Flynn, 2007. Photo by Jayne Toohey

Jake Shimabukuro, 2008. Photo by John Lupton

Ian Felice (top) and Simone Felice (bottom, Felice Brothers), 2008. Photo by John Lupton

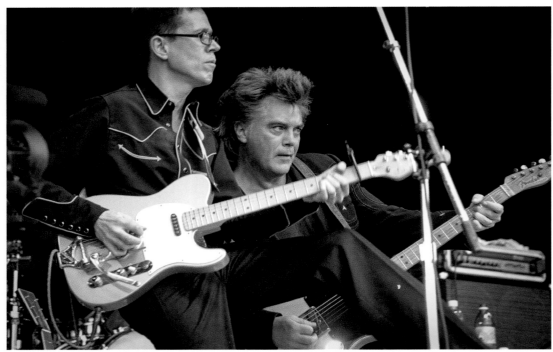

Clockwise from top left:
James Hunter, 2006. Photo by John Lupton

Marty Stuart (R) with Kenny Vaughan,
2002. Photo by Jayne Toohey

Simone Felice (Felice Brothers), 2008.
Photo by Lisa Schaffer

Alison Brown, 2003. Photo by John Lupton

Bryce Milano, 2008. Photo by Jayne Toohey

Workshop a cappella harmony, 2002.
Photo by Jayne Toohey

Clockwise from top left:
Jack Casady (L) and Jorma Kaukonen
(Hot Tuna), 2006. Photo by Jayne Toohey

Erin McKeown, 2001. Photo by Mark
Silver

DaVinci's Notebook, 2001. Photo by
Jayne Toohey

David Massengill (Folk Brothers), 2009.
Photo by Jayne Toohey

Cathy Fink, 2004. Photo by John Lupton

Clockwise from top left:
Maura Kennedy, 2008. Photo by Lisa Schaffer

Steve Earle, 2008. Photo by Jayne Toohey

(L-R): Enrique Coria, Jim Kerwin, Bryce Milano, Darol Anger, and David Grisman, 2005. Photo by John Lupton

Allison Moorer, 2008. Photo by Lisa Schaffer

Rebecca Lovell (Lovell Sisters), 2007. Photo by Jayne Toohey

Pete Kennedy, 2008. Photo by Lisa Schaffer

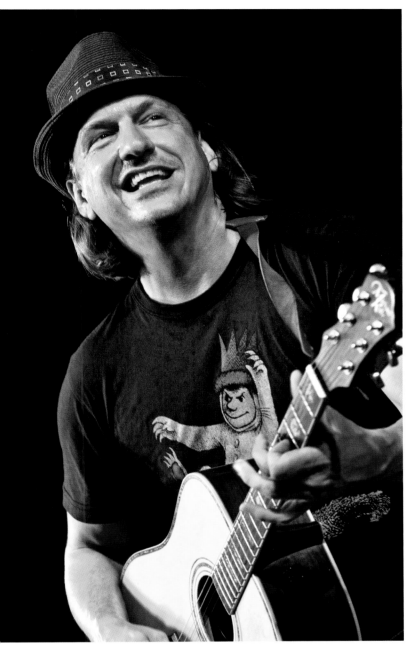

Clockwise from top left:
Ellis Paul, 2009. Photo by Mark Silver

Fiddler's Bid, 2006. Photo by John Lupton

Tom Russell, 2004. Photo by John Lupton

Ethan Flynn busking in 2006. (Apparently the allowance his dad, John Flynn, was giving him was not enough to meet expenses.) Photo by Jayne Toohey

David Roth, 2003. Photo by Jayne Toohey

Spirit Wing performing in Dulcimer Grove, 2005. Photo by Bob Yahn

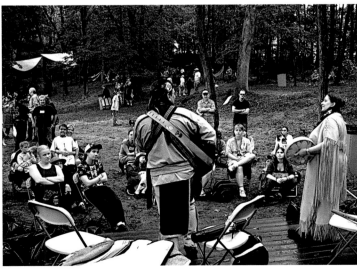

Clockwise from top left:
Quebe Sisters Band, 2007 (L-R): Sophia Quebe, Hulda Quebe, and Grace Quebe. Photo by John Lupton

At left are the three ladies of The Refugees: Cidny Bullens (with mandolin), Deborah Holland, and Wendy Waldman. Posing with them at the Tank Stage are Jean Ritchie, Janis Ian, and Nicole Reynolds, 2008. Photo by Jayne Toohey

Larry Cohen, 2002. Photo by Jayne Toohey

Fiona McBain (L) and Amy Helm (Olabelle), 2004. Photo by John Lupton

Rushad Eggleston (Crooked Still), 2005. Photo by Jayne Toohey

Clockwise from top left:
Setting up at the Tank Stage, 2006. Photo by Frank Jacobs III

Radoslav Lorkovic, 2009. Photo by Jayne Toohey

Kaigal-ool Khovalyg (Huun-Huur-Tu, Tuvan Throat Singers), 2006. Photo by John Lupton

Carl Finch (Brave Combo), 2004. Photo by Jayne Toohey

Clockwise from top left:
Sonny Landreth, 2009. Photo by Barry Sagotsky

Nanci Griffith, 2002. Photo by Jayne Toohey

Jeannie Burns (Burns Sisters), 2008. Photo by Jayne Toohey

Jessica Lovell (L) and Megan Lovell (Lovell Sisters), 2007. Photo by John Lupton

Marcia Ball, 2005. Photo by Jayne Toohey

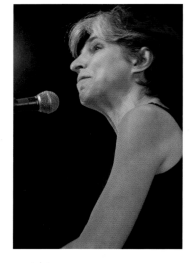

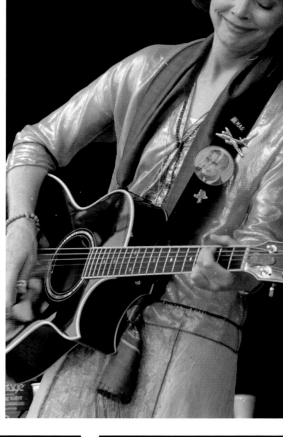

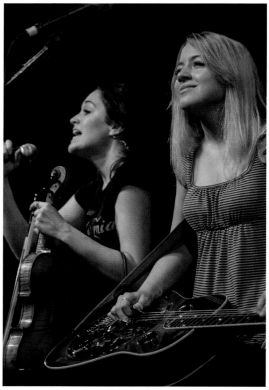

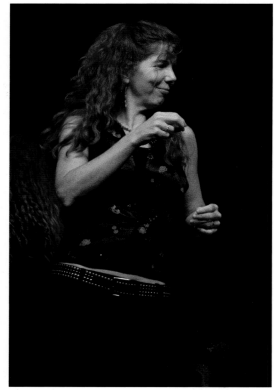

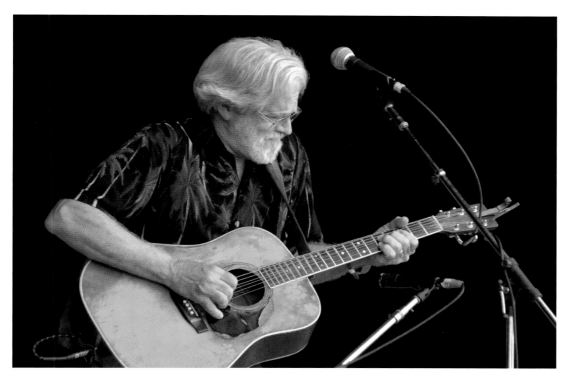

Clockwise from top left:
Jack Williams, 2007. Photo by Jayne Toohey

Cindy Cashdollar, 2004. Photo by John Lupton

Bruce Cockburn, 2002. Photo by Jayne Toohey

Member of the Vanaver Caravan troupe, 2007. Photo by Jayne Toohey

THE 2010S

2010

A.A. Bondy
Adam Brodsky
Amelia Curran
Annie and the Beekeepers
Audra Mae
Barry Rabin
Ben Arnold Band
Blame Sally
Bob Beach
Bonnie "Prince" Billy and the
 Cairo Gang
Butch Ross
Cadillac Sky
Carla Ulbrich
Charlie Miller, Scott Rovner,
 and Friends
Cheers Elephant
Chris Smither and the
 Motivators
Clay Ross and Matuto
Dave Quicks Trio
David Dye
Deirdre Flint
Dennis Hangey
DJARARA
Erin McKeown
The Fleeting Ends
Gandalf Murphy and The
 Slambovian Circus of
 Dreams
Gene Shay
Give and Take Jugglers
The Giving Tree Band
Glossary
The Great Groove Band
Harlem Blues and Jazz Choir
 Band
Helen Leicht
Hoots and Hellmouth
Horse Feathers
Iain Matthews
Jack Marks
Jah Levi and The Higher
 Reasoning
Jake Snider
Jeff Tweedy
Jesse McReynolds
Joe Pug
Joel Zoss
Johnny Miles
Justin Rutledge
Kenny Ulansey and Whirled
 Music
Kyle Offidini
Lee Harvey Osmond
Malaika

Malinky
Marc Silver and the
 Stonethrowers
Makr Ross
Mason Porter
Mickey Clark and the Blue
 Norther
Natalia Zuckerman
Nudie and The Turks
Richard Thompson
Rockin' Acoustic Circus
Ron Buchanan
Ryan Tennis
Scott Pryor and Common
 Sinners
Shannon Whitworth
The Spinning Leaves
Sonos
The Subdudes
Susan Werner with Trina
 Hamlin and Natalia
 Zukerman
The Sweetback Sisters
Taj Mahal
Tania Alexandra
That 1 Guy
Tin Bird Choir
Treasa Levasseur
Trina Hamlin
Two of a Kind
Vienna Teng

2011

Alexis P. Suter Band
Amanda Shires and Rod
 Picott
Angel Band
Arlo Guthrie
Battlefield Band
The Berrys
Birdie Busch
Bob Beach
Bob Carlin
Brad Hinton
Burning Bridget Cleary
Caitlin Rose
Campbell Brothers
Caryl P. Weiss
Charlie Miller, Scott Rovner,
 and Friends
Chris Brashear
Chris Sharp
Courtney Malley
Dala
Dan Bern
David Amram
David Bromberg Big Band
David Dye
Davis Wax Museum
Deborah Pieri
Dennis Hangey

Donna Hebert
Dry Branch Fire Squad
Elizabeth Butters
Footworks
Frank Solivan and Dirty
 Kitchen
Full Frontal Folk
Gene Shay
Give and Take Jugglers
Great Groove Band
Gregory Alan Isakov
Groovemama
Hanny Budnick
Helen Leicht
HogMaw
Hoots and Hellmouth
Jane Rothfield
Jennifer Schonwald
Jeremy Birnbaum
JessicaLea Mayfield
Jim Boggia
Jim Rooney and Bill Keith
Joel Plaskett Emergency
John Flynn
John Francis
John Hartford Stringband
Jordan Katz
Jorma Kaukonen
Justin Townes Earle
Kathy O'Connell
The Kennedys
Kim and Reggie Harris
Levon Helm Band
Madison Violet
Matt Combs
Michael Braunfeld
Mike Agranoff
Pat Wictor
Philadelphia Jug Band
Rob Deckhart
Roger Deitz
Ron Buchanan
Roy Book Binder
RUNA
Sonny Ochs
Stephen Marmel
Steve Riley and The Mamou
 Playboys
Stretch Pyott
Suzie Brown
Tempest
Terrance Simien and Zydeco
 Experience
The Turnips
The Wilderness of Manitoba
The Wood Brothers
Tom Paxton
Tom Rush
Trombone Shorty and
 Orleans Avenue
US Rails

Wes Mattheu and the New
 Way Down

2012

Aaron and The Spell
Aborea
Allan Carr
Andrew Lipke
Atwater-Donnelly
Big George Brock
Bob Beach
Brother Sun
Cabinet
Carsie Blanton
Cedric Burnside
Charlie Miller, Scott Rovner,
 and Friends
Chris Bathgate
Chris Kasper
City and Colour
Comas
Dante Bucci
David Dye
Debo Band
Deborah Pieri
Dennis Hangey
Eric Abraham
Fighting Jamesons
Gene Shay
Give and Take Jugglers
Great Groove Band
Griz
Groovemama
Harper Blynn
Helen Leicht
The High Dollar Band
The HillBenders
Holmes Brothers
Jane Rothfield
Jeremy Birnbaum
John Francis
John Fuhr
John Fullbright
John Hiatt and the Combo
Kala JoJo
Karmic Repair Company
Little Feat
Lord Jacob and the Ukuladies
Lori McKenna
Lucinda Williams
Mark Erelli
Mary Chapin Carpenter
Mary Gauthier
Mason Porter
Michael Braunfeld
Mike Cross
Mike Miller
Molly Hebert-Wilson
Paul Thorn
Philadelphia Jug Band
Pokey LaFarge and the South

City Three
Red Clay Ramblers
Reverend TJ McGlinchey
Reverend Peyton's Big Damn
 Band
Roger Deitz
Roosevelt Dime
Spuyten Duyvil
The Secret Sisters
Steve Earle and the Dukes
Strand of Oaks
Tom Coughlin
Tracy Grammer
Trombone Shorty and
 Orleans Avenue
Tuckers' Tale Puppet Theatre
The Turnips
Voices of the Wetlands
 Allstars
The Whiskeyhickon Boys
The Wooden Sky
Zach Stock

2013
Ali Wadsworth
Allan Carr
Amigos Band
Amy Helm
Andy Statman Trio

Annie Bauerlein and Chip
 Mergott
Ansel Barnum
Asleep at the Wheel
Ben Arnold
Ben Vaughn Quintet
Black Prairie
Bob Beach
Burning Bridget Cleary
Caravan of Thieves
Carolina Chocolate Drops
Cathy Fink and Marcy Marxer
Charlie Miller
The Como Mamas
Dani Mari
David Amram
David Bromberg Quintet
David Dye
David Francey
David Uosikkinen's In The
 Pocket
Del Barber
Dennis Hangey
Ellis Paul
Eric Abraham
Frank Fairfield
Gene Shay
Ginger Coyle
Give and Take Jugglers

Great Groove Band
Groovemama
Helen Leicht
Hennessey Bonfire
HogMaw
Hula Honeys
Jake Shimabukuro
Jason Hahn
Jeffrey Gaines
Jerry Hionis
Jersey Corn Pickers
Jim Albertson
Jimmy Vivino and Gabriel
 Butterfield
Joe Crookston and the
 Bluebird Jubilee
John Flynn
John Francis
John Fuhr
Juston Stens and Get Real
 Gang
Karmic Repair Company
Kathy O'Connell
The Lawsuits
Lily Mae
Lord Jacob and the Ukuladies
Lost Indian
Luella and The Sun
Manatawny Creek Ramblers

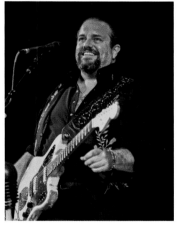

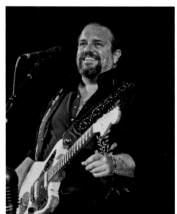

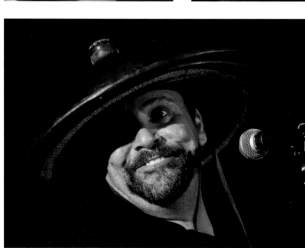

Marc Silver and the Stonethrowers
Mark Schultz
Matt Sowell
The Mavericks
Melissa Taggart
Michael Braunfeld
Mike and Ruthy
Mike Benner
Mike Miller
Mist Covered Mountains
Modern Inventors
Molly Hebert-Wilson
New Sweden
Otis Taylor Band
Psych-A-Billy
Reverend Peyton's Big Damn Band
Reverend TJ McGlinchey
Richard Thompson Electric Trio
RUNA
Sarah Flynn
Saul Broudy
Scott Rovner and Friends
Seth Holzman
Shawn Proctor
Sid Root

Sierra Leone's Refugee All Stars
Sleepy Man Banjo Boys
Spirit Family Reunion
Spuyten Duyvil
Star and Micey
Steam Powered Aereo Band
Steve Guyger
The Stray Birds
Sweetbriar Rose
Todd Rundgren
Toy Soldiers
Tracy Degerberg
Tuckers' Tales Puppet Theatre
Up the Chain
Ursula Rucker and Tim Motzer
Vinegar Creek Constituency

2014
Andrea Nardello
Angaleena Presley
Antsy McClain
April Mae and the June Bugs
Archie Fisher
Barbara Gettes
Ben Cocchiaro

Ben Kessler
Better'n Recess
Black Horse Motel
Bob Beach
Brummy Brothers
Cabin Dogs
Caroline Rose
Casey Alvarez
Charlie Miller
DakhaBrakha
Dave Fry
David Dye
Dennis Hangey
DisCanto
The Downtown Shimmy
El Caribefunk
A Fistful of Sugar
Garnet Rogers
Gene Shay
Gibson Brothers
Give and Take Jugglers
Groovemama
Helen Leicht
Honey Child
Hot Club of Cowtown
Hot Club of Philadelphia
Irene Molloy
Jake Lewis and the Clergy

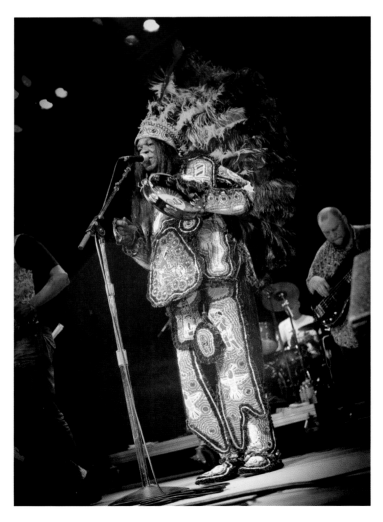

Janis Ian
Jason Isbell
Jefferson Berry and the
 Urban Acoustic Coalition
Jeremy Birnbaum
John Byrne
John Flynn
John Francis
John Fuhr
John Gallagher Jr.
Johnnyswim
Jordie Lane
Josh White Jr.
Kalob Griffin
Karla Iverson and Friends
Kathy O'Connell
Katie Frank and the
 Pheromones
Kicking Down Doors
Kwesi K
Kyle Swartzwelder
The Lone Bellow
Loudon Wainwright III
Matt Duke
Meghan Cary with the Analog
 Gypsies
Melissa Taggart
Michael Braunfeld

Mike Miller
Mutlu
Natalie MacMaster
Nick Annis
Norman Taylor
Old Crow Medicine Show
Old Man Luedecke
Orion Freeman
Orpheus Supertones
Parsonsfield
Rebecca Loebe
Rebirth Brass Band
Roger Deitz
Ryan Tennis and the
 Clubhouse Band
Sarah Jarosz
Shemekia Copeland
Sid Root
The Slide Brothers
SONiA
Sonoma Sound
Spuyten Duyvil
Steep Canyon Rangers
Steve Poltz
Sturgill Simpson
Tempest
Ten Strings and a Goat Skin
Tim Van Egmond

Tommy Emmanuel
Up the Chain
Vance Gilbert
Vulcans
The Wallace Brothers Band

2015
Aaron Nathans and Michael
 Ronstadt
Allan Carr
Andrea Nardello
Andrew Jude
Angela Sheik
Ants on a Log
Arlo Guthrie
Band of Rivals
Barry Rabin
Baskery
Black Horse Motel
Bobtown
The Britton Family: Young
 Kings of Britton
Bruce Cockburn
Cassie and Maggie
 MacDonald
Caveman Dave
Charlie Miller, Scott Rovner
 and Friends

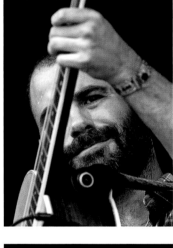

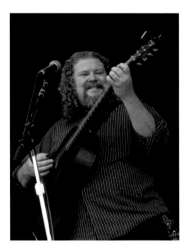

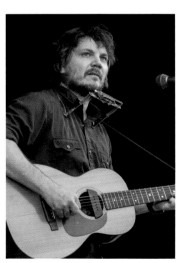

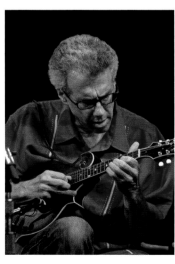

Chubby Carrier and the Bayou Swamp Band
Craig Bickhardt
Cynthia G. Mason
Dave Gunning
David Berkeley
David Dye
Della Mae
Dennis Hangey
Dylan Jane
El Caribefunk
Elspeth Tremblay
Full Frontal Folk
Gene Shay
Give and Take Jugglers
Greg Johnson
Groovemama
Hawk Tubley
Helen Leicht
The Hello Strangers
The Hillbenders
Honey and Houston
Hoots and Hellmouth
Irish Mythen
Jack Murray
Jeneen Terrana
Jeremy Birnbaum
Jersey Corn Pickers

Jesse Terry
John Beacher
John Byrne Band
John Flynn
John Francis
John Fuhr and Brandywine Ridge
John Gallagher Jr.
John Mallinen
Katherine Rondeau
Kathy O'Connell
Kevin Killen
Kicking Down Doors
Kuf Knotz
Ladybird
Larry Campbell and Teresa Williams
Lee Boys
Levee Drivers
Lindi Ortega
Little Missy
Lizanne Knott
Lovers League
Low Cut Connie
Lyle Lovett and His Large Band
Madisen Ward and the Mama Bear

Magic Maps
Man About a Horse
Mark Mandeville and Raianne Richards
Mason Porter
Matt Andersen
Mia Bergmann
Michael Braunfeld
Mist Covered Mountains
Naelee Rae
No Good Sister
North Mississippi Allstars
North Star Puppets
The Old Ways
Parker Millsap
Paul Mamolou
Paul Saint John
Pesky J. Nixon
PhillyBloco
Psych-a-Billy
Ray Owen
Rich Myers
Rolly Brown
Ron Nolen
Rootology
Scott Wolfson and Other Heroes
Selwyn Birchwood

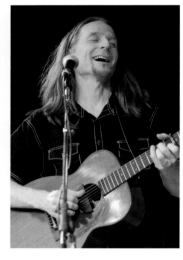

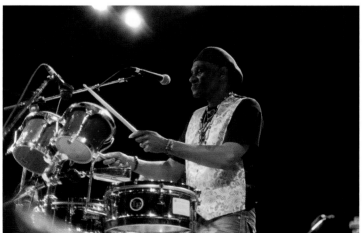

Shakey Graves
Silverton
Spuyten Duyvil
Steve Riley and The Mamou
 Playboys
Sylvia Platypus
Tall Heights
Tara Murtha
Tin Bird Choir
Todd Fausnacht
Tom Paxton
Valley Creek
The Wallace Brothers Band

2016
Acoustic Blender
Ami Yares
Anderson East
Annie Patterson and Peter
 Blood
Ants on a Log
AppalAsia
April Mae and the June Bugs
Avi Wisnia
Bakithi Kumalo and The
 South African All-Stars
Bat
Bear Cave Tower

Bethlehem and Sad Patrick
Better'n Recess
Bob Beach
Boris Garcia
Brandywine Ridge
Buffy Sainte-Marie
The Bumper Jacksons
Burning Bridget Cleary
Butch Zito
Charlie Miller, Scott Rovner
 and Friends
Christie Lenee
CJ Chenier and the
 Buckwheat Zydeco Band
Damn Tall Buildings
Darlingside
David Dye
David Myles
De Tierra Caliente
Deer Scout
Del and Dawg (Del McCoury
 and Jerry Grisman)
Dennis Hangey
Dillon and Ford
Driftwood Soldier
The Dukes of Destiny
Edge Hill Rounders
Emma Cullen

The End of America
Ethan Flynn
Ethan Pierce
A Fistful of Sugar
Fortunate Ones
Frog Holler
Give and Take Jugglers
Groovemama
Heart Harbor
Helen Leicht
The Hello Strangers
The Hoppin' Boxcars
Hot Club of Philadelphia
Hurricane Hoss
Iris DeMent
Jack Murray
Jason Ager
Jason McCue
Jeremiah Tall
Jim Boggia
John Flynn
John Francis
Jon Dichter
Kaia Kater
Katherine Rondeau
Kathy O'Connell
Katie Barbato
Kirsten Maxwell

Top row, left to right:
No Good Sister, 2015 (L-R): Meaghan Kyle, Maren Sharrow, and Jess McDowell. Photo by Howard Pitkow

Sharkey McEwen (Gandalf Murphy and the Slambovian Circus of Dreams), 2010. Photo by Jayne Toohey

Bottom row, left to right:
Tommy Emmanuel, 2014. Photo by John Lupton

SONiA (Sonia Rutstein), 2014. Photo by John Lupton

Ruth Ungar and Mike Merenda, 2013. Photo by Jayne Toohey

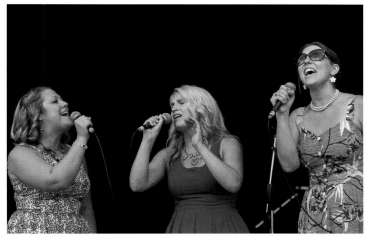

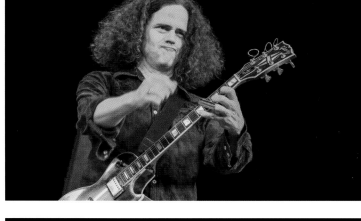

Last Chance
The Late Saints
Leslie Carey
Liz Longley
The Lone Bellow
Lord Jacob and the Ukuladies
Los Lobos
Marc Silver and The
 Stonethrowers
Marty Stuart and His
 Fabulous Superlatives
Matt Duke
Meghan Cary
Michael Braunfeld
Michael Spear Duo
Michelle Miller
Mike Agranoff
Mist Covered Mountains
Mollie O'Brien and Rich
 Moore
Mya Byrne
North Star Puppets
Owl and Wolf
Peter Mulvey
Peter Yarrow
Pine Leaf Boys
Psychedelic Elders
Quiet Life
Railroad Fever
Rare Spirits
Red Cedar Strings
Reverend TJ McGlinchey
Rich Myers
River Whyless
Robin and Linda Williams
Rock My Soul, featuring The
 Fairfield Four and
 McCrary Sisters
Roger Sprung
Rusty and Jan
Sam Gleaves
Sarah and The Arrows
Scott Wolfson and Other
 Heroes
Session Americana
Sharon Shannon
The Sheepdogs
Si Kahn
Sid Root

Sparkle Pony
Spuyten Duyvil
The Stray Birds
Stu and the Gurus
Tall Heights
Tempest
Terry Rivel
Thomas Wesley Stern
Toby Walker
Two of a Kind
Vishteèn
Walter "Wolfman"
 Washington and the
 Roadmasters
Wesley Stace
The Wood Brothers

2017

Almshouse
Andrea Nardello
Andy McKee
Ants on a Log
Apache Trails
Baile An Salsa
Bella Hardy
Ben Arnold and the 48th
 Hour Orchestra
Black Horse Motel
Boulevard Express
Brandywine Ridge
Brian Dunne
Brooke Annibale
Butter Queen Sister
Caroline Reese and the
 Drifting Fifth
Cary Morin
Charlie Miller
Chickabiddy
Corin Raymond
Courtney Malley
Cry Cry Cry
Dani Mari
David Amram
David Bromberg
 (impromptu)
David C. Perry
David Dye
David Jacobs-Strain with Bob
 Beach

Dawn Hiatt
Dennis Hangey
DK and The Joy Machine
Edge Hill Rounders
The End of America
Eric Andersen
A Fistful of Sugar
Gather Round
Gene Shay
Gene Smith Band
Give and Take Jugglers
Graham Nash
Greg Sover Band
Hannah Taylor
Harrow Fair
Heartland Nomads
Heather Maloney
Helen Leicht
Hezekiah Jones
Hot Beer
Ian Foster
The Infamous Stringdusters
Instant Bingo Jam
Jay Smar
Jeremy Aaron
Jesse Hale Moore
Jessica Graae
Joan Shelley
John Flynn
John McCutcheon
Julia Brandenberger
Kalob Griffin
Katherine Rondeau and the
 Show
Ken Tizzard
The Kennedys
Kicking Down Doors
Kristin Rebecca
Ladybird
Larry Campbell and Teresa
 Williams
Laura Cortese and The Dance
 Cards
Laura Love Duo
The Levins
Lisa Chosed
Lissick and Lincoln and
 Cohen
Man About a Horse

Matt Wheeler and Vintage
 Heart
Michael Braunfeld
Michelle Miller
Mist Covered Mountains
Molsky's Mountain Drifters
The National Reserve
No Good Sister
North Star Puppets
Old Crow Medicine Show
Otis Gibbs
Paula Ballan
Queen Esther
Quentin Callewaert
Ranky Tanky
Rare Spirits
Ray Naylor
Rich Myers
RUNA
Sam Baker
Samantha Fish
Sara Chodak
Saul Broudy
Scotty and Friends
Sierra Hull
Silverton
Skip Denenberg
Son of Town Hall
Spirit Wing
Spuyten Duyvil
Stephen Wade
Stevie and the Bluescasters
Susan Werner
Sweetbriar Rose
Sylvia Platypus
Taj Mo: The Taj Mahal and
 Keb Mo Band
The Theologicals
Tift Merritt
Two of a Kind
Vita and the Woolf
The Weight Band with the
 King Harvest Horns
Wesley Stace
The Whispering Tree
Whitehorse
The Young Novelists

Top left: Shakey Graves (L), 2015. Photo by Mark Silver

Top right: Dom Flemons (Carolina Chocolate Drops), 2013. Photo by Laura Carbone

Bottom left: Pokey LaFarge, 2012. (Photo by Laura Carbone)

Bottom right: Oliver Craven (The Stray Birds), 2016. Photo by Eric Ring

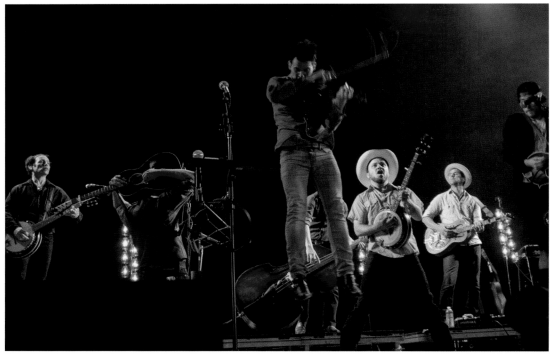

Top: Brother Sun, 2012 (L-R): Greg Greenway, Joe Jencks, and Pat Wictor. Photo by Jayne Toohey

Center left: Old Crow Medicine Show, 2014. Photo by Jayne Toohey

Center right: Chris Freeman (Parsonsfield), 2014. Photo by John Lupton

Bottom left: Breezy Peyton (Reverend Peyton's Big Damn Band), 2013. Photo by Howard Pitkow

Bottom right: Steep Canyon Rangers, 2014 (L-R): Nicky Sanders, Charles Humphrey III, Graham Sharp, Mike Guggino, and Woody Platt. Photo by John Lupton

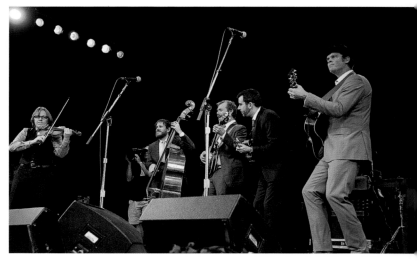

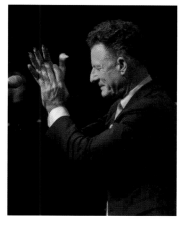

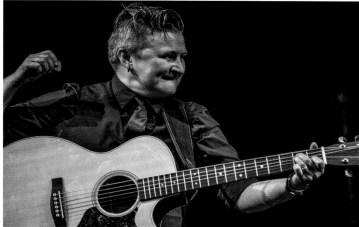

Clockwise from top left:
Lyle Lovett, 2015. Photo by Jayne Toohey

Steve Earle, 2012. Photo by Mark Silver

Irish Mythen, 2015. Photo by Jayne Toohey

Angel Band performing with Levon Helm, 2011. Photo by Jayne Toohey

John Flynn, 2014. Photo by Steve Sandick

Sturgill Simpson, 2014. Photo by John Lupton

Jake Shimabukuro, 2013. Photo by Mark Silver

219

Clockwise from top left:
"Fest Babies" Sarah and Sean Flynn,
2013. Photo by Alex Lowy

David Amram, with The Amigos, 2013.
Photo by Mark Smith

At the Camp Stage (2015) with Larry
Campbell, Teresa Williams, and the Wallace
Brothers Band. Photo by Lisa Schaffer

From Ukraine, the ladies of DakhaBrakha,
2014 (L-R): Olena Tsibulska, Iryna
Kovalenko, and Nina Garenetska. Photo by
John Lupton

Lizanne Knott, 2015. Photo by Lisa Schaffer

Butterfield Revisited, 2013. Photo by
Jayne Toohey

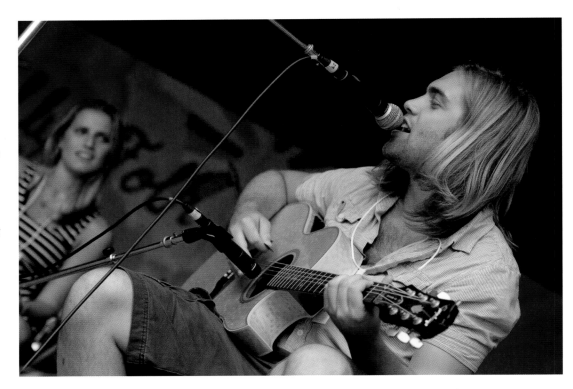

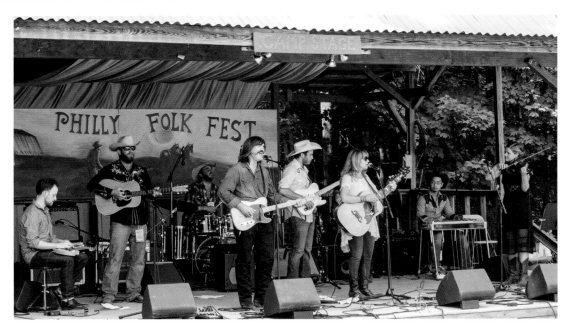

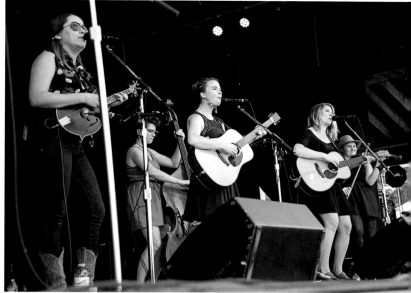

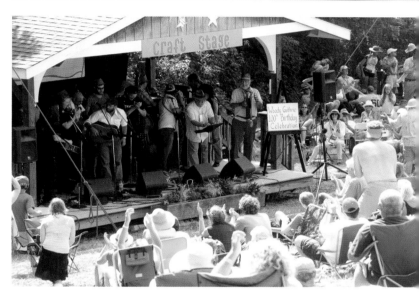

Left, top: Mike Miller leading a workshop in the Dance Tent, 2014. Photo by Lisa Schaffer

Left, bottom: Antsy McClain, 2014. Photo by Jayne Toohey

Right, top: Della Mae, 2015 (L-R): Jenni Lyn Gardner, Zoe Guigueno, Courtney Hartman, Celia Woodsmith, and Kimber Ludiker. Photo by John Lupton

Right, center: Celebrating the Woody Guthrie Centennial at the Craft Stage, 2012. Photo by Lisa Schaffer

Right, bottom: Eddie Rivers (Asleep At The Wheel), 2013. Photo by Jayne Toohey

Clockwise from top left:
Frank Zemlan (Philadelphia Jug Band), 2011. Photo by Jayne Toohey

Baskery, 2015: Greta Bondesson (banjo) and Sunniva Bondesson (guitar). Photo by John Lupton

Dry Branch Fire Squad, 2011. Photo by Jayne Toohey

Katie Frank, 2014. Photo by Bob Yahn

Gene Smith, 2011. Photo by Lisa Schaffer

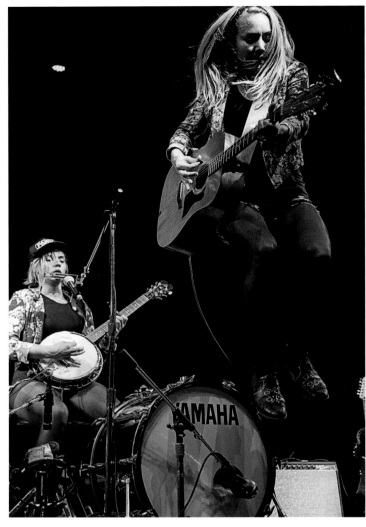

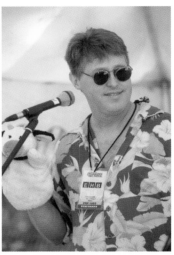

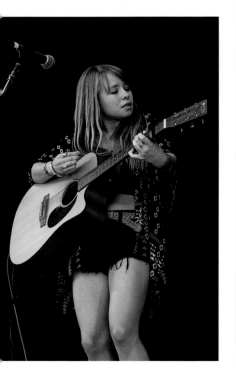

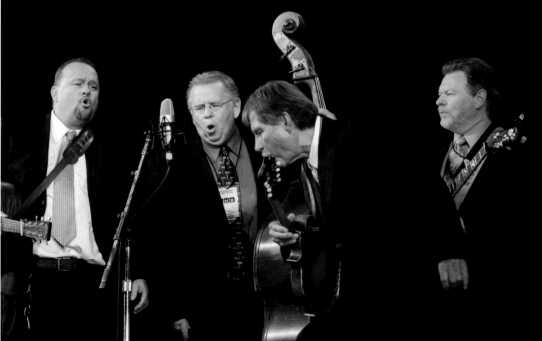

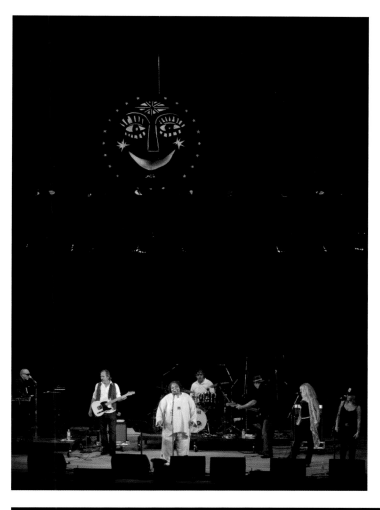
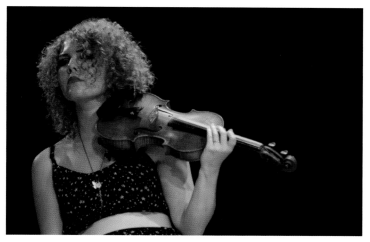
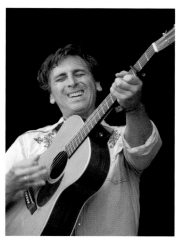
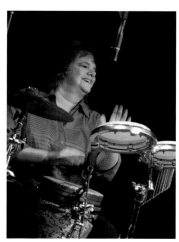
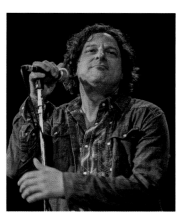
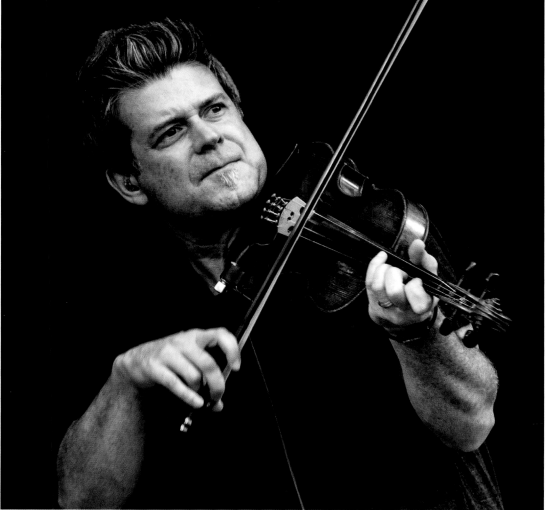

Clockwise from top left:
Alexis P. Suter Band, 2011. Photo by Lisa Schaffer

Eleanor Whitmore (Steve Earle and The Dukes), 2012. Photo by Jayne Toohey

Cheryl Prashker (RUNA), 2013. Photo by Jayne Toohey

Ben Arnold, 2013. Photo by Mark Smith

Steve Riley (Steve Riley and The Mamou Playboys), 2015. Photo by Mark Silver

Joe Crookston, 2013. Photo by Jayne Toohey

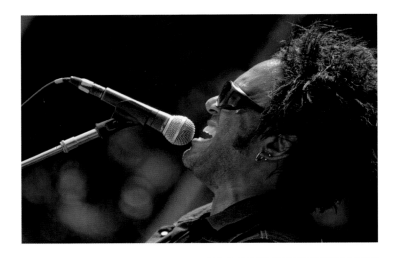

Clockwise from top left:
Jeffrey Gaines, 2013. Photo by Alex Lowy

Paul Wilkinson (Mason Porter), 2015.
Photo by Lisa Schaffer

Elizabeth McQueen (Asleep At The
Wheel), 2013. Photo by Jayne Toohey

Reverend TJ McGlinchey, 2012. Photo by
Jayne Toohey

Richard Bush (In The Pocket), 2013.
Photo by Jayne Toohey

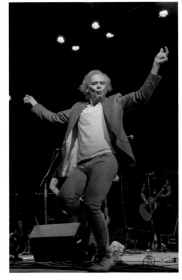

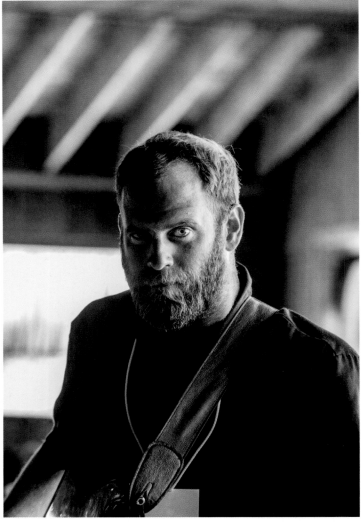

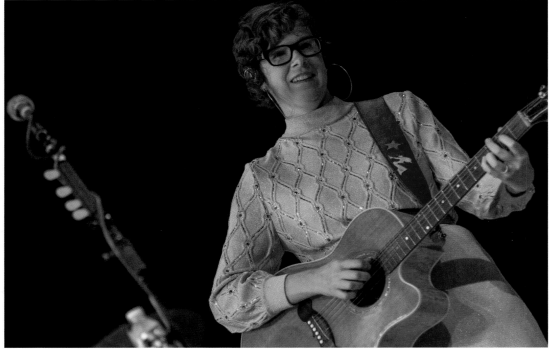

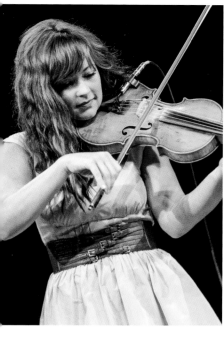

Clockwise from top left:
Amanda Shires (performing with Justin Townes Earle), 2011. Photo by Jayne Toohey

Barbara Gettes, 2010. Photo by Lisa Schaffer

Jeffrey Gaines, 2013. Photo by Alex Lowy

Todd Rundgren, 2013. Photo by Mark Smith

The Great Groove Band, 2010. Photo by Lisa Schaffer

Brother Sun, 2012 (L-R): Pat Wictor, Joe Jencks, and Greg Greenway. Photo by Bob Yahn

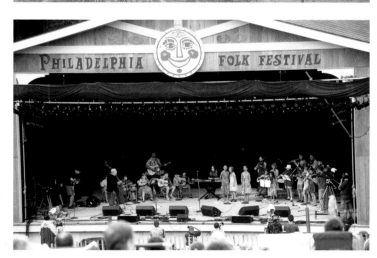

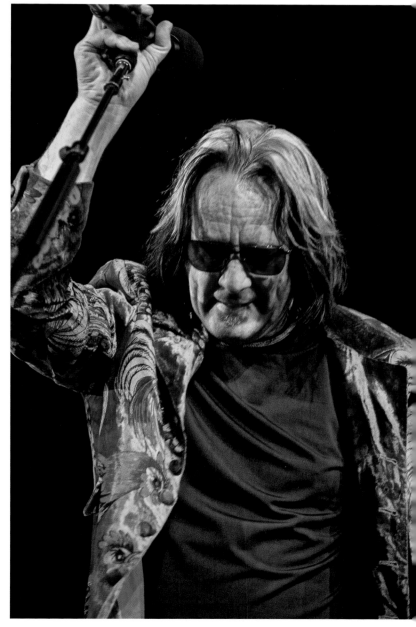

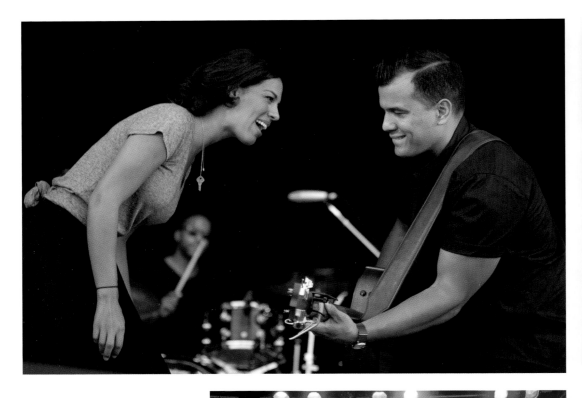

Clockwise from top left:
Johnnyswim (Amanda Sudano and Abner Ramirez), 2014. Photo by Jayne Toohey

Alexis P. Suter, 2011. Photo by Steve Sandick

Justin Townes Earle, 2011. Photo by Jayne Toohey

Cassie (R) and Maggie MacDonald, 2015. Photo by Jayne Toohey

Eddie Perez (The Mavericks), 2013. Photo by Jayne Toohey

Jerry Dale McFadden (The Mavericks), 2013. Photo by Jayne Toohey

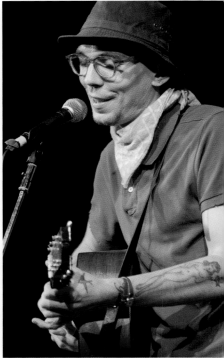

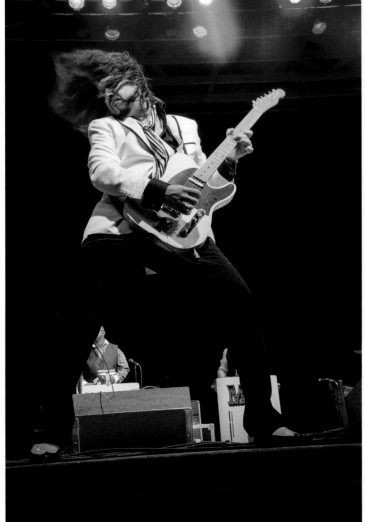

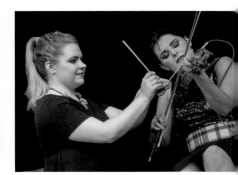

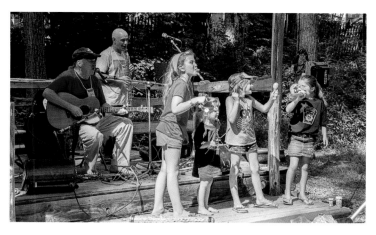

Dave Fry (guitar) and Kenny Lansing (oboe) with four of their closest friends in Dulcimer Grove, 2014. Photo by John Lupton

The people speak, 2012. Photo by Jayne Toohey

Craig Bickhardt (center), 2015. Photo by Lisa Schaffer

(L-R): Nolan Lawrence, Chad Graves, and Gary Rea (The HillBenders), 2015. Photo by Mark Smith

Spuyten Duyvil, 2013. Photo by Steve Sandick

Tink Lloyd (Gandalf Murphy and The Slambovian Circus of Dreams), 2010. Photo by Steve Sandick

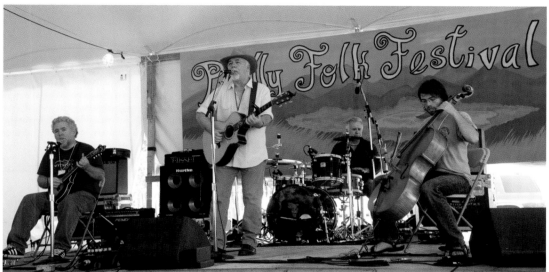

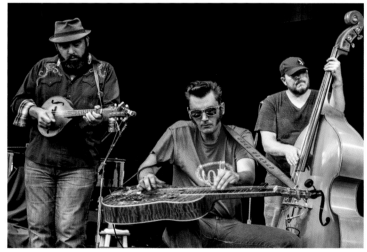

RUNA, 2013 (L-R): Cheryl Prashker, Maggie Estes, Shannon Lambert-Ryan, Dave Curley, and Fionán de Barra. Photo by Jayne Toohey

"What'd She Say?" Workshop on the Tank Stage, 2010. Photo by Jayne Toohey

Susan Werner, 2010. Photo by Jayne Toohey

Joseph Parsons (L) and Scott Bricklin, 2011. Photo by Lisa Schaffer

Lucinda Williams, 2012. Photo by Mark Smith

Roger Deitz (L) and Michael Braunfeld, 2014. Photo by Bob Yahn

The Britton Family (children and grandchildren of Philadelphia Folksong Society founder George Britton), 2015. Photo by Howard Pitkow

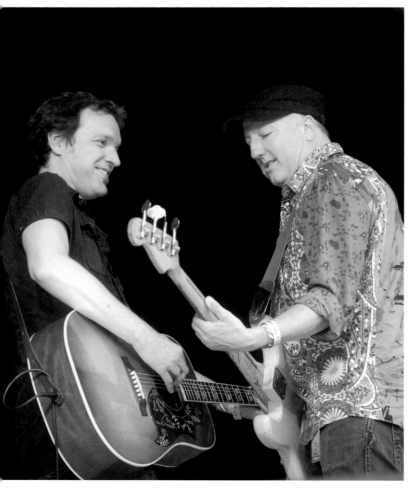

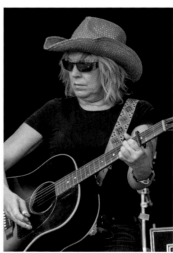

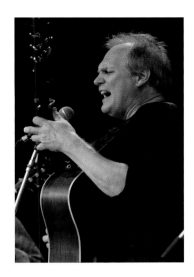

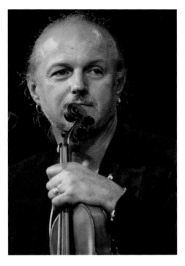

Top left: Greg Greenway (Brother Sun), 2012. Photo by Steve Sandick

Top center: Garnet Rogers, 2014. Photo by Jayne Toohey

Top right: Carsie Blanton, 2011. Photo by Lisa Schaffer

Bottom left: Shannon Lambert-Ryan (RUNA), 2013. Photo by Jayne Toohey

Bottom right: Bradley Keough (Psych-a-Billy), 2013. Photo by Frank Jacobs III

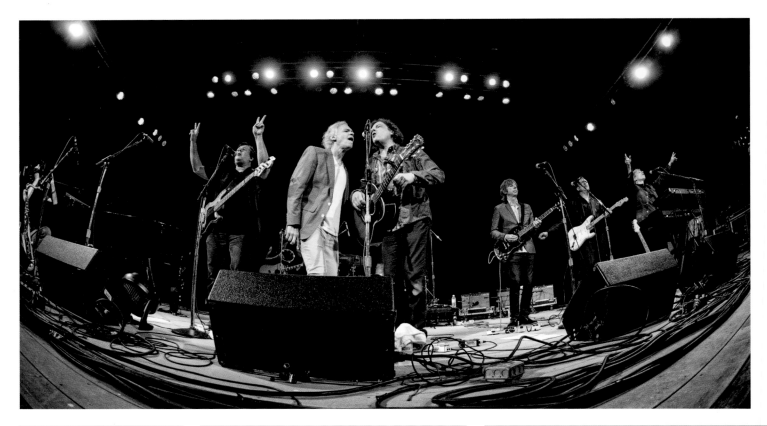

Top: In The Pocket, 2013. Photo by Mark Silver

Bottom, left to right:
Shakey Graves, 2015. Photo by John Lupton

Anne Harris (Otis Taylor Band), 2013. Photo by Jayne Toohey

Pat Wictor, 2011. Photo by Steve Sandick

Clockwise from top left:
John Hiatt, 2012. Photo by Mark Smith

John Gallagher Jr., 2014. Photo by Jayne Toohey

Steve Guyger, 2013. Photo by Laura Carbone

Andrés Mordecai (El Caribefunk), 2015. Photo by Jayne Toohey

Dante Bucci, 2012. Photo by Bob Yahn

Clockwise from top left:
Amy Helm, 2013. Photo by Jayne Toohey

Sturgill Simpson, 2014. Photo by John Lupton

Roy Book Binder, 2011. Photo by Steve Sandick

Bob Beach, 2011. Photo by Lisa Schaffer

Tracy Grammer, 2012. Photo by John Lupton

Wallace Brothers Band, 2015. Photo by Lisa Schaffer

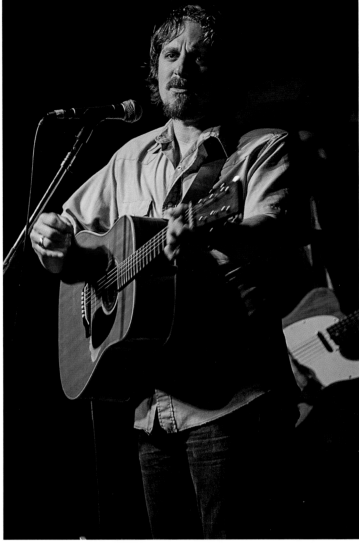

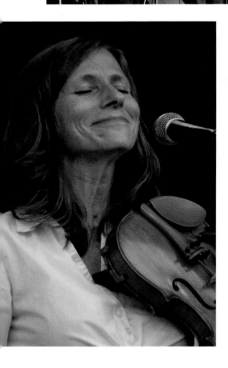

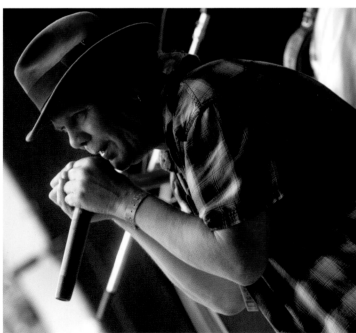

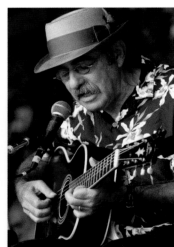

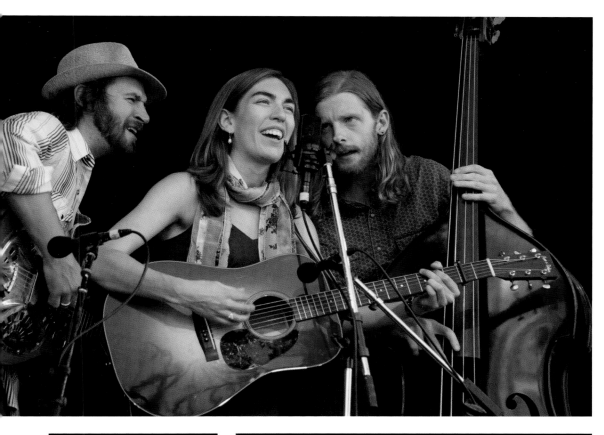

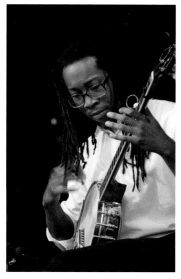

Clockwise from top left:
The Stray Birds, 2013 (L-R): Oliver Craven, Maya de Vitry, and Charles Muench. Photo by Jayne Toohey

Hubby Jenkins (Carolina Chocolate Drops), 2013. Photo by Jayne Toohey

Otis Taylor, 2013. Photo by Jayne Toohey

Kanene Pipkin (The Lone Bellow), 2014. Photo by Steve Sandick

Ray Benson (Asleep At The Wheel), 2013. Photo by Jayne Toohey

Rhiannon Giddens (Carolina Chocolate Drops), 2013. Photo by Jayne Toohey

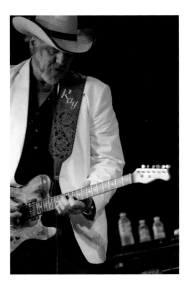

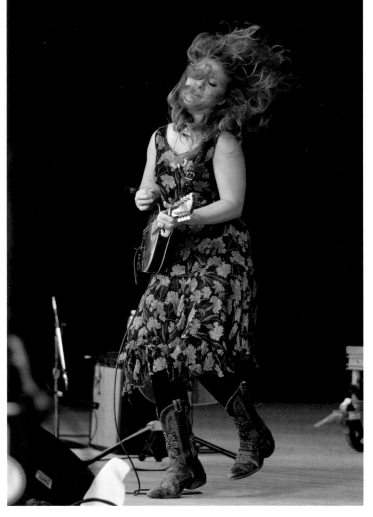

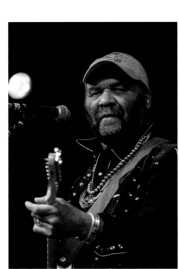

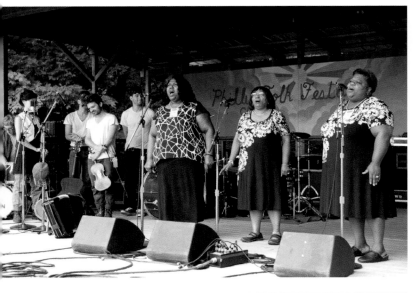
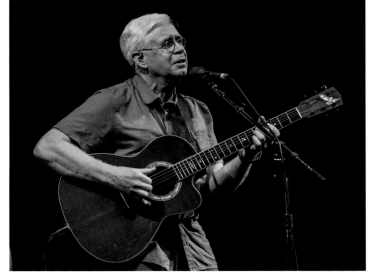

Top, left to right:
Como Mamas and Spirit Family Reunion, 2013. Photo by Howard Pitkow

Bruce Cockburn, 2015. Photo by Mark Smith

Center, left to right:
Deirdre Flint, 2010. Photo by Lisa Schaffer

Jim Boggia, 2011. Photo by Lisa Schaffer

Terry A La Berry (Arlo Guthrie Band), 2011. Photo by Jayne Toohey

Bottom: *Michael Baker (The Spinning Leaves), 2010.* Photo by Lisa Schaffer

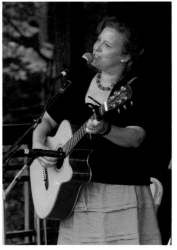
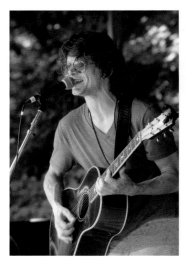

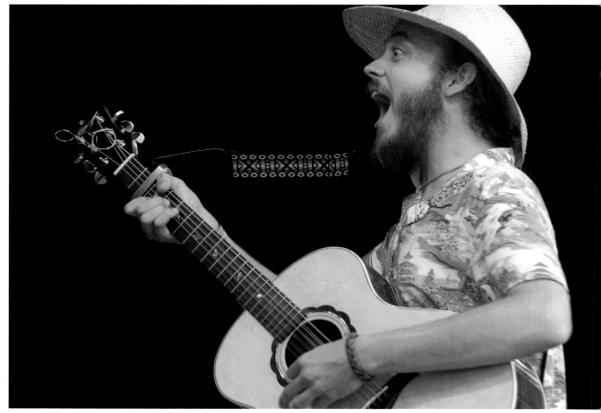

234

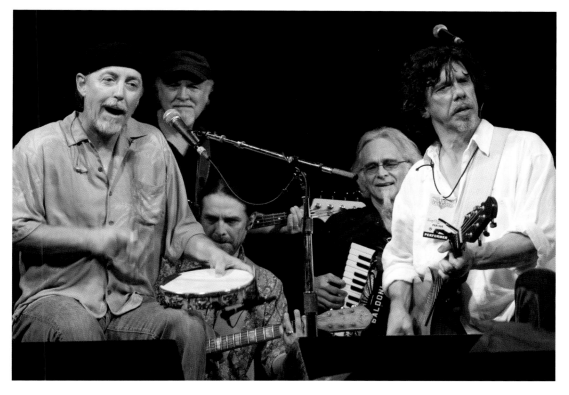

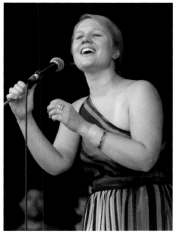

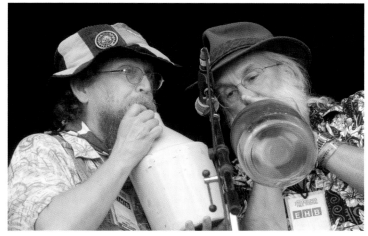

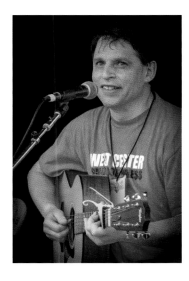

Clockwise from top left:
The Subdudes, 2010. Photo by Jayne Toohey

Parker Millsap, 2014. Photo by John Lupton

Mary Gauthier and Pat Wictor, 2012. Photo by Bob Yahn

"Doc Terry" McGrath (L) and Steve Miller (Philadelphia Jug Band), 2011. Photo by Lisa Schaffer

Volunteer Christine McHugh and her "steady," 2011. Photo by Lisa Schaffer

Kiley Ryan, 2010. Photo by Lisa Schaffer

Barry Rabin, 2010. Photo by Jayne Toohey

Birdie Busch, 2011. Photo by Jayne Toohey

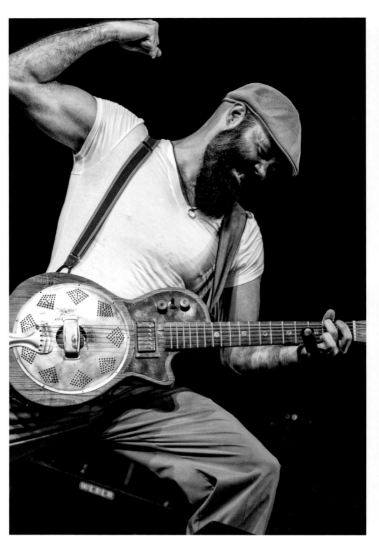

Maya de Vitry (The Stray Birds), 2013.
Photo by Jayne Toohey

Reverend J. Peyton (Reverend Peyton's Big Damn Band), 2013. Photo by Mark Silver

Chad Graves (The HillBenders), 2015.
Photo by Howard Pitkow

Joziah Longo (Gandalf Murphy and The Slambovian Circus Of Dreams), 2010.
Photo by Bob Yahn

Charles Muench (The Stray Birds), 2013.
Photo by Alex Lowy

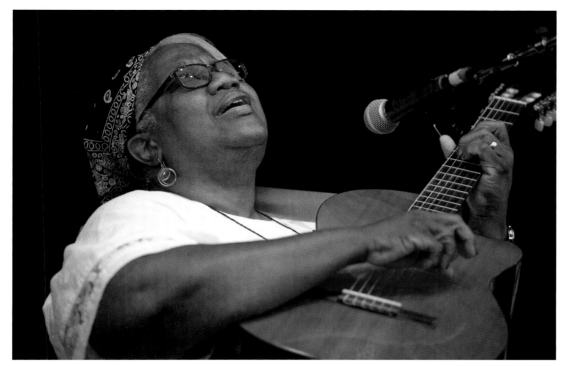

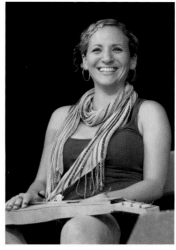

Left: Madisen Ward and The Mama Bear, 2015. Photo by Jayne Toohey

Above: Natalia Zukerman, 2010. Photo by Jayne Toohey

Far left: Leyla McCalla (Carolina Chocolate Drops), 2013. Photo by Jayne Toohey

Left: Dan Walton (Asleep At The Wheel), 2013. Photo by Jayne Toohey

Bottom: Hoots and Hellmouth, 2010. Photo by Jayne Toohey

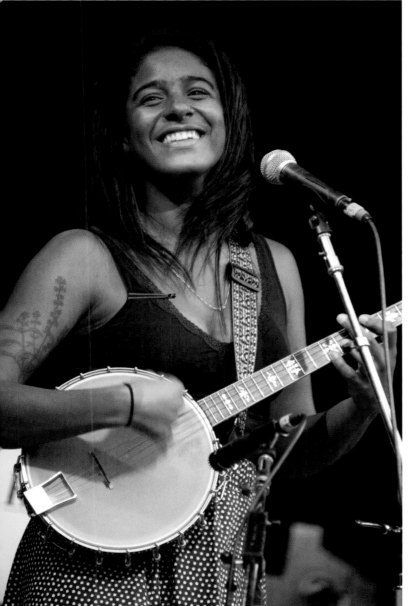

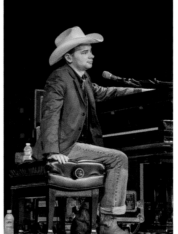

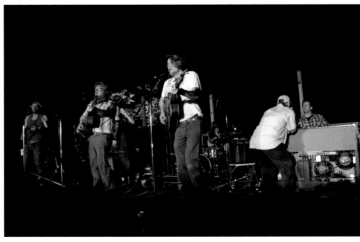

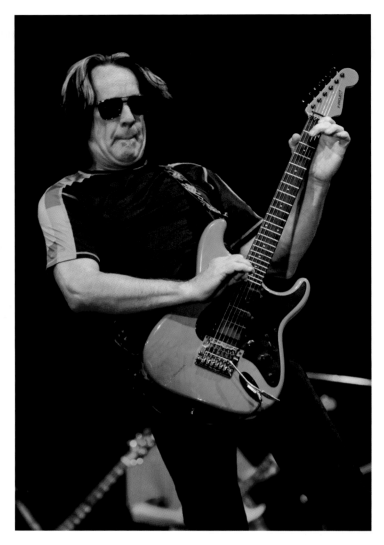

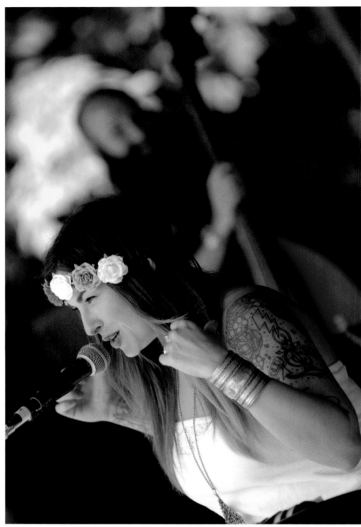

Clockwise from top left:
Todd Rundgren, 2013. Photo by Alex Lowy

Ginger Coyle, 2013. Photo by Alex Lowy

David Myles, 2016. Photo by Jayne Toohey

Manatawny Creek Ramblers, 2011. Photo by Lisa Schaffer

Irish Mythen (L) and Dave Gunning, 2015. Photo by Jayne Toohey

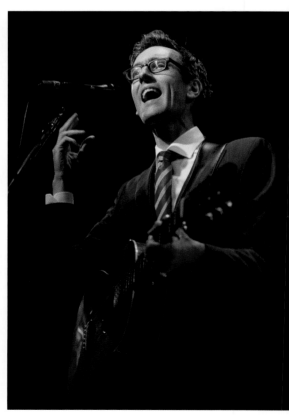

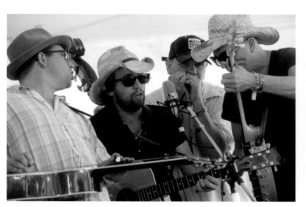

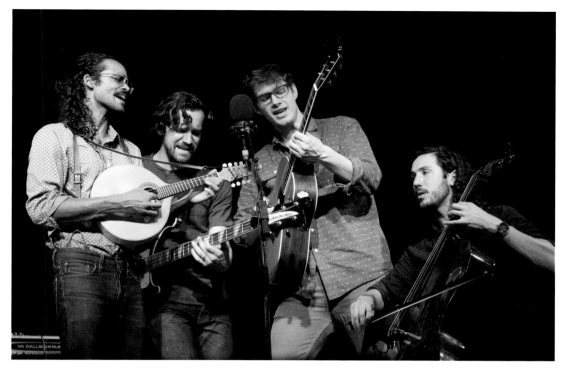

Top left: Darlingside, 2016 (L-R): Auyon Mukharji, David Senft, Don Mitchell, and Harris Paseltiner. Photo by Jayne Toohey

Top right: Anderson East, 2016. Photo by Jayne Toohey

Left: Anderson East with The Lone Bellow (Zach Williams, Brian Elmquist, and Kanene Pipkin), 2016. Photo by Jayne Toohey

Bottom: "Del and Dawg": Del McCoury (R) and Jerry Grisman, 2016. Photo by Jayne Toohey

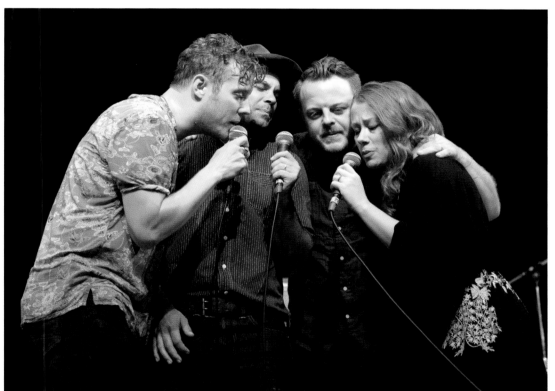

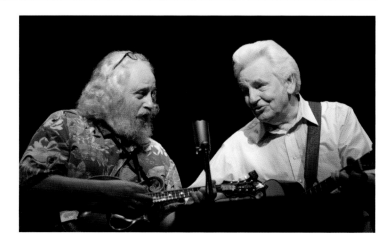

PHILADELPHIA FOLK FESTIVAL PERFORMERS 1962-2017

(Listed by Performer)

The following section provides a list of performers at each Philadelphia Folk Festival from 1962 through 2017, listed alphabetically with the year(s) they performed. This list is based on best available records and resources. No attempt has been made to parse out the names of individual band members from the bands they appeared with, and in many cases that information may no longer be possible to ascertain with any accuracy. Similarly, many individual performers listed below may also have appeared in other years as members of a band shown in this list. Following the publication of this book, updates to this list will be published on the Festival website at www.folkfest.org.

4 Way Street 2001
A. A. Bondy 2010
Aaron and the Spell 2012
Aaron Nathans and Michael Ronstadt 2015
Abby Newton 1974
Abdou Rahm Mangara 1991
Aborea 2012
Acoustic Blender 2016
Ad Vielle Que Pourra 1991, 1996
Adam Brodsky 2010
Adam Swink 2009
Adrien Reju 2009
Adrienne Young and Little Sadie 2004
Aileen and Elkin Thomas 1985, 1987
Air Dance 2005
Al Bluhm 1971
Al McKenney 1978, 1979
Al Stewart 2008
Alan Jabbour 1977
Alan Stivell 1978
Alan Stowell 1971
Alan Wolfersberger 1974
Alanis Obomsawim 1975
Albert Collins 1984
Alec Campbell and Ola Belle Reed 1966
Alela Diane 2009
Alex DePue 2006
Alexis P. Suter Band 2011
Alhaji Bai Konte 1973, 1979

Ali Akbar Khan 1965
Ali Wadsworth 2013
Alice Gerrard (Alice Seeger) 1972
Alice Gerrard, Brad Leftwich, and Tom Sauber 2002
Alice Peacock 2002
Alison Brown Quartet 2003
Alison Krauss and Union Station 1989, 1992
Alistair Anderson 1974, 1978, 1988
Alix Dobkin 1963
Allan Carr 2012, 2013, 2015
Allan Fraser and Donna DeBolt 1970, 1971
Allan Taylor 1971
Allison Moorer 2008
Almeda Riddle 1963
Almshouse 2017
Altan 1994
Alvin Youngblood Hart 1999
Aly Bain 1977
Amanda Shires and Rod Picott 2011
Amelia Curran 2010
Ami Yares 2016
Amigos Band 2013
Amos Lee 2006
Amy and Jenny 1993, 1995
Amy Fradon 2000
Amy Helm 2013
Amy Speace 2008
Anderson East 2016
Andrea Carlson 2009
Andrea Nardello 2014, 2015, 2017
Andrew Jude 2015
Andrew Lipke 2006, 2012
Andrews Balalaika Orchestra 1964
Andy Breckman 1980, 1982
Andy Kimbel 1999
Andy M. Stewart and Gerry O'Beirne 2004
Andy McKee 2017
Andy Robinson 1968, 1969
Andy Statman Trio 2013
Andy Wallace 1969
Angaleena Presley 2014
Angel Band 2005, 2006, 2007, 2011
Angel Chiango and Dan Liechty 1991
Angela Sheik 2015
Angella Irwin 2009
Ani DiFranco 1992, 1994, 2003
Ann Rabson and the Annimators 2005

Anndrena Belcher 1990
Anne Byrne 1970
Anne Hills 1989, 1990, 1996, 2001, 2003
Annie and Lynn 1984
Annie and The Beekeepers 2010
Annie Bauerlein and Chip Mergott 2013
Annie Patterson and Peter Blood 2016
Annie Wenz 1998, 2001, 2006
Ansel Barnum 2013
Anthony DaCosta 2008
Anthony Viscounte 2017
Antje Duvekot 2004, 2006
Ants on a Log 2015, 2016, 2017
Antsy McClain 2014
Apache Trails 2017
Appalasia 2016
Apple Chill Cloggers 1979
April Mae and the June Bugs 2014, 2016
April Verch 2001, 2003
Ar Log 1982
Archie Edwards 1978
Archie Fisher 1975, 1976, 1985, 1987, 2014
Archie Roach 1992
Ari Eisinger 1991, 1994
Ariane Lydon (with Jem Moore) 1995
Arlo Guthrie 1974, 1979, 1984, 1995, 1996, 1998, 2001, 2005, 2011, 2015
Arnie Solomon 1973, 1974
Arnold Keith Storm 1965
Arrogant Worms 2006
Art Rose 1967
Arthur Argo 1976
Arthur Hall Afro-American Dance Ensemble 1969, 1970, 1971, 1972, 1973, 1975, 1986
Artie and Happy Traum 1970, 1971, 1983, 1985
Artisan 1996, 2005
Arwen Mountain String Band 1977
Ashley Cleveland 1989
Asleep at the Wheel 2013
Atwater- Donnelly 2012
Audra Mae 2010
Aunt Peggy and Jay Smith 1999
Austin Lucas 2009
Avett Brothers 2005, 2006
Avi Wisnia 2016
Aztec Two-step 1981
Babatunde Olatunji 1966
Back of the Moon 2007

Backwoods String Band 1979, 1980
Bacon Brothers 2000
Bagpipers 1965
Baile An Salsa 2017
Baird Sisters 2008
Baka Beyond 2003, 2007
Bakithi Kumalo and The South African
 All Stars 2016
Balfa Toujours 1999
Balkan 1969
Bally Hoo String Band 1977
Baltimore Consort 1984
Band of Rivals 2015
The Band 1995
Barachois 1998
Barbara Barrow 1974, 2000
Barbara Gettes 2014
Barbara Kessler 1995, 1999
Barbara Reimensnyder 1979
Barde 1979
Barry Rabin 1991, 2010, 2015
Bart Singer 1963
Baskery 2015
Bat 2016
Bates McClean 1963
Battering Rams 1971
Battlefield Band 1981, 1985, 1991, 1995,
 1998, 2011
Bear Cave Tower 2016
Bearfoot 2008
Beats Walkin' 1997, 2000
Beau Django 2006
Beaucoup Blue 2005
BeauSoleil avec Michael Doucet 1990,
 1992, 1995, 1998, 2003, 2008
Beers Family 1964, 1965, 1966, 1967,
 1968, 1970, 1971, 1972
Belinda Balloon 1997, 1998
Belle Stewart 1985
Ben Arnold 1992, 1993, 2001, 2008,
 2010, 2013
Ben Arnold and the 48 Hour Orchestra
 2017
Ben Cocchiaro 2014
Ben Kessler 2014
Ben Vaughn Quintet 2013
Benny Kalanzi 1973
Bernice Reagon 1964
The Berrys 2011
Bertilla Baker 1975
Bessie Jones 1971, 1972, 1973
Bet Williams 1993, 1996, 2005
Beth Molaro 2006
Bethany and Rufus 2005
Bethlehem and Sad Patrick 2016
Better'n Recess 2014, 2016
Bettye LaVette 2007
Beverly Cotton 1980
Beverly Robinson 1977
Beverly Smith 2000
Big Blow and the Bushwackers 1995

"Big Boy" Crudup 1967
"Big George" Brock 2012
Big Night Out 1987
Bill and Livia Vanaver 1978
Bill Brooks 1969
Bill Danoff and Taffy Nivert 1971
Bill Dicey 1973
Bill Harrell and Virginians 1981
Bill Jackson 1972
Bill Keith 1963, 1986, 2011
Bill Kirchen 2004
Bill Lloyd (with Radney Foster) 1990
Bill Miller 1988, 1989, 1991, 1993, 1997
Bill Monroe and the Blue Grass Boys
 1964, 1966, 1967, 1968, 1969, 1971
Bill Morrissey 1985, 1992
Bill Price 1978
Bill Shute (with Lisa Null) 1978, 1980
Bill Staines 1979, 1980, 1983, 1987
Bill Thatcher 1964
Bill Vanaver 1963, 1968, 1971, 1975
Billy Jonas 2001
Billy Novick (with Guy Van Duser) 1980
The Billys 1994
Bio Ritmo 1999
Birdie Busch 2005, 2011
Black Horse Motel 2014, 2015, 2017
Black Prairie 2013
Blame Sally 2010
The Blind Boys of Alabama 1996
Blind John Davis 1979
Blue House 2002
Bluegrass Cardinals 1977
Bo Diddley 1981
Bob Beach 2002, 2007, 2008, 2009,
 2010, 2011, 2012, 2013, 2014, 2016
Bob Beach (with D. C. Fitzgerald) 2004
Bob Beach (with David Jacobs-Strain)
 2017
Bob Brozman 1984, 1989, 2003
Bob Carlin 1984, 1985, 1986, 1987,
 1988, 1989, 2007
Bob Davenport 1967, 1998
Bob Franke 1987, 1997, 2003
Bob Gibson 1973, 1979, 1990
Bob Goldman 1967
Bob Grossman 1963
Bob McQuillen 2004
Bob Messenger 1969
Bob Paisley (with Ted Lundy) 1978
Bob Pasquarello 1987
Bob Tanner 1971
Bob White 1971
Bob Yellin 1963, 1966
Bob Zentz 1980, 1995
The Bobs 1987
Bobtown 2015
Bodie Wagner 1977
Bonnie "Prince" Billy and the Cairo Gang
 2010
Bonnie Dobson 1962, 1963, 1964, 1966,

 1967, 1968, 1969, 1982
Bonnie Phipps 1984
Bonnie Raitt 1970, 1971, 1972
Boris Garcia 2006, 2009, 2016
Bosom Buddies 1981
Boukman Eksperyans 1992
Boulevard Express 2017
Box 5 2008
Boys of the Lough 1972, 1973, 1975,
 1983, 2000
Brad Hinton 2011
Brad Leftwich (with Alice Gerrard and
 Tom Sauber) 2002
Brandywine Ridge 2016, 2017
Brave Combo 2004
Brave Old World 1991
Breakfast Special 1973
Brian Dunne 2017
Bridget Ball 1994
Bright Morning Star 1986
Britton Family:Young Kings of Britton
 2015
Broadside Electric 1997, 1999
Brooke Annibale 2017
Brooks Williams 1996
Brother Sun 2012
Brownie McGhee (with Sonny Terry)
 1973, 1980
Bruce Cockburn 1974, 2002, 2015
Bruce Cockburn and Bernie Brothers
 1973
Bruce Martin 1967, 1968, 1969, 1970,
 1971, 1972, 1973, 1974, 1975, 1976,
 1977, 1978, 1979, 1980, 1981, 1982,
 1983, 1984, 1985, 1986, 1987, 1988,
 1989, 1990, 1991, 1992, 1993, 1994,
 1995, 1996
Bruce Yasgur 1977
Brummy Brothers 2014
Bryan Bowers 1973, 1975, 1982, 1983,
 1987, 1998
Bryce Milano 2006
Bryndle (Karla Bonoff, Wendy Waldman,
 and Kenny Edwards) 1997
Buck White 1979, 1981
Buckwheat Zydeco 1996
Buddy Guy 1968, 1982
Buddy Guy (with Junior Wells) 1966
Buddy Moss 1966
Buffalo Gals 1974
Buffy Sainte-Marie 1965, 1966, 2016
The Bumper Jacksons 2016
Bunky and Jake 1969
Burning Bridget Cleary 2009, 2011,
 2013, 2016
Burns Sisters 1994, 1996, 1998, 2006
Buskin and Batteau (David Buskin and
 Robin Batteau) 1981, 1984, 1985,
 1989, 2009
Butch Ross 2010
Butch Zito 2016

Butter Queen Sister 2017
Buzzard Rock 1986
Cabin Dogs 2014
Cabin Fever 1980, 1981
Cabinet 2012
Cadillac Sky 2010
Caitlin Rose 2011
Calvary Gospel Chorus 1971
Cameron Highlanders Pipe Band 1998
The Campbell Brothers 2005, 2011
Canebrake Rattlers 1984
Captain Bob Tuesday Nite Band 1972
Caravan of Thieves 2009, 2013
Carla Ulbrich 2010
Carnloch 1990
Carol Elizabeth Jones (with Hazel
 Dickens and Ginny Hawker) 1999
Carol Hunter 1966, 1968
Carol Mahler 2003
Carolina Chocolate Drops 2007, 2013
Caroline Reese and the Drifting Fifth
 2017
Caroline Rose 2014
Carolyn Hester 1967, 1989
Carrie Newcomer 1994
Carsie Blanton 2007, 2012
Cary Fridley and Friends 2000
Caryl P. Weiss 1974, 1981, 1982, 1983,
 1985, 1986, 1989, 1991, 1994, 1996,
 2000, 2011
Caryn Lin 2006
Casey Alvarez 2014
The Cassidys 1998
Cassie and Maggie MacDonald 2015
Cathy Fink 1977, 1985, 1987, 1990,
 1994, 1995
Cathy Fink and Marcy Marxer 2004,
 2009, 2013
Cathy Ramos (with Sue White) 1975
Catie Curtis 1992
Caveman Dave 2015
Cedric Burnside 2012
Chanterelle 2007
Charivari 2001
Charles Nolan 2006
Charles Perdue Jr. 1967
Charles River Valley Boys 1968
Charles Sayles 1977
Charlie Chin 1976 1978
Charlie Miller 2004, 2005, 2006, 2007,
 2008, 2009, 2010, 2011, 2012, 2013,
 2014, 2017
Charlie Miller and Scott Rovner and
 Friends 2015, 2016
Charlie Sweeney 2001
Charlie Zahm 1996
Charlotte Daniels and Pat Webb 1965
Charlotte Micklos 1981
Cheers Elephant 2010
Chenille Sisters 1993, 1996
Cherish the Ladies 2004

Cheryl Prashker 2005
Cheryl Wheeler 1990
Chesapeake 1996
Chicago Blues All Stars 1969
Chickabiddy 2017
Chicken Spankers 1979
Children of Skymont 1973
Chinua Hawk 2005
Chris Bathgate 2012
Chris Brashear 2011
Chris Kasper 2009, 2012
Chris Pureka 2008
Chris Sharp 2011
Chris Smither 1967, 1968, 1969, 1979,
 1990, 1992, 1994, 1996, 1999, 2001,
 2004
Chris Smither and the Motivators 2010
Christie Lenee 2016
Christine Kane 1996
Christine Lavin 1986, 1987, 1990, 1992,
 1995, 1998
Christopher Shaw 1992, 1996
Chubby Carrier and the Bayou Swamp
 Band 2015
Chuck Brodsky 1993, 1995, 1997, 2005
Chuck Klein 1971, 1972, 1973, 1974
Cindy Cashdollar and the Silver Shot
 Western Swing Review 2004
Cindy Mangsen 1979, 1987, 1990, 1991,
 1992
Cindy Mangsen (with Steve Gillette)
 1996, 1999, 2003
City And Color 2012
CJ Chenier and the Buckweat Zydeco
 Band 2016
Clandestine 1998
Clarence "Gatemouth" Brown 1976,
 1988, 1998
Clarence Johnson and Mabel Washington
 1962
Claudia Schmidt 1976, 1984. 1989, 1998
Clay Ames 1986
Clay Ross and Matuto 2010
Cliff Eberhardt 1988, 1990
Clyde Bernhardt 1976
Colleen Peterson 1975
Colleen Sexton 1999
Colonel Mike's Dance Band: Bob
 Pasquarello, Bob Stein, John Krumm
 1998
Comas 2012
The Como Mamas 2013
Compadres 2008
Connie Williams 1967
Cordelia's Dad 1997, 1999
Corin Raymond 2017
Corky Siegel 1986
Cosy Sheridan 1994
Coteau 1976
Country Gentleman of Virginia 1972
Courtney Malley 2005, 2011, 2017

The Coyotes 2007
Craig Bickardt 2008, 2015
Cranberry Lake Jug Band 1983
Craobh Rua 1993, 1996, 2000
Cresson Street Vibration 2009
Cris Williamson and Tret Fure 1994
Critton Hollow String Band 1984
Crooked Still 2005
Cry Cry Cry 1999, 2017
Cyd Cassone (with Ruthie Foster) 2001
Cynthia G. Mason 2015
DakhaBrakha 2014
Dala 2011
Damn Tall Buildings 2016
Dan Bern 1997, 2011
Dan Crary 1980
Dan Liechty (with Angel Chiango) 1991
Dan May 2007
Dan Mulberry 1986
Dan Ruvin 1974, 1975, 1976, 1978,
 1979, 1980, 1981, 1982, 1983, 1984,
 1985, 1986, 1987, 1988, 1989, 1990,
 1991, 1992, 1993, 1994, 1995, 1996,
 1997
Dana Robinson 1998
Danaher and MacCloud 2009
Dani Mari 2013
Danny Starobin 1969
Dante Bucci 2009, 2012
Dar Williams 1996, 1999
Darcie Deaville (with Jane Gillman) 1993
Darcie Miner 2005
Darden Smith 1992
Darlingside 2016
Darol Anger 2005
Dave and Kay Gordon 1985
Dave Carter and Tracy Grammer 2000
Dave Cooper 1970
Dave Fiebert 1995
Dave Fry 1987, 1993, 1999, 2002, 2005,
 2014
Dave Gillies 1977, 1978, 1979, 1980,
 1981, 1982, 1983, 1984, 1985, 1986,
 1987, 1988, 1989, 1990, 1991
Dave Gunning 2015
Dave Orleans 1991, 1998
Dave Quicks Trio 2010
Dave Sear 1965, 1986
Dave Sherman 1996, 1997
Dave Swarbrick 1979
Dave Van Ronk 1963, 1968, 1969, 1970,
 1971, 1977, 1979, 1981, 1985, 1990,
 1995
David Amram 1974, 1975, 1976, 1977,
 1978, 1979, 1980, 1983, 1986, 1990,
 2011, 2013, 2017
David Berkeley 2015
David Boise (with Denver, Boise and
 Johnson) 1968
David Bromberg 1969, 1970, 1971,
 1972, 1973, 1974, 1975, 1976, 1985,

1986, 1989, 1991, 2001, 2005, 2006
David Bromberg Big Band 2011
David Bromberg (impromptu) 1980, 2017
David Bromberg Quintet 2013
David Buskin 1994
David C. Perry 2017
David Dye 2007, 2008, 2009, 2010, 2011, 2012, 2013, 2014, 2015, 2016, 2017
David Francey 2013
David Grisman (with Del McCoury, "Del and Dawg") 2016
David Grisman Quintet 2005
David Hamburger 1998
David Holt 2007
David Jacobs-Strain 2002, 2006
David Jacobs-Strain with Bob Beach 2017
David Jones 1981, 1989
David Lindley 2006
David Mallett 1980, 1981, 1984
David Massengill 1982, 1993, 2008
David Myles 2016
David Olney 1997, 1999
David Olney Band 2004
David Perry 1998, 2002, 2004
David Roth 1990
David Uosikkinen's in the Pocket 2013
David Wilcox 1993, 1996
DaVinci's Notebook 2002, 2004
Davis Wax Museum 2011
Dawn Hiatt 2017
Dawn Iulg 2009
Dayna Kurtz 1998
De Dannan 1977, 1978, 1981, 1983, 1986
De Tierra Caliente 2016
Deadly Nightshade 1974
Dean Magraw (with Peter Ostroushko) 1993
Deanna Stiles 2004
Deb Pasternak 1999
Debbie McClatchy 1978, 1980
Debi Smith 1998
Debo Band 2012
Deborah Pieri 1985, 1989, 1999, 2002, 2006, 2011, 2012
Debra Shaw 1997, 1999, 2005
The Decemberists 2009
Dede Wyland (with Silk City) 2002
Deer Scout 2016
Deer Tick 2009
Deirdre Flint 2010
Deirdre O'Callaghan 1965
Del and Dawg (Del McCoury and David Grisman) 2016
Del McCoury (with Jerry Grisman, "Del and Dawg") 2016
The Del McCoury Band 2009
Delaware Water Gap 1978

Della Mae 2015
Dennis Brooks 1974
Dennis Hangey 1999, 2000, 2001, 2002, 2003, 2004, 2005, 2006, 2007, 2008, 2009, 2010, 2011, 2012, 2013, 2014, 2015, 2016, 2017
Dennis Stroughmatt and Creole Stomp 2006
Denver, Boise and Johnson 1968
The Derek Trucks Band 2009
Dewey Balfa 1971, 1982
Dewey Balfa and Freres (Balfa Brothers) 1972
Diana Jones 2007
Diana Markovitz 1972, 1973, 1974
Diane Davidson 1972, 1974, 1976
Diane Ponzio 2002
Dick Gaughan 1997
Dick "Richard" Albin 1996
Dick Waterman 1966, 1967, 1968, 1969
Dietrich Odes 1972
Dillon and Ford 2016
disappear fear 2003
DisCanto 2014
Disco Queen and King 1982
The Dixie Hummingbirds 1991, 1995
DJARARA 2010
DK and the Joy Machine 2017
Doc Watson 1964, 1966, 1967, 1968, 1969, 1970, 1971, 1980, 1982, 1983, 1986, 1988, 1994, 1999, 2007
Dog on Fleas 2006
Don and Barb Golden 1980
Don Cogan 1977
Don Edwards 1997, 2002
Don Henry 1991
Don Lange 1974, 1978
Don McLean 1972, 1977, 1979
Don Merlino 1984
Don Pedersen 1974
Don Reno 1974
Don Stover 1973
Donna Hebert 2011
Donna Hunt 1998, 2003, 2005, 2009
Donna the Buffalo 2002
Doris Abrahams 1972, 1973, 1976
Doug Dillard Band 1984
Doug Freeman 1974
Doug Kershaw 1971
Doug Tilgham 2001
Dougie MacLean 1993
Downchild Blues Band 1973
Downtown Shimmy 2014
Doyle Lawson and Quicksilver 1982
Dr. Joe 1992
Driftwood Soldierford 2016
Dry Branch Fire Squad 1989, 1993, 1999, 2011
Duck Donald 1977
The Duhks 2006
Duke Brier Patch Puppets 1981, 1985

Duke Robillard Band 1996
The Dukes of Destiny 2016
Dylan Jane 2015
Echoing Heart 2004, 2007
Eclectricity 1981, 1982
Ed and Joe Reavy 1984
Ed Henderson 1980
Ed Stivender 1981, 1983, 1988, 1993, 1997, 2002, 2006
Ed Taylor 1983
Eddie from Ohio 1998, 2000, 2003
Eddy "The Chief" Clearwater 1989, 1990
Edge Hill Rounders 2016, 2017
Edith Wilson 1974
Eileen Ivers 2001
Eileen Ivers Band 1999
Eileen McGann 1991
Eilen Jewell 2008
El Caribefunk 2014, 2015
Elaine Silver 1997
Elias Ladino Ensemble 1994
Eliza Gilkyson 2004, 2006
Elizabeth "Libba" Cotten 1963, 1972, 1979, 1986
Elizabeth Butters 2011
Elizabeth Corrigan 1974, 1975
Elizabeth Mitchell 2006
Ellen and Wendy Britton 1978
Ellis 2008
Ellis Paul 2009, 2013
Elspeth Tremblay 2015
Emma Cullen 2016
Emmylou Harris 1968, 1997
The End of America 2016, 2017
Enter the Haggis 2009
Entrain 2000
Eric Abraham 2012, 2013
Eric and Justin Kay 1973
Eric Andersen 1967. 1969, 1980, 1982, 1986, 2017
Eric Bibb 2000
Eric Bogle and John Munro 1982
Eric Jensen 1974, 1975
Eric Schwartz 2002
Erik Frandsen 1971, 1972, 1973, 1980, 1981
Erik Mongrain 2009
Erin McKeown 2001, 2010
Espers 2008
Essra Mohawk 2004
Esther Halpern 1963, 1975, 1978, 1979, 1981, 1982, 1983, 1986, 1988, 1991, 2001
Ethan Flynn 2016
Ethan Pierce 2016
Eugene O'Donnell 1974, 1975, 1976, 1977, 1978, 1980, 1983, 1986
Eve Rantzer 1988
The Fabulous Torpedoes 1974
The Fairfield Four 1989, 1992
The Fairfield Four (with the McCrary

Sisters) 2016
Fairport Convention 1970, 1972
Faith Petric 1984
Fats Kaplin 1975
Felice Brothers 2008
Fennig's All Star String Band 1979, 2007
Ferko String Band 1983
Ferron 1996
Fiddle Fever 1982
Fiddle Puppets 1980, 1981, 1984, 1987
Fiddlekicks 2003
Fiddlers' Bid 2006
Fiddlin' Van Kidwell 1978
Figgy Duff 1980
The Fighting Jamesons 2012
Filé 1988
Finest Kind 2002
Finger Pyx 2000, 2003, 2006
A Fistful of Sugar 2014, 2016, 2017
Fitzgerald and Beach (D. C. Fitzgerald and Bob Beach) 2004
The Flatlanders 2002
The Fleeting Ends 2010
Flor De Cana 1991
Flora Molton 1978
Flying Burrito Brothers 1971
Flying Cloud 1977
Folk Brothers 2009
Folk Dance Leaders Council 1963
Folk Tellers 1977, 1980, 1984
Footworks 2005, 2011
Fortissimo 2002
Fortunate Ones 2016
Four Bitchin' Babes 1993
Four Shadow 1999
Fourtold 2003
Fraction Theory 2009
Franconia Chorus (Mennonite) 1964
Frank Christian 1985
Frank Fairfield 2013
Frank Malley 1996, 2002, 2005
Frank Solivan and Dirty Kitchen 2011
Frank Wakefield 1969
Frankie Armstrong 1973, 1974, 1982, 1986
Fred Holstein 1973, 1977
Fred Kaiser 1998, 1999, 2000, 1996, 1997
Fred Koller 1989, 1990, 1995
Fred Small 1984, 1995
Freddie Moore 1973
Free Hot Lunch 1987, 1988
Freebo 2003, 2007
The Freedom Sound 1995, 1999
The Freight Hoppers 1998
French Toast 2002, 2005
Freyda and Acoustic AttaTude 1994
Frog Holler 2009, 2016
Front Range 1998
Fruit 2002
Fry Yellow Moon Jamb 1984

Full Frontal Folk 2002, 2004, 2011, 2015
Gabriel Butterfield (with Jimmy Vivino) 2013
Gadji-Gadjo 2008
Gamble Rogers 1974, 1975, 1976, 1979, 1982, 1984, 1986, 1991
Gandalf Murphy and the Slambovian Circus of Dreams 2005, 2006, 2010
Garnet Rogers 1985, 1987, 1998, 2014
Gary Mehalick 1979
Gather Round 2017
Gene Shay (all years through 2017 - via video and phone in 2016)
Gene Smith Band 2017
Geno Delafose and French Rockin' Boogie 1997
George Britton 1963, 1969, 1981
George Gritzbach 1977, 1982, 1983, 1985, 1987, 1989, 1991
George Houvardis 1972
George Neff 1988
George Russell 1985
George Stanford 2008
George Wilson 2004
Germantown Bagpipe Band 1964
Gerry Hallom 1982
Gerry Milnes (with Melvin Wine) 1996
Gerry O'Beirne (with Andy M. Stewart) 2004
Get the Led Out 2009
Gibson Brothers 2014
Gil Turner 1964
Giles Losier 1974
Gillian Welch and David Rawlings 1995
Ginger Coyle 2013
Ginny Hawker (with Hazel Dickens and Carol Elizabeth Jones) 1999
Girlyman 2004
Give and Take Jugglers 1992, 1993, 1994, 1995, 1996, 1997, 1998, 1999, 2000, 2001, 2002, 2003, 2004, 2005, 2006, 2007, 2008, 2009, 2010, 2011, 2012, 2013, 2014, 2015, 2016
Giving Tree Band 2010
Glen Morningstar 1988
The Glengarry Bhoys 2005
Glenn Ohrlin 1965, 1974
Glossary 2010
Good Ol' Persons String Band 1990
Gordon Bok 1967, 1968
Gospel Choir 1963
Graham Nash 2017
Grant Rogers 1965, 1966
Great Big Sea 1999, 2008
Great Groove Band 2010, 2011, 2012, 2013
Green Fields of America 1990
Green Grass Cloggers 1975, 1976, 1977, 1978, 2004
Greenbriar Boys 1962, 1965, 1986, 2002
The Greencards 2007

Greg Brown 1997
Greg Greenway 1996
Greg Johnson 2015
Greg Sover Band 2017
Griffith and Mealy 1997
Griz 2012
GrooveLily 2001
Groovemama 2006, 2007, 2008, 2009, 2011, 2012, 2013, 2014, 2015, 2016
GTV Almrausch Tyrolean Dance 1964
Guitar Wilson 1967
Guy and Candy Carawan 1992
Guy Clark 1989
Guy Davis 1998
Guy Mendilow 2006
Guy Van Duser and Billy Novick 1980
Hal Wylie 1992
Hall and Peabody 1984
Hamilton Camp 1973, 1979
Hamish Moore 1986
Hamza El Din 1969
Handsome Molly 1999
Hang The Piper 1979
Hannah Taylor 2017
Hanny Budnick 1974, 1989, 1992, 1993, 1998, 2000, 2001, 2002, 2003, 2005, 2011
Hans Theessink 1987, 1990
Hans Theessink and Blue Groove 1996
Hard Travelers 1992
Harlem Blues and Jazz Band 1976
Harlem Blues and Jazz Choir 2010
Harmonia 2000
Harper Blynn 2012
Harrow Fair 2017
Hawk Tubley 2015
Hazel Dickens 1972
Hazel Dickens, Ginny Hawker and Carol Elizabeth Jones 1999
Hazlewood 1991
Hazmatt 2005
Heart Harbor 2016
The Heartbeats 1989
Heartland Nomads 2017
Heartless Bastards 2009
Heather Eatman 1996
Heather Maloney 2017
Heather Mullen 1992
Heather Wood 1976
Hedge and Donna Capers 1968, 1969, 1970
Hedy West 1963, 1964, 1967, 1970, 1971, 1975, 1976
Heidi Barton 1973
Helen Leicht 2005, 2006, 2007, 2008, 2009, 2011, 2012, 2013, 2014, 2015, 2016, 2017
The Hello Strangers 2015, 2016
Hennessey Bonfire 2013
Henry Crow Dog 1968
Hezekiah Jones 2008, 2017

Hickory Project 2004
Hickory Wind 1976
High Level Ranters 1979
Highwoods String Band 1973, 1975, 1977
The HillBenders 2012, 2015
Hirten Family 1975, 1976
Hobart Smith 1963
HogMaw 2011, 2013
Holly Near 1987
Holly Tannen 1973, 1974
Holmes Brothers 1993, 2003, 2012
Homer and Jethro 1976
Homesick James 1973
Honey and Houston 2015
Honey Child 2014
Honolulu Heartbreakers 1979
Hoots and Hellmouth 2006, 2008, 2011, 2015
Hopezar Mid East Band 1964
The Hoppin' Boxcars 2016
Horse Feathers 2010
The Horse Flies 1988, 2006
Hot Beer 2017
Hot Club of Cowtown 2014
Hot Club of Philadelphia 2014, 2016
Hot Rize 1980
Hot Soup 1999
Hot Tuna 2006
Hotmud Family 1976, 1978, 1981, 1983
The House Band 1989, 1994, 1996
How to Change a Flat Tire 1976
Howard Armstrong (with Nat Reese) 1993
Hoyle Osborne 1969, 1970
The Hula Honeys 2013
Hurricane Hoss 2016
Huun-Huur-Tu (Tuvan Throat Singers) 2002, 2006
Huxtable, Christensen and Hood 1982
Iain Matthews 1992, 2010
Ian and Mary Kennedy 1985
Ian Campbell and Caroline Mitchell 1971
Ian Foster 2017
Ian Mitchell 1970
IGRA 1968
Ile-Ife 1973
Incredible String Band 1969
The Infamous Stringdusters 2017
Instant Bingo Jam 2017
International Folk Sounds 1998, 2001, 2003, 2005
Inti Illimani 2000
Ira Bernstein 1989, 1990
Irene Farrera 2000
Irene Molloy 2014
Iris DeMent 1992, 2016
Irish Mythen 2015
The Irish Rovers 1970
Iron and Wine 2009
Ishangi Dance Group 1964, 1965, 1966

J. B. Hutto and the Hawks 1971
J. D. Crowe and the New South 2008
J. F. Murphy 1970
J. P. and Annadeene Fraley 1977
Jack Marks 2010
Jack McGann 1971, 1974, 1975
Jack Murray 2015, 2016
Jack Rose 2008
Jack Williams 1998, 2000, 2007
Jackie Pack 1967, 1975, 1977, 1981, 1984, 1986, 1989, 1992, 1996, 2001
Jackie Washington 1965
Jackson Browne 2006
Jah Levi 2010
Jah Levi and Higher Reasoning 1991
Jaime Brockett 1970
Jake and the Family Jewels 1973
Jake Lewis and the Clergy 2014
Jake Shimabukuro 2008, 2013
Jake Snider 2010
Jamal Koram 1991
James Cotton 1980
James Hunter 2006
James Jesse Boozer 1974
James Keane 1983
James Leva 2007
James Miller 1993
James Turner 1980
Jan Alter 2002
Jane Gillman 1985
Jane Gillman and Darcie Deaville 1993
Jane Rothfield 2011, 2012
Janet Peters 1987
Janine Smith 2006
Janis Ian 1968, 1971, 1972, 1973, 1976, 1990, 1995, 1999, 2001, 2008, 2014
Jason Ager 2016
Jason Eklund 1994
Jason Hahn 2013
Jason Isbell 2014
Jason McCue 2016
Jay Ansill 1983, 1987, 1988, 1989, 1990, 1991, 1992, 1999
Jay Ansill String Section 2002
Jay Smar 2003, 2006, 2017
Jay Ungar 1974
Jay Ungar and Molly Mason 1996
Jay Ungar, Molly Mason and Swingology 2001
Jean Carignan 1974
Jean Farnworth 1990, 1991, 1992, 1993, 1994, 1995
Jean Redpath 1963, 1965, 1969, 1970, 1972, 1994
Jean Ritchie 1965, 1975, 1977, 1982, 2008
Jean Ritchie (with Brad Leftwich and Linda Higginbotham) 1984
Jeff and Gerret Warner 1971, 1972
Jeff Gutcheon 1973
Jeff Lang 2000

Jeff Pollard 1976
Jeff Tweedy 2010
Jefferson Berry and the Urban Acoustic Coalition 2014
Jeffrey Gaines 2013
Jem Moore and Ariane Lydon 1995
Jemma Walsh 1987
Jen Muscatello 2010
Jen Schonwald 2003, 2011
Jeneen Terrana 2015
Jennifer and Hazel Wrigley 1999
Jennifer Schneck (with Steve Schonwald) 1996
Jenny Reynolds 1999
Jeremiah Tall 2016
Jeremy Aaron 2017
Jeremy Birnbaum 2011, 2012, 2014, 2015
Jeremy Fisher 2008
Jerry Brown 1995, 1997, 1999, 2003
Jerry Douglas (with Peter Rowan) 1992
Jerry Hionis 2013
Jerry Jeff Walker 1968, 1969, 1989
Jerry Ricks 1967, 1998
Jersey Corn Pickers 2013, 2015
Jess Klein 2007
Jesse Fuller 1967
Jesse Hale Moore 2017
Jesse McReynolds 2010
Jesse Terry 2015
Jessica Graae 2017
Jessica Lea Mayfield 2011
Jill Hennessey 2009
Jill Sobule 2009
Jim Albertson 1980, 1981, 1983, 1987, 1988, 1989, 1990, 1991, 1992, 1993, 1995, 1996, 1997, 1999, 2002, 2005, 2013
Jim and Jesse and the Virginia Boys 1979
Jim Bianco 2008
Jim Boggia 2011, 2016
Jim Brewer 1970, 1971
Jim Couza 1974, 1975, 1976, 1977, 1978, 1979, 1980, 1981
Jim Craig 1979
Jim Croce 1970, 1973
Jim Femino 1991, 1992, 1999
Jim Hale 1990
Jim Kweskin Jug Band 1963
Jim Labig 1978
Jim Mageean 1981
Jim McCarthy 1970
Jim Post 1976, 1977, 1978, 1985
Jim Ringer 1977
Jim Ringer and Mary McCaslin 1981, 1984
Jim Rooney 2011
Jim Six 1977
Jimmie Dale Gilmore 1996
Jimmy Johnson 2001
Jimmy Johnson Blues Band 1981

Jimmy LaFave 2006
Jimmy Landry 1996
Jimmy Martin and the Sunny Mountain
 Boys 1963
Jimmy Vivino and Gabriel Butterfield
 2013
Jive 5 minus 2 2000
Joan Baez 1968
Joan Shelley 2017
Jody Hughes 2006
Jody Stecher 1968
Joe and Antoin McKenna 1982
Joe Crookston and the Bluebird Jubilee
 2013
Joe Heaney 1966, 1967, 1968, 1969,
 1971, 1972, 1973
Joe Heukerott 1989
Joe Hickerson 1970
Joe Pug 2009, 2010
Joel Mabus 1984, 1997
Joel Plaskett and Emergency 2011
Joel Rafael 2005, 2006
Joel Shoulson 1981
Joel Zoss 2010
Joey George 1975
John Allan Cameron 1976
John Basset 1967, 1969
John Beacher 2015
John Burke 1967
John Byrne 2014, 2015
John Davis 1973
John Denver 1969, 1970
John Denver (with Denver, Boise and
 Johnson) 1968
John Denver (with Mitchell Trio) 1965,
 1966
John Dildine 1967
John Flynn 1993, 1994, 1997, 2002,
 2004, 2007, 2009, 2011, 2013, 2014,
 2015, 2016, 2017
John Francis 2005, 2001, 2012, 2013,
 2014, 2015, 2016
John Francis Maher 2008
John Fuhr 2012, 2013, 2014
John Fuhr and Brandywine Ridge 2015
John Fullbright 2012
John Gallagher Jr. 2014, 2015
John Gorka 1985, 1990, 1992, 1994,
 2000, 2003
John Hammond 1984, 1994, 2000
John Hartford 1969, 1970, 1971, 1972,
 1974, 1976, 1983, 1985, 1987, 2000
John Hartford Stringband 2011
John Herald 1972 1977, 1984
John Hiatt and the Combo 2012
John Jackson 1968, 1969, 1970, 1971,
 1977, 1989
John Jennings 1991
John Jorgenson 2005
John Krumm 2001
John Lilly 2002

John Mallinen 2015
John Matulis and Friends 2003
John McCutcheon 1985, 2017
John McEuen 1982, 1997
John Pearse 1981
John Peterson 1975
John Prine 1972, 1974, 1999, 2004
John Renbourn and Stefan Grossman
 1988
John Roberts and Tony Barrand 1970,
 1971, 1972, 1973, 1975, 1978, 1985,
 1989, 1992, 1998, 2004
John Roussos 1975
John Sebastian 1984, 1987, 1991
John Vessey Ceilidh Band 1972
John Wesley Harding (Wesley Stace)
 1996
John Whelan Band 1998
Johnny "Clyde" Copeland 1992
Johnny Cunningham 1981
Johnny Duke and the Aces 2007
Johnny Irion 2001
Johnny Miles 2010
Johnny Morris 1971, 1974, 1976, 1978,
 1980, 1982, 1984, 1985, 1996
Johnnyswim 2014
The Johnson Girls 2005
The Johnston Brothers 1980, 1982
The Johnstons 1971
Jon Dichter 2016
Jonathan Edwards 1981, 1983, 1986,
 1989, 2003, 2007
Joni Mitchell 1968
Jordan Katz 2011
Jordie Lane 2014
Jorma Kaukonen 2011
Jose Borges 1972
Joseph Parsons 1993, 1995, 2001
Josh Dunson 1969, 1970, 1971, 1972
Josh White Jr. 1978, 1979, 1998, 2014
Josh White Singers 1984
Joyce Andersen 2003
Jud Caswell 2007
Judith Casselberry and Jackie DuPreé
 1990
Judith Fox 1982
Judy Collins 1964, 1965, 1966, 1986,
 2001, 2008
Judy Gorman 1989
Judy Roderick 1963, 1964, 1966, 1983
Judy Small 1984, 1985
Jug Band 1988
Juggernaut String Band 1977, 1980,
 1983, 1991, 1996, 2000, 2004
Julia Brandenberger 2017
Julie Lieberman 1976
June Rich 1996, 1998
Junior Wells 1967, 1986
Junior Wells and Buddy Guy 1966
Just Friends 1988
Just Say No Traveling 1991

Justin Rutledge 2010
Justin Stens and the Get Real Gang 2013
Justin Townes Earle 2009, 2011
Kaia Kater 2016
Kala JoJo 2000, 2004, 2007, 2012
Kalanit Dancers 1977
Kalob Griffin 2014, 2017
Karan Casey 1999
Karen Farr 1993
Karen Shaw 2002
Karen Terri Ludwig 1998
Karla Iverson 2014
Karmic Repair Company 2012, 2013
Kat Eggleston 2001
Kate and Anna McGarrigle 1975, 1993,
 1997
Kate Campbell 1997
Kate Gaffney 2005
Kate McGarrigle 1973
Kate McGarrigle and Roma Baran 1970
Kate Wolf 1977, 1978
Katherine Rondeau 2015, 2016, 2017
Kathy Mattea 1993, 2008
Kathy McMearty 1995
Kathy O'Connell 2007, 2011, 2013, 2014,
 2015, 2016
Katie Barbato 2016
Katie Barber 2013
Katie Frank and the Pheromones 2014
Katie Laur 1980
Katie Webster 1989
Katy Moffatt 1996
Keb' Mo' (with Taj Mahal, „TajMo") 2017
Keb' Mo' 1997
Keith Sykes 1972
Kelly Jo Phelps 1996
Kelly Ruth 2009
Ken Bloom 1975, 1996
Ken Goldstein 1962, 1963, 1964, 1965,
 1966, 1967, 1968, 1969, 1970, 1971,
 1972, 1973, 1974, 1975, 1977, 1978,
 1979, 1980, 1981, 1982, 1983, 1984,
 1985, 1987, 1989, 1990, 1991, 1992,
 1993
Ken Jacobs 1970
Ken Kaplan 1995
Ken Perlman 1985
Ken Tizzard 2017
Kendall 1973
The Kennedys (Pete and Maura
 Kennedy) 1995, 1998, 2002, 2011,
 2017
Kenny Kosek 1972
Kenny Ulansey and Whirled Music 2010
Kenny White 2008
Kerr's Bal Caribe Dancers 1965
Kerri Powers 2009
Kevin Killen 2015
Kevin Roth 1974, 1977, 1982, 1985,
 1986, 2003
Kevin Welch 1990

Kicking Down Doors 2014, 2015, 2017
Kierstan Gray 2008
Kilby Snow 1964
Killbilly 1992, 1994
Kim and Reggie Harris 1986, 1995, 2001, 2011
Kimati Dinizulu 1989
Kimya Dawson 2008
Kingsessing Morris Men 1989, 1992, 1994, 1996,
Kinvara 1984
Kirsten Maxwell 2016
The Klezmatics 1995
Klezmer Conservatory 1983, 1984
Klezmorim 1982
Koerner, Ray, and Glover 1964, 1996
Koko Taylor and her Blues Machine 1979, 1985, 1991, 1995, 1998
Kris Delmhorst 2002
Kris Kristofferson 2004
Kristin Rebecca 2017
Kristina Olsen 1997
Kuf Knotz 2015
Kurt Anderson 1971
Kwesi K 2014
Kyle Offidini 2010
Kyle Swartzwelder 2014
La Bottine Souriante 1988, 2004
Ladybird 2015, 2017
Langhorne Slim 2009
Lanie Melamed 1967
Larchmont Sid Dermis 1968
Larry Campbell and Teresa Williams 2015, 2017
Larry Johnson 1974
Larry Packard 1972
Last Chance 2016
The Late Saints 2016
Laura Cortese and the Dance Cards 2017
Laura Love Band 1997, 2001
Laura Love Duo 2017
Laurie Freelove 1992
Laurie Lewis 1991, 2001
The Lawsuits 2013
Led Kaapana 2003
The Lee Boys 2008, 2015
Lee Harvey Osmond 2010
Lee-Ellen 1993
Brad Leftwich, Linda Higginbotham and Jean Ritchie 1984
Len Chandler 1966, 1967
Leo Arons 1972, 1974, 1975, 1976, 1981, 1982, 1983, 1984, 1985, 1986, 1987, 1988, 1989, 1990, 1991, 1992, 1993, 1994, 1995
Leo Kottke 1983
Leon Redbone 1973, 1974, 1987, 1993
Leon Rosselson 1992
Leonda 1967, 1969
Les Barker 1998
Les Sampou 1995, 1997

Les Yeux Noirs 2007
Lesley Mitchell and Kelly Ray 1994
Leslie Berman 1973
Leslie Carey 2016
Leslie Smith 1974, 1975
Lessick and Lincoln and Cohen 2017
Lester Chambers 2005
Levee Drivers 2015
The Levins 2017
Levon Helm Band 2011
Lew London 1976, 1977
The Lewis Brothers 1975, 1989, 2009
Liam O'Flynn 1971
Libana 1993
Lila Downs 2001
Lilly Brothers 1973
Lily Mae 2013
Linda Cohen 1980
Linda Goss 1982
Linda Higginbotham (with Brad Leftwich and Jean Ritchie) 1984
Linda Morley 1971
Linden Sherwin 1989
Lindi Ortega 2015
Lisa Chosed 2017
Lisa Null and Bill Shute 1978, 1980
Lisa Pack-Miller 1989
LisaBeth Weber 1993, 2004, 2008
Little Brother Montgomery 1974
Little Feat 2012
Little Missy 2015
Liverpool Judies 1979, 1980, 1986, 1995, 2001
Livingston Taylor 1970, 1982, 1987, 1990, 1994
Liz Bradley 2000
Liz Carroll 1980
Liz Longley 2007, 2016
Lizanne Knott 2006, 2015
Lloyd Miller 1969
Lo Jai 1986
Local Youth 1978
The Lone Bellow 2014, 2016
Lonnie Johnson 1963
Lord Jacob and the Ukuladies 2012, 2013, 2016
Lori McKenna 2012
Los Afortunados 1990
Los Lobos 1994, 2016
Los Quinchamali 1973
Lost Indian 2013
Lou and Peter Berryman 1989, 1996
Loudon Wainwright III 1972, 1973, 1981, 1986, 1989, 1993, 1999, 2003, 2014
Louis Killen 1967, 1968, 1969, 1971, 1972, 1973, 1977, 1978, 1980,1982, 1985, 1987, 1995
Louise Sherman 1989, 1996
Louise Taylor 1995, 1998
Louisiana Red 1973, 1977

The Lovell Sisters 2007
Lovers League 2015
The Low Anthem 2009
Low Cut Connie 2015
Low Road 1993
The Lowlands 2007
Lucas Rivera and Grupo Huracon 2002
Lucille Reilly 1985
Lucinda Williams 1992, 2012
Lucy Kaplansky 1997, 1999
Luella and The Sun 2013
Lui Collins 1998
Luke Daniels 1993
Lunasa 2002
Luther Allison 1970
Lyle Lovett and his Large Band 2015
Lynn Ungar 1974
Mabel Hillery 1966
Mabel Washington (with Clarence Johnson) 1962
Mac Benford and the Woodshed All-Stars 1997
Mac Parker 1990
Mac Wiseman 1971
Mad Pudding 1998, 2000
Maddy Prior 1994
Madisen Ward and the Mama Bear 2015
Madison Violet 2011
Magenta Music 1992
Magic Maps 2015
Magpie (Greg Artzner and Terry Leonino) 1984, 1988, 1995, 1998, 2003
Mahotella Queens 2002
Malaika 2010
Malinky 2010
The Mammals 2001, 2005, 2007
Mamou 1990
Man About a Horse 2015, 2017
Manatawny Creek Ramblers 2013
Mance Lipscomb 1972
Marc Silver and The Stonethrowers 2010, 2013, 2016
Marcia Ball 2005
Marcy Marxer 1988, 1990, 1994, 1995
Marcy Marxer (with Cathy Fink) 2004, 2009, 2013
Marg Barry and Mich Gorman 1965
Margaret Christl 1978, 1993
Margaret MacArthur 1972, 1985
Margo Hennebach 1995
Margot Kurtz 1967
Maria Muldaur 1972, 1973, 1988
Marian Barnes 1987
Marilyn Quine 1976
Marissa Nadler 2009
Mark Cosgrove 1997
Mark Dvorak 2000
Mark Erelli 2003, 2012
Mark Mandeville and Raianne Richards 2015

Mark Ross 1973, 1976
Mark Schultz 2013
Mark Silber 1990
Marshall Dodge 1972, 1973, 1976, 1979
Martha Burns 1983
Martha Radcliff 1971
Martin and Jessica Simpson 1991
Martin Carthy 1974
Martin Harris 1976
Martin Sexton 1996
Martin, Bogan, and Armstrong 1971, 1972, 1975, 1976, 1978
Marty Singleton 1967
Marty Stuart 2002
Marty Stuart and His Fabulous Superlatives 2016
Mary Chapin Carpenter 1987, 1988, 1990, 2003, 2012
Mary Faith Rhoads 1977, 1981
Mary Gauthier 2000, 2012
Mary McCaslin 1977, 1995
Mary McCaslin (with Jim Ringer) 1981, 1984
Mary Roth 1996
Mary Travers 1980
Mary Zikos 1982
Maryland Pace Steel Orchestra 1980
Mason Porter 2010, 2012, 2015
Matt Andersen 2015
Matt Combs 2011
Matt Duke 2006, 2008, 2014, 2016
Matt Sowell 2013
Matt Wheeler and Vintage Heart 2017
The Mavericks 2013
Mavis Staples 2007
The McCrary Sisters (with the Fairfield Four) 2016
McLain Family Band 1988
Megan McDonough 1990
Meghan Cary 2016
Meghan Cary and the Analog Gypsies 2014
Melanie 1988
Melissa Martin and The Mighty Rhythm Kings 2009
Melissa Taggart 2013, 2014
Melody Gardot 2006
Melvin Wine and Gerry Milnes 1996
Merle Travis 1976
Mia Bergmann 2015
Michael Braunfeld 1991, 1998, 2011, 2012, 2013, 2014, 2015, 2016, 2017
Michael Cooney 1967, 1968, 1969, 1970, 1971, 1975, 1977, 1981, 1982, 1983, 1985, 1986, 1987, 1988, 1989, 1990, 1991, 1993, 1994, 1996, 1998, 1999, 2001
Michael Feldman 1980
Michael Jerling 1997
Michael Johnson (with Denver, Boise and Johnson) 1968

Michael McNevin 1994
Michael Miles 1992
Michael Ronstadt (with Aaron Nathans) 2015
Michael Smith 2000, 2003
Michael Spear Duo 2016
Michael, McCreesh and Campbell 1980
Michelle Miller 2016, 2017
Michelle Shocked 1995
Mick Moloney 1973, 1974, 1975, 1976, 1977, 1978, 1980, 1983, 1986
Mickey Clark 1977, 1978
Mickey Clark and the Blue Norther 2010
Mickie Singer-Werner 1988
Mighty Kings 1966
Mike Agranoff 1982, 1983, 1984, 1985, 1986, 1987, 1988, 1989, 1990, 1991, 1992, 1993, 1994, 1995, 1996, 1997, 2000, 2002, 2004, 2011, 2016
Mike and Ruthy 2013
Mike Benner 2013
Mike Cohen 1971
Mike Craver 2007
Mike Cross 1982, 1983, 1984, 1985, 1986, 1988, 1989, 1991, 1992, 1994, 1996, 2000, 2012
Mike Dugan 1986
Mike Miller 1967, 1968, 1969, 1978, 1979, 1980, 1981, 1982, 1983, 1984, 1985, 1986, 1987, 1988, 1989, 1990, 1991, 1992, 1993, 1994, 1995, 1996, 1997, 2002, 2004, 2012, 2013, 2014
Mike Seeger 1963, 1964, 1971, 1972, 1983, 1991
Mike Smith 1974
Mill Creek Cloggers 1982, 1983
Mindy Simmons 1998
Mindy Smith 2004
Mississippi Fred McDowell 1970
Mississippi John Hurt 1963, 1966
Mist Covered Mountains 2013, 2015, 2016, 2017
Mitch Greenhill 1964
Mitchell Trio 1965, 1966
Moch Pryderi 2005
Mock Turtle Marionette Theater 1983, 1992
Modern Inventors 2013
Modern Man 2005
Moira O'Casey 1984
Mollie O'Brien (with Tim O'Brien and the O'Boys) 1995
Mollie O'Brien 2000
Mollie O'Brien and Rich Moore 2016
Molly Hebert-Wilson 2012, 2013
Molsky's Mountain Drifters 2017
Moravian Group 1963
Moses Rascoe 1987, 1988
Mount Nebo Gospel Choir 1966
Mountain Laurel 1986
Moving Cloud 2000

Moving Star Hall Singers 1965
Moxy Fruvous 1995, 1997, 1999
Mum Puppet Theater 2006
Murray Callahan 1978, 1981
Murray McLaughlan 1973, 1974
Murv Shiner 1964
Mustard's Retreat 1994, 1998, 2000, 2003
Mutlu 2014
Mya Byrne 2016
Na Cabarfeidh (Rare Air) 1980
Naelee Rae 2015
Nanci Griffith 1985, 2000
Nancy Tucker 1995
Nano Riley 1971, 1974
Nashville Bluegrass Band 1994, 2002
Nat Reese and Howard Armstrong 1993
Natalia Zukerman 2006, 2010
Natalia Zukerman (with Susan Werner and Trina Hamlin) 2010
Natalie MacMaster 1994, 1997, 2000, 2004, 2014
The National Recovery Act 1975
The National Reserve 2017
Ned Bachus 1987
Nerissa and Katryna Nields 2003
Nevard Barrelhouse 1983
New Grass Revival 1976
New Lost City Ramblers 1966, 1967, 1988
The New Saint George 1988, 1995
New Sweden 2013
Nick Annis 2014
Nick Plakius 1984
Nick Seeger 1978, 1980
Nickel Creek 2000, 2001
Nicole Reynolds 2008
The Nields 1994, 1996. 1998, 2000
Nightingale 1996
No Good Sister 2015, 2017
No Relation 1976
Noel and Sarah McQuaid 1991
Nomos 1997
Norman and Nancy Blake 1977, 1987
Norman Blake 1974, 1996
Norman Kennedy 1967, 1968, 1969, 1970, 1971,1972, 1973
Norman Taylor 2014
North Mississippi Allstars 2015
North Star Puppets 2015, 2016, 2017
Northern Lights 1977
Nova 1980
Nudie and The Turks 2010
Odetta 1968, 1969, 1977, 1993, 2003
Okefenokee Joe 2004
Ola Belle Reed 1970, 1975, 1977
Ola Belle Reed (with Alec Campbell) 1966
Old Crow Medicine Show 2014, 2017
Old Man Luedecke 2014
Old Reliable String Band 1967

Old Springs Pike 2007
The Old Ways 2015
Old World Folk Band 1999
Ollabelle 2004
One Drum 2000
Original Hurdy Gurdy Man 1989
Original Sloth Band 1979
Orion Freeman 2014
Orlando Puntilla 1986
Orpheus Supertones 2005, 2014
Orrin Star 1979, 1986
Oscar Brand 1967, 1968, 1969, 1970,
 1971, 1979, 1980, 1983, 1986, 1991
Oscar Lopez 2000
Ossian 1988
Otis Brothers 1984
Otis Gibbs 2017
Otis Rush Blues Band 1972
Otis Taylor Band 2013
Outward Bound 1977, 1978, 1983
Owen McBride 1967, 1970, 1971, 1972,
 1973, 1977, 1978, 1998
Owl and Wolf 2016
Papa John Kolstad 1978
Pappy Sherrill (with Snuffy Jenkins)
 1974
Parker Millsap 2015
Parsonsfield 2014
Pat Alger 1975
Pat and Victoria Garvey 1970
Pat Donohue 1995
Pat Humphries and Sandy O 2004
Pat Webb (with Charlotte Daniels) 1965
Pat Wictor 2005, 2007, 2011
Patchwork: A Storytelling Guild 1992,
 1994
Patrick Chamberlain 1973, 1974, 1975,
 1976
Patrick Sky 1965, 1966, 1968, 1969,
 1970, 1971, 1974, 1984, 1991
Patrick Street 1989
Patty Larkin 1986, 1988, 1990, 1993,
 2000
Patty Nunn 1971
Paul Berliner 1973
Paul Butterfield Band 1965
Paul Cadwell 1962, 1964, 1969, 1970,
 1971, 1972, 1973, 1974, 1975, 1976,
 1979
Paul Geremia 1969, 1970, 1971, 1988
Paul Kaplan 1994
Paul Mamolou 2015
Paul Saint John 2015
Paul Siebel 1971, 1975
Paul Thorn 2012
Paul Ubana Jones 1993
Paula Ballan 1968, 1971, 1973, 1975,
 2017
Paula Lockheart 1978, 1979, 1986, 1988
Peasant 2008
Peg Leg Sam 1974

Peggy Atwood 1989
Peggy Seeger 1991, 2005
Pele Juju 1997
Pennsylvania Dutch Cloggers 1963
Penny Lang 1968
Penny Seeger 1991
The Pennywhistlers 1965, 1966, 1967,
 1968, 1969, 1970
Pepe Castillo-Criolla 1981
Percy Danforth 1989
Persuasions 1980, 1981
Pesky J. Nixon 2015
Pete Kennedy 1991
Pete LaBerge 2005
Pete Seeger 1962, 1967, 1978, 1991
Pete Sutherland 1990
Peter Alsop 1982, 1986, 1992
Peter Bellamy 1979, 1990
Peter Blood (with Annie Patterson),
 2016
Peter Eckland 1974, 1976
Peter Mulvey 2016
Peter Ostroushko 1979
Peter Ostroushko and Dean Magraw
 1993
Peter Paul Van Camp 1979
Peter Rowan and Jerry Douglas 1992
Peter Yarrow 1972, 2016
PG Six 2008
Phil Ochs 1964, 1965, 1968
Phil Roy 2004
Philadelphia Jug Band 2002, 2011, 2012
Philadelphia Tap Dancer 1981
PhillyBloco 2015
Pierce Pettis 1992
Pierre Bensusan 1985
Pieta Brown with Bo Ramsey 2003
The Pine Leaf Boys 2007, 2016
Pinmonkey 2003
Pint and Dale 1993
Pipeline 2006
Pitz Quattrone 1998, 2000
Planete Folle 1998
Plena Libre 2003
Plywood Cattle Company 1988
Pokey LaFarge and the South City Three
 2012
Polish American String Band 1981,
 1982, 1986
Poor Old Horse 1996
Princeton Ethnic Dancers 1972, 1975
Priscilla Herdman 1977, 1978, 1980,
 1983, 1989, 1990
Professor Longhair 1975
Providence 2002
Psych-a-Billy 2013, 2015
Psychedelic Elders 2016
Pullin' Teeth 1976
Putnam String County Band 1974
The Quebe Sisters Band 2007
Queen Esther 2017

Queen Ida 1983, 1985, 1987, 1989
Quentin Callewaert 2017
Quetzal 2005
Quiet Life 2016
Quiet Riot 1978, 1979, 2007
Quilt 1983, 1988, 1992, 1994
R. Paul Bergsman 1970, 1971
Radney Foster and Bill Lloyd 1990
Raelinda Woad 1995
Raianne Richards (with Mark
 Mandeville) 2015
Railroad Earth 2002
Railroad Fever 2016
Raintree 1979
Raise the Roof 2002
Ralph Rinzler 1962, 1963
Ralph Stanley and the Clinch Mountain
 Boys 1970, 2003
Ramblin' Jack Elliott 1962, 1984
Ranch Romance 1992, 1994
Ranky Tanky 2017
Rare Spirits 2016, 2017
Raul Malo 2006
Raun MacKinnon 1963, 1971, 1972,
 1973
Ray Gray 1981, 2005
Ray Kamalay 1986, 1987
Ray Naylor 1997, 2017
Ray Owen 2015
Ray Wylie Hubbard 1999
Rebecca Loebe 2014
Rebirth Brass Band 2009, 2014
Red Cedar Strings 1977, 1981, 1984,
 1987, 1992, 2012, 2016
Red Molly 2008
Red Stick Ramblers 2005
Reel World Band 1985
Refugees 2008
Regis Mull 1975
Reilly and Maloney 1984, 1985, 1987
Reverend Dan Smith 1971, 1972, 1977
Reverend Gary Davis 1962, 1966, 1969
Reverend Ian Campbell 1970
Reverend Peyton's Big Damn Band 2012,
 2013
Reverend TJ McGlinchey 2012, 2013,
 2016
Ribbon of Highway, Endless Skyway
 2006
Rich Hughes (with Scott Walter) 1971
Rich Moore (with Mollie O'Brien) 2016
Rich Myers 2015, 2016, 2017
Richard Drueding (with Tom Gala) 1988
Richard Fegy 1976
Richard Hughes 1969
Richard Rachelson 1971
Richard Thompson 1994, 2002, 2010
Richard Thompson Electric Trio 2013
Richie Havens 1981, 1982, 1986, 1991,
 2001
Rick Ilowite 1994

Ricky Skaggs and Kentucky Thunder 1996
Riders In The Sky 1981
RIG 2001
Rik Palieri 1999, 2001, 2005, 2007
River Whyless 2016
Rob Deckhart 2011
Rob Lutes 2004
Rob O'Connell 1983
Rob Peck 1979, 1980
Robbie MacNeill 1976
Robert and Pete Williams 1966
Robert Earl Keen 1989
Robert Hazard 2004
Robin and Linda Williams 1978, 1979, 1981, 1983, 1986, 1988, 1990, 1992, 1995, 2004, 2016
Robin and Linda Williams and Their Fine Group 2002
Robin Moore 1982, 1985, 1993, 1997, 2003, 2006
Robin Roberts 1971
Robin Williamson 1976, 1989
The Roches 1981, 1986, 1994, 2006
Rock My Soul - The Fairfield Four and McCrary Sisters 2016
Rockin' Acoustic Circus 2010
Rod MacDonald 1986
Rod Picott (with Amanda Shires) 2011
Rodney Crowell 2006
Roger Abrahams 1963
Roger and Gail Casey 1977
Roger and Joan Sprung 1971
Roger Deitz 1984, 1985, 1986, 1988, 1987, 1989, 1990, 1991, 1992, 1994, 2003, 2011, 2012, 2014
Roger McGuinn 2002
Roger Sprung 1964, 1965, 1966, 1967, 1968, 1974, 1975, 1977, 1978, 1979, 1980, 1981, 1982, 1983, 1984, 1985, 1986, 1987, 1988, 1989, 1990, 1991, 1992, 1993, 1995, 2016
Rolly Brown 1981, 1982, 1988, 1994, 1997, 2009, 2015
Ron Buchanan 2007, 2009, 2010, 2011
Ron Evans 1980
Ron Nolen 2015
Ronstadt-Ramirez Santa Cruz River Band 2006
Rooftop Singers 1967
Roosevelt Dime 2012
Roosevelt Sykes 1976
Rootology 2015
Rory Block 1985, 1989, 1992, 1997
Rosalie Sorrels 1967, 1969, 1970, 1971, 1975, 1981, 2000
Rosanne Cash 1997
Rosemary Woods 1998
Roy Berkeley 1967
Roy Book Binder 1975, 1978, 1984, 1987, 1996, 2001, 2011

Royston Wood 1976
Run of the Mill String Band 2003, 2006
RUNA 2011, 2013, 2017
Russell Fluharty 1966
Rusty and Jan 2016
Ruth Pelham 1986
Ruthie Foster with Cyd Cassone 2001
Ryan Montbleau 2008
Ryan Tennis 2010, 2016
Ryan Tennis and the Clubhouse Band 2014
Sacred Harp Group 1977
Sadie Green Sales 1998, 2000, 2005
Saffire, the Uppity Blues Women 1991, 1992, 1997
Sailor Bob Schmidt 1974
Salamander Crossing 1997
Sally Fingerett 1990
Sally Rogers 1982, 1983, 1989
Sam Baker 2017
Sam Bush 2007
Sam Gleaves 2016
Samantha Fish 2017
Samite of Uganda 1998
Samuel James 2008
Sandy Pomerantz 2002
Sandy Zerby 1974
Sara Chodak 2017
Sara Cleveland 1968, 1970, 1972, 1973
Sara Grey 1966, 1967, 1969, 1970, 1972, 1977
Sara Hickman 2009
Sarah and The Arrows 2016
Sarah Flynn 2013
Sarah Jarosz 2014
Sarah Lee Guthrie 2001
Satan and Adam 1993
Saul Broudy 1971, 1972, 1973 1974, 1975, 1976, 1977, 1978, 1979, 1980, 1981, 1982, 1983, 1984, 1985, 1986, 1987, 1991, 2006, 2013, 2017
Saw Doctors 2000
Scartaglen 1987
Schuylkill Bayou Ramblers 1993
Scott Alarik 1981, 1983, 2000, 2002
Scott Bricklin 2001
Scott Pryor and Common Sinners 2010
Scott Rovner (with Charlie Miller and Friends) 2015, 2016
Scott Rovner and Friends (Scotty and Friends) 2011, 2012, 2013, 2017
Scott Walter and Rich Hughes 1971
Scott Wolfson and Other Heroes 2015, 2016
Scrub-Board Slim 1977, 1978
Sean McGlynn 1980
Sechaba 1987
Secret Sisters 2012
The Seldom Scene 1985, 1987, 1993
Selwyn Birchwood 2015
Session Americana 2016

Seth Holzman 2013
Shakey Graves 2015
Shannon Lambert-Ryan and RUNA 2009
Shannon Whitworth 2010
Sharon Katz and the Peace Train 2002
Sharon Shannon 2016
Sharon Van Etten 2008
Sharon, Bram and Friends 2000
Shawn Colvin 1988
Shawn Proctor 2013
The Sheepdogs 2016
Shemekia Copeland 2002, 2006, 2014
Shetlands Young Heritage 1993
Shirley Lewis 1995
Shooglenifty 2002
Shoshana Damari 1966
Si Kahn 1984, 1990, 1997, 2016
Sian Frick 2005
Sid Root 2013, 2014, 2016
Sierra Hull 2017
Sierra Leone's Refugee All Stars 2013
Sileas 1989
Silk City with Dede Wyland 2002
Silverton 2015, 2017
Simon St. Pierre 1978
Simple Gifts 1998
Sippie Wallace 1973
Sir Douglas Quintet 1969
Sisters 3 2008
Skip Denenberg 2017
Skip James 1965, 1968
Skookill Express 1974
Skye Morrison 1988
Skyline 1978, 1983, 1987
Slaid Cleaves 1998
Sleepy Man Banjo Boys 2013
The Slide Brothers 2014
Slippery Elm 1975
Slo-Mo featuring Mic Wrecka 2009
Small Potatoes 1996, 1998, 2001
Smith Sisters 1985
Snuffy Jenkins and Pappy Sherrill 1974
So's Your Mom 1993, 1999, 2000
Solas 1997, 2001
Son House (Eddie James House) 1967, 1968
Son of Town Hall 2017
Son Seals Band 1983
Son Volt 2007
Sones de Mexico 2004
SONiA 2001, 2014
Sonny Landreth 2009
Sonny Miller 1962, 1963
Sonny Ochs 2011
Sonny Terry 1984
Sonny Terry and Brownie McGhee 1973, 1980
Sonoma Sound 2014
Sonos 2010
Sons of the Birds 1967
Sons of the San Joaquin 2003

Sotavento 1988
Sparkle Pony 2016
Sparky Rucker 1978
Spatz 1985
Spencer Nelson 1979, 1980, 1981, 1982, 1983, 1984, 1985, 1986, 1987, 1988, 1989, 1991, 1992, 1993, 1994, 1995
The Spinning Leaves 2010
Spirit Family Reunion 2013
Spirit Wing 2003, 2017
Spirit Wing and Friends 2005
Spoons Williams 1983
Spuyten Duyvil 2012, 2013, 2014, 2015, 2016, 2017
Stacey Earle 1999
Stan Rogers 1978, 1982
Star and Micey 2013
Star Spangled Washboard Band 1975, 1977
Stars of Faith 1969, 1970
Steam Powered Aereo Band 2013
Steeleye Span 1987
Steep Canyon Rangers 2014
Stefan Grossman (with John Renbourn) 1988
Stephen Cohen 2008
Stephen Kellogg and the Sixers 2008
Stephen Marmel 2011
Stephen Wade 1976, 1977, 1991, 2007, 2017
Steppup Puppets 1977
Steve Blackwell and Friends 1997, 2001
Steve Burgh 1973, 1975, 1976
Steve Cormier 1983
Steve Earle 2008
Steve Earle and the Dukes 2012
Steve Earle Group 1995
Steve Forbert 1991, 1999
Steve Gillette 1966, 1967, 1968, 1986, 1991, 1992
Steve Gillette and Cindy Mangsen 1996, 1999, 2003
Steve Goodman 1970, 1971, 1972, 1973, 1976, 1978
Steve Guyger 2013
Steve Key 1991
Steve Mandell 1974
Steve Poltz 2014
Steve Pullara 1995
Steve Riley and the Mamou Playboys 1995, 2011, 2015
Steve Schonwald 2003
Steve Schonwald and Jennifer Schneck 1996
Stevie and the Bluescasters 2017
Stewarts of Blair 1988
Stewed Mulligan 1990
Still on the Hill 1999
The Story 1992
Strand of Oaks 2012
Strange Creek Singers 1972

Strangelings 2008
Strauss and Warschauer Duo 2001
The Stray Birds 2013, 2016
Stretch Pyott 1977, 1978, 1979, 1980, 1981, 1982, 1983, 1984, 1985, 1986, 1987, 1988, 1989, 1990, 1991, 1992, 1993, 1994, 1995, 1996, 1997, 1998, 1999, 2001, 2002, 2003, 2005, 2011
Stu and the Gurus 2016
Sturgill Simpson 2014
The Subdudes 2010
Sue Dupre 1985, 1996
Sue White and Cathy Ramos 1975
Sukay 1979, 1992
Sun Rhythm Section 1991
Suni Paz 1978
Susan Herrick 1994
Susan Piper 1985, 1995, 1997
Susan Werner 1992, 1993, 1995, 1998, 2002, 2017
Susan Werner with Trina Hamlin and Natalia Zukerman 2010
Susie Burke and David Surette 2005
Susie Monick 1976
Suzanne Gross 1963, 1975
Suzanne Vega 1985
Suzie Brown 2011
Suzy Bogguss 1999
Suzzy Roche 1997
Svitanya 2005
Swallowtail 1983, 1984
Sweet Accord 1983
Sweet Honey in the Rock 1975
Sweet Stavin' Chain 1968, 1969
Sweetback Sisters 2010
Sweetbriar Rose 2013, 2017
Sylvia Platypus 2015, 2017
Taffy Nivert (with Bill Danoff) 1971
Taj Mahal 1979, 1980, 1982, 1985, 1988, 1990, 1992, 2004, 2010
Taj Mahal (with Keb' Mo', "TajMo") 2017
TajMo (Taj Mahal and Keb' Mo') 2017
Tall Heights 2015, 2016
Tambo 1975
Tania Alexandra 2010
Tannahill Weavers 1982, 1993
Tanner Brothers 1969, 1970
Tao Rodriguez-Seeger 2001
Tara Murtha 2015
Tarbox Ramblers 2001
Tarheel Slim 1974
Ted Fink 1993
Ted Lundy and Bob Paisley 1978
Tempest 1995, 1997, 1999, 2001, 2003, 2005, 2008, 2011, 2014, 2016
Ten Strings and a Goat Skin 2014
Teresa Pyott 1996, 1997, 1999, 2004
Terrance Simien and the Zydeco Experience 2008, 2011
Terri Allard 1999
Terri Hendrix 2003, 2006

Terry Garland 1991, 1992
Terry McGrath 2000, 2001
Terry Rivel 2016
Tex Logan 1973
That 1 Guy 2010
Theodore Bikel 1963, 1965, 1966, 1969
The Theologicals 2017
Thomas Wesley Stern 2016
Tift Merritt 2017
Tim and Mollie O'Brien and the O'Boys 1995
Tim Britton 1978, 1980, 1987
Tim Harrison 1980
Tim Motzer (with Ursula Rucker) 2013
Tim Van Egmond 2014
Time for Three 2004
Timoney Irish Dancers 1998, 2000
Tin Bird Choir 2008, 2010, 2015
Tish Hinojosa 1993
Toby Fagenson 1981, 1982, 1983
Toby Walker 2007, 2016
Todd Fausnacht 2015
Todd Rundgren 2013
Todd Snider 2003
Tom Brandon 1966
Tom Chapin 1986
Tom Coughlin 1986, 2012
Tom Dahill 1986
Tom Dundee 2000
Tom Gala 1981, 1996, 2003
Tom Gala and Richard Drueding 1988
Tom Lewis 1995
Tom Paxton 1964, 1965, 1966, 1967, 1969, 1970, 1975, 1977, 1978, 1983, 1985, 1986, 1988, 1991, 1994, 1998, 2001, 2008, 2011, 2015
Tom Prasada-Rao 1994
Tom Rush 1965, 1966, 1969, 1974, 1977, 1979, 1980, 1981, 1984, 1986, 1988, 1990, 1991, 1995, 2001, 2009, 2011
Tom Russell 2004
Tom Sauber (with Alice Gerrard and Brad Leftwich) 2002
Tom Winslow 1977, 1978, 1981, 1988
Tommy Emmanuel 2002, 2014
Tommy Makem 1991
Tony Barrand (with John Roberts) 1970, 1971, 1972, 1973, 1975, 1978, 1985, 1989, 1992, 1998, 2004
Tony Bird 1979, 1980
Tony Hughes 1970, 1971
Tony Saletan 1963
Tony Trischka Band 2009
Topper Carew 1971, 1972, 1973
Tori Barone 2005, 2007
Tossi Aaron 1962, 1963
Tossi and Lee Aaron 1967, 1970
Toucan Jam 1999
Touchstone 1984
Toy Soldiers 2013

Tracy Dares 1994
Tracy Degerberg 2013
Tracy Family Band 1979, 1980, 1982, 1983
Tracy Grammer 2002, 2012
Tracy Grammer (with Dave Carter) 2000
Tracy Schwarz 1964
Trapezoid 1978, 1984
Treasa LeVasseur 2010
Tret Fure (with Cris Williamson) 1994
Trina Hamlin 2010
Trina Hamlin (with Susan Werner and Natalia Zukerman) 2010
Trinidad Steel Band 1972
Trombone Shorty and Orleans Avenue 2011, 2012
Trout Fishing in America 1993, 1994, 1997, 2008
Tuckers Tales Puppets 1987, 1993, 2002, 2012, 2013
The Turnips 2011, 2012
Twelve Moon Storytellers 1981
Two of a Kind 1994, 1997, 2000, 2003, 2005, 2010, 2016, 2017
Uncle Bonsai 1987
Uncle Earl 2004
Unlikely Cowboy 2007
Up the Chain 2013, 2014
Ursula Rucker 2008
Ursula Rucker and Tim Motzer 2013
US Rails 2011
Utah Phillips 1970, 1971, 1972, 1975, 1978, 1979, 1990, 2001
Valley Creek 2015
Vanaver Caravan 2008
Vance Gilbert 1994, 1999, 2007, 2014
Victoria Spivey 1973, 1974

Vienna Teng 2010
Vin Garbutt 1975, 1979
Vince Masciarelli 2002
Vinegar Creek Constituency 2013
Vinx 2008
Vishten 2016
Vita and the Woolf 2017
Voices of the Folk 1994, 1997
Voices of the Wetlands Allstars 2012
Vulcans 2014
Wailin' Jennys 2005
The Wallace Brothers Band 2014, 2015
Walt Michael 1993
Walt Michael and Company 1987
Walter "Wolfman" Washington and the Roadmasters 2016
Wanamaker Lewis 1985
Wareham Family 1981
Washboard Slim Young 1967, 1983
Washington Square 1984
Wayfaring Strangers 2001
Wayne Toups and Zydecajun 1990
We're About Nine 2004
Weavermania 2000
The Weight Band with the King Harvest Horns 2017
Wendy Beckerman 1996
Wendy Grossman 1978
Wes Mattheu and New Way Down 2011
Wesley Stace 2016, 2017
Wesley Stace (as John Wesley Harding) 1996
West Philadelphia Orchestra 2009
Whetstone Run 1985
Whirligig 2001
Whiskeyhickon Boys 2012
White Water 1999

Whitehorse 2017
The Whites 1990
Wild Asparagus 2004
The Wilderness of Manitoba 2011
Wildflowers 1971
Wildweeds 1970
Wilf Wareham 1973
Wilfred Guilette 1971
Willa Ward Gospel Group 1975
William Brooks 1967, 1968
Willy Porter 1999
Winnie Winston 1976, 1977, 1978, 1979, 1982, 1992, 1994
Wishing Chair 2004
Wissahickon Chicken Shack 2009
Wolfstone 1996, 2005
Women's Sekere Ensemble 2000
The Wood Brothers 2011, 2016
Wooden Sky 2012
Works Progress Administration 2009
Xavier Rudd 2003
The Young Novelists 2017
Young Tradition 1968
Zach Djanikian 2009
Zach Stock 2012
Zachary Richard 1993
Zan McLeod 2007
Zenith String Band 1977, 1978
Zenska Pesna 1979
Zima 2000, 2002, 2005
Zulu Spear 1992
Zydeco A-Go-Go 2004

THE PHOTOGRAPHERS

Rebecca Barger was a staff photographer for the *Philadelphia Inquirer* from 1985–2005, resulting in two Pulitzer Prize nominations for her photographs. Currently she photographs weddings and events in the Philadelphia and surrounding regions. Rebecca is a music lover who has sporadically attended the Philly Folk Festival since 1978, when she volunteered as a photographer for about ten years. Rebecca can be reached at rebeccabarger.com.

Laura Carbone is a practicing physician, as well as a well-known photographer for the blues scene. Her pictures have been selected for album covers, posters, artists' web pages, and dozens of national magazines. Laura is in the New York Blues Hall of Fame, a regular contributor to *Elmore Magazine*, *Big City Blues*, and *Blues Music Magazine*, as well as album cover photos, and has now has taken on producing shows, bringing national bands to upstate New York.

Robert Corwin, says Peter Yarrow (of Peter, Paul and Mary), "brilliantly captures Folk, Blues, Bluegrass, Country, Cajun, Jazz, Rock, and other roots musicians in classic and historic imagery . . . [he is] perhaps best known as the most gifted documentarian of the spirit, personality, and ethos of the folk music scene and the performers who give it its vitality . . . he manages to portray essence in gesture, in the 'decisive moments.'"

Peter Cunningham has been among the elite music photographers in the United States since the early 1970s. His first professional assignment was to shoot Bruce Springsteen's first publicity shots for Columbia Records in 1973, and nine years later he shot the first publicity stills of Madonna for Warner Brothers. Peter remains very active, and examples of his work—past and present—can be found at petercunninghamphotography.com.

Melissa June Daniels is a Pennsylvania photographer whose photographic pursuits and love of music and community have drawn her into the Philly Folk family as an annual volunteer. She enjoys putting her long exposure skills to the test in the campgrounds after dark.

Diana Davies was one of the leading photojournalists documenting the feminist and gay liberation movements of the 1960s and '70s. Her photographs cover the early days of diverse women's and LGBT social movements, as well as the Civil Rights, Peace, and farm workers' rights movements. Her work is housed in the Ralph Rinzler Folklife Archives and Collections in the Smithsonian Center for Folklife and Cultural Heritage, the New York Public Library, Howard University, the Greenwich Village Society for Historic Preservation, the Sophia Smith collection at Smith College, and the Swarthmore Peace collection.

Sandra Dillon is a local photographer and film editor who has been photographing the Philly Folk Festival since she was fifteen. An avid traveler, she has traveled to more than thirty-six countries—and counting. Some of her zany adventures include trekking on horseback through the volcanic landscape of Iceland and camping under the stars in the Sudanese desert. Her favorite adventures are late at night, roaming the Festival campgrounds with her sister Sharon and traveling minstrels Graham and Eric of the Karmic Repair Company. Find her at sandradillon.com.

Wanda Fischer is an amateur photographer who attends many festivals and had the pleasure of shooting at some Philly Folk Fests in the early 1970s. A longtime folk music DJ in the Albany, New York, area, she has been involved in folk music since she was very young, making her singing debut at the age of four. In addition to radio, her folk music activities include Folk Alliance International and the Northeast Regional Folk Alliance. She lives in Schenectady, New York, with her husband of forty-five years, Bill.

Donald Hoy has lived his entire life in the suburbs of Philadelphia, has been a Folk Festival attendee and volunteer since 1978, and has been among the leading figures in the Festival's recycling efforts. He first developed an interest in photography in the late 1970s, and in the past eight years has been attempting to take it to the next level. He is also an amateur musician, playing around with fiddle, mandolin, and harmonica.

Daniel C. Hulshizer is a veteran news and arts photographer whose work has appeared for many years in many settings, including the Associated Press.

Frank Jacobs III is a retired photojournalist of twenty-one years at the *Trenton Times*. He is now a photographer "out to pasture" in the Delaware Valley, where he photographs wedding-type events, high school and college sports, and all related activities, as well as his number one love, photographing music festivals in beautiful *and* muddy weather. Frank resides in Trenton, New Jersey, and can be easily found on Facebook.

Stephanie P. Ledgin is an award-winning journalist and photographer. The author of three acclaimed books, she is the recipient of several honors, including the 2007 International Country Music Conference's Career Award for Excellence in Country Music Journalism and the 2005 International Bluegrass Music Association (IBMA) Print Media Award. A former member of the IBMA Board of Directors and a founding member of Folk Alliance International, Stephanie's next book, *Exceptional Music: A Retro/Futurespective*, will arrive in 2018. Find her online at ledgin.com.

Alex Lowy says, "1973 was a memorable year, having the [life-changing] experience of meeting music superstars and then being on stage with them during their performances . . . first Michael Jackson and then Stevie Wonder (along with many other music icons at the Hampton Jazz Festival, where I was responsible for arranging the microphones for every group). It fueled an inner drive to be around performers more and more, capturing them with my camera. I

still feel the same joy I derived from my experiences at HJF yearly at Philly Folk Fest."

Ellen Nassberg and her partner Jim Tarantino have been photographing festivals around the country since at least the 1980s. In addition to her Philly Folk photos, Ellen has extensive archival shots of other longtime regional festivals, such as the Delaware Valley Bluegrass Festival.

Richard Nassberg was a gifted artist whose portfolio of black-and-white photography spanned decades, and was shown multiple times at the Houston FotoFest. In the 1980s, he was invited by Arkansas State University to be a visiting artist. Recently his art was featured in a show at the Samek Art Museum at Bucknell University, where some of his work was acquired by the museum for their permanent collection. His work also stands as a part of many private collections. Sadly, Richard passed away in January 2018.

Robert Penneys says, "I wonder if any of my old stuff was useful for this new book." Turns out it was. A graduate of the Germain School of Photography in New York City, he operated a studio in Center City Philadelphia for many years until the neighborhood was torn down to make way for the Convention Center. He moved out to Havertown, is still active, and is a member of the American Society of Media Photographers.

Howard Pitkow specializes in images of events and music. His first Philadelphia Folk Festival experience was more than fifty years ago, and he has been returning to the Old Pool Farm ever since. At the Festival he focuses on performers, people enjoying the festival, and "behind the scenes" photography. Find him at howardpitkow.com.

Neal Pressley grew up in Littlefield, Texas, and moved to Lancaster, Pennsylvania, in 1974. He began working in photography with a 35 mm camera in 1978, to document the birth of his son. He gradually moved into the world of fine art photography through the study of black-and-white film in art school at Millersville University of Pennsylvania, as well as numerous workshops with master photographers throughout the US.

Steve Ramm is a music journalist and photographer who has been capturing the Philly Folk Fest since 1970. He is a "Top 50 Reviewer" on Amazon.com and continues to write his "Anything Phonographic" column after nearly thirty years.

Barry Sagotsky spends most of his time as a management consultant and has been an avid Philly Folk Festival attendee since 1966, and a photographer since 1971, missing only two Festivals in that time. In his professional life, Barry helps people and Fortune 500 organizations plan, implement, and achieve personal and corporate goals. In that role, Barry volunteered to work with the Philadelphia Folksong Society board for a couple years to help them create and begin implementation of a new aspirational strategy. In his photography, Barry's intention is to show the viewer what it feels like to be in that moment with the performer or audience.

Steven Sandick got his first camera at age ten, a gift from his uncle. He had an immediate love for the art of photography. Steven spent years honing his skills by photographing portraits, landscapes, weddings, sports, still lifes, etc. He finally combined his photography with his love of music and became a music photographer. His goal and favorite compliment of his work is when critics say, "they can actually hear the music from my photos."

Lisa Schaffer says, "I've been going to the Philadelphia Folk Festival since 1997, including being around seven months pregnant at two of them. I started a business as a freelance photographer specializing in the Philly music scene in 2004. I also started photographing the Folk Festival that same summer. It has been so exciting hearing the lineup announced every year, which includes so many of my clients/friends, and watching them perform at Fest is such a highlight for me!"

Mark Silver says, "I came. I saw. I photographed."

Mark Smith started attending the Philadelphia Folk Festival in 1970, and says he has been lucky to get photographer credentials every year since 2004. He has heard great music, made some great friends—and took a couple pictures.

Bryce Swanker is rumored to be a close associate of the Spam Hogs.

Murray Weiss was a New York City native who specialized in shooting natural landscapes, architecture, and environments in Greece, Cape Breton (Nova Scotia), Mexico, and the United States. He was affiliated for several years with the Philadelphia College of Art and co-founded the Milwaukee Center for Photography, serving as director since 1975. He passed away in 2016.

Thom Wolke is a professional photographer—though not a career cameraman—whose work is primarily centered around music related images, many of which have appeared in dozens of newspapers and important music related magazines like *Dirty Linen*, *Blues Review*, *Billboard*, and *Us*, and in books, including the one celebrating the fiftieth anniversary of the legendary Caffè Lena in Saratoga Springs, New York. He currently resides in the Connecticut Valley of New Hampshire, raising his daughters and managing the career of blues artist Guy Davis.

Bob Yahn discovered folk music and photography at about the same time. His first photo encounters were the New Jersey Folk Festival and the Mine Street Coffeehouse in New Brunswick, and he learned about the larger festival calendar from there, "graduating" to the Philadelphia Folk Festival, Great Hudson River Revival, and Appel Farm Festival. Bob is now involved with the Susquehanna Folk Music Society, and is always discovering new events to attend with his camera.

IN RECOGNITION

We would like to thank the following people who donated to this project during our Indiegogo® campaign; without your help this book would not have been possible.

Joshua Banta

Maya Bass

Linda Becker

Barbara Bonner

Ernie Bouey

Lee A. Bowers

Jim Burdick

Robert M. Carlino

Meghan Cary

Larry and Janet Chrzan

Rhonda and David Cohen

Crandall Public Library

Anthony Creamer

The Crilley Family

Steven Davidson

Sue and Don Diesinger

Marie Dolton

Brian Donnelly

Maryann Doud

Eric Eckstein

The Edge Hill Rounders

Sharon Fine

Tina Floyd

John R. Foster

James P. Fox

Jennifer French

Greg Frost

Edward R. Geller

Jennifer Gillman

Deborah Goddard

Willis Godshall

Lisa Gohr

Robert Grimley

Suzanne Grimley Santangelo

Joe Hochreiter

M. Christine Holden

John and Ruthanne Hoover

William Houston

Donald Hoy

Jessica Hull

Laurel Bree Husk

Hugo and Sharon Immediato

Margaret Innes

Sandy Johnson

Robyn Kaleta

John Kearney

Lance Lehman

Robert Leonetti

Matthew J. Lisowski

Robert Livrone

Jesse Lundy

Paul Mamolou

Greg and Evie McCullian

Jillian McGillian

TJ McGinchey

John and Johnnie Sue McGinchey

In Loving Memory of Ray Sommerville

Debbie Goddard playing guitar at their camp.

Carol and Emily Goddard in Dulcimer Grove.

Phil McLaoughlin

Charlotte Micklos

Vicki Miller

Carolyn Miller

Charlie Miller

Joyce K. Moore

Ray Naylor

Regina Oboler

Nina Owens

Gary and Karyn Pendleton

David Quain

Carmen Reynal

Amie Richan

Rita Rueger

Jessica Rutkowski

Robert Ryan

Susan Samitz

Paul and Barbara Schaffer

Lisa Schwartz

Amy B. Shafer

Vicki Sharpless

William Shaw

Joanne Shea

Lynn Sherran

The Shoulson Family

Alan Sigman

Howard Smith

Charles Smith

Anne Smith

Diana Snyder

Harvey Soifer

Nina J. Soloner

Ray and Monica Sommerville (In

Memory of Ray Sommerville)

Judith Space

Barbara Sundin Henry

Dr. Bob and Dianne Tankle

Randall Taylor-Craven

Hank Voigtsberger

Mary Ann Volk

Jamie Walko

Melissa Wallen

Kyle Webb

Audrey Wells

Tom West

Joseph Winoski

Jeff Zolitor

Carl Zuckerman